Mastering Canon EOS Flash Photography

NK Guy

Mastering Canon EOS Flash Photography

rockynook

NK Guy, photonotes.org

Editor: Gerhard Rossbach
Production Editor: Joan Dixon
Copyeditor: Lisa Danhi
Layout and type: Petra Strauch, just-in-print@gmx.de
Cover design: Helmut Kraus, www.exclam.de
Cover photos: NK Guy
Printer: Lifetouch, Inc. through Four Colour Print Group, Louisville, Kentucky
Printed in USA

ISBN 978-1-933952-44-4

1st Edition
© 2010 NK Guy
Rocky Nook, Inc.
26 West Mission Street, Ste 3
Santa Barbara, CA 93111-2432

www.rockynook.com

Library of Congress Cataloging-in-Publication Data

Guy, NK.
 Mastering Canon EOS flash photography / NK Guy. -- 1st ed.
 p. cm.
 ISBN 978-1-933952-44-4 (alk. paper)
 1. Electronic flash photography. 2. Canon camera. I. Title.
 TR606.G89 2009
 778.7'2--dc22

 2009043427

Distributed by O'Reilly Media
1005 Gravenstein Highway North
Sebastopol, CA 95472

All photographs and illustrations by the author.

This book is printed on acid-free paper.

For Dad. Who taught me that to find a photograph, you've sometimes got to wait.

Table of Contents

Foreword by David Hobby

Twenty-five years ago, when I first became a professional photographer, I scraped together $650 (which went much further than it would today) and bought a specialized Polaroid back for my Nikon. It was ridiculously expensive, but it did one thing very well. For just two dollars and a two-minute wait, I could see a tiny, near-instant photograph from my 35mm camera.

And I did it for one reason: to help me improve my flash photography.

The device was painfully expensive to buy and to use, but it was worth every penny. I finally had the instant feedback I needed to adjust my lighting on the fly. I could see what I was doing wrong and fix it immediately. Or, more often, see that my lighting was too boring and kick it up a notch.

Fast forward to 2009, and everyone has Polaroid backs, disguised as small screens, on the backs of their cameras. Instead of two minutes and two dollars, the result of your just-taken photo is displayed instantly, and for free.

Combine that with the availability of small, powerful and sophisticated flashes, and the result is literally hundreds of thousands of new photographers around the world experimenting with light in new and interesting ways.

But even though we have the feedback from the screen, flash is intimidating for many of us. The process is somehow mystical in that it happens all at once, which makes it harder to understand than a continuous light source.

Though it can be a bit of a hurdle to overcome, learning how to use your flash—both on-camera and off—is worth the effort. Photographers write with light, and there is no small light more versatile and/or more powerful than the small flash built for your DSLR.

When we shoot with the flash on the camera, we see the world as if we are walking around with the sun behind us. Sure, the detail is recorded, but all three-dimensionality is lost. It is as if we are taking pictures of our world with a photocopier.

But move the lights away from the camera, and shape is revealed. That difference between what the camera sees and what the light sees creates form, texture, mood, and feeling.

Light is the single most important element that determines the feel of a photograph. And yet so many of us are held captive to whatever available light is provided. Taking the leap to learn how to control your own lighting opens the door to a completely new world of photography. Your vision—your creativity—becomes limitless. You can create any look you want.

And all of the magic happens in less than a 1/1000 of a second. All you have to do is understand the principles well enough to start to experiment and play.

If you were a painter, you would take the time to learn about paint: how to color it, how to mix it, how to apply it, and how to shape it.

You are a photographer. Make the same commitment to learn those things about light.

David Hobby
Strobist.com
Columbia, MD, USA
August 2009

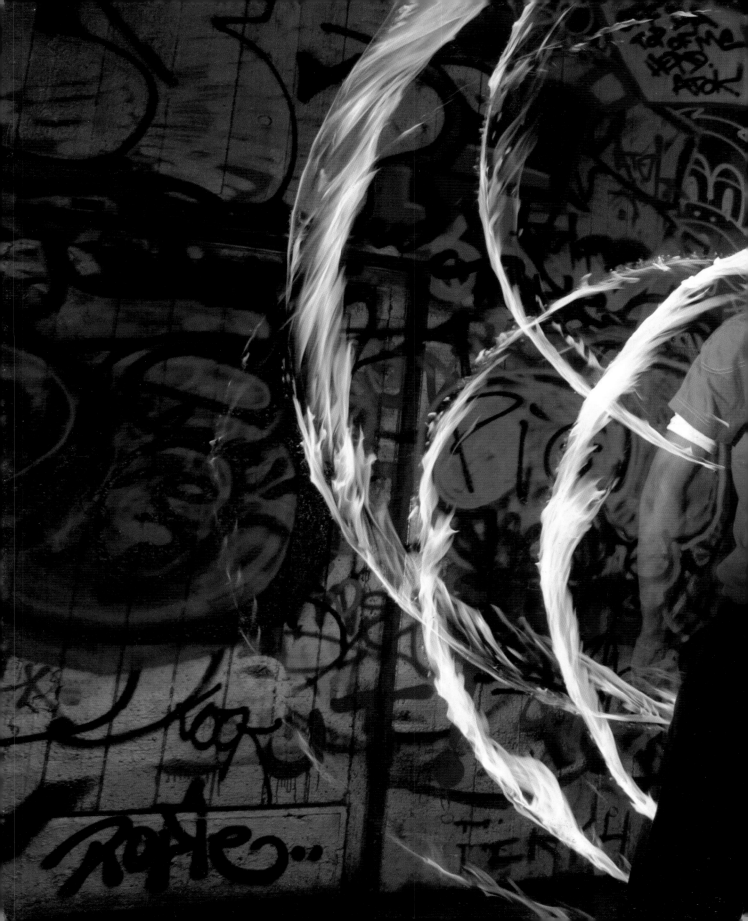

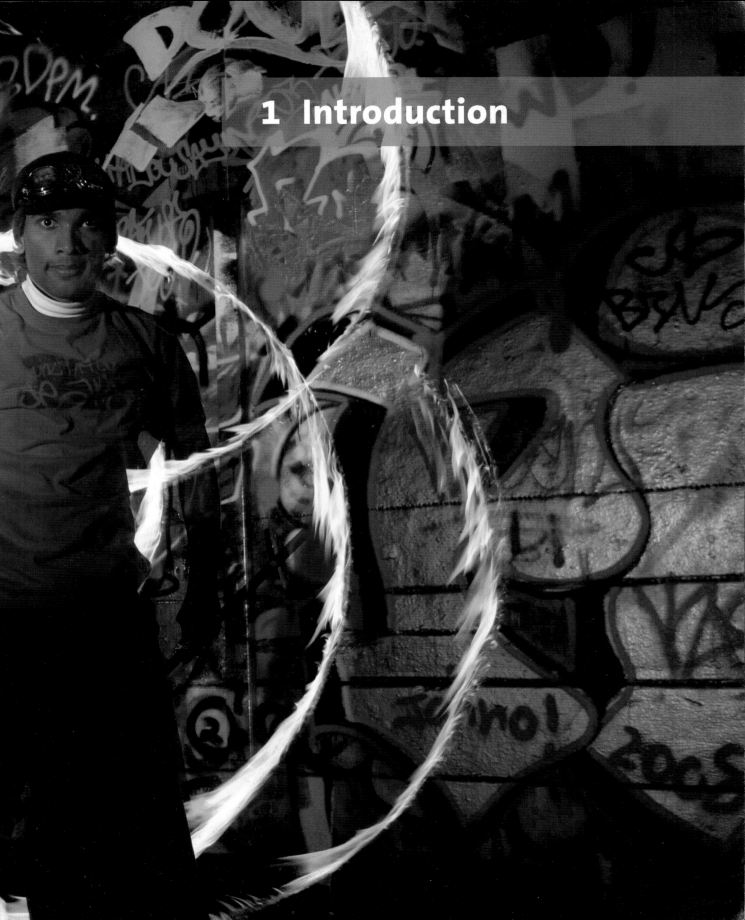

1 Introduction

The invention of electronic flash, and its subsequent miniaturization and automation, completely transformed photography. The earliest photographers were constrained by the availability of sunlight, but today reliable and portable light sources are at every photographer's disposal.

Electronic flash was first used in the 1930s as a tool for freezing motion and illuminating dark scenes with artificial light, but flash is now used for all types of photography, creative and mundane. Its uses range from supplementing daylight to designing complex scenes lit by multiple light sources.

But flash photography is also a difficult artistic and technical challenge. When most people hear the word "flash", they think of harshly lit snapshots: friends in a dark cavern of a restaurant or living room, staring into the lens like deer in the headlights. This represents the typical experience of flash photography—but it doesn't have to be that way.

So the basic question is, how to go from this... to this?

Both photos were taken with the same camera, the same lens, the same lens focal length, and the same model. Everything was identical—except that the first photo was taken using the camera's built-in flash, whereas the second photo was taken using a two-light studio setup.

This book will help you master the use of flash, covering everything from Canon's Speedlite flash system to off-camera portable flash and professional studio lighting. It begins with the fundamentals of flash metering technology, discusses key concepts, documents the various features and functions available with EOS equipment, explores flash accessories and studio equipment, and concludes with a review of basic lighting techniques. Much of this material is relevant to users of any camera system, but most of the details of automated flash (TTL and E-TTL) are specific to Canon EOS.

It also covers the exploding field of off-camera flash, whether through portable battery units or traditional studio lighting. This is an area traditionally seen as too daunting for all but professional photographers, but the combination of digital's immediacy and ease of use, and popular websites such as Strobist.com, have brought off-camera flash to a whole new audience.

Finally, this book is intended to be as thorough as possible. Every item was tested and evaluated before being included—this is no mere advertising brochure. Products are described as honestly and fairly as possible. Unfortunately, a few popular product lines are not included because some manufacturers and distributors declined to participate.

About this book

This book is structured in three separate sections. Part I explains the technology of flash photography and how it works. Part II deals with the nitty-gritty of the equipment in finer detail. Part III offers some lighting techniques to help take great-looking photographs.

Because of the complex and interrelated nature of the topics, the book isn't necessarily structured in order of difficulty.

Why this book

In 1987 Douglas Adams wrote, "If you really want to understand something, the best way is to try and explain it to someone else". This idea was the germ of my series of PhotoNotes.org articles, which I initially wrote in 2000–2002 when I was struggling to understand flash technology.

In those pre-digital (for me) days, the feedback loop was quite long and expensive. I had to take photos, make copious notes, develop the film, and hope I hadn't lost the notebook by the time I got the photos back from the lab. I couldn't afford one of David Hobby's Polaroid backs. My articles began as a simple set of notes for my own use, but soon evolved into one of the main online resources for Canon EOS flash information.

In 2008, I approached Rocky Nook about the possibility of using those articles as the starting point for a new book, and *Mastering Canon EOS Flash Photography* was born. Flash photography using the EOS system has long been an area of mystery and sparse documentation, and hopefully this book will change all that.

NK Guy
London, England

PART A: GETTING STARTED

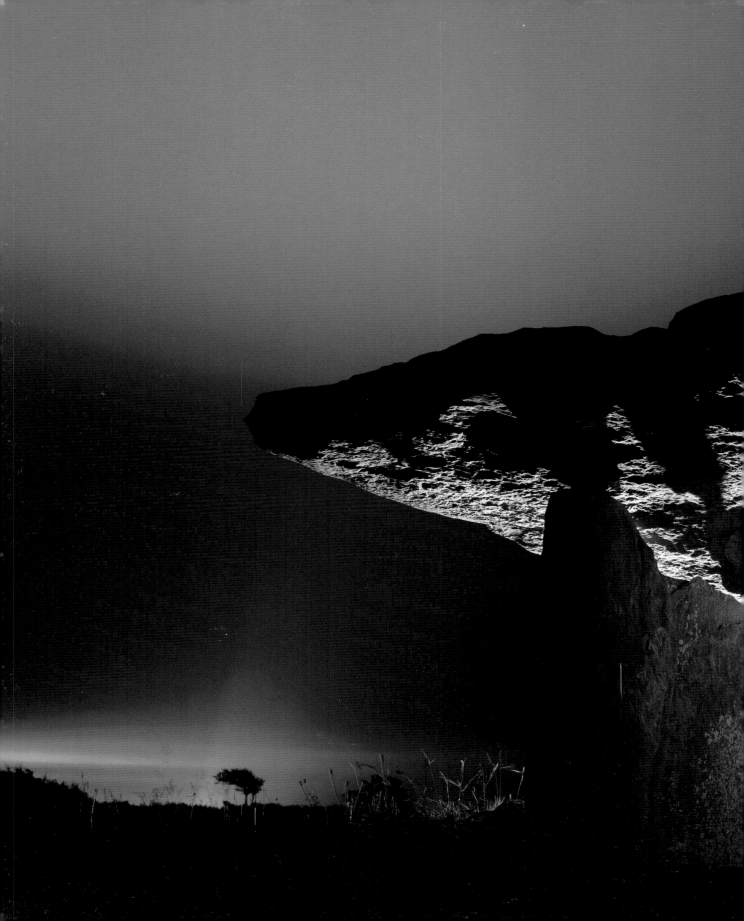

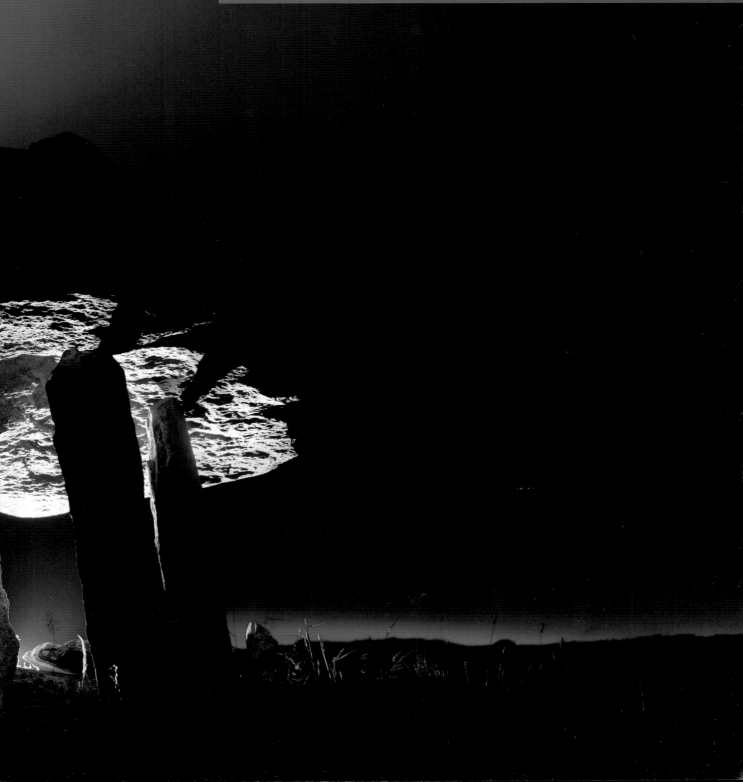

2 Getting Started

Figure 2-1

A t its simplest, flash photography is nothing more complicated than lighting a scene with a single, brief burst of light. Even so, flash photography has always been a very difficult technique to master on any camera system.

This is largely because the human eye can't fully discern the effects of a flash burst at the time an image is taken—the pulse of light is just too short. It's also because small light sources can produce a very unnatural form of light. Mastering flash, therefore, requires two basic skills: the ability to understand how flash will light a scene, and the ability to modify the intense, direct light to best suit a photograph.

Most of this book is dedicated to describing how things work and what tools are available. But if you want to get going right away, here are some quick and easy starting points.

2.1 A beginner's configuration: Canon Rebel T1i/500D with a 430EX II flash unit

The EOS Rebel T1i or 500D camera (same product, different markets) is an entry-level digital SLR camera. While it contains a perfectly functional built-in popup flash unit, there is a lot of versatility and power to be gained by adding an external flash unit.

The Speedlite 430EX II is a medium-sized flash unit that is fully compatible with all the automatic features of the camera (though since the camera is so tiny, the 430EX II is a bit large by comparison!) ● *Figure 2-1*.

Most of the information here also applies to most digital EOS cameras and to the Speedlite 430EX.

Figure 2-2

● To begin, install four new or freshly charged AA cells into the flash unit. Be careful to follow the polarity diagram in the battery compartment: if even one battery is upside-down, the unit won't power on. ● *Figure 2-2*

● Slide the foot of the flash unit into the hotshoe on the top of the camera, as shown here. The base of the flash foot has a rotating lever mechanism which must be in the left-most position before attaching. The lever is then turned to the right to lock the flash unit firmly into place. The 420EX and 430EX have a rotating pressure ring instead of a lever lock. The ring must be rotated all the way to the right (clockwise when looking at the base of the flash unit) before attaching, then tightened by turning the other way. ● *Figure 2-3*

Figure 2-3

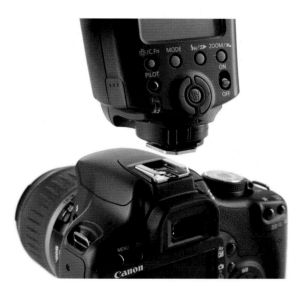

> Next, turn on the flash unit using the ON/OFF switch. After a few moments, a light marked PILOT will appear on the back of the flash unit, indicating that it's charged and ready to go. ● *Figure 2-4*

Figure 2-4

❯ If you half-press the shutter button on the camera, you'll notice the ⚡ symbol in the viewfinder, indicating that the camera recognizes the presence of the flash unit, and that it's charged up and ready. ◉ *Figure 2-5*

Figure 2-5

❯ Point the camera at your subject, then press the shutter release button all the way to take a photo. The flash will fire automatically if it's fully charged. ◉ *Figure 2-6*

Figure 2-6

2.2 Flash exposure compensation (FEC)

Examine your photo. Is the area lit by the flash too dark or too bright? The output level of the flash unit is determined by the camera's automatic flash metering system, but it isn't capable of making artistic decisions.

❯ To make the output of the flash brighter, press the SEL/SET button on the back of the 430EX II. When the ⚡ symbol starts blinking on the screen, press the − or the + button. This is one way of applying more or less flash output, a feature known as flash exposure compensation (FEC) (sections 6.17 and 9.9). Adjust to taste. In the example shown here, the flash has FEC dialed down by 2/3 of a stop. ● *Figure 2-7*

Figure 2-7

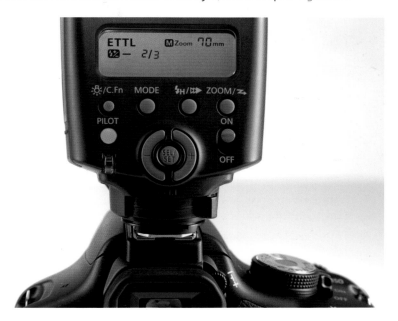

2.3 Bounce flash

Direct flash is a notoriously harsh form of lighting, since most of the light illuminating the subject is shone in a small and focused beam. This is very efficient, but not a very good way of making a great portrait of someone.

One way to soften the light is to reflect it off a larger surface so that the light hitting the subject no longer originates from a small area. This is known as "bounce" flash, which is a simple way to improve flash photos at essentially no extra cost. All that's required is a flash head that can be rotated and tilted independently of the flash unit's body. Fortunately the 430EX II has this feature.

◉ Let's start with figure 2-8 which was lit by direct flash. The flash unit's head is pointed directly at the model, and the result is a pretty unflattering shot. Every slight skin blemish is highlighted, and the slight sheen to her face has turned into a bright glare. Also, since the camera was rotated 90° into portrait configuration, a dark ugly flash shadow has appeared to the right of our model. ● *Figure 2-8*

◉ This photo is being taken in a room with a white ceiling of average height, so bounce upwards is a good possibility. To adjust the 430EX II's flash head, press the release catch on the side of the flash unit that's marked PUSH, and tilt the flash head so it points directly upwards. ● *Figure 2-9*

Figure 2-8

Figure 2-9

◉ Figure 2-10 is the result, and it's a good improvement. The light from the flash has scattered across the surface of the ceiling and bounced back to the model. This has eliminated the flash shadow, and the softer light is much more flattering for portraiture. There are still problems, though. Since most of the light is coming from the ceiling, her eyes and neck are somewhat shadowed, and her forehead is a little shiny. The picture is also lit in a fairly symmetrical fashion, which isn't very interesting. ● *Figure 2-10*

Figure 2-11 was done using wall bounce. This simply involves rotating the flash head sideways and bouncing the light off the wall to camera left. Since the wall is off-white and fairly close, it provides a good lighting surface. Additionally, the wall light is reflected in her eyes, providing a lively and friendly "catchlight". Finally, although there's plenty of light reflecting off the right-hand wall, more light is coming from the left, providing some interesting shadowing to the model's face. This picture looks both softer and more three-dimensional. ● *Figure 2-11*

Figure 2-10

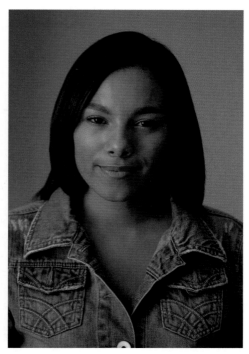

Figure 2-11

These are three very different-looking photos, yet the only change is the angle of the flash unit's head.

Obviously, bounce flash isn't a universally handy technique. It doesn't work particularly well outdoors or in huge rooms where there's nothing nearby to serve as a reflector. It can also be a problem if the walls or ceiling are painted bright or dark colors. Fortunately, in a typical small indoor location, it's an effective and simple way to get a more flattering portrait.

2.4 Daylight fill flash

Flash seems like the sort of thing that's only really useful at night, but in fact flash has its uses in bright sunshine as well. When flash isn't the primary source of light in a scene like this, it's referred to as "fill flash" since it's filling in the shadowed areas.

● Consider this photo, which was taken in direct sunlight. Sunlight on a cloudless day casts very sharp shadows, as can be seen under the model's eyebrows and neck. ● *Figure 2-12*

● This photo, on the other hand, was taken with a 430EX II as on-board fill. Note how the use of flash has certain advantages and disadvantages. ● *Figure 2-13*

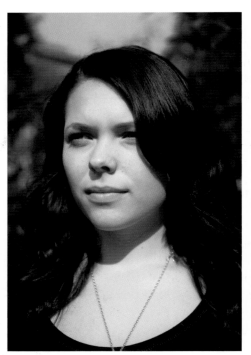

Figure 2-12

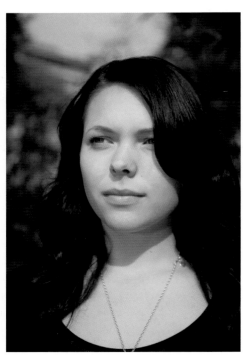

Figure 2-13

● On the positive side, the shadows are less high-contrast. Fill flash lightens shadows more than it lightens areas that are already bright. The flash also causes a bright catchlight to appear in the model's eyes.

● On the negative side, the image is now flatter and less three dimensional in appearance. In fact, if fill flash is too bright, it can give a sort of cardboard cutout look to a portrait.

◆ From a user's point of view, enabling fill flash is not much more compli-cated than turning on the pop-up flash or connecting a Speedlite. Canon EOS cameras automatically apply fill flash if they detect that they're photographing scenes lit by daylight levels of light. However, if your camera is applying too much flash, it can be useful to use FEC to dial down the flash output slightly.

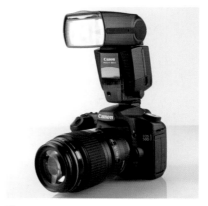

2.5 An advanced configuration: Canon EOS 50D with two 580EX II flash units

The EOS 50D is a camera aimed at advanced amateurs: people who take their photography seriously, but who don't necessarily earn a living in the field. Advanced amateur cameras are well-equipped and high quality, but a bit less rugged than the heavy tanks taken out into the field by working pros.

Figure 2-14

The 580EX II is the flagship of Canon's flash line at time of writing. It's a sturdy and powerful unit with all the latest features. One of the key func-tions is its ability to control other flash units wirelessly, or be controlled in turn. This allows you to set multiple flash units around a scene for complex lighting setups. ◉ *Figure 2-14*

Note that the information in this section applies to all digital EOS cam-eras. You don't need a 50D to take advantage of wireless flash—this is just an example.

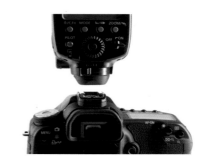

Figure 2-15

◆ Load batteries into the flash unit and attach it to the camera's hotshoe. Turn it on. ◉ *Figure 2-15*
◆ Note that the flash unit has a two-color PILOT light. Green means that the flash will fire, but it's not yet fully charged. Red means that it's charged. ◉ *Figure 2-16*
◆ The flash unit is now in standard single-unit mode. To enable wireless on the 580EX II, press and hold the button marked ZOOM. Note that the **⁺z⋮ᴵ** symbol appears next to this button—this means "wireless master/slave flash" in Canon's symbology.
◆ After a second or two, the Z symbol will start blinking on the flash unit's screen. Rotate the control wheel to the right. The words "MASTER ON" will appear on the screen. Notice that an arrow will appear pointing away from the picture of the flash unit, representing wireless com-mands going out. Press the center SEL/SET button. The unit is now in master mode, ready to control re-mote flash units. If using a 580EX, simply turn the "OFF/MASTER/SLAVE" switch to "MASTER."

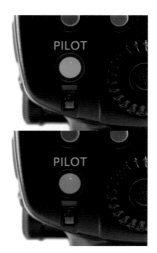

Figure 2-16

⊙ Do the same for the second 580EX II flash unit, but rotate the dial to choose "SLAVE ON" rather than master. An arrow will appear towards

the on-screen flash unit picture, representing commands coming in. If using a 580EX, simply turn the wireless switch to "SLAVE." Note that a slave-capable 400 EX series flash unit can also be used as a slave if desired.

⊙ Position the remote "slave" flash unit in an interesting location off-camera relative to the subject. The Speedlite ships with a small plastic stand that can be used to prop the flash unit off the ground. ⊙ *Figure 2-17*

⊙ Take a photograph. If both flash units are in the same room, or within sight of each other, they should fire simultaneously. The result is a picture lit by both the on-camera Speedlite and the off-camera unit. Wireless E-TTL supports multiple off-camera flash units, so complex photos can be designed with as many slave units as your lighting style and your budget allow.

Figure 2-17

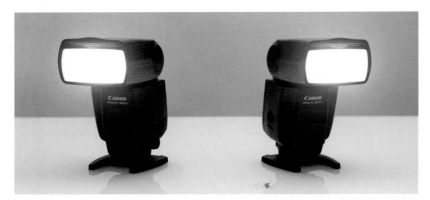

2.6 A practical example of wireless flash

For this example, we'll take another portrait in a dimly lit room. The standard direct flash photo looks, to be frank, absolutely horrible. This is an example of why direct flash lighting does such a disservice to humanity. ⊙ *Figure 2-18*

⊙ To cut the harshness, the flash is put into bounce mode and directed to the ceiling. The problem is that the background is still pretty dark. The solution? A second light source.

⊙ First, the on-board 580EX II is put into master mode. Then a 430EX II is put on a light stand and positioned behind the model, camera right. Its beam is narrowed down by setting the zoom to 80mm, it's put into slave group B, and it's pointed at the curtains.

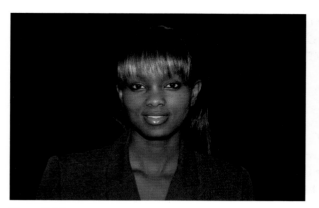

Figure 2-18

Figure 2-19

❺ When a photo is taken, the on-board 580EX II is bounced off the ceiling, providing softer light to the model. Then the rich maroon curtains are lit by the second flash unit, providing a more sophisticated texture. It looks like a photo of a completely different person. ● *Figure 2-19*

❺ In basic wireless mode, both flash units will fire at the same output level. For more control over multiple flash output, wireless E-TTL supports a concept known as "ratios". This allows for finer control between different groups of flash units. It's also possible to prevent the on-camera master unit from lighting the scene. For more details on wireless E-TTL flash, consult sections 9.17 and 11.8.

❺ The 50D can't control a remote Speedlite slave without a master unit attached to it, but starting with the EOS 7D Canon added the ability to control remote slaves by using the built-in flash. In other words, the built-in flash can serve as a wireless E-TTL master on those cameras.

2.7 Dragging the shutter

One of the challenges we face as photographers is conveying motion in a still image. One way to take a photo of a moving dancer or a speeding race car is to try to freeze the action as much as possible by using a short shutter speed. Another way is to use a long shutter speed to record a blurring, flowing motion.

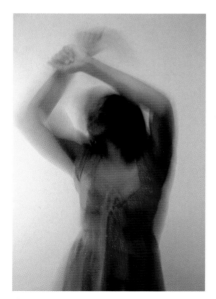

Figure 2-20

❺ Here's a photo of a dancer taken at 0.4 seconds. ● *Figure 2-20*

❺ Although the shot looks fine as it is, it's also too blurry to make out the dancer's face. But what if flash is fired at the same time? Flash is so short in duration that it freezes motion for that one moment. By combining flash and a long exposure, we get a sort of double exposure. ● *Figure 2-21*

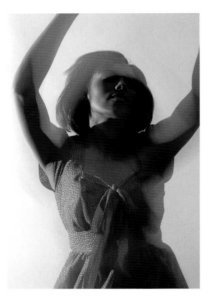

Figure 2-21

- This technique is known as slow shutter sync or "dragging" the shutter. You can see how the flash has recorded the dancer's face quite well, but there are also blurring swirls of motion.
- To use this technique on a Canon EOS camera, set the camera to Av, Tv or M modes. Don't use P mode or most of the icon modes, as they can't drag the shutter.
- Turn on the flash as usual. In this example, the flash is actually an off-camera 430EX unit positioned camera left and triggered wirelessly.
- It may be best to set Tv and experiment with different shutter times to record more or less of the subject motion. This can be tricky if light levels vary, so M mode is often the most reliable way to use this technique.
- While useful for photographing wedding dances and rock concerts, dragging the shutter is a little hit-and-miss by its very nature. It often takes quite a few shots to get one that truly captures the moment perfectly.
- The keen-eyed will note that the areas of the image lit by flash are a different color than the slow, swirly areas. This is because light from a flash is fairly blue in color, and light from an ordinary tungsten light bulb, which was used to light the scene, is fairly orange. For more information on this phenomenon, known as color temperature, check out section 7.18.

2.8 Getting the flash off the camera

One of the key lessons in any book on flash photography is that it's vitally important to get the light source away from the lens. With a handful of exceptions, such as ring flash and light applications of fill flash, most subjects don't look very good when lit with on-camera flash.

Take the previous examples. While technically the bounce flash shots were lit by on-camera flash, it's important to note that the light from the flash was actually reflected off a nearby surface. Accordingly, the shots were lit from the wall, not the camera.

So, however you do it—cables from camera to flash, wireless E-TTL as described above, or professional radio-based flash triggers—try moving the flash off camera. The results may surprise you!

Figure 2-22

This children's fairground ride was photographed with available light. Frankly, it isn't a particularly interesting shot, and too much clutter is visible.

Figure 2-23

The same shot, but this time lit with a handheld flash on a cord, positioned low and to the left of the camera. The result is more interesting—and quite a bit spookier!

3 Top Ten FAQs

1 **My camera already has a built-in flash. Why should I buy an external one?**

The answer to this question depends on what you want to do with your photography. Built-in popup flash units are great for simple snapshots. You can't lose them unless you lose the whole camera, they don't add weight or bulk, and additional batteries aren't needed.

On the other hand, the light from a popup flash is limited in range and tends to result in harsh-looking photos. External flash units always provide much more power, and thus greater lighting distances. External flashes are also more flexible lighting devices, and they can enable the creation of more attractively lit photos when using the proper techniques. For example, an external flash with a swiveling head can bounce light off a nearby wall or ceiling, resulting in softer lighting than direct flash.

Nonetheless, it's also fair to say that flash can't solve every photographic lighting problem. It's obviously a valuable tool, but sometimes the best way to ruin a nice picture is to blast tons of light onto the scene with a flash unit. Available light photography forces you to slow down and consider the light around you, which can ultimately help you become a better photographer. This may sound like a surprising thing to say in a book about flash photography, but the goal of any photographer should be to use whatever tools are appropriate to get the shot.

 Why are the backgrounds of my flash photos pitch black? It looks like I was in a cave!

In P (Program) mode, and all flash-using icon modes except for night mode, Canon EOS cameras assume that the flash is going to be the primary light source for the foreground subject. The camera is programmed to use a brief shutter speed (short exposure time) in these conditions.

However, if the ambient light levels are low, such as at night, the background will turn out very dark. This is because the flash can't illuminate the background; additionally, the shutter speed is too short to expose adequately for background areas.

The light from any battery-powered flash unit is always limited. You can't expect to light up the Grand Canyon or the Eiffel Tower. You can only reasonably expect to light up people standing in the foreground or close backgrounds such as small room interiors. Simply cranking up the power of an on-camera flash unit won't help, since that will cause the near foreground to be overexposed.

To avoid the problem of black backgrounds, you will need to take the photo in Av, Tv, or M modes, as described in section 6.6, or use a second flash unit to light up the background.

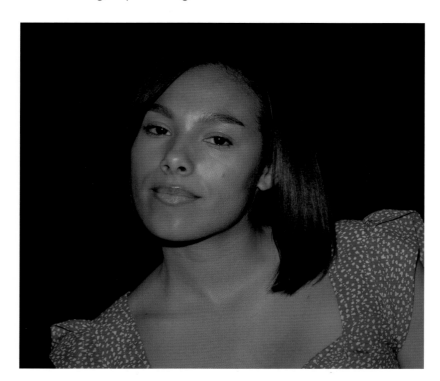

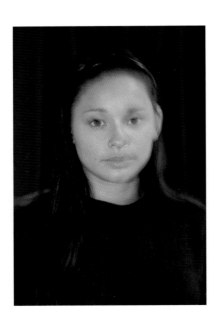

 Why does the camera set a really slow shutter speed when I use a flash? Parts of my photos look sharp, but there's weird fringing.

This situation is the reverse of the previous question. It occurs when you try to take a flash photo in low-light conditions and the camera is in Av (aperture priority) mode or the night icon mode, if your camera has it.

In Av, night, and Tv (shutter speed priority) modes, the camera meters for ambient (existing) light and fills in the foreground subject using flash. It does not assume that the primary light source is the flash unit, and therefore the shutter speed it sets is the same as if you weren't using flash at all.

In low light, this results in very long shutter times. If the shutter speed is very long, you'll need a tripod to avoid motion blur during the exposure. If something in the photo, such as a person, moves during the shot, then you'll end up with a double exposure. The flash-illuminated person will appear sharp and crisp, but the person will also be illuminated by ambient light, leading to ghosting or fringing. This can be desirable in some cases, as it lends a sense of motion, or it can look like a smudgy mess.

Alternatively, you can switch to full auto (green rectangle) or P (Program) modes, which automatically expose for the flash-illuminated subject and not the background. These modes try to ensure that the shutter speed is high enough to let you handhold the camera without a tripod. The drawback of P and full auto modes is described above—dark backgrounds under low light conditions.

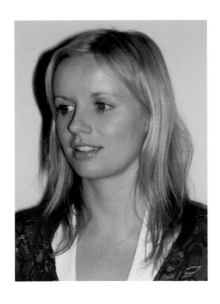

 Why are the eyes of my friends and family glowing an evil red?

This is the "redeye" effect, a common problem with flash photography. It's caused by white light from the flash unit reflecting off the red blood vessels lining the interior of the eye. "Greeneye" in cats and dogs is similar, though with a different underlying cause.

The easiest way to minimize photographic redeye is to use an external flash unit rather than a built-in flash, and reflect ("bounce") the light from the flash unit off a wall or ceiling. For more detail, consult section 9.8.

If, however, the evil glowing eyes are visible in real life and not just in your photos, then you should probably consider arranging an exorcism. Contact a tabloid first if you want to exploit the situation to your financial advantage.

 Why won't my camera let me set a high shutter speed when I turn on my flash?

Each camera model has a top shutter speed that can be used with flash. This is known as the flash sync or X-sync speed, and it varies from 1/90 second on low-end cameras to 1/500 sec on one pro model. If you set a high shutter speed (say, 1/2000 sec) and you turn on a built-in flash unit or a Speedlite, the camera will automatically lower your shutter speed to the X-sync value.

The maximum shutter speed when flash is used is always lower than the maximum shutter speed of an EOS camera, for complex mechanical reasons described in section 7.10. The X-sync value can be circumvented if your camera and flash unit both support high-speed sync (section 7.12).

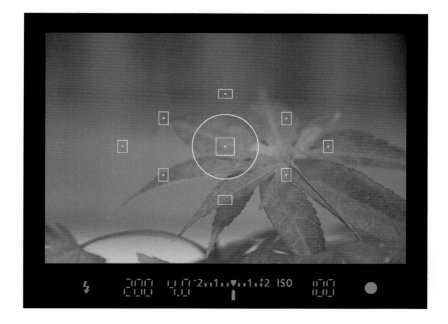

 I have an old flash unit. Will it work on my new Canon EOS digital camera?

Maybe. It depends on what type of flash unit you have and how you want it to work.

Canon EOS digital cameras work automatically with Canon Speedlite flash models ending in EX. However, if your Canon flash unit has a model name which ends in E or EZ or anything else, then its automated features will *not* work with EOS digital. It will fire at full power only, or not fire at all, depending on the camera.

As for flash units manufactured by other makers, check the specifications to see there's support for "E-TTL flash metering." If not, or if only "Canon TTL flash metering" is listed, then the unit probably won't work automatically with a digital body (see section 7.2.2).

Some flash units have manual output controls, usually in the form of push buttons. Such manual controls let you specify the flash unit's power output by hand. While this sounds limiting, manual flash as described in chapter 10 is actually a great way to light a scene.

If it's a very old flash unit (pre-1980 or so), or if it's a large studio flash unit that runs off AC power, it's worth confirming that its trigger voltage won't destroy your camera (see section 10.5).

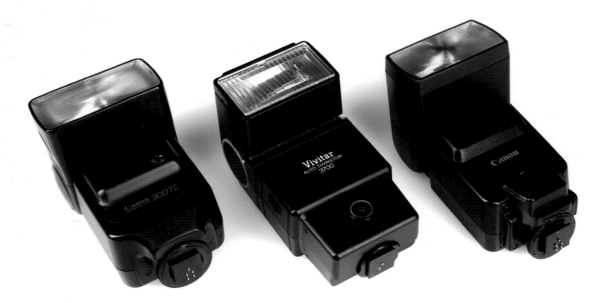

 I took two flash photos in rapid succession. Why is the second one totally dark?

All flash units take a number of seconds to charge up between flash bursts; this is referred to as cycle time. If your second photo is dark, it probably means that your flash unit hasn't had time to recharge after the first burst. You have to wait for the unit to charge back up (and the pilot light on the back goes on) before taking the second photo.

Some flash units have "Quick Flash" ability that lets them fire when only partially charged. If your flash can do this, then you probably took the second photo too quickly; the flash unit didn't have enough time to recharge to an adequate power level but tried to fire anyway.

Different types of batteries charge up the flash at different speeds, so you might want to consider your battery options. To achieve a more rapid cycle time, external battery packs (section 12.12) are often used by wedding and news photographers. Note also that if your camera has a small built-in flash, it probably recharges more quickly than an external unit.

 Why are my photos dark when I use a Speedlite EX or built-in flash to trigger my studio flash equipment?

The short answer is that manual flash metering (flash output set directly by the photographer) is not compatible with automatic flash metering (flash output controlled by the camera). You can't reliably mix and match the two when optical slave triggers are used.

The slightly longer answer is that Speedlite EX flash units, when operating in E-TTL mode, send out at least one brief flash of light before the actual scene-illuminating flash. This "preflash" will prematurely trigger the optical sensors used by many studio flash units and optical slave sensors. Consequently, since the light from the studio gear will have faded by the time the shutter opens, the resulting pictures will be too dark. For more details, consult section 11.7.3.

In this shot, E-TTL prefire triggered the studio flash too soon. The camera has recorded the reddish tail end of the slave flash unit inside the antique camera's flash bulb.

⑨ Why use flash at all? Why not just use a fast lens and a high ISO?

As digital cameras improve and their image quality at high ISO settings becomes less noisy, this question becomes even more relevant. Why not shoot at f/1.8 with ISO 3200? There are a number of reasons why you might want to consider using flash, and a number of reasons why you might want to avoid it.

Shooting at wide apertures like f/1.8 means that the depth of field (DOF)—the area of the image in sharp focus—will be very, very thin, especially with a longer lens. If more than one person appears in the photo, for example, it probably won't be possible to get the eyes of both people in focus. If people are moving around, e.g., at a wedding, it probably won't be possible to nail accurate focus with such narrow DOF.

Shooting with a high ISO means that the picture will be noisier. Even the latest cameras have grungy-looking digital noise at high ISO settings, which can mar the appearance of the photo.

Finally, with flash you have total control over the lighting. Available lighting is great, but there are times when being able to specify precisely what light goes where can be very valuable. In a sense, this is about building a photo rather than finding it.

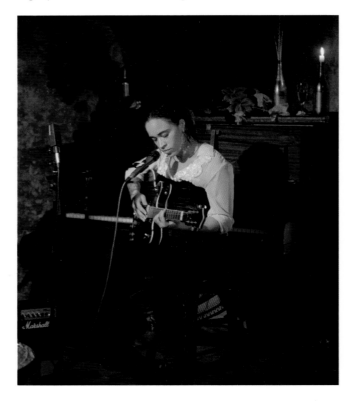

 Why do my flash photos look so lousy? Do I need to buy a better camera or a more expensive flash unit?

Camera advertising often suggests that modern, fully-computerized flash has the magic ability to let even inexperienced photographers take amazing photos. However, while automated flash has certainly taken a lot of the drudgery and guesswork out of using flash, it hasn't eliminated the need for good technique.

The first step in improving flash photography is to understand the nature of lighting. On-camera flash originating from a small light source is usually going to result in hard-edged, harsh, and unflattering photos. That's what most people think of when they think of flash.

The first step is to move the flash unit off the camera or to use multiple flash units. The second step is to start experimenting with light-modifying tools such as diffusers, softboxes, umbrellas, and filters. These are ways of improving the quality of light so it's not just a harsh, blue-white beam emitting from the top of the camera, right over the lens.

While much of this book focuses on automated flash, automatic lighting is often just the beginning. Most of the best flash-illuminated photos out there are taken by experienced photographers using purely manual equipment.

4 Terminology

There is a variety of confusing and inconsistent terminology related to flash photography. For the sake of simplicity, this book uses the following conventions:

AUTOFLASH

A flash unit which meters its power output through a sensor built into the flash unit itself. Common in the 1970s; rare today.

AUTOMATIC / AUTOMATED FLASH

Flash technology in which the output of the flash unit(s) is controlled by a computer inside the camera.

BUILT-IN FLASH

Synonyms: popup flash and internal flash. A flash unit that is part of the camera itself. In the case of Canon EOS cameras, a flash unit that pops up from the top.

EXTERNAL FLASH

In Canon EOS idiom, a compatible flash unit that is fastened directly to a camera (or by a special cable) but is not wireless.

FLASH

A bright pulse of light, usually produced by an electronic device, for photographic lighting.

FLASH CARD, FLASH MEMORY

A solid state memory device for digital cameras.

FLASH UNIT

An electronic light-producing device used for flash photography.

MANUAL FLASH

The power output of the flash unit(s) set directly by the photographer.

MONOLIGHT

A self-contained studio flash unit, powered by AC current.

OFF-CAMERA FLASH

A flash unit that is not built into or fastened to the camera itself.

PACK

A power source for a studio flash unit (see Generator, p. 35).

SPEEDLITE

Canon's trademark for its line of battery-powered flash units.

STROBOSCOPIC

Multiple flash pulses, usually at regular time intervals, from a flash unit.

STUDIO FLASH UNIT

A flash unit designed for use in a photographic studio; usually powered by AC current.

WIRELESS FLASH

A flash unit which is controlled remotely without wires, and which is not physically connected to the camera.

The following terms are not used, largely because of their potential for ambiguity:

FLASHGUN

A small battery-powered flash unit.

FLASHLIGHT

An occasional synonym for flash unit; easily confused with a battery-powered lantern.

GENERATOR

(UK) A power pack for studio flash lighting (see Pack, p. 34).

MONOBLOC

(UK) A monolight.

SPEEDLIGHT

A Nikon trademark; sometimes refers generically to a small battery-powered flash unit.

STROBE

(US) Sometimes any flash unit; sometimes only an AC-powered studio flash unit.

PART B: TECHNOLOGY

5 A Brief History of Flash

The first photographers could only take their pictures in sunlight—bright sunlight, in fact—since early photographic processes reacted very slowly to light. The oldest known photograph, taken in 1826 by French pioneer Joseph Nicéphore Niépce, took a whole day to expose. The earliest Daguerreotype processes cut this down to minutes, but artificial light was still too weak for most photography. In fact, one of the principal requirements for a photographic studio in Victorian times was a skylight to provide adequate illumination.

Scientists and inventors labored throughout the 1800s to devise artificial photographic lighting, many intuitively understanding that a brief bright burst of light could illuminate a scene as effectively as dimmer light used for a longer period of time; this concept is the fundamental basis of all flash photography. As early as 1851, Briton William Henry Fox Talbot demonstrated how electric sparks could capture freeze frames of moving objects. By the late 1870s, studios in rainy London were proudly advertising their use of electric lighting for portrait photography. But these early light sources, including electric arcs, oxyhydrogen (limelight) lamps, and battery lamps, weren't particularly bright or relied on large generators.

Figure 5-1

Michael Faraday's magnetic laboratory at the Royal Institution of Great Britain, London. It was most likely this lab, restored in 1972 to appear as it did in the 1850s, which saw the first recorded photographic use of flash. EOS 5D, on-camera ST-E2 trigger, 580EX to camera left with 1/2 CTO filter, 580EX with 1/2 CTO filter, 420EX on floor unfiltered.

5.1 Pyrotechnics

Talbot's pioneering spark experiments were frustrated by the limited amount of energy produced by the batteries of the day. The first viable form of artificial photographic illumination was the intense white light created by burning magnesium metal. Its potential was recognized before the widespread use of electric lights, and one of the first documented public demonstrations was performed by Alfred Brothers at the Royal Institution in 1864.

The following year Scottish-Italian astronomer Charles Piazzi Smyth, notorious for his bizarre theories tying the Egyptian pyramids to Biblical prophecy, used magnesium wire to photograph the interior of the Great Pyramid of Giza. Some two decades later in Germany, Adolf Miethe and Johannes Gaedicke added an oxidizing agent to powdered magnesium, commercializing *Blitzlichtpulver,* or "powder which produces lightning-like light".

Magnesium powder became more than a flash in the pan when Jacob Riis, a Danish-born journalist living in the U.S., used it to document the poverty and privation of New York City slums. His book of photo illustrations and muckraking essays, titled *How the Other Half Lives,* shocked the American public of 1890, including a then-police commissioner by the name of Theodore Roosevelt.

The technique employed by Riis was quite dangerous. He would set up a camera in a dark or dimly lit room, pour some powdered magnesium and an oxidizer into a frying pan, open the shutter, and then ignite the powder. The result was a brilliant burst of light, startled subjects, and a billowing cloud of noxious smoke and ash. While his photos changed American views of immigrant housing, he is said to have set his clothes and surroundings on fire on a number of occasions.

Figure 5-2

From left to right: Eastman (Kodak) flash "pistol" circa 1900–1905, a device for igniting magnesium flash cartridges. The leather guard was meant to protect the photographer's hands from burns.
Kodak magnesium ribbon dispenser, circa 1915–1920. The thin ribbon could be measured out in length (and thus time), and was used mainly for exposing photographic paper.
Flash sheets, which had shorter burn times, were more commonly used for portraits.
Magnesium powder sold in teabag-like envelopes by Seuthelin, circa 1925.
A long paper strip dangled down from the bag which, when lit, served as a simple self-timer.

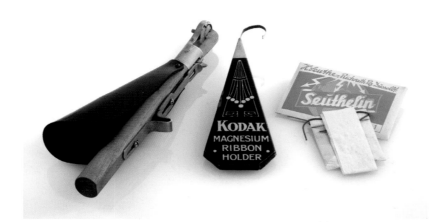

Magnesium was used, packaged in various forms such as cartridges and sheets, well into the 20th century. Textbooks and instruction manuals of the time speak quite matter-of-factly about techniques required to minimize the risk of accidents and fire.

5.2 Flash bulbs

A breakthrough in photographic safety was developed in Germany in 1929—30 when Johannes Ostermeier patented the first mass-market flash bulb, sold under the Sashalite (GE) and VacuBlitz (Osram) names. These foil-filled glass bulbs, when connected to a low electric current, would burst with white light and a loud pop.

Press photographers from the 1930s through the 60s, immortalized by scenes on the courtroom steps in countless films, burned through huge quantities of disposable bulbs. They also burned their fingers, as the bulbs were quite hot after firing. A later innovation was a lacquer or plastic coating to reduce the risk of subjects being injured by flying glass if the bulb shattered. Bulbs designed for color photography had blue-tinted lacquer to improve the color balance.

Flash bulbs eventually shrank down and became incorporated into consumer products such as the FlashCubes, MagiCubes, and FlipFlashes which illuminated countless birthday parties and family snapshots in the 1960s and 70s.

Figure 5-3
A three-cell Graflex flash handle, reflector, and flash bulbs. These were used with Speed Graphic press cameras in the 1940s and 50s. Trivia note: a handle of this type was used as Luke Skywalker's light saber in the original *Star Wars* film of 1977.

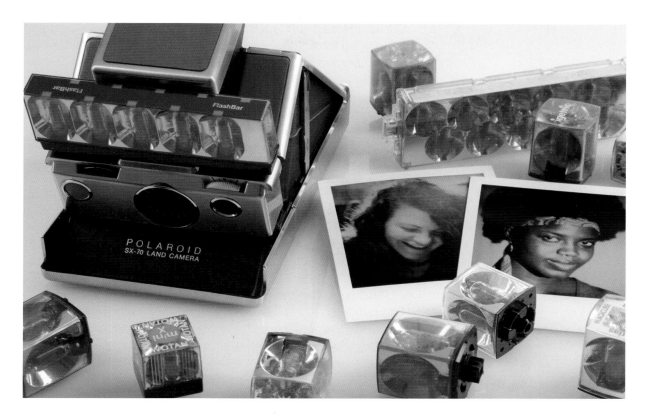

Ultimately, however, such single-use flash bulbs were an evolutionary dead end. Flash bulbs are mainly used today for historical reenactments (e.g., period movies), theatrical special effects, and special applications such as cave photography because they can produce massive amounts of light despite their small size.

5.3 Electronic flash

It was the xenon flash tube, first developed for photographic purposes in the 1930s by American researcher Harold Edgerton, which brought about the demise of the flash bulb. Edgerton's work at MIT initially focused on arresting motion for engineering research, but it soon became clear that flash tubes would be convenient for general photographic lighting as well. For years, flash tubes mainly stayed in the studio because of their power requirements. Early portable electronic flash systems were also quite heavy: a battery-powered unit built by Kodak in the early 1940s weighed 16 pounds! But by the 1960s and early 1970s, improvements in battery and capacitor technology made electronic flash affordable, convenient, and portable.

Figure 5-4
A Polaroid SX-70 instant camera from 1972, equipped with a flashbar. Next to it are a FlipFlash and an assortment of Magicubes and Flashcubes. The photos were taken using Artistic Time Zero film manufactured during the final production run at Polaroid's last factory.

Figure 5-5

The flash tube from a Quantum Instruments unit. While most units have straight bare tubes, this one is pretzel-shaped to maximize tube length in a small space. It is enclosed in a protective glass shell.

All electronic flash units have the same basic design. First, a component known as a capacitor is charged up with electricity. The accumulated energy is then sent to a glass tube filled with the inert gas xenon. The electricity causes the gas to ionize, producing an electrical discharge which emits a brilliant split-second burst of white light.

Flash tubes are ideal for photography because they can be fired many times, their outputs can be precisely controlled, they allow for brief motion-freezing exposures, and the basic design can scale from tiny pocket flash units all the way up to huge studio equipment.

But there were two fundamental technical problems that had to be solved before electronic flash could become the widespread lighting solution that it is today: *synchronization* and *metering*. Both problems stem from the fact that flash usually involves a single brief burst of light rather than a continuous and steady glow.

5.4 The first challenge: flash synchronization

Flash synchronization is simply the matter of firing the flash at the right time so that it correctly exposes the film or image sensor. Ordinary, ambient lighting doesn't require synchronization, because the output from the sun or a light bulb is constant in nature and normally doesn't vary through the course of the exposure. But if a flash fires before the shutter has opened or after the shutter has closed, then it will obviously be unable to expose the image.

5.5 Open flash

The simplest way to synchronize a flash with the shutter is to do it manually, just like Riis with his magnesium powder. The camera is placed in a dark or low-light area, the shutter is opened up, the flash is fired by hand, and then the shutter is closed. This works, but the technique is obviously very limited, since it basically requires darkness. This process, which requires long shutter times and careful manual work, was really the only way to synchronize flash until about the late 1930s.

It may be simple, but open flash is still used today for special purposes such as night photography. It can also be used for high-speed flash photography, as described in section 15.9. ⬤ *Figure 5-6*

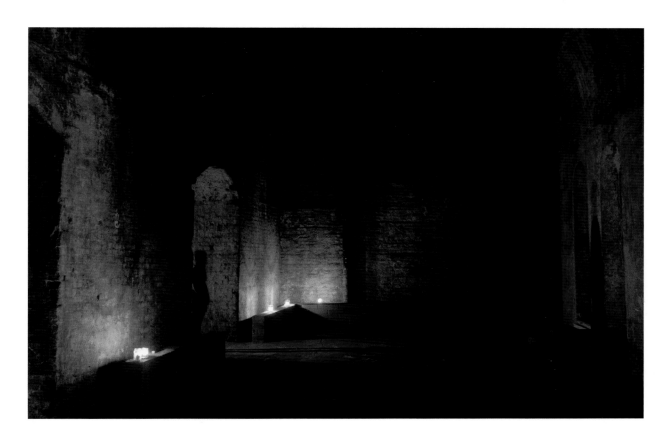

Figure 5-6
This shot is lit by two light sources: the candles and a red-filtered 580EX II, which was fired manually twice at full power on the other side of the left-hand portal. EOS 5D Mark II, 30 sec at f/4, ISO 200, 35mm.

5.6 Flash sync

Because open flash is inconvenient—and useless in bright ambient light situations—automatic flash synchronization was developed. At first glance, flash sync doesn't seem very complicated. After all, a flash could simply be rigged to fire when the shutter release button is pressed. But this approach doesn't actually work, because flash pulses are incredibly short in duration. Moreover, mechanical shutters are so comparatively slow to move that by the time they've physically opened up, the flash pulse would long be over. Thus flash must be fired *after* the shutter has opened all the way and not before.

By the 1950s, most quality camera shutters were equipped with tiny switches or sensors to detect when the shutter was open and tell the camera to fire the flash. Flash sync for electronic flash became known as "X-sync", probably in reference to xenon gas. (X-sync can also refer to maximum shutter speed with flash, which is described in section 7.11.) ⬤ *Figure 5-7*

> • **KEY POINT**
>
> Automatic flash sync fires the flash once the camera shutter is fully open. All EOS cameras have this basic capability.

Figure 5-7

The shutter mechanism from a Canon EOS camera. The copper coils are tiny electromagnets which move the silver-colored paddles, opening and closing the shutter blades. The tiny thin gold fingers are metal contacts which open or close as the shutter mechanism operates, enabling flash sync.

Other forms of flash sync, now obsolete, include M sync for "medium-speed" flash bulbs and FP sync for bulbs for "focal plane" shutters. The burning metal inside flash bulbs took a split second to reach optimum brightness. Such bulbs actually had to be fired before the shutter was fully open, hence the different sync modes.

5.7 Controlling flash exposure

In regular (non-flash) photography, there are three basic ways to control the exposure of an image.

1. Shutter speed. The length of time that the shutter is open affects the duration of the exposure, since ambient light is essentially constant.
2. Lens aperture. The adjustable size of the diaphragm on most lenses governs the quantity of light that enters the camera.
3. Sensitivity of the digital sensor (ISO) or the film speed.

There is one critical way in which flash differs from ambient lighting. Flash bursts are so brief—sometimes in milliseconds—that a mechanical shutter has no way of moving fast enough to restrict the amount of light from a flash unit that hits the film or sensor (an exception being high-speed sync mode, discussed in section 7.12). Therefore, shutter times only affect the exposure of ambient light.

> **• KEY POINT**
>
> Regular flash exposure is not usually affected by shutter speed settings.

There are five basic ways to control exposure when using a flash unit, though the first four have limitations because they affect other things.

1. Lens aperture: Lens aperture settings also affect the amount of ambient light striking the film or sensor, as well as the picture's depth of field.
2. Distance from the flash unit to the subject: Light falloff follows known physical laws (the inverse square, section 7.14) and can be reliably calculated. Moving the light around is acceptable in a studio setting but inconvenient for casual or photojournalist photography. Also, altering flash unit/subject distances affects the relative size of the flash light source, which in turn affects the quality of the light and shadows.
3. Sensitivity (ISO setting) of the digital sensor or film speed: This affects both ambient and flash exposure, and also the noisiness/graininess of the image.
4. Diffusers or light baffles between the flash unit and subject: These can be inconvenient, and they also affect the quality of light.
5. Adjustments to the energy output or the duration of the flash pulse: This last method is the most useful since it doesn't affect ordinary exposure of ambient light in any way. The adjustments simply affect the intensity of the flash produced.

> **• KEY POINT**
>
> Flash metering is the technique for determining the correct light output of a flash unit in order to expose a scene correctly. EOS cameras can handle this process automatically or let the photographer do it manually.

5.8 The second challenge: flash metering

Flash metering is a more complex problem than synchronization. In most SLR cameras, metering for available light occurs when the photographer looks through the viewfinder and presses the shutter release halfway down. The evaluative (ambient) light sensor, located inside the viewfinder assembly, is active whenever objects can be seen through the viewfinder. ● *Figure 5-8*

Since flash pulses don't happen continuously, an evaluative light meter can't measure light that isn't being produced. Also, when the mirror lifts up and the shutter opens to expose the film or sensor, light stops reaching the viewfinder. So, a subject-illuminating flash pulse can't be measured by the ambient light sensor when the shutter is open.

There are therefore four basic ways to meter for flash: one manual and three automatic. ● *Figure 5-9*

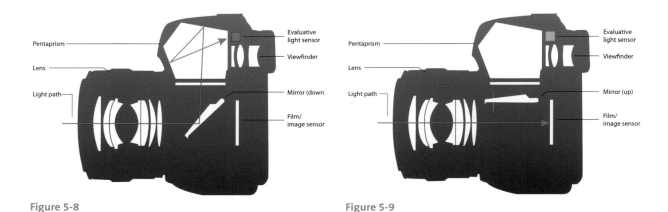

Figure 5-8

Figure 5-9

5.8.1 Manual metering

The photographer can manually measure some test flashes using a flash meter, or perform distance calculations based on the known power output of the flash unit. The flash output is then set by hand, by operating a control on the flash unit.

5.8.2 Automatic flash-based (autoflash) metering

A fast-reacting electronic system can measure the strength of the flash pulse while it's actually being emitted. Such a system detects light reflecting off the subject back to the flash unit, and cuts off power to the flash tube when adequate exposure is accomplished. This is done via a special flash sensor built into the unit itself, and it's the basis for the *autoflash* metering used by many flash units sold in the 1970s.

5.8.3 Automatic camera-based (TTL) metering

This method is the same as above, but the flash sensor is inside the camera and thus measures light directly entering the lens. The flash sensor is a separate internal component from the ambient light sensor.

5.8.4 Automatic camera-based preflash (E-TTL) metering

The camera instructs the flash unit to send out a low-power test pulse (a preflash) of known brightness, measures the light reflecting back from the preflash, then bases the required flash output on that data. The preflash is measured by the same sensor used for ambient light. The camera then raises the mirror, opens the shutter, and instructs the flash unit to send out the actual scene-illuminating pulse. Canon refers to this method as E-TTL, for evaluative through-the-lens metering.

To summarize, there are three basic methods for automatic metering. Of those three, autoflash is rarely used today. Pre-1995 Canon EOS film cameras employ TTL metering, whereas later EOS film cameras and all EOS digital cameras use E-TTL metering. Other camera systems employing the same basic techniques include Nikon iTTL, Pentax P-TTL, and Sony Pre-flash TTL.

> **• KEY POINT**
>
> Automatic *flash metering with pre-flash* (E-TTL) is used by EOS digital cameras and post-1995 EOS film cameras.

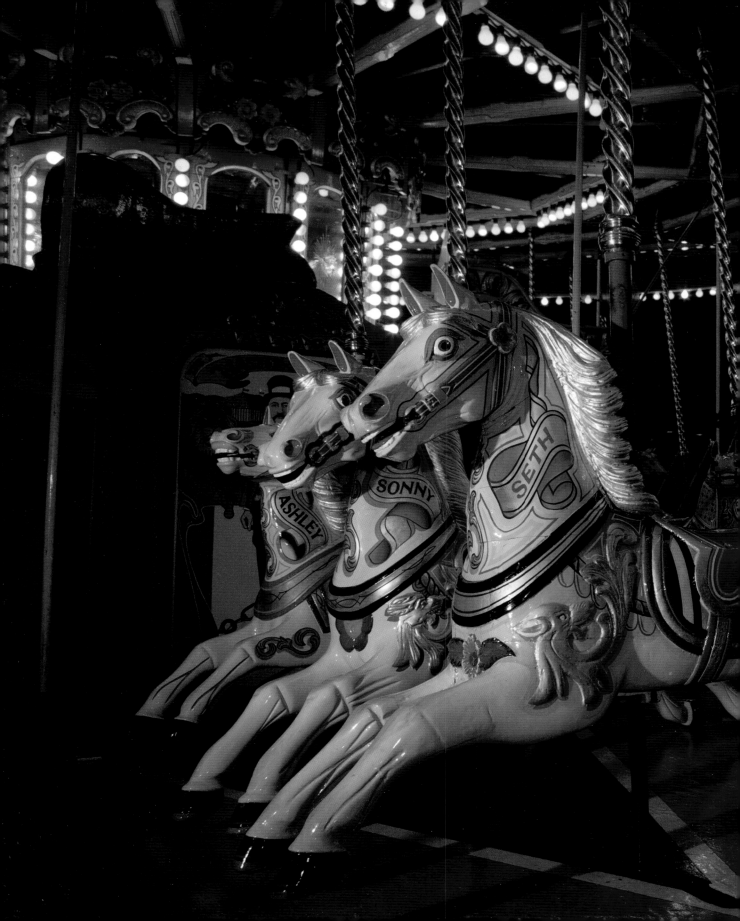

6 Automatic Flash Metering

As described in the previous chapter, there are two basic ways in which flash is commonly used today: automatic and manual.

All Canon EOS cameras have the ability to set flash output levels automatically when using integral popup units, clip-on Canon Speedlites, or other compatible products.

Automatic EOS flash relies on sophisticated light sensors controlled by computers built into the cameras. The cameras communicate electronically with the flash units to determine effective levels of light output. For this to work, the flash unit must be fully compatible with the EOS camera.

A host of flash technologies and functions has been developed over the years, some interoperable and some not, and the key points of these automatic features are discussed in this chapter.

6.1 Enabling internal flash and external Speedlites

Most EOS cameras with built-in flash have a flash button marked with a lightning bolt icon (⚡), typically on the left side of the camera body. Pressing the button pops up the flash head and charges it almost instantaneously. ● *Figure 6-1*

To make use of an external flash unit, load it with fresh batteries, slide it into the metal bracket on the top of the camera, and turn it on. If it's a Canon Speedlite or compatible automatic flash unit, the camera will immediately recognize its presence and adjust itself accordingly. ● *Figure 6-2*

In either case, the camera will fire the flash unit automatically when a photograph is taken. How the flash behaves depends on a variety of settings and conditions.

Figure 6-1

Figure 6-2

6.2 Subject and background in flash photography

The typical photograph lit by a single flash unit has two basic regions which are governed by distance from the flash tube. The *foreground* or *subject* is the part of the scene which is illuminated by flash. It usually, though of course not always, covers the area which is in focus. The *background* is everywhere else and is often lit entirely or mostly by ambient light rather than by flash.

Foreground versus background is an important distinction because all flash units have a limited range. As noted in the FAQ section, a small flash unit can't illuminate the Eiffel Tower, the Grand Canyon, or even a large indoor space such as a ballroom. The reason for this limit in flash range is known as the inverse square law (section 7.14).

This picture of the Great Buddha of Kamakura, Japan, shows how on-camera flash can illuminate nearby objects but can't reach much farther. The result is a somewhat disappointing picture; the foreground is overexposed by the flash while the background is underexposed. ● *Figure 6-3*

6.3 Ambient light metering versus flash metering

From the point of view of the camera, there are two light sources being used at the same time when a flash unit is fired. Except in total darkness, there will always be some ambient lighting, which is any available light (such as reflected light from the sun or artificial light sources). The camera has no direct control over this lighting. The camera—and you, the photographer—can specify how much of that ambient light hits the film or sensor by adjusting the aperture, shutter speed, and ISO settings.

In the case of automatic flash, the output from the flash unit is fully under the camera's control. The camera can specify when the flash fires and how much light it produces, up to its maximum output.

6.4 Freezing motion

An important consequence of this double exposure effect is the ability to freeze motion. The duration of the pulse of light from a flash tube is extremely short, often between 1/750 and 1/1000 second. Exposures this brief mean that flash photography can be extremely effective for freezing motion even with longer shutter speeds.

This is why a photo taken with flash may seem sharper and crisper than a photograph taken without. Areas of the photo lit predominantly by normal flash essentially have a shorter exposure time because of the flash pulse. The brief exposure allows less time for motion blur to occur. However,

> **• KEY CONCEPT**
>
> The foreground in flash-illuminated photos is usually the area lit by flash.

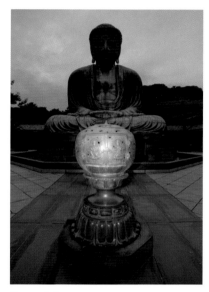

Figure 6-3

> **• KEY CONCEPT**
>
> Flash photography can be thought of as a kind of double exposure, or a photo with two separate lighting zones. Control over ambient light metering (measuring the amount of light illuminating a scene as is visible to the eye) and control over flash metering (measuring the output of a flash unit) are always handled separately and independently.

areas of the photo lit mainly by ambient light may not appear as sharp if the flash is combined with a longer exposure time.

Figure 6-4
Although the shutter speed for this photo was only 1/60 second, it was taken in low light conditions. The brief burst of light from the blue-filtered flash unit behind the model's shoulder has frozen the spray of water droplets in the air. The spray, incidentally, was accomplished by a very high-tech technique which involved crouching on the floor with a hand-pumped houseplant sprayer.

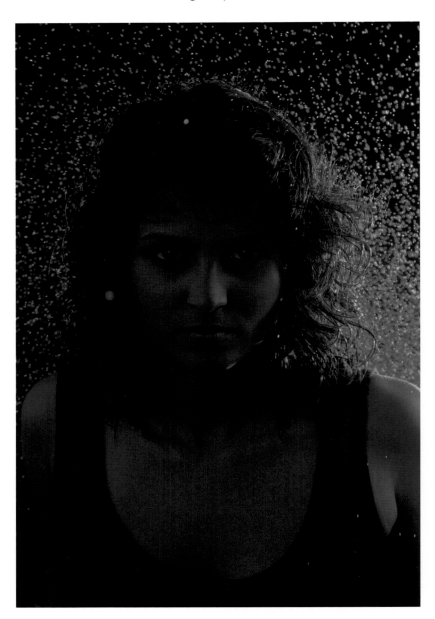

6.5 Normal flash sync

The most basic mode for automatic flash operation, especially when light levels are low, is to use a brief shutter speed to keep blurring induced by camera movement to a minimum. The flash unit, controlled by the camera's flash metering system, then fires enough light to illuminate the foreground. This typically leaves the background dark, the way most people think of flash when using a simple point-and-shoot camera.

Canon EOS cameras also work this way when in P (Program) mode (green rectangle mode), most of the icon modes, and when using either a built-in flash or an external Speedlite.

While its high level of automation makes normal flash sync simple to use, it can sometimes yield unattractive results, especially when ambient light levels are low. This is partly because the flash lights the foreground subject while anything in the background simply ends up veiled in darkness.

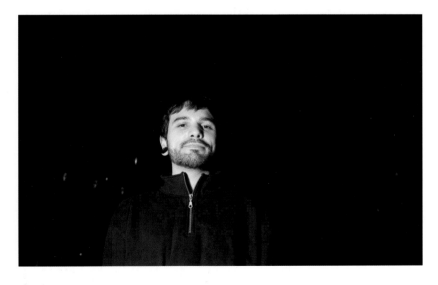

Figure 6-5
The classic Disappointing Tourist Photo, taken with a normal flash sync. The camera keeps the shutter speed short to allow hand holding and blasts the scene with flash. This picture has such a dark background that it could have been taken anywhere.

6.6 Slow shutter sync

Another way to take flash photos when light levels are low is to leave the shutter open longer in order to allow more of the background to show up while still illuminating the foreground subject.

This technique is called *slow shutter sync,* slow sync, or "dragging" the shutter, and it actively demonstrates the double-exposure nature of flash photography. Some camera systems, notably Nikon, have explicit settings for slow shutter sync. EOS cameras do not have such a switch, but you can

use this technique in Tv or Av modes. It's also available in M mode if the shutter speed is long enough, and the night icon mode on most Canon consumer cameras. Slow shutter sync is never used in other automatic modes.

A classic use of slow shutter sync is to shoot someone standing in front of a famous landmark at night. If the shutter speed is kept brief as in normal flash sync, the result will be a flash-illuminated person standing in front of a pitch-black backdrop (unless the landmark is extremely brightly lit or unless a high ISO or fast film is used). But by specifying a longer exposure setting (shutter speed), the result will be a photo of a person standing against a properly exposed background.

Figure 6-6
Same scene as previous photograph. Here a slow shutter speed of about a second was used to let the background expose properly. Because of the long exposure time, this technique requires that the subject remain absolutely motionless and that the camera be securely attached to a tripod.

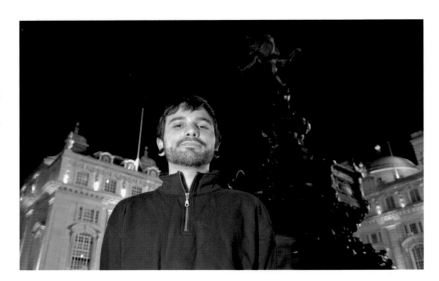

Figure 6-7
This is the result of camera motion during the exposure. The flash-lit areas are sharp and clear, but other parts of the image are badly ghosted and blurred.

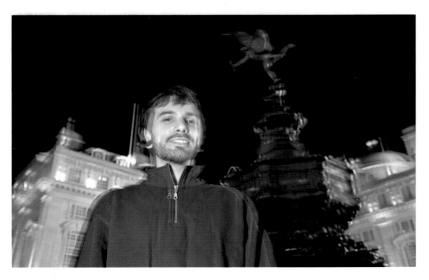

Changing shutter speeds in slow shutter sync can be seen as a method of adjusting the ambient (background) light while the flash-illuminated (foreground) light remains constant. But the drawback is obvious. By slowing the shutter speed, a tripod may be needed to avoid camera motion blur, especially with long shutter speeds like 1/30 second or slower.

6.7　EOS flash and icon modes

Most consumer and midrange EOS cameras have a selection of icon modes with pre-programmed settings to make it easier for beginners to take certain types of photographs. Each icon mode has been crafted by the camera's engineers to be generally useful for the type of setting indicated by the picture.

Icon modes give most of the control over the camera to its built-in computer and software. The photographer really only has control over when the photo is taken (i.e., when the shutter release button is pressed), where the image is focused, and the focal length in the case of a zoom lens.

Icon modes are sometimes referred to as Basic Zone modes, or Programmed Image Control/PIC modes in older documentation. While quick and convenient, they're not necessarily a good way for beginners to learn how cameras work because most internal settings can't be altered and the interaction between those settings isn't particularly obvious. Arguably, icon modes can also be a little misleading. For example, the macro icon mode in an SLR can't alter the characteristics of a lens in any way that makes it better at taking closeup photos.

Figure 6-8
Flash icon modes

When using the following four modes, the popup flash will raise and fire if light levels are low enough and there's nothing attached to the hotshoe. The autofocus assist light (section 9.7) will also go on automatically if required. Night Portrait is the only mode which permits slow shutter sync, all other modes use "normal" flash, much like Program mode.

☐ Full auto (green rectangle), 🧑 Portrait, 🌷 Macro, 🌃 Night Portrait

In these modes, the popup flash will not raise automatically and will not fire even if raised or turned on. Also, the AF assist light will never engage.

🏔 Landscape, 🏃 Sports, ⚡ Flash Off

6.8 CA (creative auto) mode

More recent digital models aimed at the consumer market have a mode known as "CA" for "creative auto". This is essentially an enhanced green rectangle mode which attempts to explain the *consequences* of adjusting various settings rather than simply letting the user change them. It therefore serves as an educational tool. For example, altering the lens aperture is described as making the background more "blurred" or more "sharp".

Figure 6-9

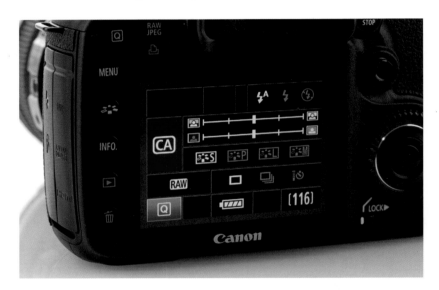

Flash control in this mode is limited to auto (flash will pop up if light levels are low), on (flash always fires), or off (flash never fires). In other respects, CA mode operates like P mode and does not engage slow shutter sync.

6.9 EOS flash and ambient metering modes

Beyond the pre-programmed icon modes, virtually all EOS bodies provide four basic modes for setting the shutter speed or aperture based on ambient or available light levels: P (program auto-exposure), Tv (shutter speed priority or time value), Av (aperture priority or aperture value), and M (metered manual). These four modes, supplemented by DEP/A-DEP and bulb on certain models, are sometimes referred to as the "creative" auto-exposure modes by Canon (not to be confused with "Creative Auto"), since they afford more control.

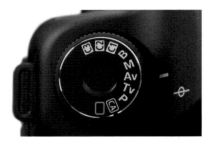

Figure 6-10

These different metering modes specify the way available light is measured and also handle flash differently, especially when ambient light levels are low. While logical in their own way, the differences between

ambient metering modes on Canon EOS cameras account for the primary source of confusion for beginners. They can also confuse people used to other camera systems, particularly Nikon, which sometimes operate on a different set of assumptions.

Here's a summary of how the four fundamental exposure modes work when either a built-in flash or an external Speedlite is turned on. This summary assumes that high-speed sync is not enabled (section 7.12). It also refers to a camera's X-sync value, which is the fastest shutter speed for a given camera model when flash can be safely used (section 7.11).

Exposure Mode	Shutter speed	Lens aperture
P (Program)	Automatically set by the camera's built-in computer, from 1/60 sec to the camera's maximum flash-safe (X-sync) speed	Automatically set by the camera according to ambient light levels
Tv (Shutter speed priority)	The photographer can set any shutter speed between 30 seconds and the camera's maximum X-sync speed	Automatically set by the camera between 30 seconds and the camera's maximum X-sync speed to yield sufficient ambient exposure based on the shutter speed setting
Av (Aperture priority)	Automatically set by the camera, from 30 seconds to the camera's maximum X-sync speed, to yield sufficient ambient exposure based on the aperture setting	The photographer can set any lens aperture available (i.e., any of which the lens is capable)
M (Metered manual)	The photographer can set any shutter speed between 30 seconds and the camera's maximum X-sync speed	The photographer can set any lens aperture available

6.10 Program (P) mode

In Program (P) mode, the camera chooses both shutter speed and aperture settings based on its reading of ambient light levels and according to a software program run by its computer; hence the name. Modern point-and-shoot cameras usually work this way.

When using either a built-in flash unit or an external Speedlite, P mode operates in one of two modes, depending on the ambient (existing) light levels.

- If ambient light levels are fairly bright (above 13 EV, see section 7.17), then P mode assumes that the photographer wants to fill flash (see below) the foreground subject. It meters for ambient light and uses flash, usually at a low-power setting, to fill in (brighten) the foreground with supplementary light.
- If ambient light levels are not bright (below about 10 EV), then P mode assumes that the photographer's goal is to illuminate the foreground subject with the flash. It sets a shutter speed between 1/60 sec and the fastest X-sync speed (see above) the camera can attain. The aperture is determined by the camera's built-in program.

> **• KEY POINT**
>
> The overriding principle of Program (P) mode in Canon EOS flash photography is that the camera tries to set a high shutter speed so that the camera can be held by hand without a tripod. If that means the background is dark, so be it.

P mode will not allow exposures to be shifted with the main control dial when automatic flash is used.

6.11 Tv (shutter speed priority) mode

In this mode, the photographer chooses a shutter speed by rotating the main dial next to the shutter release button. The camera then automatically chooses an aperture setting to expose the background correctly. Since the photographer explicitly specifies the value of the shutter time, the Canon abbreviation for this mode is "Tv," for "time value," though other brands refer to it as "S" for "shutter speed" mode. Flash output is determined automatically and separately by the flash metering system.

If the maximum aperture value of the lens starts flashing in the viewfinder, it means the background of the scene is too dimly lit, and the shutter speed should be decreased to compensate. Otherwise the camera will just try to expose the foreground with flash, and the background will come out dark. Naturally, at slower shutter speeds, a tripod will be needed to avoid blurring caused by camera shake.

If either the built-in flash unit or an external Speedlite is powered on, the camera prevents the photographer from selecting a shutter speed that exceeds the camera's maximum flash-safe (X-sync) unless high-speed sync is available and engaged. If the minimum aperture value of the lens starts flashing, the shutter speed is too long even with the lens fully stopped down. The scene is very bright and will be overexposed. The ways around the problem are to engage high-speed sync if it's available, use a lower ISO setting or slower film, or put a neutral density (light absorbing) filter on the lens. Alternatively, turn off flash altogether and simply use a reflector of some type to bounce ambient light onto the subject if required.

> **• KEY POINT**
>
> In Tv mode, EOS cameras always try to expose the background adequately, unlike P mode. In low-light conditions, Tv mode uses slow shutter sync.

6.12 Av (aperture priority) mode

In this mode, the photographer chooses a lens aperture value by rotating the main dial. The Canon abbreviation is thus "Av" for "aperture value," though it's often called "A" mode by other brands. The camera then chooses a shutter speed ranging from 30 seconds to the camera's X-sync speed, in order to expose the background correctly. Flash output is automatically determined by the flash metering system.

There is an exception. Many EOS cameras have a custom function which locks the shutter speed to X-sync, letting the camera behave more like P mode when in Av mode. Other models also have a custom function which chooses a shutter speed between 1/60 sec and X-sync, the way P mode does.

> **• KEY POINT**
>
> In Av mode, EOS cameras try to expose the (ambient) background correctly. If that means the shutter speed is a really long value, such that a tripod is needed to avoid camera-shake blur, so be it. In dark conditions Av mode uses slow sync.

If either the built-in flash unit or an external Speedlite is powered on, then the camera will not exceed its built in X-sync speed unless high speed sync is available and engaged. If the shutter speed value of 30" blinks in the viewfinder, then there isn't enough light to expose the background correctly and a larger aperture or higher ISO setting/faster film are required. If the camera's X-sync value blinks in the viewfinder, then the lens aperture must be decreased, high-speed sync engaged if it's available, or a lower ISO/slower film used.

6.13 M (metered manual) mode

In manual exposure mode, the photographer can specify both the aperture and shutter speed at will. It is thus technically not an automated exposure mode, but one *assisted* by the automatic system since an exposure meter will appear in the viewfinder. However, this is just a guide, and the camera does nothing to override any ambient light setting chosen.

Using metered manual mode does not affect the flash system's control over flash output. Manual mode affords complete control over ambient metering, though it also requires experience to use it effectively.

6.14 DEP (depth of field), A-DEP (automatic DEP), and B (Bulb) modes

DEP and A-DEP modes do not work with flash, and their metering settings revert to P mode if flash is turned on. In B, or bulb mode, the camera behaves as it would in M mode.

6.15 Fill flash

If ambient light levels are fairly high, such as outdoors during the day, flash can serve as a supplementary form of light. Flash can lighten shadows, temper the harsh contrast of full sunlight, or brighten up dull images. This is called "fill flash", "fill-in flash", "balanced fill flash", or "daylight synchro".

Fill flash is often a source of surprise for non-photographers, who don't expect to see flash units being used outdoors on sunny days or in brightly lit settings. In such situations, the fill flash serves as a sort of portable reflector, adding a little extra light. A backlit subject is a common situation for fill flash: exposure compensation can't be used to expose the subject correctly, since the background would be overexposed.

> **• KEY POINT**
>
> In M mode, shutter speed and aperture determine how the background (ambient lighting) is exposed. The foreground, however, will still be illuminated automatically since the flash metering system operates independently of the ambient light metering system.

Another classic example is a person with long hair or a hat on a sunny day. Hair and hat brims often cast dark shadows over a subject's face, and a little flash can lighten up these shadows nicely.

As always, the amount of ambient light hitting the film or sensor is governed by the lens aperture and shutter speed, while flash levels are governed by flash metering. Adjusting the output of the flash unit essentially adjusts the ratio between the flash-illuminated subject and the ambient-illuminated scene.

In fact, one could argue that flash as primary light source versus ambient light as primary light source is an artificial distinction, and that all flash photography is fill photography in a sense. It's just that, in the first case, the ambient lighting is so low as to be insignificant, whereas in the second case it's the reverse. The distinction is nonetheless useful, particularly when considering the way full auto and P modes work versus Tv, Av, and M modes.

Automatic fill flash was one of the chief technical innovations in flash usage developed in the 1970s and 80s. For decades, photographers knew that low levels of flash could be useful for filling in shadowed areas in a daytime photograph, but determining the flash output for suitable fill required a lot of skill and experience before the advent of flash automation.

> ● **KEY POINT**
>
> Canon EOS cameras always default to fill flash mode when the camera is in Tv, Av, and M modes. They also perform fill flash in P mode if ambient light levels are high enough. There's no separate switch or push button to engage fill flash on EOS cameras.

Figure 6-11
Nature photography can benefit from a little fill flash as well. Here, the flash prevented the heron from getting lost in the shade under the trees. The drawback was that it also overexposed the near branches to the right. Heian Jingu temple garden, Kyoto, Japan.

Figure 6-12

The Raygun Gothic Rocketship was designed and built by Sean Orlando (shown), David Shulman, and Nathaniel Taylor. The art piece made its debut at the annual Burning Man arts festival in Nevada's Black Rock Desert.

The first photo, taken at sunset following a dust storm, demonstrates the low foreground light compared with the background (essentially a backlight condition). In the second image, a fairly natural-looking photograph is achieved by applying fill flash to balance the foreground. EOS 5D Mark II, 580EX II, 1/80 sec at f/8, ISO 100, 40mm.

6.16 Fill flash ambient light reduction

There is one non-obvious exception to be aware of when using fill flash. EOS cameras that use E-TTL adjust exposure settings downwards when ambient light levels are low.

To test if a given camera reduces exposure settings, put the camera into Av mode and meter a fairly dark scene. Note the settings the camera wants to use, then turn on a flash unit. Meter again, and there'll probably be a drop in the exposure settings of a half to a full stop. This unadvertised feature makes the foreground image pop a little, but not always in a fashion that's desirable.

6.17 Flash exposure compensation (FEC)

Sometimes it may be desirable to adjust a flash unit's power above or below the mid-tones that the camera anticipates. For example, a scene that's mainly white or mainly dark can fool automated sensors. A manual shift up or down in flash output is known as flash exposure compensation (FEC), which is referred to as "fill-in ratio control" or "flash level control" in older Canon manuals.

In a sense, FEC can be seen as the opposite of slow shutter sync, since it allows flash-illuminated (foreground) levels to be adjusted while leaving the ambient (background) levels untouched. FEC also differs from ordinary exposure compensation, which adjusts only ambient exposure levels on EOS cameras. Exposure compensation on some other systems, such as Nikon, adjusts both ambient and flash levels simultaneously.

Figure 6-13

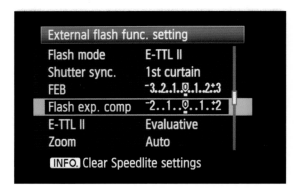

As noted in the section on fill flash, a common use of flash is lightening shadows and toning down high-contrast sunlight. Adding a subtle catchlight to the eyes is another. For cases like this, it may be necessary to dial in an additional minus stop or two of flash compensation over the camera's

built-in flash program to avoid blasting out a ton of fill flash that would wash out the subject's face or cast flash shadows. The camera's default fill flash settings can be a little too bright and obvious, resulting in a cardboard cutout effect to portraits.

It may also be necessary to override the default flash controls in situations that are hard for the flash system to meter. Wedding photos of a man in a black tuxedo in a large room, or a woman in a white dress next to a white cake, are common metering problems.

Flash compensation is enabled in different ways depending on the camera and flash unit in use (section 9.9).

7 Technical Topics

This chapter covers a series of fairly technical subjects that describe the underpinnings of modern flash technology. Reading it will provide sufficient background for many of the complex issues that govern how flash works. It isn't the easiest part of this book, but if you skip it, you may want to refer back to this section later.

7.1 Canon EOS flash metering

As described in the previous chapter, automatic flash metering on EOS cameras is performed by the camera and flash unit working together in concert, and is essentially handled independently of metering for ordinary ambient light. Canon has, over the years, built two fundamental types of flash metering technologies into its EOS cameras: TTL, which is used only by film cameras, and E-TTL, which is used by later film cameras and all digital cameras. Here is how this technology works.

Figure 7-1
A digital EOS 500D (Rebel T1i) camera with Speedlite 430EX flash unit, shown attached to an optional SB-E2 flash bracket. Like all EOS digital cameras, this model uses E-TTL flash metering exclusively.

7.2 TTL flash metering

"Through-the-lens", or TTL flash metering, was a technology pioneered by Olympus in the mid-1970s. The first Canon camera to use it was the legendary T90 manual focus camera, and the feature was standardized in the EOS film camera lineup shortly thereafter. While virtually all EOS film cameras use TTL, no digital EOS models do.

TTL flash metering measures the pulse of flash-generated light bouncing back off the subject and entering the lens. The light sensor isn't located between the lens and the film, since that would obviously block the exposure, but is positioned at the bottom of the mirror box. It actually detects the light reflecting off the surface of the film itself, and is thus known as an off-the-film (OTF) sensor. The light produced by the flash unit is shut off, or "quenched", when the camera determines enough light has been emitted to achieve a satisfactory flash exposure. ● *Figure 7-3*

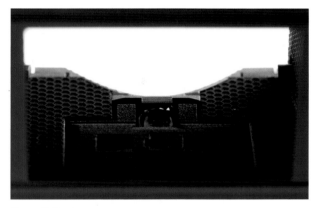

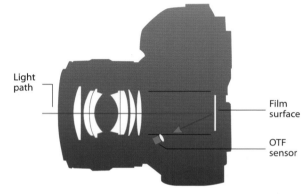

Light path

Film surface

OTF sensor

Figure 7-2

The base of a film camera's mirror box, looking from the film side of the camera. The small lens covers the TTL flash sensor. The other openings are for the autofocus sensors.

Figure 7-3

While TTL is similar to autoflash (section 10.7) in that the scene-illuminating pulse is measured in real time as it is emitted by the flash tube, it differs significantly since the flash sensor is inside the camera and not on the flash unit. For this reason TTL flash must be designed into the camera from the ground up, and camera and flash unit must be able to communicate with each other. Technologically, this is very different from manual flash and autoflash, which rely solely on a simple "produce light right now!" sync command from the camera body.

TTL records only the light that makes up the final image. Unlike autoflash sensors built into a flash unit, it can't be fooled by reflective objects outside the frame. TTL doesn't care about any light-modifying devices or filters placed on the flash or lens, since it records reflected light and not the output of a device. TTL is highly automated, freeing the photographer from the burden of calculating the distance from flash to subject or adjusting flash output settings.

Almost every EOS film camera supports TTL, with two exceptions that are described in section 7.6.1.

7.2.1 TTL limitations

TTL is not without disadvantages. The flash sensors can easily be fooled by highly reflective surfaces visible in the frame or by off-center reflections. TTL is optimized for the way light reflects off typical color negative film and may have subtle metering problems when used with different film emulsions. TTL does not work well with multiple flash units and does not support wireless operation. And, like all automated flash metering systems, TTL can't be reliably mixed with manual flash.

EOS cameras have only one, three, or four TTL sensors, depending on the model. This means they tend to overexpose off-center subjects, since the flash sensor doesn't receive much reflected light back from them. Canon TTL doesn't use distance data, so it can't distinguish between a reflective object that is far away and a less reflective object close at hand.

7.2.2 Digital cameras and TTL flash

The development of digital image sensors caused a huge problem for engineers at Canon and other camera companies when it was discovered that TTL flash didn't work reliably with them. This is because digital sensors reflect light in a different way than film surfaces. Fortunately, Canon already had E-TTL metering developed by that point.

For this reason, digital EOS bodies from the EOS D30 onwards lack TTL flash electronics and support E-TTL only. TTL-only Speedlites, or any EX Speedlite set to TTL mode, will either fire at full power or not at all when used on a digital camera.

When shopping for a Speedlite for a digital EOS camera, be sure to avoid the older non-EX Speedlite models, no matter what sellers may claim about their compatibility. If buying a third party unit, make sure it says E-TTL and not just TTL. For a comprehensive features list, please see appendix C.

> **• KEY POINT**
>
> TTL-only flash units (Speedlite E, EG, and EZ models) *cannot* meter automatically when used with a digital EOS camera. The same applies to EX Speedlites if set to TTL mode.

7.3 A-TTL flash metering

"Advanced" TTL flash metering is a Canon TTL variant available to all TTL-compatible film cameras when a Speedlite EZ model is attached.

In A-TTL mode, the flash unit fires a brief pulse of light during the metering phase, before the shutter actually opens. A-TTL units have a special sensor to record light bouncing back from this preflash, and that data is factored into normal TTL operation. In other words, the A-TTL preflash is supplementary, does not supply the primary metering data, and is measured by the flash unit and not the camera.

EZ units have a second front-mounted flash tube that can produce the A-TTL preflash. The tube is covered by black plastic, which blocks most visible light but which allows invisible infrared energy through.

The preflash occurs when the shutter release button is pressed halfway. It's either invisible infrared from the secondary tube or visible white light from the main tube, depending on the model. The 300EZ will always fire an infrared preflash. When the flash head is set to point straight ahead (i.e., direct flash mode, not bounce flash), the 420EZ and 430EZ will fire infrared preflashes in Av, Tv, or P modes but will fire annoying white flashes if the flash head is tilted or swiveled. These units revert to TTL in M mode. The 540EZ will fire an infrared preflash in P mode when in direct flash mode, but reverts to TTL in bounce mode or if the camera is in Av, Tv, or M modes.

A-TTL, despite its name, offers little advantage over regular TTL and was abandoned when E-TTL was introduced. No EX flash unit supports it. The preflash is really only used in P mode and tends to end up setting a pretty small aperture in order to assure wide depth of field. No third party flash unit appears to support A-TTL.

Figure 7-4

The round lens covers the A-TTL sensor. The glowing red area to the left of the sensor is the near-infrared prefire for A-TTL metering. It's basically an ordinary flash tube hidden behind a light-blocking plastic panel.

7.4 E-TTL flash metering

"Evaluative through-the-lens" (E-TTL or preflash) flash metering was introduced in 1995 and is the current way that EOS cameras meter for flash. It's completely incompatible with TTL and uses the same evaluative light sensor as regular ambient lighting, rather than a separate OTF flash sensor.
● *Figure 7-5*

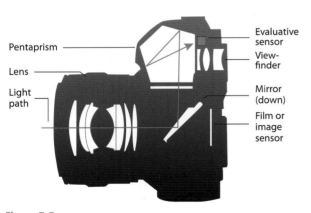

Pentaprism
Lens
Light path
Evaluative sensor
Viewfinder
Mirror (down)
Film or image sensor

Figure 7-5

Figure 7-6

The pentaprism from an EOS camera. The circuit board behind the small plastic lens contains the ambient light sensor. This assembly is buried inside the top of the camera and can't be seen from the outside.

> **• KEY POINT**
>
> E-TTL flash fires at least one low-power flash for metering purposes prior to the actual scene-illuminating flash.

E-TTL measures correct flash exposure by firing a low-powered preflash of known brightness from the main flash tube. The reflectance of the preflash-illuminated scene is measured using evaluative metering, and the camera calculates the light required to achieve a mid-toned subject. The camera flips up the mirror and opens the shutter, then instructs the flash unit to fire the scene-illuminating pulse at the pre-computed output level.

Like A-TTL, E-TTL uses a preflash which occurs before the mirror rises. E-TTL also relies on the camera doing all the metering and calculating. But the systems are otherwise completely different, in terms of the timing of the preflash, its purpose, and the way it's measured.

First, the E-TTL preflash occurs immediately *before* the shutter opens and not when the shutter release is pressed halfway. The E-TTL preflash is essential, not optional, to determining flash exposure. Some users may be surprised to learn that E-TTL actually fires a preflash at all. Under normal circumstances, the process happens so quickly that the preflash is difficult to notice—though it is quite obvious when using flash exposure lock (FE lock) or second-curtain sync and a long shutter setting. However, the preflash explains why a slight flash is visible when looking through the viewfinder: the subject-illuminating flash can't be seen through the viewfinder since the mirror is up at that point.

Second, the preflash is analyzed by the same evaluative metering system that the camera uses to meter ambient light. This means it meters through the lens and is harder to fool than external sensors, isn't confused by bounced light, doesn't read anything off the surface of the film, and examines more discrete zones of the image.

E-TTL is also generally superior to TTL and A-TTL when it comes to fill flash. The E-TTL algorithms are usually better at applying subtle and natural fill flash to daylight photographs. E-TTL exposure is also linked to the current AF focus point, which, in theory, results in finer-grained exposure biasing than TTL flash sensor systems (which only have one or three zones).

E-TTL requires both an E-TTL camera and an E-TTL flash unit. EOS film cameras sold since the mid-1990s and all EOS digital cameras since the D30 support it, but older TTL cameras cannot be upgraded. All Canon Speedlite flash units with "X" in the name speak E-TTL.

7.4.1 Limitations of E-TTL

E-TTL has developed a good deal over the years. Many early E-TTL film cameras didn't support wireless flash ratios or modeling flash. Early EOS digital cameras also had problems with E-TTL metering. Canon has improved its flash algorithms, and the introduction of E-TTL II has helped significantly,

so more recent EOS digital models work better with flash than early models such as the D30 and 10D.

More abstractly, E-TTL is a very automated system, and it's not always immediately obvious how it will respond. However, there are a few key issues to be aware of when using E-TTL.

The main issue is that E-TTL links to, or biases, the active focus point when using autofocus. In other words, it makes the assumption that the current active focus point is located over the primary subject. When that isn't the case, or when the subject is particularly light or dark, flash metering problems can occur.

This is one of the causes of flash metering errors when using the traditional "focus and recompose" technique. Since flash metering occurs *after* ambient light metering, focus and recompose will lock ambient metering but not flash metering. The recomposing stage will then probably confuse the flash metering.

The ways to avoid this problem are to select the focus point that's closest to the subject in order to bias flash exposure to that area, use flash exposure lock (FE lock) to lock down flash metering, or switch the lens to manual focus. Since there are no AF points in manual focus mode, E-TTL will average exposure across the frame. These techniques all have their drawbacks, and this aspect of E-TTL is addressed by E-TTL II (see below).

Another problem associated with E-TTL is that the preflash can cause people who blink quickly to be photographed mid-blink, even though a

Figure 7-7
E-TTL eye droop.

Figure 7-8
Even birds aren't immune to the phenomenon.

74

miniscule amount of time passes between the preflash and the main flash. It's not uncommon for group photos to feature a number of droopy or closed eyelids. A similar problem can affect nature photographers who photograph skittish birds. The problem is heightened when using second-curtain sync with slow shutter, since a longer period of time can elapse between the preflash and the flash.

The only reliable way around the issue is to fire the preflash manually by pressing the FE lock button, waiting a moment, and then taking the actual photo. When using FE lock, it's wise to warn the subjects that there'll be two flashes; otherwise, they might look away after the preflash, thinking the photo has already been taken.

Finally, the E-TTL preflash can prematurely trigger optical slave flash units that work by detecting the light from the triggering flash (section 11.7.3). This results in the main flash being underexposed or nonexistent, since the optical slave is triggered too soon. The preflash can also confuse handheld flash meters.

7.5 E-TTL II

E-TTL II, introduced in 2004, is a refinement of E-TTL that brings two significant changes to the way Canon DSLRs perform metering. E-TTL II does not require any changes to either the flash units or lenses used with an E-TTL II camera—the changes are all internal to the camera body. Cameras that support E-TTL II always do so; there's no "fallback" to E-TTL. An older camera cannot be upgraded to E-TTL II.

7.5.1 E-TTL II's improved flash metering algorithms

E-TTL II examines the camera's central evaluative metering zones both before and after the E-TTL preflash goes off. Any areas with relatively small changes in brightness are weighted, or given greater priority. This reduces the E-TTL problem of reflective materials throwing off flash metering. The camera does not examine the metering zones around the periphery of the frame during flash metering, since it assumes that the subject will not be that close to the edge.

In a sense, E-TTL II meters flash data across an imaginary flat plane rather than at a point, and the area being metered for flash depends more on the subject size. It also meters the same regardless of whether autofocus or manual focus is used.

Normally, E-TTL II uses evaluative algorithms for its flash metering, but some cameras can use averaging rather than evaluative for flash metering. This option may be useful when using lenses with no distance data. ● *Figure 7-9*

> **• KEY POINT**
>
> Unlike E-TTL, E-TTL II never links exposure to the active focus point.

Figure 7-9

7.5.2 Distance data

Most Canon EF and EF-S lenses contain rotary encoders that detect the approximate distance from the camera to the subject in focus. Under certain conditions, E-TTL II can factor the distance into the calculations for determining proper flash output. This is primarily used for confirming whether a highly reflective or nonreflective area is at the same distance from the camera as the subject in focus. It's particularly useful when using focus and recompose without setting FE lock; E-TTL II can help minimize flash metering errors under these conditions.

Figure 7-10
Magic encoder ring. This is what the distance encoder from an EF 70–200 4L lens looks like.

While many Canon lenses have distance data capability, EOS cameras rarely made much use of it before the advent of E-TTL II. Some icon (beginner) modes on some cameras did incorporate distance data into their exposure calculations. A list of lenses with encoders is included as appendix F.

7.5.3 Cases in which distance data is not used

E-TTL II uses distance data only for straight-ahead direct flash. Distance data is not used when the lens cannot provide it, when the flash head is tilted or swiveled, with macro flash, or with wireless E-TTL II.

When using bounce flash (i.e., when the flash head is in almost any position other than straight on), there is no way for the camera to know the distance the light traveled to reach the subject from the flash unit. Light will be scattered off walls or ceilings or other surfaces. Since bounce flash is a common technique to improve the quality of a flash-illuminated scene, it means that the primary advantage of E-TTL II in this situation is just improved evaluative flash metering. There is one minor exception: when 500 EX series units have their flash heads tilted downward 7°, distance data is not disabled.

The remaining two conditions are similar. With macro flash, the camera is too close to the subject for the lens to determine useful information; and with wireless E-TTL flash, the camera has no idea where the flash units are positioned in relation to the subject.

However, E-TTL II can still use distance data if the flash unit is connected to a camera via an Off-Camera Shoe Cord (section 11.5.1). This means that users of flash brackets won't be left out. It also means that if the flash unit is positioned closer to or farther from the subject than the camera, or if the flash unit is pointed away from the lens axis while the flash head is locked in a straight-ahead position, then flash metering may be thrown off slightly. The use of distance data cannot be disabled if the lens has it, though setting the flash head to a slight off-center bounce position will disable distance data while not significantly altering the flash coverage.

The important point is, therefore, that while E-TTL II uses distance data when it's available and when it's appropriate, it doesn't *rely* on distance data.

7.6 Type A and type B cameras

When E-TTL was introduced, Canon clarified compatibility by designating E-TTL-compatible camera bodies as "type A" and TTL-only bodies as "type B". This terminology isn't used much today, since EOS cameras have supported E-TTL for years. Most type B bodies aren't described as such in their manuals, since they predate the A/B distinction.

There are also unlabeled subvariants of type A technology. Specifically, the first generation of type A cameras does not support wireless E-TTL flash ratios and modeling flash; the second and third generations do. The third generation adds support for E-TTL II. Most type A film cameras support legacy TTL flash.

All EOS digital cameras are second or third generation type A and do not support TTL.

7.6.1 TTL, E-TTL, and EOS film cameras

Nearly all film-based Canon EOS cameras support TTL flash metering if an older Speedlite is attached. However, those film-based EOS cameras with built-in flash units and E-TTL support still rely solely on TTL for flash exposure control of internal flash. The film camera exceptions are the EOS 300X/Rebel T2 and the oddball Canon EF-M.

The EOS 300X/Rebel T2/Kiss 7 (same camera with different names for different markets) is a 35mm film camera that supports E-TTL II only, as it has no TTL components. The EF-M is basically an EOS Rebel/1000 that uses

EF-mount lenses but lacks both autofocus and TTL flash circuitry. A special low-powered autoflash, the Speedlite 200M, was sold uniquely for the EF-M. ● *Figure 7-11*

7.6.2 Kodak Digital Science (DCS) cameras

The Canon EOS D30 of 2000 was the first digital SLR built wholly by Canon. From 1995 to 1998, Canon produced cameras in collaboration with Kodak. These pioneering digital SLRs were actually EOS 1N bodies with either the back or the film transport mechanisms removed. "Digital Science" processing units made by Kodak were then attached, converting the film cameras into digital units.

Figure 7-11

 The DCS models were sold under different names by Canon and Kodak, and include the DCS 1, DCS 3, DCS 5, DCS 520, DCS 560, D2000, and D6000. Most used a modified version of TTL, and accurate flash metering was not a strength of these cameras.

 Very few DCS cameras were sold, and they are not covered in this book. So while it's technically true that a few early digital EOS cameras did use TTL, from the point of view of useful discussion it's fair to say that all EOS digital bodies are E-TTL only.

7.7 Flash technology availability summary

- TTL/A-TTL and E-TTL are incompatible systems. Many EOS film cameras can use either one, but the two metering technologies cannot be used simultaneously.
- Nearly all EX-series (i.e., E-TTL capable) flash units also support TTL metering and will automatically revert to TTL metering when used with an older type B camera.
- Nearly all EOS film cameras support both TTL and A-TTL metering. They can all use most E-series flash units in TTL mode and EZ-series flash units in A-TTL mode.
- EOS digital cameras support either E-TTL or E-TTL II. They do not meter automatically with TTL-only units or EX-series units if set to TTL mode.
- If the camera and flash unit support both TTL and E-TTL (i.e., the camera is a type A film body and the flash unit is an EX model), then E-TTL will be used unless specifically overridden by on-flash controls.

7.8 Metering patterns

Unlike human eyes and brains, which can interpret the importance of various sections of a scene, a camera simply detects a rectangular field of light reflected off objects. It has no idea what's important and what's not. Consequently, a number of different ways or patterns of measuring ambient (available) light levels have been developed by Canon and other camera makers. The application of these patterns depends on the camera model, user settings, and whether ambient light or flash is being metered.

7.8.1 Ambient metering and metering patterns

All EOS cameras contain light meters tucked away inside the top of the viewfinder (section 5.8). These electronic devices measure light levels and are used by the camera's computer system to set the exposure automatically.

There are a number of ambient metering patterns used in Canon EOS cameras. Most digital EOS models allow the photographer to select any desired mode at will, as long as the camera is in a letter mode for metering (P, Av, Tv, M, B, DEP). However, some earlier models did not permit user selection of metering modes and chose them according to built-in programs.

7.8.2 Center-weighted average metering

This is one of the simplest ways to meter ambient light, and it was commonly found in SLRs of the 1970s. The camera's light meter measures light across the entire frame. If the metering is center-weighted, then it gives additional importance (weighting) to the area around the center. ● *Figure 7-12*

Figure 7-12

7.8.3 Spot metering

The camera measures the light around a very tiny section of the entire frame, typically 2 to 4% of the total frame area. Usually, the spot is right at the center of the frame, but on some cameras it can be around the active autofocus point. This more advanced form of metering, favored by professionals, requires the photographer to select the area to be metered very carefully. ● *Figure 7-13*

Figure 7-13

7.8.4 Partial metering

This pattern is considered sort of a fat spot. The camera measures the light around a larger area, typically 8 to 10%. Though less precise than spot metering, partial is more forgiving and easier to use. ● *Figure 7-14*

Figure 7-14

7.8.5 Evaluative metering

The most automated form of metering, evaluative metering divides the frame into a series of small cells or zones. Complex computer programs inside the camera examine the light levels recorded by each cell and analyze them using proprietary software. ● *Figure 7-15*

Figure 7-15

Canon has used many types of evaluative metering sensors over the years, ranging from early EOS cameras, which divided the frame into a mere six zones, to the latest 63-zone sensors. This type of metering is also known as multi-zone or matrix metering on other systems. ● *Figure 7-16*

Figure 7-16

7.9 Flash metering patterns

In addition to metering patterns for ambient lighting, there are differences in the way flash metering is handled.

7.9.1 Film cameras and ambient metering with TTL flash

Film-based cameras vary from model to model in terms of how ambient light metering is handled when TTL or A-TTL flash is used. These differences stem from the fact that the camera needs to meter for the background and not the subject when using flash. Consequently, the camera's ambient metering patterns may change silently when flash is turned on.

Cameras with single zone ambient metering, such as the T90 and the original Rebel/1000 cameras, use center-weighted average metering for the background when using TTL and A-TTL flash.

EOS film cameras equipped with partial metering buttons use partial metering patterns for ambient light metering. The T90, EOS 1, 700, 750, and 850 are exceptions: they do not switch to partial metering for flash.

EOS film cameras with multiple metering zones for ambient metering typically examine only the outer segments of the evaluative metering sensor when using TTL and A-TTL flash.

7.9.2 Digital cameras and ambient metering with E-TTL flash

When flash is enabled, most E-TTL cameras do not alter their metering patterns; that is to say, they retain the user-selected ambient metering pattern. However, 1 series cameras are different. When flash is enabled, these cameras switch to evaluative metering, but weight as if the center focus point is active. The end result is that flash on these models requires metering for ambient in a fashion similar to center-weighted averaging.

7.9.3 TTL and A-TTL flash metering zones

TTL and A-TTL flash, which rely on separate flash sensors from the regular ambient light sensors, use considerably simpler metering patterns than ambient light. The earliest EOS film cameras have only one focus point and a single flash sensor located at the bottom of the camera's mirror box. This sensor meters flash exposure across the entire frame in a center-weighted averaging pattern, so photos with off-center subjects may meter poorly.

All EOS cameras with multiple focusing points have multiple TTL metering zones, referred to as the Canon AIM system for "Advanced Integrated Multi-point". The number of zones available depends on the model.

Figure 7-17
The EOS 5/A2/A2E camera has five focus points and three A-TTL flash metering zones.

For instance, the EOS 10/10s has three AF points and three flash metering zones, and flash metering uses whichever point or points are active. The EOS 5/A2 uses the same sensor as the 10/10s, so it has only three flash metering zones even though it has five autofocus points. The Elan II/EOS 50/55 has three AF focusing points and a four segment / three zone flash sensor. This means the flash sensor has four segments but it chooses two consecutive segments to yield three possible zones. The full list is in appendix C.

Multiple zone flash sensors let the camera bias the flash exposure to the currently selected AF point. The camera biases to the central zone in manual focus mode. The A2E/5 is somewhat different from other multiple AF point cameras since it only biases flash exposure to the nearest AF point if that point is manually selected. In automatic and eye-control focus (ECF) modes, it always chooses the center zone.

7.9.4 E-TTL flash metering patterns

It isn't possible to describe the algorithms used by E-TTL flash for metering in much detail. They have never been published by Canon and are considerably more complex than the relatively simple TTL rules. Metering behavior also varies from model to model, and it has improved over the years as E-TTL has evolved.

E-TTL uses the same light meter as ambient light metering, simply employing it at a different stage. E-TTL typically uses an evaluative metering pattern, though some cameras allow the user to select which metering pattern to use via a custom function. Some also use averaging when in manual focus mode.

When in autofocus mode, E-TTL cameras bias flash metering toward the currently selected AF point. Most early digital EOS cameras perform evaluative metering for the background when flash is on; they don't use spot or partial metering patterns. When in manual focus mode, some EOS bodies switch to averaging.

As discussed earlier, heavy biasing to the active point is potentially problematic, since flash metering is done in almost a spot-metering fashion. Many E-TTL flash metering problems appear to be linked to this issue. If the focus point happens to be over a dark object, for example, flash metering can be considerably overexposed, and vice-versa.

The standard answer to this problem is to use FE lock and meter off something mid-toned, but this is clearly not a solution for rapid-shooting situations such as weddings and sports. Another approach is to set the lens to manual focus as described above, but that is also awkward.

The earliest digital EOS models—the D30 and D60—are known for E-TTL flash issues in this regard. The 10D and later models reduce the risk of flash metering inaccuracies by defaulting to an averaging metering pattern in E-TTL, even when the lens is set to autofocus.

7.9.5 E-TTL II flash metering patterns

E-TTL II takes a very different approach to flash metering by not biasing the active focus point. Instead, it examines each evaluative metering zone before and after the preflash. It then calculates the weighting for each zone independently, biasing *against* those zones with high reflectivity in the preflash. E-TTL II does not have a flash metering pattern as such, since it's calculated dynamically for each shot. Cameras with E-TTL II should generally have more reliable flash metering than their predecessors.

Figure 7-18
Female Japanese jorō-gumo spider, *Nephila clavata*. Fushimi Inari Taisha, Kyoto, Japan. This case would have been a real problem for TTL, with its three or four zone metering system, and E-TTL, which biases heavily to the focus point. The spider occupies a small area of the image but is relatively shiny and reflective. E-TTL II metering does a decent job of lighting the spider without blowing out the highlights. Slow shutter sync was used to expose the background correctly.

7.10 How mechanical camera shutters work

Camera shutters are often thought of as simple panels that slide aside to expose the film or image sensor, and then move back again to end the exposure. This is sometimes the case with point-and-shoot cameras, but modern SLR shutters are much more complicated.

Figure 7-19
The shutter mechanism
from a Canon EOS camera.

SLR shutter mechanisms consist of thin overlapping "blades" which slide back into a recess, much like an elevator door. But unlike most elevators, camera shutters have two separate doors known as "curtains", both of which fully cover the film or sensor when closed. Instead of having a pair of sliding panels like a typical elevator door, EOS shutters have four or five blades per curtain, made of composite plastic materials or aluminum alloy. This shutter design is known as a "focal plane" shutter, since it's located right next to the film or image sensor which is the plane of focus.

The following is the normal shutter opening sequence, not counting special cases such as silent shooting in digital Live View mode, or when the shutter speed exceeds the camera's X-sync value.

- The "second curtain" (rear curtain in Nikon parlance) opens first. The camera's computer activates an electromagnetic motor, or release catch, which raises the second curtain blades vertically out of the light path. However, the image area is still covered by the first (front) curtain at this point.

- Next, the first curtain lowers, exposing the image area to light. The shutter stays open for the time period specified by the camera's shutter speed setting. Normally, this is the point when a flash sync signal is sent to a flash unit.

- When the camera's computer determines that the correct shutter time has elapsed, it closes the second curtain, blocking the light path. The first curtain stays lowered and open.

- Once the second curtain has closed, the film or sensor is fully covered and exposure comes to an end.
- Finally, the shutter resets itself in preparation for the next shot by raising the first curtain back to its starting position. The film or sensor is now completely covered by both shutter curtains.

7.11 Maximum X-sync

So what does SLR shutter design have to do with flash photography? Quite a lot, it turns out. At most shutter settings, the shutter blades move so rapidly that the entire image area can be exposed to light with each shot. But mechanical shutters simply can't move fast enough to allow for really short shutter times, even though the blades may reach a remarkable 20mph/35kph.

The solution for high shutter speeds is to start closing the second curtain *before* the first curtain is fully open. When this happens, the image area is never completely exposed to light. Instead, the curtain motion forms a slit of light that travels across the frame, a bit like a flatbed scanner or photocopier. The speed of the blades never actually changes on most cameras, what varies is the time between one curtain opening and the other closing.

Figure 7-20
The black bar on the side of the frame was caused by the camera using a shutter speed that exceeded X-sync

In the case of ambient lighting, where light output remains constant, a moving slit exposes the image evenly and the picture will turn out fine. But with flash photography, the flash pulse is just a brief blink of light. If the exposed area is a narrow slit at the time, then the whole frame won't be properly exposed. The result of using a higher shutter speed than the camera can handle looks like the example photo. ● *Figure 7-20*

There is one complication for digital cameras: "electronic shutters". An electronic shutter turns the image sensor on and off to simulate a mechanical shutter. Mechanical shutters are still mostly used on SLRs today because of timing issues with CMOS digital sensors. However, image chips of the future will probably eliminate the need for physical shutters on SLRs, thereby lifting X-sync restrictions. In fact, the EOS 1D, which has a CCD sensor and not a CMOS sensor, has both an electronic shutter and a mechanical one, which is why it has an unusually high X-sync of 1/500 second.

At the time of writing, EOS cameras with Live View can use an electronic first curtain. This means that the sensor is turned on electronically to simulate the shutter opening, but exposures are ended cleanly by relying on the traditional, mechanical second curtain.

7.11.1 Maximum X-sync limits

Under normal circumstances, an EOS user will never see a picture marred by a dark rectangular flash shadow because the camera will prevent the use of a shutter speed that exceeds X-sync. This is why a camera's shutter speed setting may drop when a flash unit is turned on or popped up: the camera is enforcing this internal limit.

Maximum X-sync will vary from as low as 1/90 second on consumer cameras to 1/250 or 1/300 on professional bodies (and 1/500 for the EOS 1D). Cameras with small image sensors or APS film tend to have higher maximum X-sync speeds than equivalent full-frame/35mm cameras because their smaller shutters operate more quickly.

One film camera, the EOS 5/A2/A2E, has an unusual mode dial setting called "X". This mode is like Av mode except that it sets the shutter speed to one of four user-selectable common flash sync speeds: 1/200 sec, 1/125, 1/90, or 1/60.

On the other hand, there are three cases where X-sync can be exceeded when flash is used. The first case is non-Speedlite flash units. If a flash unit is triggered via a manual connection (chapter 11), then the camera will have no idea that flash is actually in use. Only automatic, Speedlite-compatible flash units connected to a camera's hotshoe (and, of course, built-in flash) can be sensed by the camera's computer. This is why it's easy to get black X-sync bars by mistake when using studio flash.

> • **KEY POINT**
>
> Cameras with focal plane shutters have a top shutter speed that can be used with normal flash. This is the camera's maximum flash sync, often shortened to "X-sync".

Figure 7-21

Sometimes there's a discrepancy between the computer-restricted X-sync and the actual physical limits of the shutter. It may be possible to use a given camera with a higher shutter speed setting than the camera's published X-sync when using non-automatic flash, it's worth experimenting with different shutter speeds to find out.

Canon also specifies a lower X-sync for studio flash units than for Speedlites because most studio units have longer duration flash pulses. Flash units controlled by radio triggers may have an additional transmission delay. The specific timing values of each studio unit vary from one model and configuration to another, so all-manual studio flash (chapter 12) is another area where it's worth doing some tests at different shutter speeds.

The second case where X-sync can be exceeded, high-speed sync, is described in the next section. The third case, PocketWizard HyperSync, is described in section 11.11.3.

7.12 High-speed sync (HSS) / FP (focal plane) flash

In the 1950s and 60s, many cameras with focal plane shutters could use focal plane (FP) flash bulbs. FP bulbs burned longer than regular bulbs, sustaining their light output long enough to expose a full frame at high shutter speeds. This was a workaround that could effectively raise the camera's maximum X-sync limit.

With the introduction of E-TTL, Canon added the ability to surpass a camera's X-sync shutter speed barrier. High-speed sync flash, a technology first implemented by Olympus, lets a camera take flash photos at any shutter speed desired.

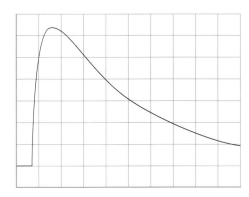

Normal flash

Figure 7-22

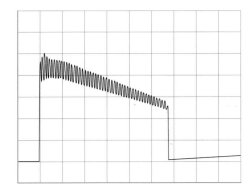

High-speed sync flash

Figure 7-23

In high-speed sync mode, the camera pulses the flash tube at an extremely rapid rate—about 50 KHz. At this speed, the flash tube barely has enough time to decrease in brightness before it's fired again, effectively creating continuous light. However, the pulsed flash has to be produced on a single charge of the capacitor (there isn't time to recharge the capacitor between pulses), and the mode comes at the cost of reduced total light output. The pulsing of the tube starts slightly before the shutter opens and continues for the duration of the exposure. ● *Figure 7-22 and Figure 7-23*

Confusingly, this feature is referred to as "FP flash", "FP mode", "high-speed sync", and "hi-speed (shutter sync)" in various places throughout Canon manuals and menus, but these terms all stand for the same thing. In this book, this feature is called high-speed sync because FP flash is something of an anachronism. FP is analogous to the old FP bulbs, though it can also be thought of as "fast pulse" mode, since that's how it works.

Figure 7-24

Normal focal plane shutter operation

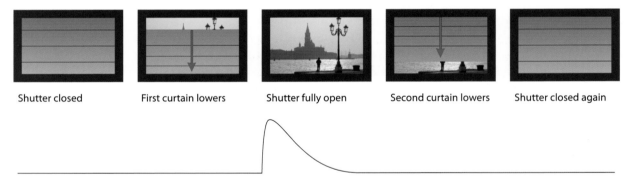

Shutter closed First curtain lowers Shutter fully open Second curtain lowers Shutter closed again

Single pulse of light from flash unit; synchronized with shutter opening

High-speed sync shutter operation

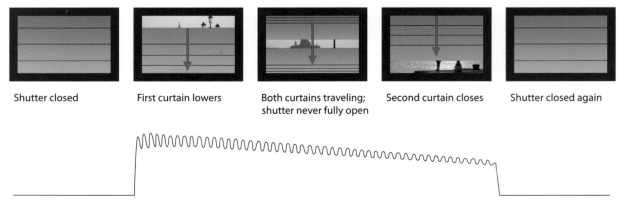

Shutter closed First curtain lowers Both curtains traveling; shutter never fully open Second curtain closes Shutter closed again

Flash unit pulses continuously while shutter curtains travel (pulse frequency not to scale)

7.12.1 Using high-speed sync mode

High-speed sync (HSS) is useful for shooting with fill flash outdoors with wide lens apertures. It also helps when taking photos in daylight where the flash itself is the primary light source; it's often referred to casually as "killing the ambient" (section 15.5).

Normally it isn't possible to shoot with fill flash under bright lighting conditions unless the lens is stopped down to a small aperture or unless a very low ISO setting/slow film is used. However stopping down the lens increases the depth of field, which is often undesirable for portrait photography where backgrounds should be blurred. Wide apertures let in more light, and increasing the shutter speed means the camera will hit its X-sync limit.

HSS solves this problem by letting the shutter speed break the X-sync barrier. The photographer can select shutter speeds up to the camera's maximum (usually 1/2000 or 1/4000 sec), allowing for large apertures under bright conditions. The primary drawback is the decrease in range caused by the pulses.

Because HSS does not freeze motion in and of itself, the name "high-speed sync" can be a bit misleading. "High shutter speed flash sync" is more accurate. Normal flash photography is very good at freezing motion, since a burst of electronic flash can be incredibly brief. When a scene is lit mainly by a short flash of light, there won't be much motion blur—it's like using a shutter speed in the thousandths of a second. This fact is exploited by certain types of high-speed photography, as described in section 15.9.

However, in HSS mode, the flash unit pulses the light output over a longer period of time in order to produce a longer-duration burst of light. If HSS mode is used with a very brief shutter speed, then it may well freeze motion. But if HSS is used with a shutter speed that barely exceeds the camera's X-sync, then it may not. High-speed sync refers to the ability to synchronize flash exposure with high shutter speeds, not that it always takes high-speed photographs.

There are different ways of enabling high-speed sync, depending on the camera and flash unit in use. This is detailed in section 9.14.

Figure 7-25

This photo, taken under the blazing California sun in the early afternoon, clearly shows the difficulty the camera's sensor has in recording the wide range of brightness in the image. The foreground is too dark compared to the background, so the camera just averages everything out. The result is a flat photo with an underexposed foreground. EOS 5D Mark II, 1/125 sec at *f*/7.1, ISO 100, 22mm.

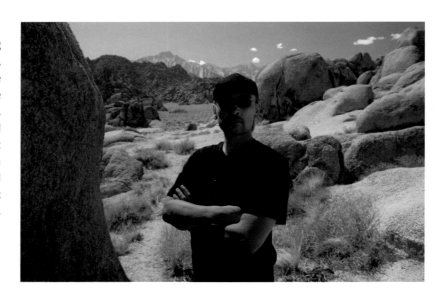

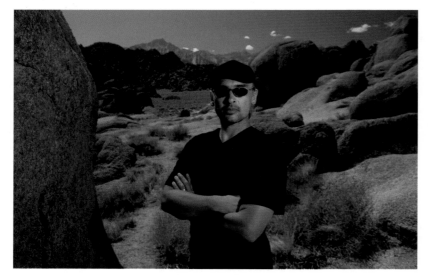

Figure 7-26

By using off-camera flash (a 420EX fired by a RadioPopper on a 580EX), the foreground can be lit adequately to drop the exposure to the background, making a more dramatic photo. Admittedly the lighting is a little illogical for those looking carefully (why is the sun coming from two directions?), but generally most people don't notice this sort of thing. The shot employed high-speed sync so that its shutter speed could be high enough to permit a moderately large aperture setting, in order to make the background slightly softened. While this shot used a radio trigger, given the short distance from camera to flash, regular wireless E-TTL could also have been used. EOS 5D Mark II, 1/400 sec at *f*/6.3, ISO 100, 22mm.

7.13 First and second curtain sync

Figure 7-27 **A:** Regular flash sync. Flash only; no ambient light from the tungsten lamp.

Figure 7-28 **B:** Ambient light. No flash; tungsten lamp is the sole light source.

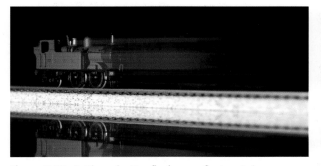

Figure 7-29 **C:** Slow shutter flash sync, first curtain. Both flash and lamp are used. The flash is fired at the *start* of the exposure.

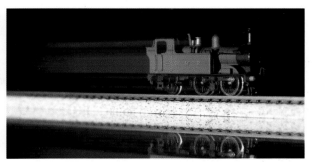

Figure 7-30 **D:** Slow shutter flash sync, second curtain. Same as C, but the flash is fired just *before the end* of the exposure.

High-speed sync notwithstanding, a single pulse of light from a flash unit is always much briefer than the shortest shutter time that a camera can manage. So a flash could be fired at the beginning, middle, or end of a shot with no difference in the final exposure. But, while the exposure would not be affected, the final photo would look noticeably different with long shutter times if moving objects were in the frame.

Consider this example. The tiny model steam engine was lit by two light sources, both positioned camera left. One was an ordinary tungsten light bulb in a reflector, and the other was a Speedlite equipped with a 1/2 CTO filter to approximate the color of tungsten light.

Shot A was taken with the flash only; the tungsten bulb was turned off. The split-second pulse of light froze the motion of the model, making it appear completely stationary. While this provides a detailed picture, it doesn't convey any sense of movement. ● *Figure 7-27*

In shot B, the tungsten light is turned on and the flash is turned off. A long exposure (0.8 seconds) is needed. This records the motion of the model down the track, but unfortunately, the result is a smudgy, streak-like blur. ● *Figure 7-28*

As a solution, both flash and ambient light can be used: slow shutter sync. In other words, the flash unit is fired, but it's combined with the same 0.8 sec shutter time in order to provide adequate ambient exposure. This essentially creates a double exposure because two separate light sources with different durations are used.

Unfortunately, this creates an interesting problem, as shown in shot C. The flash fires at the beginning of the exposure as normal, and then as the exposure continues the movement of the object is recorded by the ambient light. The resulting photo looks like the engine is traveling *backwards* because the flash occurred at the wrong end of the exposure, as it were. This is the problem with first curtain sync, since it happens when flash is fired immediately after the first curtain opens. ● *Figure 7-29 and Figure 7-32*

7.13.1 Second curtain sync

The solution to the first curtain sync problem is to wait until the end of the ambient light exposure, and then fire the flash a split second *before* the second curtain closes. This is known as "second curtain" or "rear curtain sync", and it produces more natural looking results. As shown in shot D, the model now looks like it's moving forward since it is illuminated by the flash when it is in its frontmost position. ● *Figure 7-30 and Figure 7-31*

Second curtain sync, an innovation introduced with the Canon T90, is an option available across most of the EOS line. A handful of early EOS film cameras lack the capability, and the T90's second curtain is not compatible with E-series flash units. Second curtain sync requires a Speedlite flash unit and is not normally available with nonautomatic flash units, such as studio flash (chapter 13). Canon identifies second curtain sync with a triple triangle ▷▷▶ icon.

Figure 7-31

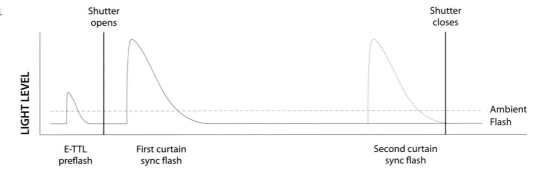

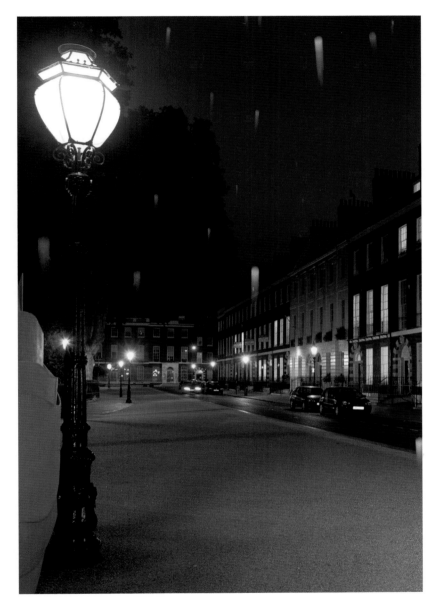

Figure 7-32
The first curtain problem can turn up at unexpected moments. Examine this photo, which was taken just as heavy rain was beginning to fall. Note how the raindrops mysteriously appear to be moving upwards. This is because the picture was taken with on-camera flash in first curtain sync mode. The long trails occur because the flash unit was firing at full power, which results in a burst of light followed by a long tail of gradually decreasing output.

7.13.2 Issues with second curtain sync

While useful, second curtain sync isn't always appropriate for photos of moving objects, since it's more difficult to shoot and expose for long exposures. With first curtain sync, it's easy to see an object moving in the viewfinder and trigger the shutter at the precise moment. But with second curtain sync: a) it isn't possible to see the moving object when the shutter

is open because the mirror will be flipped up; and b) it becomes necessary to accurately predict whether or not the object will still be in the frame at the end of the exposure period. For these reasons, photographers who do portraiture and the like usually find first curtain sync more appropriate.

EOS cameras default to first curtain sync. For details on enabling second curtain sync, see section 9.15.

Finally, the E-TTL preflash occurs prior to the shutter opening, and so the flash will visibly fire twice when using long shutter speeds and second curtain. The preflash always fires before the shutter opens; it's just that with a long shutter speed and second curtain sync, the time delay between the two flashes is more apparent.

Figure 7-33
For many slow shutter sync shots, curtain doesn't actually matter. The cars on this amusement park ride, for instance, have no obvious fronts or backs for direction of travel, so first curtain sync is fine.

There are two cases in which this delay might be a problem. First, if the subject moves a significant distance, then the preflash metering might be wrong for the final exposure and FE lock may be required. Second, the preflash can confuse human subjects if they're expecting just one flash.

7.14 Inverse square law

Light drops off from a source surprisingly rapidly. For instance, a campfire is a pool of light surrounded by darkness, and a flashlight shone into the night sky is a bright column of light that rapidly fades to nothing. You might think that when the distance from a light source doubles, then light is cut by half, but it doesn't work like that—actually, there is only a quarter as much light.

Space is three dimensional, so imagine a sphere drawn around a light source that's producing photons. As you get farther away from the light source, this imaginary sphere increases in size. The surface area of the sphere also increases, but it's being illuminated by the same amount of light. It's not a simple $1:1$ relationship; the sphere is not twice as large when you are twice as far from it.

The actual relationship between the distance from the light source and the light output is known mathematically as the "inverse square law". The light output is proportional to the inverse square of the distance.

This sounds more complicated than it really is. If the distance is doubled, the result is $1/2^2$, or one quarter as much light. If the distance is quadrupled, the result is $1/4^2$, or one sixteenth as much light. Notice how the light decreases quite quickly. ● *Figure 7-34*

Figure 7-34
Consider two nested spheres with a light source at the very center. At a distance of one unit from the source, the light covers an area of one square. But at two units from the source, the light has spread out to cover an area of four squares.

All ordinary light sources (lasers are one exception) follow this rule, which is why light from a flash unit drops off pretty fast. The implications of this rule are even worse for flash photography because the light has to travel from the flash unit to the subject and back to the camera.

Add the fact that much of the light is absorbed by the subject and not reflected, and it's a wonder that flash units work at all. This is why little flash range is gained by a moving to a slightly bigger flash unit, and why foreground objects are much more brightly lit by a camera-mounted flash unit than distant objects. ● *Figure 7-35*

• KEY POINT

Light decreases very rapidly with increased distance from its source, in accordance with the inverse square law. This is why it's easier to illuminate a nearby object with flash than an object slightly farther away.

Figure 7-35

Light is projected along a wall and reflected off the model's face. Note how rapidly the light falls off in brightness.

In short, the limits imposed by the inverse square law explain the differences in lighting between foreground and background in a typical flash-illuminated photograph. A flash unit needs four times the power output in order to throw light twice as far.

7.15 Guide numbers

The maximum distance range of a portable flash unit is often described by its guide number (GN). Users of automatic flash metering may never deal with guide numbers at all, but they can be used to calculate the aperture required to illuminate a subject at a certain distance, or vice-versa. The GN describes the distance coverage of a flash unit, not its power output.

To find the aperture (*f*-stop number) required, divide the flash unit's guide number by the distance to the subject. To find the maximum distance that can be reasonably illuminated using the current aperture, divide the GN number by the *f*-stop. In each case, the distance from the flash unit to the subject is important, not the distance from the camera to the subject. These two distances may be the same with on-camera flash, but not with off-camera flash or, more complicatedly, with bounce flash.

f-stop number = GN / distance distance = GN / *f*-stop number

A guide number is only useful if the distance units and the sensitivity of the film or sensor are known. Canon provides guide numbers in meters for ISO 100. The Speedlite product names, such as 580EX, include the highest metric guide number of the flash unit (the guide number on maximum zoom in the case of zooming flash units) multiplied by 10.

Older Canon USA literature uses guide numbers in feet, though newer documents list both feet and meters. The former can be confusing: a flash unit of GN 43 sounds great, but not if it's actually a metric GN 13. Only metric guide numbers are used in this book to be consistent with the Speedlite naming system. To convert to a GN in feet, simply multiply the metric GN by 3.

Remember that the GN takes film/sensor sensitivity into account, since flash range increases with ISO. So if an ISO/film speed other than ISO 100 is used, that must be factored in. The math is based on the inverse square law: quadruple the ISO to double the guide number. Here's a quick conversion method that avoids square roots:

ISO doubles: GN x 1.4
ISO halves: GN x 0.7

Another critical point when comparing flash units is that zooming flash heads affect the GN. For example, two units may have identical power circuits and flash tubes, but one has a zooming head that goes to 105mm whereas the other goes to 80mm. The former unit will have a higher maximum guide number, since it can concentrate its beam of light farther. Studio units with interchangeable reflectors have similar issues.

Finally, a fair bit of subjectivity goes into determining the guide number. After all, how is an "adequately exposed" subject determined? Guide numbers are not a reliable way to compare flash units built by different manufacturers. Companies tend to be somewhat optimistic when it comes to assigning guide numbers to their products.

7.16 Quantifying flash output

One challenging aspect of comparing flash products from different companies is that each firm measures output differently. There is no one standard, so it's virtually impossible to know whether one company's flash unit puts out more light than another's without performing empirical tests with a meter.

A fundamental problem is that each company measures a different thing. They're not necessarily being dishonest; measuring light is a complicated subject. Consider ordinary household lighting. Years ago, when tungsten bulbs were the only household electric light source available, people got into the habit of referring to the brightness of a bulb by its wattage. Everyone knew how much light a 60-watt bulb produced. Unfortunately, wattage refers to the electricity *consumed* by the bulb, not the amount of light *produced* by it. So this simple system fell apart when fluorescent bulbs arrived on the scene. All of a sudden there were more efficient bulbs that produced the same amount of light but at a lower wattage.

The other major issue involves area and distance. Think of a regular bulb in a ceiling fixture. It spreads light evenly and gently around the room. But what if the same bulb were in a desk lamp? All of a sudden its light would seem very intense. The same amount of light is produced; it's just closer to the eye and more concentrated when on a desk.

These two issues affect measuring systems used by flash units as well, with the added complication that flash involves brief pulses of light, not continuous streams.

7.16.1 Watt-seconds (Joules)

The two terms are synonymous, and they are a measure of the amount of energy produced by a device's electrical system; they are not an indication of light output. This is a common measurement, but unfortunately not always a useful one. A highly efficient electronic design may consume fewer Joules than a badly designed one, yet put out as much light.

7.16.2 Effective watt-seconds

A marketing variant on watt-seconds. A manufacturer may claim that its flash units are more efficient than another's and thus produce as many "*effective* watt-seconds" as their competitor's products. Nobody really knows what this means.

7.16.3 Guide number

A measurement of flash coverage described above. The key point is that the guide number is highly dependent on the coverage of the flash head, not just the light output of the flash tube. This measurement also takes film sensitivity/ISO into account.

7.16.4 Lumen-seconds

A metric measurement of the amount of light (the "luminous flux"), weighted to the sensitivity of the human eye, produced by a light source for a period of one second. Unfortunately, discussions of lumens veer off rapidly into the arcane provinces of physicists and engineers. (The official definition of the lumen involves concepts such as solid angles of steradians and single-frequency 540 terahertz lights.) Nonetheless, it is a proper and

honest way of evaluating the amount of light produced by a device, though not one commonly used by flash unit manufacturers.

7.16.5 Beam candlepower seconds (BCPS)

A measurement of the intensity of a light source, taking the qualities of a reflector or a lens into account (i.e., the "beam").

7.17 Exposure value (EV)

The sensitivity of camera gear at autofocusing or determining correct exposure metering is rated in terms of EV—exposure value—for a given lens type and film speed or digital ISO.

Since the amount of light hitting the film or sensor is determined by exposure time (shutter speed) and lens aperture, EVs are simply combinations of shutter speeds and apertures that produce the same exposures. For example, $f/4$ at 1/30 sec has an EV of 9, which is the same EV as $f/2$ at 1/125 sec.

Both speed/aperture combinations let the same amount of light hit the film or sensor; the only differences between the two are depth of field and type of motion recorded. Depth of field decreases as the aperture increases, and subject motion blur increases as shutter speed decreases.

However, it's only meaningful to compare exposure values if they're rated for the same film speed or ISO. Canon rates EV values in its documentation for a standard 50mm f1.4 lens using ISO 100.

7.18 Color and shades of white

When it comes to interpreting color, the human eye (or, more accurately, the brain) is extremely adaptable. A sheet of white paper in a room lit by an incandescent tungsten bulb will look pure white to a human. The same sheet of paper carried outdoors and examined in sunlight will still look white. But to a machine, the light reflected off the paper will look completely different. Tungsten bulbs and the sun produce different colors of light, tungsten light is fairly orange whereas sunlight is relatively blue.

Normally the human brain compensates for these differences in color temperature automatically. For example, one of the few times they become really noticeable is when encountering different types of light at dusk.

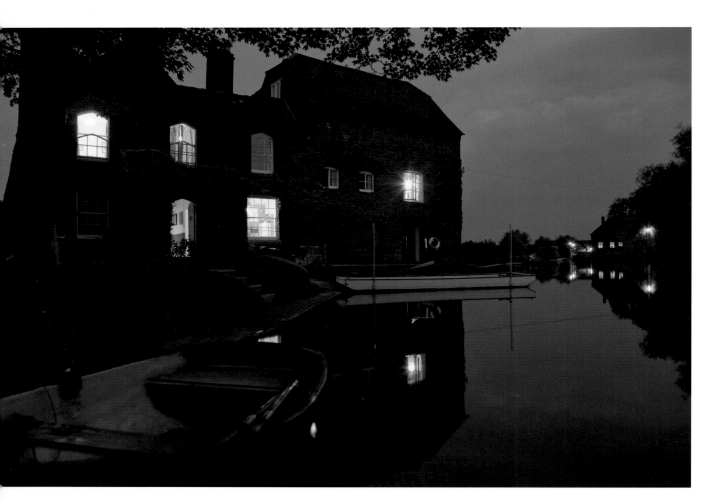

Figure 7-36 Take the classic scene above. The incandescent light spilling from the windows of the old mill looks quite orange-yellow in tone compared to the blue of the evening sky.

In colloquial English, we say that yellowish or reddish light is "warmer" than bluish light. Yet according to a physicist or a photographer, bluer light has a *higher color temperature* than reddish light. Why is this, and what does this mean?

7.18.1 Color temperature

Color temperature is a scientific model that explains certain aspects of the concept of "white". Imagine a plain iron bar. At room temperature, it may appear almost black. But, when heated, it will start to glow with a dull red light. As it gets heated further, the light becomes yellow and eventually white as it melts.

This is the basis of color temperature. Instead of a lump of iron, the model relies on a theoretical notion: a "black body", or an imaginary substance that absorbs all light and is, therefore, black to the eye. As it's heated, this black body will start to radiate energy that we can see as light. The color of light is described by the temperature required to create it, measured in Kelvin units. (Kelvin is similar to the Celsius scale but uses absolute zero, −273.15°C, as the starting point rather than the freezing temperature of water.)

Regular incandescent light has a theoretical color temperature of about 3200 Kelvin, though this varies and household bulbs often produce about 2900K. They also drop in color temperature as they age or when put on a dimmer circuit. Tungsten halogen bulbs (usually just called "halogens") and non-daylight-corrected photoflood bulbs are usually slightly higher, sometimes reaching 3400K. The light from a candle flame is quite low in temperature, hovering around 1400–2000K.

Figure 7-37

Daylight is between 5000K and 6000K, often given as 5500K for the temperate midday sun. Naturally these values can vary depending on time of the day, latitudes and altitudes, and weather conditions. In fact, natural light can vary from around 2000K at sunset to over 20,000K in blue evening shade. Skylight, or the sun's light scattered by the atmosphere, is extremely blue in color. ● *Figure 7-37*

Critically the Kelvin color temperature value does not necessarily refer to the actual physical temperature of an object. This description of color temperature is also a vast oversimplification of the physical theory, but one that covers the basic areas of interest to photographers. For example, the apparent color variations of the sun are caused by scattering of sunlight and not by actual changes in color temperature.

> **● KEY POINT**
>
> The photographer can think of color temperature as a way of quantifying, or conveniently labeling, shades of white on a linear orange to blue spectrum.

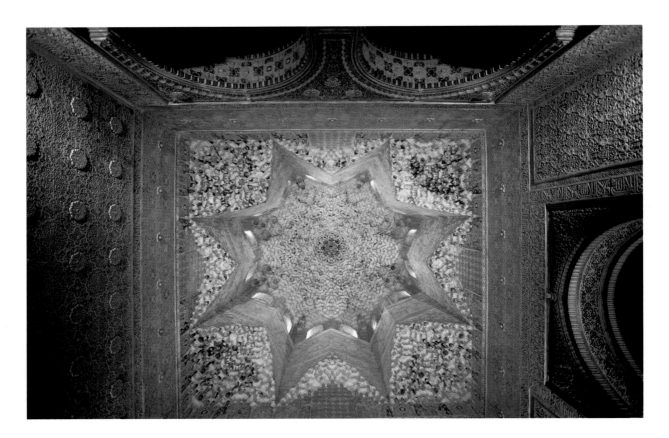

Figure 7-38

This picture, taken at the Alhambra in Granada, Spain, shows a tremendous difference between the tungsten-lit interior and the daylight shining in from outside. The stone is the same color, but the light sources have different color temperatures.

Figure 7-39

7.18.2 Color temperature and film

Color temperature isn't some theoretical issue. It's a real problem for color film users because film records light as chemical processes, does not offer any interpretation, and cannot adapt to changing light conditions. Film is formulated in the factory to assume a certain color temperature is white.

This is what is meant by "daylight" film and "tungsten" film—they're film types designed to assume that daylight and regular tungsten light bulbs are white, respectively. Color shifts will occur if the wrong type of film is used. A tungsten-lit room shot on daylight film will look quite orange, and a daylight-lit room shot on tungsten film will look quite blue. So it's important to use film that matches the lighting conditions, or use appropriate filters. ● *Figure 7-38*

Color-matching issues can be quite a problem for film photographers. Photographers who need high-speed films in tungsten lighting (e.g., shooting in a dark theater) either have to use color-correcting filters or switch to digital. There are very few film emulsions still available which are tungsten-balanced, and most of those are very slow. ● *Figure 7-39*

7.18.3 Color temperature and digital

Color temperature is more of an opportunity than a problem in the world of digital. Digital cameras record color as a collection of numbers inside a computer, rather than on a physical material with complex chemical interactions. So it's pretty easy for a digital camera to assume different colors are the correct white point. This can easily be used to creatively alter, as well as simply correct, mismatches in lighting color.

Digital white balance (WB) offers a number of choices. A camera can operate in automatic mode (AWB), or a photographer can specify different preset or custom white balance settings as required. In AWB mode, the camera examines the recorded scene and decides the dominant color cast, at least between 3000K and 7000K. (Two early EOS digitals, the 1D and the 1Ds, also used an external white balance sensor.) Preset color balance settings make certain assumptions about color conditions, such as daylight, flash, cloudy skies, and so on. And custom white balance settings allow a photographer to take a picture of a white object lit by ambient light so that the camera measures white balance against that.

Icon	White balance type	Approximate temperature
AWB	Automatic	3000K – 7000K
☀	Temperate daylight	5200K
🏠	Shade	7000K
☁	Cloudy/twilight	6000K
💡	Tungsten bulb	3200K
🔆	White fluorescent	4000K
⚡	Flash	6000K
⊿	Custom (user set)	2000K – 10,000K
K	Kelvin units	2500K – 10,000K

Figure 7-40

Figure 7-41
White balance settings

EOS digital bodies use a color temperature of 6000K with the flash white balance setting in order to match the light from common studio flash units. Since Speedlite flash units are designed to more closely match daylight color temperature (at 5500K or so), a photo lit with a Speedlite and the flash white balance setting can end up being a little on the cool side. Automatic white balance (AWB) or daylight white balance may be better options. Alternatively, a custom white balance setting can be used, particularly since most EOS bodies have user-defined custom white balance.

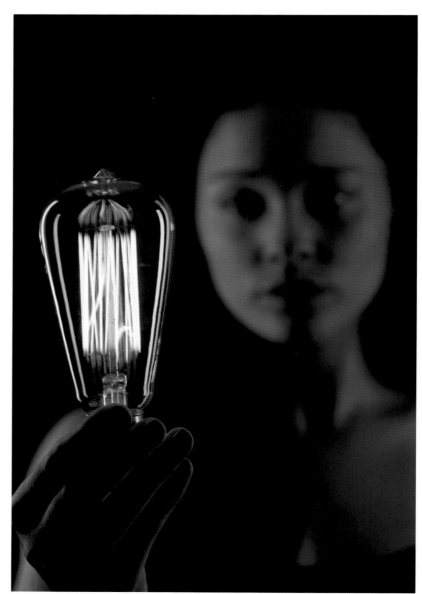

Figure 7-42
This photo shows how a camera's automatic white balance system can have problems. The camera assumed that the orange glow from the "squirrel cage" tungsten light bulb is the dominant light source and balanced for that accordingly. The bulb, driven at half power, is producing very orange light compared to the two Elinchrom D-Lite studio units (equipped with narrow striplights to get the striped effect on the bulb) actually lighting the scene. The final result is that the white balance of the model's face is far too blue.

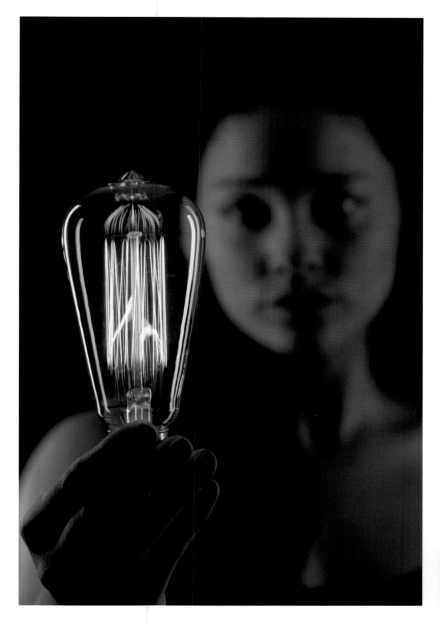

Figure 7-43
This version was manually white balanced to restore the proper warm color to the model's face. This also heightened the orange of the bulb's filaments, but that isn't really a problem for this shot. EOS 5D Mark II, 1/10 sec at f/5.6, ISO 50, 100mm.

Finally, digital white balance is actually more complex than this. Instead of simply representing color on a single yellow-blue axis, white balance also uses a magenta-green axis. The color temperature scale is just the one we encounter in everyday life more regularly, owing to the way common light sources work. ● *Figure 7-44*

Figure 7-44

7.19 Color filters

The light from a portable flash unit is pretty close to direct noonday sun in a temperate latitude: around 5500K to 5600K, or a slightly bluish white light. But this type of simulated daylight is not the right color for every photograph. Daylight may be too warm or cool, and it may clash with existing light. Or perhaps a dramatic color, such as a rich red or dark blue, is needed for a special effect. This is where color filters come in.

White light consists of colors of various wavelengths across the whole color spectrum, as Newton discovered with his famous prism experiments. The human brain interprets this sensation of light energy as something we call "white". Since light has so many wavelengths of energy, it's easy to put a translucent material in front of a light source that will block or absorb certain frequencies. Our brains then interpret the remaining wavelengths of light as a different, non-white color.

Color filters for light sources typically serve one of two purposes. First, they are commonly used for color correction, which usually means altering the color temperature of white light for color matching. Second, they are used to produce specific strong colors for special effects.

Figure 7-45

The 1980s called, and they want their filters back. This shot was backlit by an unfiltered Bowens Gemini monolight, with the foreground fill by a 580EX II zoomed to 105mm and filtered with a red gel.

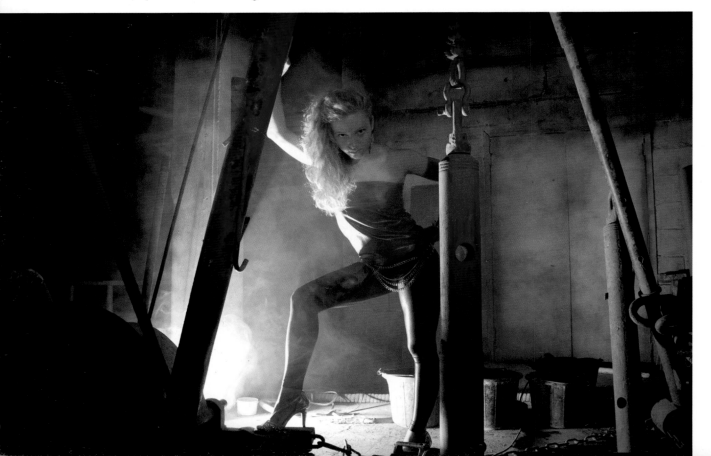

Filters can be put in different places. To affect the look of an entire scene, a filter can be placed over the lens. To affect the output of a specific lamp, a flexible gel filter can be put over a specific light. A filter or colored diffuser can be put over a flash unit's head to affect just the light it produces.

7.19.1 Color temperature correction

Since the light from a flash unit is a neutral to bluish white, it can easily be altered. It might be necessary to balance the light from a flash unit to match ambient lighting conditions, for example. It could be a problem if the dominant or supplementary light from a flash has a radically different color from existing light, since the colors can clash in an unnatural fashion. Or perhaps the converse is true—maybe the flash-lit areas need to be a dramatically different color temperature from the ambient lighting for creative effect.

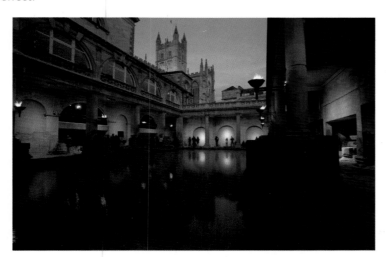

Figure 7-46
The lower right side of this photo is poorly lit and quite dark. This is a shame, since it's the original Roman section of the Roman baths in Bath, England. The Victorian reconstruction is well lit with artificial lighting. Fill flash can help in this regard, but light from a normal flash would be too blue in color.

Figure 7-47
This shot has some fill from a Speedlite 580EX II. A "color temperature orange" (CTO) warming filter was used so that the light from the flash unit would approximate the orange-yellow artificial lighting.

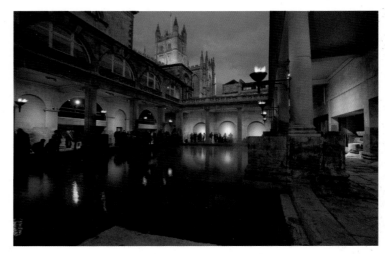

Color temperature conversion can go in one of two ways. To go from yellow-orange light (tungsten) to blue light (daylight), a "cooling" filter is required. To go the other way, a "warming" filter is needed. As noted earlier, these names are somewhat confusing since cooling involves an increase in color temperature and vice-versa. The names reflect ordinary casual usage of the words and not color temperature theory. Consequently, cooling filters are blue and warming filters are orange-amber.

7.19.2 Non-tungsten artificial lighting

Color casts also occur from other forms of artificial lighting. The light from fluorescent tubes can be nasty, frequently veering off into green. Full-spectrum fluorescent bulbs have a slightly more pleasing color balance, though they don't have the smooth color output curve associated with incandescent lights. The color output tends to "spike", or produce slightly more intense colors in narrow bands. This is one reason why fluorescent light, even from compact fluorescents designed to simulate tungsten light, can look unnatural.

To minimize fluorescent color issues, many photographers carry pale green filters, particularly on news-gathering expeditions. These filters help flash units to more closely match the unhealthy greenish glow of fluorescent. When shooting digital, the camera is then set to fluorescent white balance, and the result should be more consistent color in the final photo.

More problematic are the high-pressure mercury lamps used for industrial/public space lighting and the yellow sodium lamps used for streetlights. These gas-discharge sources produce light in very narrow bands, resulting in unpredictable color casts that depend on the formulation of the bulbs. Complicating matters is that such discontinuous light sources don't glow but flash on and off many times per second (60 Hz or times per second in North America and parts of Japan; 50 Hz in most of the rest of the world). For this reason, photos taken with brief shutter speeds may have inconsistent exposure or color if the picture happens to be taken at a low point or high point of the lamp's power cycle. ◉ *Figure 7-48*

The term "color temperature" does not technically apply to fluorescent and gas-discharge lights, since they don't employ incandescent filaments. However, approximate equivalent color temperature numbers—i.e., correlated color temperature values—are often supplied by manufacturers as a convenience.

Figure 7-48
Like many public spaces, the Piazza
San Marco in Venice is lit by high-
efficiency, gas-discharge lights.
Building interiors are lit by tungsten
and fluorescent sources. These
artificial lights look very yellow and
orange against the blue twilight sky.

7.19.3 Mixed light sources

Shooting in mixed lighting conditions can be very challenging without some filtration. The colors in the final photo will be all over the map, and it can be difficult or impossible to fix digitally after the fact. Color correction filters to modify the light output of a flash can tame more extreme color differences.

Short of switching to black and white, the easiest way of dealing with mixed lighting sources is to gel any artificial lighting to match the dominant ambient light. It's never possible, or indeed necessarily desirable, to get every light source to match precisely; the goal should be to minimize gross or obtrusive color differences. For example, a room lit with tungsten light would clash with unfiltered fill flash. The simple addition of a 1/2 CTO filter on the flash head could be enough to bring the fill close enough in line to the ambient artificial light (full CTOs can be too yellow). ● *Figure 7-49*

With that in mind, there's often something to be said for emphasizing various color sources. Take the photo that opens this chapter, for example. Lyle Rowell's LRRY, a walking kinetic sculpture powered by a car engine, is lit by three basic light sources. The first is a snooted studio flash unit to camera left for fill. Directly behind the sculpture, illuminating the smoke with bluish-white flash, is a high-powered studio unit. And the intense light from the propane flames bathe the front of the sculpture in yellow light. The different colors of light create a far more interesting shot than if all the light sources were the same color.

Figure 7-49

This photo is lit by two light sources. One is an AlienBees B1600 flash unit, powered by a generator, located camera right. The other is the stream of flame itself. The result is two different shadows of two different colors. This shot was adjusted digitally to make the flash-illuminated areas slightly warmer, but this resulted in a rather orange patch of ground lit by the flame.

7.19.4 Special effect filters

Filters are available in almost every color imaginable, from subtle to lurid. Simply by installing a filter over a light, a white backdrop can be changed to blue or green. A red filter can simulate neon lighting coming through the window of a motel room. The key thing to remember is that filters have to be darker (i.e., more saturated) than one might expect to achieve rich colors, particularly with bright flash units and other high-powered light sources. A red-filtered light might end up casting a rather pinkish light, for example. ● *Figure 7-50*

7.19.5 Filter naming

Filters used for changing the color of light sources all have manufacturer-specific codes or names. However, gels for color temperature conversions are often described as "color temperature orange/CTO" or "color temperature blue/CTB" depending on whether they're warming or cooling filters.

Less saturated versions of these filters are usually named in fractions, such as 1/2 CTO or 1/4 CTB. Stacking a pair of 1/2 CTO filters will yield the same color as a single full CTO, for example.

Note that a CTO from one maker will not have precisely the same color as a CTO from another—there are always slight differences. A CTO variant that a lot of photographers find useful is "color temperature straw/CTS", which has similar color temperature shifting properties to CTO but with a less reddish tone.

Table 7-1 Yellow-orange "warming" filters

Full CTO	5500K–2900K
3/4 CTO	5500K–3200K
1/2 CTO	5500K–3800K
1/4 CTO	5500K–4500K
1/8 CTO	5500K–4900K

Table 7-2 Blue "cooling" filters

Full CTB	3200K–5500K
1/2 CTB	3200K–4100K
1/4 CTB	3200K–3500K
1/8 CTB	3200K–3300K

Figure 7-50
This picture was taken using three Speedlites. A 580EX on-camera was used for white light fill and as an E-TTL master. A 580EX II was on a tall light stand, camera left, and filtered red. A 430EX II was on a lower light stand, camera right, and filtered blue. A haze machine was used to complete the illusion of stage lighting.

Some manufacturers of lens filters use the Wratten series of numbers. More than a century ago, British inventor Frederick Wratten developed a fairly arbitrarily numbered series of color filters. Kodak bought Wratten's company in 1912, though Wratten-branded filters are now sold by Tiffen. Orange-colored Wratten filters are in the 85 series, and blue-colored Wratten filters are in the 80 series. German manufacturers use a different system in which KB is a cooling (blue) filter and KR is a warming (orange) filter.

Filters for special effects do not have any sort of standardized names. They tend to have cheesy names like paint colors, of the "moonlight blue", "neon carrot", and "exploded strawberry pink" variety.

7.19.6 Limitations of filters

One important thing to remember about filters is that they cannot shift colors along the spectrum, per se. All a filter does is simply prevent certain wavelengths of light from passing through. So, by definition, color-correction filters always *reduce* the amount of light entering the camera or produced by a light source. Blue filters in particular can easily cost a stop of light.

As discussed above, filters can change the color of white light by removing certain wavelengths, so filtering a flash head or tungsten bulb works well. But if a scene is illuminated by, say, pure red light, then it isn't possible to apply any sort of filter on a lens to make things a different color. Filters can't add light of any wavelengths or convert incoming light to a different wavelength.

It's therefore difficult to do much with filters to change the color of scenes illuminated by light sources such as yellow-orange sodium streetlights, mercury vapor gymnasium/industrial lighting, or LEDs. Such lamps produce light of very narrow spectral bands, so filtering out the dominant color doesn't leave much else.

This problem of filtration limits color-correction choices considerably when dealing with chemical-based photography. There are ways of doing color alteration in the darkroom, but they're expensive and cumbersome. In contrast, color mismatches are a mere inconvenience for digital users, since all colors on a computer are represented digitally. The only complication is when numerous light sources of different colors illuminate a scene, as then different colored patches of light will show up everywhere.

7.20 Infrared (IR)

From a non-technical perspective, infrared (IR) can be thought of as invisible light used by devices such as TV remote controls and night vision cameras. From a technical perspective, IR refers to a band of electromagnetic radiation that is just outside the range of human visual perception. The word stems from the Latin "infra", for "below"; in this case, the light is below the red section of the light spectrum in terms of frequency.

Contrary to popular misconception, IR-sensitive cameras do not record heat since they aren't thermal imagers. Infrared photography records *reflected* IR from an IR source such as the sun. Ordinary xenon flash tubes are also an excellent source of IR, and cameras or film capable of sensing IR can easily be used with flash. This fact can be exploited for flash photography in which the subjects can't see the flash.

For example, 1940s American news photographer Weegee (Arthur Fellig) sneakily took a series of famously voyeuristic photographs of people watching movies and making out in theaters. They were shot using infrared-sensitive film and a flash filtered to pass IR and block visible light, so that the subjects didn't know they had been photographed. The ethics of this type of photography are perhaps best discussed elsewhere.

Figure 7-51
Digital Voyeurvision! This picture was taken in near-complete darkness. The scene was lit by an on-camera flash unit with infrared filtration, and the camera was a digital EOS 10D modified to record IR but not visible light.

True infrared-sensitive film is only available from professional suppliers, and most digital cameras have IR-blocking filters installed over their image sensors. However, many digital cameras can be modified by removing these filters, making them sensitive to a range of IR energy.

Flash tubes also produce ultraviolet (UV) energy at the other end of the spectrum. This is much more difficult to use photographically, however, since it requires lenses manufactured from special UV-passing glass. In addition, most flash units have treated glass to reduce their UV output, since UV adversely affects visible-light photography. Some Pyrex domes (section 13.2.1) are also coated to block UV.

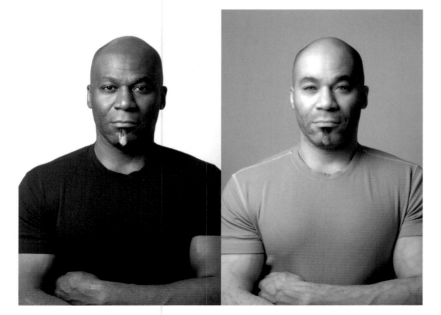

Figure 7-52
The mysterious world of infrared portraiture. The left-hand photo was taken with a EOS 5D recording ordinary visible light. The right-hand photo was taken with a modified 10D that had a light-blocking IR-passing filter over the lens. In both shots, a single Elinchrom D-Lite 4 monolight was used.

Note how light-absorbing areas of the photo, such as dark brown irises and black synthetic fabric, actually tend to reflect infrared. Skin takes on a strange alabaster-like look, and veins suddenly become quite visible, a characteristic helpful to medical researchers and forensics investigators.

Item Name	Value
File Name	8888.CR2
Camera Model	Canon EOS 5D Mark II
Firmware	Firmware Version 1.0.7
Shooting Date/Time	08/18/09 13:24:59
Owner's Name	
Shooting Mode	Aperture–Priority AE
Tv(Shutter Speed)	1/160
Av(Aperture Value)	2.8
Metering Mode	Evaluative Metering
Exposure Compensation	0
ISO Speed	100
Auto ISO Speed	OFF
Lens	EF100mm f/2.8 Macro USM
Focal Length	100.0mm
Image Size	5616x3744
Image Quality	RAW
Flash	Off
FE lock	OFF
White Balance Mode	Auto
AF Mode	One-Shot AF
Picture Style	Standard
Sharpness	3
Contrast	0
Saturation	0
Color tone	0
Color Space	Adobe RGB
Long exposure noise red...	1:Auto
High ISO speed noise re...	0:Standard
Highlight tone priority	0:Disable
Auto Lighting Optimizer	0:Standard
Peripheral illumination c...	Disable
File Size	24194KB
Dust Delete Data	No
Drive Mode	Single shooting
Live View Shooting	OFF
Date/Time(UTC)	
Latitude	
Longitude	
Altitude	

Figure 7-53

7.21 EXIF

One of the great hidden benefits of digital cameras, from a learning perspective, is that they automatically label each photo with shooting data in EXIF (Exchangeable Image File) format. This makes it easy to go back after a shoot and see exactly what shutter speed, aperture, focal length, etc. was used. This is obviously much more convenient than jotting down information in a notebook while taking photos.

Some flash-related data is stored as well. EOS cameras record where flash is fired or not, whether flash exposure compensation is applied, what the FEC value is, and whether redeye reduction is enabled. Note that this data is stored only if a fully automatic Speedlite flash unit (or popup flash) is used: the camera has no way of knowing if a manual external flash unit is fired. Unfortunately, wireless E-TTL settings are not recorded in EXIF.

To view EXIF information, open an image using Canon's Digital Photo Professional software, or any other photo-editing application such as Adobe Photoshop that can display EXIF metadata. ● *Figure 7-52*

7.22 Safety and physical properties

7.22.1 Overheating and fire hazards

A flash unit generates a surprising amount of heat when fired. Even a battery-powered flash unit feels remarkably hot if the flash head is held on skin. Normally the heat dissipates rapidly, since the flash burst is so brief. But in a rapid-fire situation, the heat can accumulate quite quickly, risking damage to the flash tube, its clear plastic cover, or anything touching it. A flash tube can actually scorch or ignite cloth or paper.

Heavily used battery flash units often have a yellow or orange patch in the middle of the plastic flash lens. This occurs when using high-powered flashes repeatedly (e.g., wedding photography) or when using high-speed sync or modeling flash for extended periods. Filters or other accessories over the flash head can increase the risk of overheating as well.

To minimize this risk, some flash units like the Nikon SB900 and the Elinchrom D-Lites contain temperature sensors which shut off the unit if it becomes too hot. The unit must then be left to cool down. The Speedlite 580EX II has such a temperature sensor and also counts the number of shots fired within a specific time frame. It then forces an increased wait

time between firings, though there's no way to override this. Some photographers are willing to risk damaging their flash units if it means they won't lose the shot, but the 580EX II does not permit that. Some EOS cameras with built-in flash units also restrict firings for safety reasons. If a camera displays the message "BUSY" and refuses to fire the flash unit for a few seconds, this is why.

Another significant fire risk is posed by the incandescent bulbs used as modeling lights in AC-powered studio gear. These can start a fire in moments if they touch fabric or plastic, such as a softbox or other diffuser. ⬤ *Figure 7-54*

Some high-powered studio units have optional glass domes (section 13.2.1) that can be installed over the flash tube and modeling lamp to protect both.

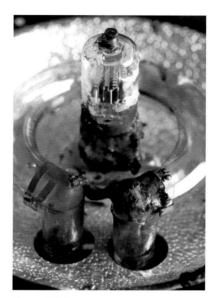

Figure 7-54
The risk of fire is not hypothetical. This high wattage bulb touched the side of a light diffuser for a few seconds with incendiary results.

7.22.2 Flash safety and babies

A common concern is whether flash photography can damage the sensitive eyes of babies and infants. I put the question to the Pediatric Service of the Moorfields Eye Hospital in London, and they confirmed that they were not aware of any serious dangers from occasional use of flash at normal distances from the eye.

Having said that, this is obviously not a free license to blast a poor baby with flash. At the very least, the baby is probably going to find it an unpleasant experience. This also doesn't apply to firing a flash close to a baby's face (which is something that should never be done to anybody) and which sometimes happens because babies are so small and a common tendency is to put the camera close to them.

In short, taking the odd flash photo in a room that happens to have a baby in it is unlikely to cause any problems for the baby's vision. But enforcing flash safety measures is a good way to keep Uncle Bob from sticking his flash-equipped point-and-shoot into the baby's face. And frankly, baby photos are probably going to benefit from soft natural light rather than harsh flash light anyway.

7.22.3 Shock hazards

Electronic flash technology involves extremely high voltages—literally hundreds of volts. The internal components of any flash unit maintain a high-voltage kick *even when the device is turned off.* It takes quite a while for this high-voltage energy to drain out of a flash unit's capacitors. Even cheap disposable cameras with built-in flash units can produce severe shocks if they're disassembled.

For this reason, it's very important that an electronic flash unit, whether powered by small batteries or AC power, *never* be opened up except by an experienced technician ● *Figure 7-55*. The capacitors might literally give a nasty shock, which could be deadly to those with susceptible heart conditions. It's also essential to never expose a flash unit to moisture or liquids.

Figure 7-55
Don't try this at home. Really. This is the interior of a high-powered studio flash unit. The large black cylinders are energy-storing capacitors.

7.22.4 Noise

Flash units always produce sound. Battery units usually emit a high-pitched whistle that increases in frequency as the unit is charged up. This is caused by an oscillator circuit that converts DC to the high AC voltages needed to charge the capacitor. Some flash units, like the 540EZ and the 550EX, have multiplexer circuits that make particularly noticeable noises when idling. Some recent EX models, such as the 580EX II, are specifically designed to cut down on charging noises by making them so high-pitched that they're inaudible to the human ear.

Zooming flash units make a hollow rattling buzz as the small electric motor moves the tube inside the flash head. Finally, all flash units make a soft popping sound when fired.

Unfortunately, no current Canon Speedlite has a beeper or sounder. These optional beepers can be very useful for wireless flash setups, as they provide audio feedback that a remote flash unit is charged and ready to fire.

PART C: EQUIPMENT

8 Dedicated Flash Units

> **• KEY POINT**
>
> A *dedicated* flash unit is one that contains computerized electronics and that is designed uniquely for one particular camera maker's products.

n the early years of electronic flash photography, synchronization with the shutter was the only control the camera had over the flash unit. The output level and shutoff time were both determined by the flash unit itself, since two-way communications between camera and flash unit were not possible.

In the 1960s and 70s, companies such as Honeywell, Braun, and Vivitar had thriving sales of autoflash flash units that were compatible with any camera. Such generic products had simple electrical contacts to receive the camera's flash sync signal.

However, in the 1980s camera manufacturers started designing new "dedicated" flash systems that would enable advanced features such as flash metering—but only with their own cameras. No universal standards were ever developed for camera-to-flash communications. In terms of automated features, a Nikon camera can't use a Canon flash unit, a Pentax flash unit can't be used with a Sony camera, and so on.

8.1 Built-in (popup) flash

Figure 8-1

Older EOS film cameras, such as the EOS 5/A2 (left), often had large flash housings containing motorized zoom mechanisms (section 9.5) and redeye lamps (section 9.8). Early digital EOS models such as the EOS 10D (center) eliminated the zoom motors and lamps, resulting in lower profile flash housings. Later EOS digitals such as the 50D (right) feature longer flash arms, allowing the flash head to be raised higher from the camera body.

The most dedicated flash units are arguably those built right into the camera body. Nearly all consumer-level Canon EOS cameras have integral flash units in the angular top housing that contains the camera's prism or mirror. These internal flash units are useful for quick snapshots and the like, since they're always available at a moment's notice. They can never be misplaced or forgotten, are useful for applying a little fill flash when outdoors, and recharge very rapidly since they use the camera's own battery as a power source.

All built-in flash units are mounted on a hinged assembly and are normally retracted. Some are motorized and pop up immediately in most icon modes if the camera thinks flash is needed, or at the touch of a button when in a "creative zone" (letter) mode. A few have no motors and require

the user to lift up the head manually. Some early EOS film cameras could both pop up and retract the flash unit automatically.

Most EOS popup flash units only rise a short distance above the prism or mirror. Since the mid 2000s, Canon has used an improved arm design that raises the flash unit farther away from the optical axis (i.e., higher up). This helps reduce the problem of flash shadows cast on the scene by large lenses and hoods. It also reduces the chances of redeye very slightly. However, the flash struts used in these cameras do rattle slightly when the camera is closed.

Almost all EOS film cameras use standard TTL metering to control popup output, whereas digital cameras and the Rebel T2/EOS 300X/EOS Kiss 7 use E-TTL. (The EOS 7D is the first EOS body to support manual flash metering with popup flash.) Built-in flash is sometimes described in Canon documentation as "serial controlled", meaning under the control of a computer.

8.1.1 Popup flash limitations

Unfortunately, built-in flash units have many drawbacks including the following.

- They have very limited power output and range: typical guide numbers are around 11 to 13. This is fine for snapshots of friends in restaurants, but not much more unless high ISO settings/fast film are used.
- They have flash heads located fairly close to the lens axis, likely to cause the redeye effect when photographing people.
- They don't extend very far above the top of the camera body, so their light can be partially blocked by large lenses or lenses with large lens hoods.
- They don't offer any tilt or swivel options and generally have coverage areas of only 28mm or 35mm (18mm to 22mm on crop sensor cameras).
- They run down the camera's battery more rapidly.
- With the exception of the EOS 7D, they cannot serve as wireless E-TTL masters and so can't usefully control other flash units.
- Finally, and most importantly, they don't offer particularly nice lighting quality, since lighting rarely looks good originating from tiny on-camera sources.

No EOS camera permits the use of the internal flash unit when an external flash unit is mounted on the hotshoe, since external flash units physically collide with the internal flash mechanism. An EOS camera with a motorized internal flash unit has small electrical switches built into the hotshoe that detect the presence of a device and disallow internal flash popup,

Figure 8-2

The classic crescent shadow shown above is a hallmark of popup flash.

Figure 8-3

Error message 05, resulting when an external flash unit is mounted on the hotshoe.

issuing errors BC, 05, or 83 depending on the model (figure 8-3). The internal flash won't rise automatically even if a bubble level or something else non-electrical is mounted on the hotshoe. The switches can also occasionally stick, rendering the internal flash inoperable.

None of the professional EOS cameras (1, 3, 5D series) have built-in flash units for the reasons listed above and because of the difficulty of weatherproofing a popup flash mechanism.

8.1.2 Improving built-in flash

It's pretty well guaranteed that if the popup flash is turned on and ambient light levels are low, lousy photos will result. Or, to be more fair, harshly lit photos. This may be the whole point of the exercise, and plenty of edgy fashion shots are taken this way deliberately, but generally speaking, built-in flash is a bad choice for aesthetics.

There are three ways around this problem. The first is to avoid flash altogether and rely on ambient light. The second is to use an external flash unit or units, particularly positioned off-camera. The third is to install a flash accessory over the built-in flash. These come in two forms: diffusers and reflectors.

Gary Fong Puffer

The Puffer is a small plastic diffuser that fits on a frame and slides into the camera's hotshoe. The frame is designed to avoid the shoe's sensors which normally would disable the popup flash's electronics. The diffuser is adjustable to accommodate various heights of flash heads.

As a diffuser, the Puffer is meant to enlarge the light-emitting surface area slightly and reduce its specular nature. It also spreads light around, which can improve lighting a bit if there are nearby walls or ceilings for the light to bounce off. On the whole, the Puffer reduces the harshness of built-in flash but does little to avoid its directionality. ● *Figure 8-4*

Professor Kobré's Lightscoop

The Lightscoop takes a different approach. It's a mirrored reflector mounted inside a plastic frame, which also fits inside the camera's hotshoe and allows the popup flash to fire. It reflects the light from the flash unit directly up towards the ceiling, so it's completely useless if there is no ceiling. This device is intended for use indoors with light-colored low ceilings, or in portrait configuration, with nearby walls. ● *Figure 8-5*

However, built-in flash units are pretty weak, and a load of light is lost when it's bounced off the ceiling. For this reason, the Lightscoop manual

Figure 8-4

instructs the user to set the camera to ISO 800, flash exposure compensation to +2, and the aperture to the widest setting possible.

The Lightscoop works sufficiently well within its limitations. In particular, not all cameras produce very clean images at ISO 800, and some can be rather noisy. Since it deflects most light upwards, it provides little frontal fill; the traditional problem of "raccoon eye" shadow with bounce flash can occur if the room is darkly colored.

There are two versions—one with a silver mirror and one with a gold mirror. The gold is warmer and thus supposedly a closer match to tungsten lighting, though it's really too yellow.

8.2 Canon Speedlites

Over the years, Canon has made many add-on flash units for its cameras. All are marketed under the "Speedlite" name, and all are lightweight, battery-operated devices that plug into or fasten onto the hotshoe attachment of every EOS camera. All Speedlites since 1987 have been fully integrated with the Canon EOS system, offering fully automatic flash metering and other features.

Figure 8-5

Figure 8-6
The basic Speedlite lineup at time of writing: 270EX, 430EX II, and 580EX II.

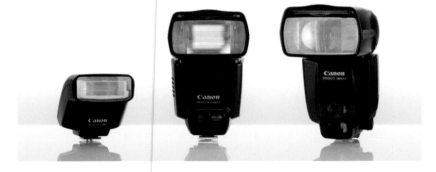

They come in five basic physical configurations: small hotshoe flash units, standard and pro tilt-head hotshoe flash units, handle flash units, and macro flash units.

8.2.1 Small hotshoe flash units

These are the most basic models—small, pocket-sized boxes. Most have fixed flash heads that can't be tilted or rotated. They produce a bit more light than a popup flash unit, but their very limited range makes them most suitable for casual indoor photography. They include Speedlites 160E, 200E, 300EZ, 200EX, 270EX. ● *Figure 8-7*

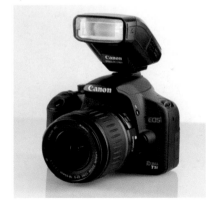

Figure 8-7

8.2.2 Consumer-level tilt-head hotshoe flash units

This is what most people think of when they think of an external flash unit for a camera. Occasionally known as a "cobra" design because of its form, the L-shaped hotshoe flash with an independently tiltable head is ubiquitous; most camera makers produce similar products. The consumer-level units offer reasonable power output but lack advanced features such as the ability to control other flash units wirelessly. They include Speedlites 380EX, 420EX, 430EX, and 430EX II. ● *Figure 8-8*

Figure 8-8

8.2.3 Pro-level tilt-head hotshoe flash units

The most full-featured flash units in the Canon lineup are the pro models, which are larger and more powerful than their consumer counterparts. They often support features such as wireless master control, rapid recharging, stroboscopic output, and weatherproofing. They include Speedlites 420EZ, 430EZ, 540EZ, 550EX, 580EX, and 580EX II. ● *Figure 8-9*

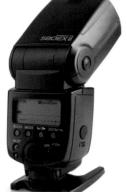

Figure 8-9

8.2.4 Handle flash units

Canon only made only one model of this design for EOS cameras, but some other makers, such as Metz, continue to produce them. They are large, high-output devices made in the shape of a big handle or grip with an integral flash bracket. They are often used by news photographers and the like. This is the Speedlite 480EG. ● *Figure 8-10*

8.2.5 Macro flash units

These are specialized flash units with small flash tubes that fasten to the end of a macro lens. They may have a ring shape or independently movable heads. Because they're intended for close-up photography, they do not have particularly high light output, making them unsuitable for general photographic use. They include the Macro lites ML-3, MR-14EX, and MT-24EX. ● *Figure 8-11*

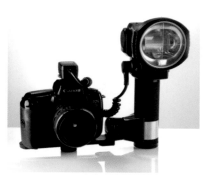

Figure 8-10

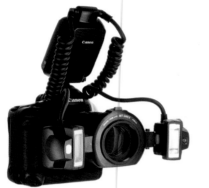

Figure 8-11

8.3 Speedlite naming scheme

The nomenclature of Speedlites is consistent and fairly logical. Here's what
"Speedlite 580EX II", a typical example, means.

Speedlite	The product name for most Canon external flash units (versus "Speedlight" for Nikon)
580	The maximum guide number (an output rating of the flash in meters) multiplied by 10 to make it sound cooler
E	Works with EOS cameras
X	Supports E-TTL flash technology
II	This unit is the second model to have this particular configuration (most flash units lack a Roman numeral designation, since the I is implied).

All Speedlites shipping at time of writing are EX units, and most work with
the majority of film and all digital EOS cameras. Units starting with "M",
such as the MT-24EX, are macro flash units. Other ending codes include the
following:

Letter code	Examples	Meaning
E	160E, 200E	EOS TTL for film cameras only
EZ	430EZ, 540EZ	EOS TTL and A-TTL for film cameras only; zooming flash heads
EG	480EG	Grip-shaped TTL-only unit
EX	220EX, 580EX	EOS E-TTL for film and digital cameras; current series
A	199A	For manual-focus A series cameras such as the A-1; not compatible with EOS
T	299T	For manual-focus T series cameras such as the T70; not compatible with EOS
TL	300TL	Designed for the T90; partially compatible with TTL film EOS cameras
M	200M	Autoflash only and no support for TTL

Although this naming system is reasonably logical and consistent, it's easy
to confuse different models that happen to have identical guide numbers.
For example, the 430EZ and 430EX flash units are completely different

products despite the single letter difference. The 420EZ and 420EX flash units are also easily confused. It thus pays to be very careful when shopping for used flash products. EZ units, for example, are not fully compatible with digital EOS cameras.

8.4 Older Canon Speedlites

Figure 8-12
Canon Speedlite 300TL

Older Canon Speedlites lack the letter E in their names and predate EOS cameras. They are not useful with modern cameras.

Such units will physically fit an EOS camera's hotshoe and may trigger at full power when a photo is taken, but they can't use modern automated flash metering. They have to be used in autoflash mode if they have such a setting (set the camera to a shutter speed up to the camera's X-sync) or in manual mode if they have manual controls (most don't), or else the units will fire at full power. Many should have a safe triggering voltage, but always check before attaching one of these vintage units to a camera.

The one exception is the 300TL. It was designed for the Canon T90 but can be used with EOS film cameras in basic TTL mode. ⬤ *Figure 8-12*

8.5 Third-party flash units

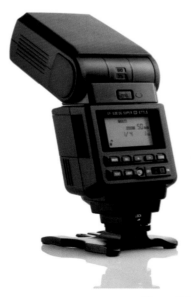

Figure 8-13
Sigma EF-530 DG Super Flash unit

A number of companies ("third-parties" such as Metz and Sigma) sell flash units for the EOS system. However, Canon has never published or licensed the data protocols—the digital language—used by their cameras. So, any flash product billed by a third-party as Canon compatible has been made through a process known as reverse engineering. The third-parties have examined the behavior of existing Canon products, deciphered the command language used to control them, and made their own compatible products.

While reverse engineering is effective when done diligently, there is one significant risk. Canon can alter the design of its products at any time. When this occurs, there is the possibility that older third-party units will not be able to communicate with newly released products.

Occasionally Canon will introduce a new line of products that breaks compatibility with previous products. For example, the switch from film to digital meant that newer digital cameras could not use older TTL flash units. Generally speaking, however, Canon ensures that new products can operate well with its older lineup. A brand new Speedlite 580EX II, for example, will work just fine on an EOS 650 camera from 1987, though of course the 650 may not be able to take advantage of all the Speedlite's new features. Be cautioned that Canon does not test third-party products for compatibility issues during development; Canon just tests their own.

Some third-party products are upgradable to avoid this risk. For example, more recent Metz flash units have USB connectors so the latest firmware (internal computer software) can be downloaded from the Internet to the flash unit if Metz releases an update to improve compatibility. Most third-party units do not have this level of "future-proofing" built in, though it's sometimes possible to send them to the manufacturer for firmware upgrades.

Another common problem involves AF assist lights. Almost all third-party flash units cannot illuminate the AF assist light when a focus point other than the center point is selected on a multiple focus point camera.

Figure 8-14
Mecablitz 15 MS-1 ring flash

9 Canon Speedlites

Here is a comprehensive and fairly exhaustive (if not exhausting) list of the various features offered by Canon Speedlite flash units. Not every model will offer every function, of course. Consult the complete table in appendix C for details.

Figure 9-1

Key parts of a Speedlite 580EX II flash unit

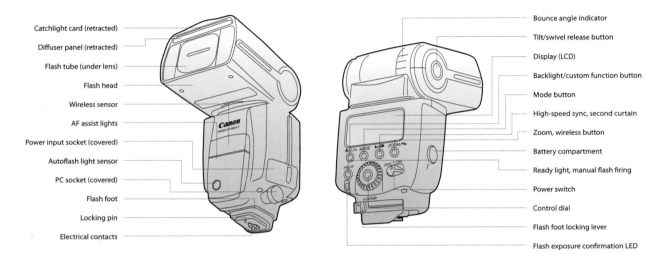

Catchlight card (retracted)
Diffuser panel (retracted)
Flash tube (under lens)
Flash head
Wireless sensor
AF assist lights
Power input socket (covered)
Autoflash light sensor
PC socket (covered)
Flash foot
Locking pin
Electrical contacts

Bounce angle indicator
Tilt/swivel release button
Display (LCD)
Backlight/custom function button
Mode button
High-speed sync, second curtain
Zoom, wireless button
Battery compartment
Ready light, manual flash firing
Power switch
Control dial
Flash foot locking lever
Flash exposure confirmation LED

9.1 Hotshoes

Hotshoes are the traditional, squarish slide-in sockets on the top of all EOS cameras, and indeed most SLRs sold today. Despite the dramatic name, hotshoes carry no risk of electrocution and don't get warm. "Hot" is just slang for their electrical connectors, though non-electrical accessories such as bubble levels and flash diffusers can also be installed. Coldshoes are simply brackets with no electrical connectors.

The earliest hotshoes from the late 1940s contained a single electrical contact in the middle that carried the sync signal. The metal frame served as electrical ground. EOS cameras have four additional small contacts arranged behind the main stud. They are used for carrying computer instructions, which is how they can support a host of advanced features such as flash metering and flash head zooming. The signals sent by these four contacts are wholly proprietary to Canon.

In the early 1990s, Canon started painting its hotshoe frames black, which looks great out of the box. However, the paint tends to scratch and flake off, potentially insulating connectors, and so newer EOS bodies have gone back to unpainted metal frames.

Hotshoes are something of a weak link in the chain for any camera. They were initially designed over half a century ago for small accessories and have been modified by different manufacturers to accept increasingly large flash devices. Nearly all camera makers, with the exception of

Sony/Minolta, employ the same basic hotshoe design, though usually with slightly different contact configurations.

If a flash fails to fire reliably, the first thing to check is the shoe. The screws holding it in may need tightening, or the contacts may require gentle cleaning. Never use anything more than a soft cloth to clean the contacts, though light application of deoxidizing contact cleaner can help. Pencil erasers and emery cloths are abrasive and will permanently damage the contacts over time.

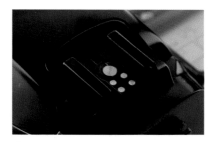
Figure 9-2
Plastic flash foot

9.1.1 Flash feet

The base of a flash unit that fastens to a hotshoe is known, logically enough, as its foot. Over the years Canon has used four basic flash foot designs.

The earliest models employ plastic feet with rotating pressure rings. These collars push the foot down in place, preventing the flash unit from falling off the camera. The tightening direction is usually specified with an arrow, sometimes marked with "L" for lock. The main drawback of this design is that the rings can occasionally bind, making it difficult to remove the flash unit. In such cases, try tightening slightly, then firmly untightening the ring.

The plastic design has an advantage in the case of blows and accidental damage—the plastic foot can break, sacrificing itself to minimize damage to the rest of the flash unit. ● *Figure 9-4*

Later models have pressure rings with a small retractable pin at the front of the foot. This pin lowers down into a matching hole in the shoe, making it less likely that the flash unit can slide out inadvertently. The pin is spring-loaded, so the flash will still fit in hotshoes that lack the locking pin hole. This is the most common type of Speedlite foot.

The most recent design is the metal latching foot. Billed as sturdier than the plastic design, it may also include a rubber shroud which matches the shoe on weatherproofed cameras, minimizing water and dust penetration. (See section 9.32 on weatherproofing.) Instead of a ring, there's a quick-release latch. Turn the latch right to lock it; press the release button and turn it left to unlock it. ● *Figure 9-5*

The latches are quick and easy to operate, but can't always tighten as firmly as the traditional pressure ring design, especially if the camera is held sideways in portrait configuration. If this occurs, inconsistent contact with the connectors may result. A flash unit might, for example, suddenly switch from E-TTL mode to TTL if it loses communication with the camera. On a digital body, this can mean the flash unit fires at full power or not at all. ● *Figure 9-6*

Finally, tiny units have simple sliding latches. ● *Figure 9-7*

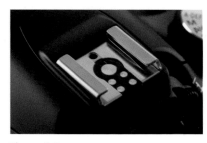
Figure 9-3
Metal flash foot

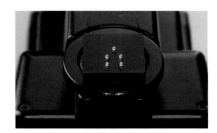
Figure 9-4
Flash foot with collar

Figure 9-5
Flash foot with collar and pin

Figure 9-6

Flash foot with quick release

Figure 9-7

Foot with latch

Figure 9-8

The feet on any unit are only so sturdy, and it's a bad idea to lift a joined camera and flash unit by the flash unit. Pick up the camera body to avoid placing undue strain on the flash foot.

9.2 Flash heads

In keeping with the body metaphor, the section of the flash unit in which the xenon-filled flash tube is mounted is called its head. The tube is mounted inside a small reflector and covered with a protective plastic lens. The lens is molded in a Fresnel-type pattern to concentrate the light output. There's sometimes a slightly yellowish tint to the plastic to help warm the flash-produced light. ● *Figure 9-8*

9.3 LCDs

Higher-end Speedlite flash units, including all the 500 series models and most of the 400 series models, are equipped with liquid crystal display (LCD) panels. These LCDs show important operational information to the user. They all have optional backlights for low-light operation, and can be illuminated for a few seconds by pressing a back panel button.

Figure 9-9

ETTL ⚡H	ISO Ⓜ Zoom *188* mm ▤
±🔲 ▨ +*8 ₽/188 188*+*18.8* Hz	
MULTI ≳▸◨ CH. MASTER RATIO	
C.Fn ▷▷ ◂∠,◨ 1 2 3 4 SLAVE A:B:C	

8:1	4:1	2:1	1:1	1:2	1:4	1:8
0.5 0.7	1 1.5	2 3	4 6	9 13	18 m	
1.7 2.3	4 5	7 10	15 20	30 40	60 ft	

This is all the information that can be displayed on the LCD of a 580EX II unit, though of course it never actually looks like this at any one time. ● *Figure 9-9*

9.4 Swivel and tilt for bounce flash

Most Speedlite flash units, with the exception of the small pocket units, have flash heads that can be tilted and swiveled to point independently of the body. This allows for bouncing light off large reflective surfaces such as walls or ceilings. It also means the flash head can point one way while the

Figure 9-10

front of the unit's body, where the wireless E-TTL sensor is located, can face back towards the camera. Tilting on non-macro units is usually adjustable from 0° (straight forward) to 90° (vertically upwards), with 500 series units allowing a 7° downwards tilt for slightly improved close-up photography. ● Figure 9-10

Most swiveling units can go from 0° to 180° left, which is facing backwards. Right swivel is either 0° to 90° or 180°, depending on the model. There are click stops at various detent positions, and most units have spring-loaded tilt latches. Recent models conveniently use a single push-button latch to unlock both tilt and swivel. Some units with LCD panels show a small icon indicating whether a unit's flash head is in tilt mode or not. ● Figure 9-11

This ability of a Speedlite to detect whether its flash head is in bounce mode is available in some cases. When ISO is set to AUTO, EOS bodies starting with the Rebel T1i/500D and 7D deliberately increase the ISO if a flash unit is detected to be in bounce mode, to compensate for the reduction in range.

Figure 9-11

Figure 9-12
While tilt and swivel are normally used for bounce flash, they have other creative uses as well. In this shot, the on-camera 580EX II was deliberately angled upwards to illuminate the model while keeping the lower half of the freight elevator dark and mysterious.

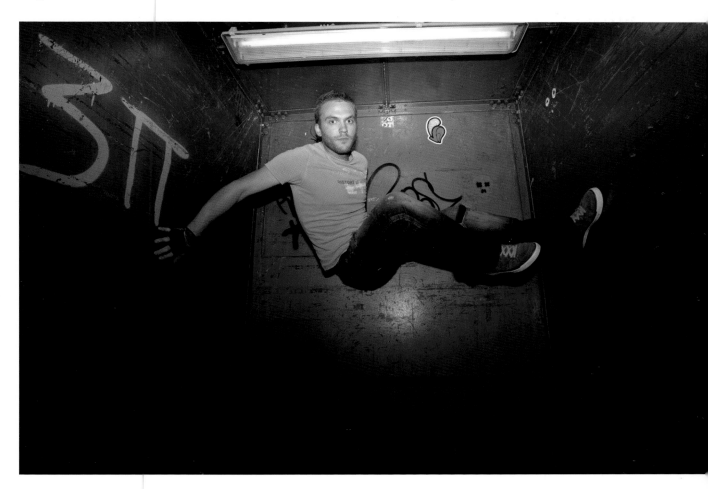

Low-end flash units that lack tilt and swivel heads can also be used for bounce flash. Simply attach the flash unit to the camera via an Off-Camera Shoe Cord (section 11.5.1) and point the flash in any desired direction. However, the smaller flash units are also the lower output models, so too much power might be lost for this technique to be useful.

9.5 Zooming flash heads

Lenses with different focal lengths take in different amounts of a scene, and the coverage of light from a flash unit needs to match, or slightly exceed, that of the field of view. A wide-angle lens used with a flash unit designed to cover a longer lens results in a darkened periphery. ● *Figure 9-13*

Figure 9-13

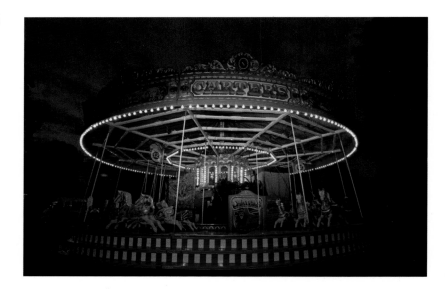

The converse can also occur. A flash unit designed to cover a wide area essentially wastes a lot of its light if it illuminates areas of a scene that aren't captured by a longer lens. ● *Figure 9-14*

Figure 9-14

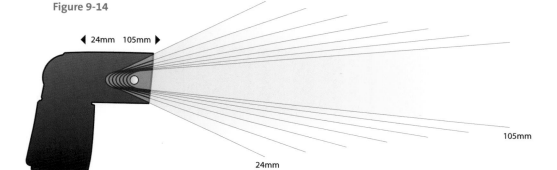

Many Speedlites have adjustable coverage areas, thanks to small motors that move the flash tube. The closer the tube is to the clear plastic Fresnel lens at the front, the wider the coverage angle (and vice versa). This is known as a "zooming" flash head.

Figure 9-15

The motorized mechanism from a 580EX's flash head, showing the fixed, white plastic reflector inside on which the flash tube assembly moves. Note the small size of the flash tube itself, which is mounted inside a silver frame. Note also that inexperienced users should *never* open up a flash unit like this, as doing so exposes dangerously high voltages that remain inside the device even when the power is switched off. There is a serious shock hazard if the wrong part is touched!

Most units cover the range of 24–80mm or 24–105mm lenses, as used by 35mm or full frame digital cameras. The motors have several detented steps matching popular prime lens focal lengths, such as 24–28–35–50–70–80–105mm. Continuous zooming to arbitrary focal lengths is not supported.

A flash unit's upper zoom limit doesn't mean it's incompatible with longer lenses, but that it can't concentrate its light beyond a certain point for more efficient coverage of a narrower area. The reverse is not true for the wider end. For example, a flash unit with 24mm coverage at the wide end will cause a vignetting effect (darkening of corners or edges) when used with a 17mm lens.

The primary disadvantage of zooming is that the flash head has to be larger and longer to accommodate the mechanism. Also, PC cables and other cables that carry sync signals only will not carry automatic zoom position commands, since they lack the additional four pins for transmitting digital data.

9.5.1 Automatic zooming

Speedlites with motorized flash heads can adjust zoom settings fully auto-matically. Canon EF and EF-S lenses—and third party lenses fully compati-ble with the EF standard—contain computer chips that send the current focal length to any Canon EOS camera. Likewise, EOS cameras can com-municate digitally with Speedlite and compatible flash units that are either fastened to the camera's hotshoe or connected using a fully compatible TTL or E-TTL cable.

Motorized Canon Speedlites automatically use the nearest zoom set-ting that is equal to or less than the focal length of the lens whenever they are connected to a compatible camera, and when the shutter release is pressed halfway. They automatically change motor positions with a little whirring buzz if the zoom position is changed within six seconds of the shutter button being half-pressed, or if the button is continuously held down in the halfway position.

This automatic focal length setting occurs whenever the flash head is pointing directly ahead. Speedlites typically default to a 50mm zoom set-ting when their flash heads are in bounce mode (i.e., tilted or rotated). If a lens that isn't EF compatible is attached (an old fully manual lens attached to the camera using a lens adapter ring, for example), or if an EF lens isn't fully locked onto the camera, then the camera has no way of knowing what the focal length is. It will then typically set the zoom head to a focal length of 35mm or 50mm.

Wireless-capable units with zooming heads (section 11.8) automati-cally zoom to 24mm when in wireless slave mode.

9.5.2 Manual zooming

Figure 9-16

Most motorized flash units have override support for the zoom setting. This is typically engaged by pressing the button marked "ZOOM". On newer flash units with combined zoom/wireless buttons, use the control dial or +/− buttons to adjust the setting. On other flash units, press the "ZOOM" button repeatedly to cycle through the settings.

The focal length setting will go around in a loop step by step as it's ad-justed, accompanied by the buzz of the flash head motor. The letter "M" will appear next to the zoom setting if the flash head has been set manu-ally. Some older units will also display "A ZOOM" if the unit is in automatic zoom mode. If the zoom setting displays "−−" then the flash head is tilted or swiveled in auto mode. (Zoom position can still be manually overridden.) If the lowest zoom setting possible blinks continuously on the LCD, then the current focal length of the lens is shorter than the flash unit's widest coverage.

Cameras with menu control over compatible Speedlites can also adjust zoom settings via a menu option.

Note that two models—the 300TL and the 270EX—lack motors, so their zoom heads must be slid back and forth by hand.

9.5.3 Creative zooming

While adjustable flash coverage is intended to increase light efficiency when using longer lenses, it's also a useful creative tool. A flash head can be deliberately zoomed out to a longer focal length to concentrate the light. This lets the flash unit work like a sort of soft-edged spotlight, sending pools of light to specific areas. In a sense, the flash unit behaves a bit like it would if a snoot or other light-restricting device were installed. Adjusting zoom coverage is also useful for ensuring that a flash unit's light fills an umbrella or reflector.

Consequently, zooming heads with manual control are a particularly useful feature for a flash unit that's used off-camera. Each slave unit can have its coverage angle set independently.

Figure 9-17

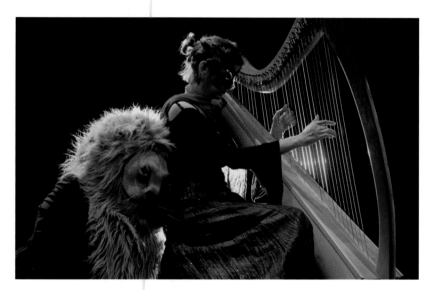

Figure 9-18
This performance photograph was lit primarily by available lighting—a pair of stage spotlights. But for added drama, a Speedlite 580EX was positioned behind the performers on a Manfrotto nano stand. The head was zoomed out to 105mm in order to create a narrow beam, providing a backlit spot effect.

9.5.4 Zoom compensation

Camera bodies with image capturing areas less than that of 35mm film (APS film cameras and most EOS digital cameras) don't require as much area illumination as 35mm/full frame digital cameras because of the cropped frames. So a flash unit designed for a 35mm camera is, in effect,

Figure 9-19

Figure 9-20

wasting light when taking a photo using a cropped sensor camera, since areas outside the edges of the picture will be illuminated unnecessarily. This ends up costing flash range.

Later model EOS digital cameras and Speedlite flash units can compensate for small sensors automatically. When a compatible camera/flash unit combination is used, a small nested rectangle icon will appear in the flash unit's LCD, showing that the flash unit knows to adjust for the reduced size of the sensor. Such flash units actually have the ability to set the flash zoom to detented positions between the common points, but not in a user-adjustable fashion.

9.5.5 Zooming camera flash

Two EOS film cameras, the Elan/100 and the A2/5, have three-position automatic zoom motors built into their popup flash units. These zoom motors explain the unusually high guide number (metric 17 at 80mm) of these flash units when using longer lenses, as well as the chunky size of their flash housings. However, no later cameras contain such motors. The expense and bulk of the zooming mechanism were deemed to outweigh the benefit of improved guide numbers.

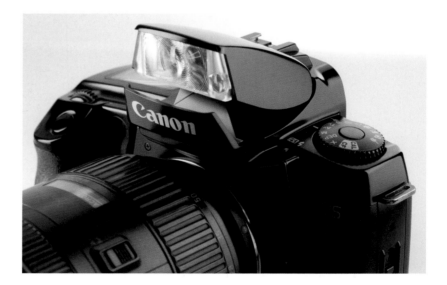

Figure 9-21

9.6 Flash head diffuser panels

The 500-series and some 400-series Speedlites contain pull-out "wide" or "diffuser" panels. These translucent plastic panels slide out of the flash head housing and can be flipped down to widen the coverage. They typically cover 14mm, 17mm, or 18mm, though at the cost of range since the light is spreading wider.

Such panels are important for wide-angle photography, since flash heads aren't typically designed to cover huge areas. Fisheye lenses in particular represent a bit of a problem, since they have such wide coverage (nearly 180° diagonal for 15/16mm fisheyes, and nearly 180° vertical for 8mm fisheyes). Some experimenting with diffusers is required for successful flash-illuminated fisheye photography.

When a panel is extended, auto zoom is set to its widest position and the zoom motor is shut off. If the flash head is swiveled or tilted when the panel is extended, then the entire LCD panel will blink repeatedly. This is a warning that the wide panel is being combined with bounce mode, something Canon does not recommend.

Note that the components are fairly delicate and must be treated carefully. If either the panels or their internal switches break, the flash unit will think the panel is permanently extended and zooming will be disabled. If this happens on a 540EZ, turn the unit to SE mode while keeping the MODE and ZOOM buttons pressed to re-enable the zoom motor. On later models, try to push the panel all the way back into the flash head. ● *Figure 9-22*

These panels can also serve as weak bounce cards if they are pulled up partway and left to extend vertically from the head. However, the panel is more vulnerable to breakage if used in this way.

The 200E, 200M, and 480EG units also have optional clip-on diffuser panels that increase or decrease the coverage area of the flash heads. ● *Figure 9-23*

Figure 9-22

Figure 9-23

Figure 9-24

9.6.1 Catchlight panels

Some 500-series Speedlites have small, thin, white plastic cards that reside alongside the diffuser panels inside the flash head. This design is essentially like having a tiny index card tucked away inside the flash unit when not in use. The catchlight cards are normally used fully extended and with the flash head tilted so that it points upwards vertically. This directs the majority of light up, while the card bounces a small amount of light forward onto the subject.

The idea behind these cards is to create a tiny amount of fill and, more importantly, to cause a small bright area (a "catchlight") that can be reflected back from a person's eyes. ● *Figure 9-24*

9.7 Autofocus (AF) assist light

Older point-and-shoot cameras sometimes have "active" autofocus mechanisms that send a beam of light or infrared out to the subject. This energy reflects back from a subject and is used to calculate correct focus settings.

On the other hand, cameras with "passive" autofocus mechanisms, including all EOS models, work on a different principle. They don't normally send out any light themselves, but instead analyze the light reflecting back from a scene. This usually works quite well, but even good AF systems like the phase detection sensors used by EOS cameras are stymied by low light levels, especially when trying to focus on a featureless low-contrast surface such as a wall.

For this reason, most Speedlite flash units and some EOS cameras can optionally shine a little light in order to give autofocus a helping hand when light levels are low. These AF assist lights come in different forms. They may be a relatively discreet patterned red light from a bright red LED, a dazzlingly bright white incandescent light, or a rapid-fire strobe of the main flash tube. ● *Figure 9-25*

Figure 9-25

9.7.1 Red AF assist lights

Most E-series Speedlites have patterned red AF assist lights (sometimes called AF auxiliary lights in older Canon manuals) positioned at the front. These lights use one, two, or three high-brightness LEDs and project red circles of light striped with dark lines. When ambient light levels are low, the LEDs can illuminate automatically, giving the camera's autofocus system something to focus on. The lights produce stripes so that there are high-contrast edges, making it possible to focus the camera on blank surfaces such as white walls. ● *Figure 9-26*

Figure 9-26
The red AF assist lights project striped red patterns.

While AF assist is great in low light conditions, it does slow autofocus down. This is because the light needs to fire at least a couple times—once to give the AF system a target to focus on, and a second time to confirm that focus was attained. The process is repeated if AF still fails, which is particularly likely if the subject moves between AF assist firings.

The maximum range of the AF assist light varies from unit to unit, but is typically a distance of around 5–10 meters / 15–30 feet from flash unit to subject. Flash units that cover more than one focus point have lower AF assist ranges for outer points.

These red AF assist lights blink when a Speedlite is in slave mode, as a reminder that it's charged up and waiting to be triggered remotely. The lights also help line up the slave units to their targets. There's no way to disable the lights in slave mode other than by applying some black tape.

AF assist only illuminates if the camera is in one-shot drive mode—it will not work in AI Servo or in any icon AE mode that employs AI Servo, such as Sports mode. This is because the camera is constantly focusing and refocusing in AI Servo mode to track subject motion. AF assist also does not work if a digital camera is in Live View mode.

The red light is sometimes described as being "near infrared"; it peaks at a wavelength around 700nm, though it is quite visible to the human eye. It's easily recorded by other cameras, which can be a problem during weddings and other events when video equipment is used.

9.7.2 Red AF assist and multiple focus point minutiae

If the camera body has multiple focusing points and the Speedlite's AF assist light isn't lighting up in low light, it's probably because the AF light on the flash unit can't cover the currently selected (i.e., non-center) focusing point. Many flash units have AF assist lights which can only illuminate the area around the central point. Switch to the central focusing point, and the Speedlite's AF assist light should start working. Additionally, there are focal length limitations. Speedlites cannot provide AF assistance if a lens wider than 28mm is in use and a focus point other than the central point is selected.

As for the coverage of these AF lights and multiple focus points, it depends on when the flash unit was introduced and its position in the marketing lineup. For example, the 430EZ flash was introduced at a time when all Canon cameras had only one focusing point, and so its AF assist light cannot cover the non-central focusing points of multiple-point cameras. The 420EX, however, has an AF assist light that covers all seven points used by later cameras. The 430EX and 430EX II cover nine points. The 500 EX series units can cover all 45 points of the area focusing system used by most 1 series cameras.

Coverage depends in part on the number of LEDs the unit has. Many Speedlites have a single red AF assist LED, but some have two (e.g., the 430EX) and some have three (e.g., the 580EX). Which LEDs activate in multi-LED units depends on which focus point or points are selected. Some LEDs project horizontal lines and others vertical.

Some flash units cover all nine AF points if the focus point is selected manually, but fail to illuminate the upper or lower points if they are selected manually because of firmware limitations. The majority of third-party flash units can only cover the central point if they have AF assist lights.

Finally, a handful of early film EOS cameras such as the EOS 10/10s only fire body-integral AF assist lights and never fire the LEDs on a Speedlite.

Figure 9-27

9.7.3 Flash brackets and alignment

Red AF assist lights are carefully aligned so that they correctly illuminate the area covered by the lens. However, if the flash is moved off camera with an off-camera shoe cord or flash bracket, the AF lights may go out of alignment. AF lights can also be blocked by add-on accessories, such as some softboxes and ring light attachments.

9.7.4 White light macro AF assist

Canon macro flash units have small white incandescent bulbs for modeling and focusing rather than red AF assist LEDs. Conveniently, the Macro Twin Lite MT-24EX can be configured so that double-tapping the shutter release halfway turns these lamps on. The ML-3 and MR-14EX require a press of the controller-mounted "lamp" buttons to enable the lamps.

The earliest EOS digital bodies, the D30 (not to be confused with the 30D) and the D60, are also equipped with bright white lights that provide limited autofocus assist.

9.7.5 Main flash tube pulsing

As noted, many consumer and mid-level EOS cameras do not have a separate AF assist light built in. As a substitute, they can produce a bright staccato burst of light from the main flash tube of the built-in flash unit. This is a cost-effective solution since no additional LEDs are required, and it also has the advantage of covering all focus points on the camera. Unfortunately, it's also very distracting and irritating to human subjects, and it does not help the camera focus on featureless surfaces such as white walls since no striped pattern is projected. Fortunately, most recent cameras with this feature can disable AF assist, though at the cost of low-light focusing.

The Speedlite 270EX lacks an AF assist light and can also pulse its flash tube annoyingly. However, this functionality works only with digital EOS bodies with external Speedlite control. Its pulse AF assist will not activate on older models. It may also be necessary to upgrade the firmware on certain models to support this feature on the 270EX. (Alternatively, enable it on a newer camera, then move the unit to an older model.) ● *Figure 9-28*

The EOS 7D is capable of differentiating between Speedlites that have red AF assist lights (which it somewhat incorrectly refers to as "infrared") and those units that pulse the main tube, such as the 270EX. Custom function III-11 on the 7D can enable red AF assist lights if desired.

Figure 9-28

9.7.6 Disabling AF assist; disabling main flash

Many advanced Speedlite models and many cameras have the ability to shut off the AF assist light if it's obtrusive. All Speedlites with custom functions have one for disabling AF assist, as do many cameras. If both the camera and flash unit have an AF assist custom function, it appears that setting either to "Disable" will shut off the feature. Some cameras can also enable the AF light on an external flash unit while disabling the internal AF

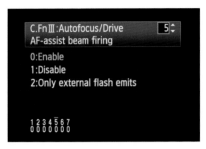

Figure 9-29

assist. For some reason, control over AF assist does not appear in any camera's "External Speedlite control" menu at time of writing; it's always turned on or off through a custom function.

Conversely, these cameras and flash units also have the ability to let an external AF assist light illuminate while preventing the flash tube from firing, which is a useful solution for improving low-light autofocus performance. This is usually done through a custom function or menu item. To do this on a camera with menu control over Speedlites, for example, go to "Flash Control" and select "Flash firing". Set it to "Disable". Be sure that the flash unit is set to emit the AF assist. ● *Figure 9-29*

9.7.7 ST-E2

The Speedlite Transmitter ST-E2 is a small device which can serve as a wireless E-TTL master controlling other flash units, but which does not produce any visible white light itself. The ST-E2 also has a pair of autofocus assist LEDs built-in and can serve as an AF assist device for cameras that lack the feature. The transmitter is relatively small and runs for ages on an ordinary disposable lithium battery. Owners of early EOS digital cameras with poor low-light autofocus, such as the D30 and 10D, may find the ST-E2 a useful solution. ● *Figure 9-30*

Figure 9-30

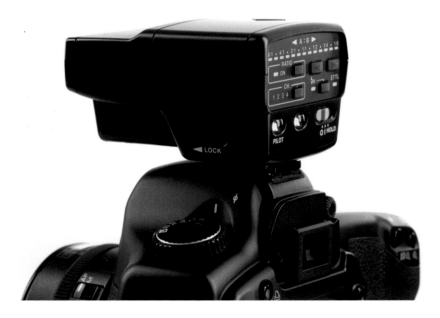

9.8 Redeye

Redeye, the bane of point-and-shoot snapshots, occurs when light hits the fine red mesh of blood vessels lining the retina of the eye and is reflected back to the camera. Glowing, rather evil-looking, red eyes are the result.

Figure 9-31

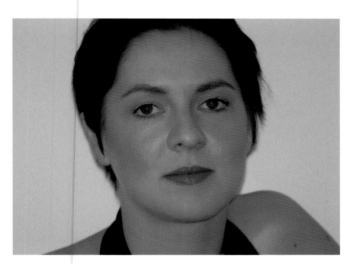

Redeye is rarely seen in everyday life for three reasons. First, the light source has to be much brighter than the ambient lighting. Second, the pupils must usually be quite dilated (open) for the reflected red light to be noticeable. And third, the light source has to be as close as possible to the viewing axis (i.e., to the viewing eye).

Unfortunately, these three conditions are met handily when doing flash photography in dim lighting conditions. Flash involves a tremendous burst of light. Since ordinary consumer flash units are attached to the camera or built into the camera body, they're often located very close to the lens. Tiny point-and-shoots are particularly vulnerable to the problem, partly because they tend to be used in low-light situations like restaurants and living rooms, and partly because their built-in flash units are located very close to the lens.

Flash photography of cats and dogs can involve a related problem called greeneye. Cats and dogs have a reflective membrane in their eyes called the *tapetum lucidum* which helps their night vision. The tapetum reflects light very efficiently and tends to color it green, yellow, or blue. The membrane also causes the eyes of animals by the side of the road at night to be visible as brilliant points of light. Humans lack this layer, so we don't have tapetal reflections. ● *Figure 9-32*

9.8.1 Redeye reduction

Redeye can be colored over with a black pen on the final prints or concealed via an image editing program, but these are obviously crude ways to solve the problem. The best solutions for avoiding redeye are either to avoid flash altogether or to move the flash unit as far as possible from the lens.

Figure 9-32

Figure 9-33

A Canon G9 point-and-shoot, a 50D with popup flash, a 50D with shoemount Speedlite 430EX, and a 50D with a 430EX on a Custom Brackets CB Junior bracket. Note the relative distances between the center of the lenses and the center of the flash units.

Good techniques for reducing redeye are to use off-camera flash, put the camera onto a flash bracket, or tilt the flash head so that light bounces off the ceiling or the wall. Unfortunately, none of these techniques are possible with a camera's unaided built-in flash unit.

One drawback with moving the flash unit, aside from the inconvenience of doing so, involves low-light photography. When light levels are low, the pupil of the eye dilates to let in more light, just like a lens diaphragm. If a flash photo is taken of a person, the irises don't have enough time to react to the burst of light, so the pupils remain dilated and huge.

Because redeye compensation techniques are inconvenient, camera makers have come up with another idea: shine a bright light into the eyes first, which makes the pupils contract and less likely to reflect red light. Many cameras come equipped with redeye reduction lamps—typically bright white lights or fit-inducing pulses of blinding light from the popup flash unit. Unfortunately, these lights usually have the effect of making people look dazed and stunned. Blank and glazed, or red and evil-looking: with onboard flash photography, the choice is yours!

Redeye reduction is typically enabled by a menu item or pushbutton, and is indicated by a small eye icon *(figure 9-34)*. Many cameras show a graphical countdown timer while the redeye reduction light is glowing. This is meant to guide the photographer as to how long their victims must stare into the light to let their pupils contract. ● *Figure 9-35*

None of these tricks are particularly useful for photos of pets, which have eyes like reflective road signs or safety tape on high-visibility vests. In these cases, off-camera or bounce flash is the way to go. The light is still reflected back to the source; it just happens to be in a different location than the camera lens.

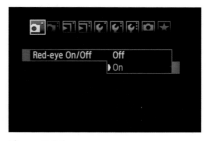

Figure 9-34

Figure 9-35

9.9 Flash exposure compensation (FEC)

Flash exposure compensation is the ability to increase or decrease a flash unit's power over the automatically chosen output setting. How FEC is applied depends on the camera and body being used. Many EOS bodies have the ability to specify FEC by pressing a button marked with the FEC icon. This engages FEC mode, and rotating the camera's dial will adjust the flash output. ● *Figure 9-36*

Usually the FEC button is tied with another function, such as metering mode or ISO. In such cases, and if the camera has two control dials, each dial controls a separate function.

Other cameras have the ability to apply FEC via a general menu option or the flash control menu.

Figure 9-36

Figure 9-37

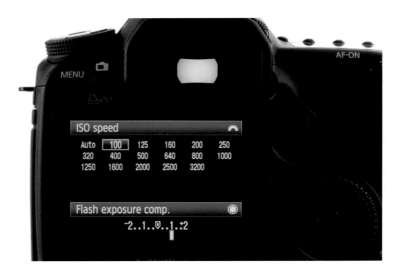

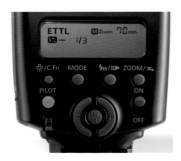

Figure 9-38

Many Speedlites have FEC controls on the back. On earlier models, these are the + and – buttons. Later models typically require pressing the SEL/SET button first to activate those buttons. The 580EX and 580EX II have a rotating dial instead of buttons, and a custom function determines if the SEL/SET button needs to be pressed first. When FEC is set to anything other than zero, an FEC icon appears on flash units with displays.

Flash exposure compensation is not cumulative or additive on EOS bodies. In other words, if both camera body and flash unit have the ability to set FEC, and the flash unit's FEC controls are set to anything other than zero, the settings on the flash unit take priority and the camera's adjustments are ignored.

As noted earlier, EOS bodies automatically apply auto fill reduction under brighter ambient lighting conditions. So it may not be necessary to dial in any FEC in the case of fill flash, particularly when using E-TTL. Remember that any FEC applied manually is in addition to any auto fill reduction that the camera may apply.

Figure 9-39
Wing of Chinese oak moth, *Antheraea pernyi*. Flash exposure compensation over a five-stop range: minus two, minus one, normal, plus one, plus two.

−2 −1

However, most pro and semi-pro EOS cameras have a custom function that can disable automatic fill flash reduction. This is useful when shooting backlit objects, as fill flash reduction may not be needed.

9.9.1 Micro adjustment for flash exposure

In addition to FEC, some cameras, starting with the EOS 1D Mark IV, support "micro adjustment" for flash exposure. This custom function allows the photographer to bias normal flash metering by up to one stop in 1/8 stop increments. It's essentially a secondary level of flash exposure compensation that can be set permanently and that alters the zero point that FEC starts from.

Micro adjustment is used primarily to customize a camera to suit a photographer's particular needs and style, which is handy if it seems the flash exposure compensation settings are permanently set. It's also possible to compensate for very minor variations from one camera body to another for precise studio work.

9.10 Flash exposure lock (FE lock or FEL)

EOS cameras that support E-TTL also support flash exposure (FE) lock when used with EX flash units. The feature "locks" flash exposure settings, allowing an image to be recomposed and improving flash metering in certain difficult cases. Canon first introduced FE lock in 1986 with the T90 camera and 300TL flash, but dropped it with the first EOS cameras. FE lock made its return with E-TTL in 1995.

FE lock works by firing the usual E-TTL preflash when the AEL or FEL button is pressed on the camera, rather than immediately before the scene-illuminating flash is fired. It then stores the flash exposure values based on that preflash in memory.

0 +1 +2

FE lock is useful for taking photos when the subject is not covered by one of the focus points, when photos contain reflective surfaces that can fool flash metering, or occasionally when the subject is moving. In the case of E-TTL (though not E-TTL II), it's also useful for scenes in which flash exposure needs to be biased to something other than the current focus point.

The main drawback with FE lock, aside from the extra button pushing, is that the manually triggered preflash can confuse human subjects who may think that a photograph has just been taken when it actually hasn't.

9.10.1 Engaging FE lock

On most EOS cameras, the AE (autoexposure) lock and flash exposure lock features are tied together, so pressing the ✱ button locks both ambient and flash metering. But conveniently, most 1-series EOS cameras have separate FEL buttons that allow for setting the AE lock and FE lock independently. The EOS 10D's custom function 13-4 allows the assist button to be a dedicated FE lock, and the EOS 7D's M-Fn button can also be used for this function.

Figure 9-40
This 50D, like most non 1-series cameras, ties FEL and AE-L to the same button

Figure 9-41
All 1D series cameras have a dedicated FEL button near the shutter release

Whichever button is pressed, the camera stores locked flash exposure data for a 16-second period, or for as long as the shutter release is pressed halfway. It will also briefly indicate FEL in the viewfinder, top deck LCD, or rear panel LCD on some camera models; additionally, the ⚡✱ symbol may appear. During this time, the picture can be recomposed in the viewfinder, or the aperture and shutter speed can be altered (overriding AE lock, which is set when the AE lock button is pressed). If the flash symbol in the viewfinder

blinks upon setting FE lock, then the subject is too far away to be illuminated sufficiently.

Some cameras have a custom function which specifies whether partial metering and FE lock are to be tied to the central focus point—the default—or to the active focus point instead.

FE lock is not available if the camera is in an icon mode or CA mode, or if digital Live View is enabled. Some early film models may not support FE lock if the flash unit is in high-speed sync mode. The flash unit must be in E-TTL mode for FE lock to function, in the case of flash units that also support TTL.

9.10.2 Flash exposure level

Most 1-series professional Canon cameras have the ability to display the flash exposure level in the viewfinder. When the FEL button is pressed (the small button near the shutter release) a vertical sliding scale will appear in the viewfinder on the right side. ● *Figure 9-42*

The flash exposure level will be displayed on the far right bar of this scale. The output on the flash unit can then be adjusted via flash exposure compensation.

Figure 9-42

9.11 Fill flash ratios

A traditional tool for thinking about artificial light in photography is the ratio. In a two-light portrait, for example, a photographer might consider the ratio of the key light (the main light illuminating the photo) to the fill light (the secondary light which fills in the shadows). Ratios are sometimes used in the context of fill flash as well, and are used to describe the amount of ambient (available) light illuminating a scene compared to the amount of flash.

However, ratios are not a very useful model for automated flash, particularly for fill flash. There are a number of reasons for this. First, there are two different ways of specifying a ratio, depending on whether you're considering light output (incident light) or reflected light bouncing off a surface. Second, ratios may make some sense in a studio where it's easy to have full control over all light sources. But it's not at all straightforward when dealing with ambient lighting. Third, when using automated flash systems it isn't really possible to measure the flash output. And finally, EOS cameras don't use the ratio model for specifying flash output anyway. They do unfortunately use ratios when dealing with controlling the output of wireless flash groups, but that's a different topic altogether.

The first point can lead to a lot of confusion. Does a ratio refer to the ratio of ambient light plus fill flash combined, compared to fill flash alone? (effectively the reflected light that makes its way back to the camera) Or does it simply mean the ratio of ambient light to fill flash? (the incident light hitting the subject) For example, a fill flash ratio of 1:1 can mean that the flash is the sole source of light. Or 1:1 can mean that the flash and ambient light levels are the same: two very different situations.

When using automatic flash metering, EOS cameras work in terms of "compensation" rather than ratios. In other words, in bright light conditions the camera will attempt to illuminate the foreground with a flash output that its designers thinks should work well. With experience, and judicious examination of the preview screen in the case of digital, it then becomes possible to know if this automatic setting works for you. If it doesn't, you can increase or decrease the flash output using flash exposure compensation with most cameras and flash units. This is done in terms of "stops" of output. (see section 6.17)

9.12 Auto fill reduction

EOS cameras use regular flash exposure with no compensation when ambient light levels are low, i.e., 10 EV or lower. (Exposure values are described in section 7.17.) However, when ambient light levels are bright, 13 EV or higher, the camera switches to fill flash mode and reduces the flash unit's output level. This feature, sometimes called "automatic reduction of flash output", works in TTL mode by dropping flash output by 1.5 stops. Between 10 and 13 EV, the camera smoothly lowers the flash unit's output by half a stop for each EV.

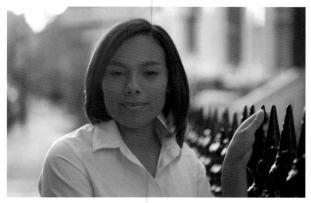 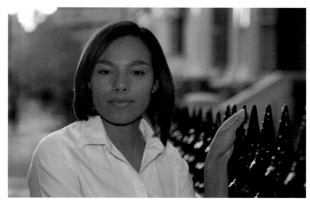

Figure 9-43
This strongly backlit photo is a great situation for automatic fill flash. Notice how E-TTL II has filled in the foreground without blowing it out badly, and without resulting in a flat cardboard cutout look.

E-TTL flash works in a similar fashion, though flash output may be lowered by as much as two stops when ambient lighting is bright. It does so in a more sophisticated fashion than TTL, since it examines each zone as lit by ambient and preflash to compensate for highly reflective areas. The E-TTL fill reduction algorithms have not been published.

Some mid to high-end EOS cameras allow auto fill reduction to be disabled by means of a custom function (see flash exposure compensation, sections 2.1 and 6.17). Any flash compensation applied manually is in addition to this auto fill flash reduction, unless of course it's been disabled.

9.13 Flash exposure bracketing (FEB)

The 500 EX series Speedlites and the two EX macro units all support flash exposure bracketing. This is similar to auto-exposure bracketing (AEB), only instead of changing ambient exposure settings the camera locks the shutter speed and aperture. Then it shoots a series of three photographs with

normal flash exposure settings, positive flash compensation, and negative flash compensation. ● *Figure 9-44*

Figure 9-44
Chrysanthemum taken with flash exposure bracketing: normal, minus 1 stop, plus 1 stop.

Bracketing values can be in half, third, or full stops, and the flash star icon may appear in the viewfinder during the sequence. FEB auto cancels once the three-photo sequence is complete and uses whichever drive mode the camera is set to. FEB can be used in conjunction with both flash exposure lock (FE lock) and flash exposure compensation (FEC).

9.14 High-speed sync (HSS)

Figure 9-45

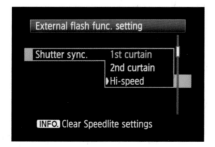

Figure 9-46

High-speed sync, described fully in section 7.12, is the ability of a flash unit to pulse rapidly in order to surpass a camera's flash synchronization limit (X-sync). HSS flash is turned on by a switch on some flash units, by pressing the + and − buttons simultaneously on others, and by pressing a high-speed sync/second curtain sync button on yet others. On newer units like the 430EX and 580EX II, pressing the HSS/second curtain button cycles through three sync choices: HSS, second curtain (if the flash unit is not in wireless mode), and normal first curtain. ● *Figure 9-45*

High-speed and second curtain sync are mutually exclusive options: the former involves continuous flash firing for the duration of an exposure, whereas the latter involves the flash firing once at the end of an exposure. Cameras with menu control over Speedlites can set HSS mode by selecting "Hi-speed" from the "Shutter sync" menu. ● *Figure 9-46*

HSS mode is indicated by the ⚡H symbol appearing on the flash unit's LCD or by an indicator LED. The mode is confirmed by the same symbol in the viewfinder. If this symbol does not appear but HSS is engaged on the flash unit, then the shutter speed is below the camera's X-sync speed.

When the flash unit is in HSS mode, it is possible to set a shutter speed higher than the camera's X-sync. The flash unit will revert to normal flash firing behavior if the shutter speed goes back down below X-sync. Canon Speedlites will remember the HSS mode setting and will switch back to it if the shutter speed is set beyond X-sync once more, but some third-party

flash units will inconveniently cancel HSS mode if the shutter speed drops below X-sync.

HSS mode typically results in roughly a third less range than normal flash. This may not be a problem with a powerful flash unit, but it could be a serious impediment when using a smaller flash unit, if the subject is far away, or if using a low ISO setting. Of course, if HSS mode is being used simply for a little fill flash rather than actual subject illumination, then this loss of range may be less of an issue.

HSS mode is tied to E-TTL technology and is only available with EX-series flash units on type A bodies. There was one exception: the EOS 1N film camera could be reprogrammed by Canon to add HSS mode, but no other E-TTL feature. No EOS popup flash supports HSS.

9.15 Enabling second curtain sync

Second curtain sync, described in section 7.13, records more natural motion trails of moving objects when using flash. Availability of the feature is entirely dependent on the specific camera/flash unit combination that's being used. Here things get a little complicated.

Physical controls on flash unit
Any Speedlite with its own physical controls can use second curtain sync with virtually any EOS camera. The type of control used depends on the model, but it is usually a button or switch marked with a triple triangle symbol or the word SYNC.

On the 430EZ and early EX models such as the 550EX, the + and − buttons must be pressed simultaneously to engage second curtain sync. On the 300EZ and 300TL, there's a small slide switch. On the 430EX, 580EX, and their Mark II versions, a button marked with the ▷▶ symbol is pressed to cycle through sync modes. Press once to engage high-speed sync (⚡H), press twice to engage second curtain sync, and press once more to return to normal first curtain sync. Second curtain sync can't be enabled if the flash unit is in any wireless mode.

Custom functions / menu items
Most midrange and professional EOS bodies from the early 1990s onwards have a custom function or menu setting that enables second curtain sync. If both the camera and the flash unit have second curtain controls, then the physical switch or button on the flash unit takes priority. These function/menu settings default to first curtain sync, and second curtain must be deliberately set.

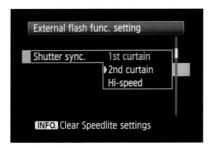

Figure 9-47

External Speedlite control

Later EOS digital bodies are capable of communicating with recent Speed-lites to enable a host of different flash unit settings, as detailed in section 9.29. Such cameras can control second curtain sync on compatible recent Speedlite models. Select "Shutter sync." and choose "1st curtain" or "2nd curtain". ● *Figure 9-47*

Unfortunately, on some camera models the "Flash control" menu item titled "External flash func. setting" cannot communicate with older flash units. A message will be displayed saying that an incompatible flash unit is attached; this means the flash unit doesn't support menu control, not that it's incompatible altogether. Since these cameras lack a second curtain sync custom function, a problem can arise.

In short, such cameras cannot engage second curtain sync when using older Speedlites that lack physical controls on the flash unit itself. It will only be possible to engage second curtain sync if the flash unit has physical controls, or if it's a recent model capable of full function control. See appendix C for a list of flash units and cameras that have this menu feature.

9.15.1 Second curtain limitations

Second curtain sync has a number of specific limitations. First, it can only be used in the "creative zone" modes: P, Av, Tv, M, B, DEP, and A-DEP. It can't be enabled in any icon mode, green rectangle mode, or CA mode. Second curtain sync is also incompatible with both stroboscopic and high-speed sync modes, and it cannot be used with wireless E-TTL. Second curtain cannot be activated if the shutter speed is faster than about 1/60 sec. Finally, second curtain sync does not work with all-manual flash units (see below).

9.15.2 Enabling second curtain sync with manual equipment

Canon EOS cameras can only support second curtain sync when using automated Speedlite flash units connected directly or via an off-camera shoe cord. When using sync-only manual flash, the camera cannot command a flash unit to fire when the shutter is about to close. This is because EOS cameras send the sync command digitally in second curtain mode, rather than simply triggering the hotshoe's center pin. The same issue affects sync-only radio triggers (section 11.10). Accordingly, second curtain sync will not work in sync-only situations unless the flash unit or radio trigger supports its own implementation of second curtain sync (PocketWizard and Quantum, for example).

Figure 9-48
This shot used wireless E-TTL from a 580EX master on the camera to trigger a 580EX II positioned above the model to light the falling water. However, because second curtain sync isn't possible wirelessly, the water drops look like they're falling upwards because the image was shot with first curtain sync.

There is one workaround, though it is a little inelegant and doesn't help with sync-only radio triggers. The trick is to use a Speedlite flash unit to trigger manual gear equipped with an optical slave. For this to work, the Speedlite cannot be in E-TTL mode because the preflash will set off the slave unit too soon (section 11.7.3).

The best solution is to use a Speedlite with manual output control. Set the Speedlite to second curtain sync and put it in M mode at a low power, such as 1/64 or 1/128. This will allow the flash unit to send a pulse of light bright enough to trigger a nearby optical slave unit, but not bright enough to contribute light to the scene. Even ancient EZ units can be put to use in this way. For example, the 430EZ doesn't support E-TTL, but it can fire in manual second curtain sync mode when used with a new EOS digital camera.

9.16 Manual flash

High-end Canon flash units support full manual mode, which lets output power be specified by hand rather than by an automated system like TTL or E-TTL. Note that manual *flash* metering is not the same thing as the *camera's* manual exposure (M) mode; the latter is used for ambient (non-flash) light metering. For more information, review the chapter on manual flash metering.

Flash output is specified in fractions, from 1/1 (full power) to the minimum power output setting, usually 1/64 or 1/128, depending on the model. Some units allow for additional sub-increments between these fractional settings. The sub-increments

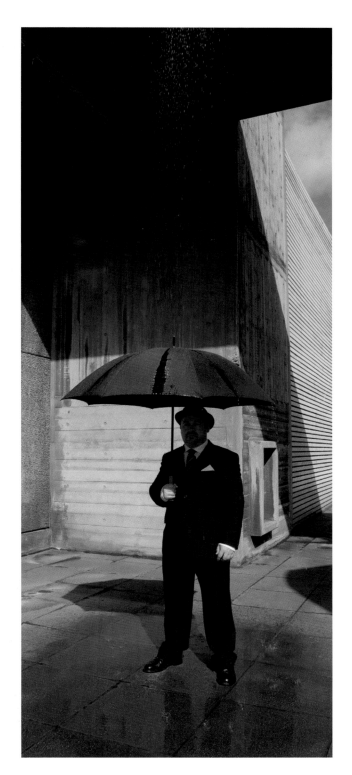

Figure 9-49

A 430EX set to 1/4 manual power with an additional minus 1/3 stop

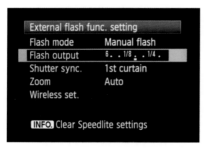

Figure 9-50

may be half a stop or one-third stop, and are particularly useful for the big drop in power between full power and 1/2 power.

Speedlite 420EZ

Press the MANU button to engage manual mode. Press MANU repeatedly to cycle through the manual power output settings.

Speedlites 430EZ, 540EZ, 550EX, 430EX, 430EX II

Press the MODE button to cycle through mode settings until the letter "M" appears on the LCD. To change output, press the SEL/SET button. The output setting will start to blink. Press the + or − buttons to increase or decrease the power. Press SEL/SET to confirm the change. ● *Figure 9-49*

Speedlites 580EX, 580EX II

Press MODE until the letter "M" appears, then press SEL/SET. The output setting will start to blink. Rotate the dial to increase or decrease the power. Press SEL/SET to confirm the change.

Flash units with menu control have on-screen sliders on the camera's LCD for adjusting manual output. One flash unit, the 270EX, is manual capable but only when used with an EOS camera that has menu controls built in. In other words, the 270EX lacks physical buttons to allow for manual control. ● *Figure 9-50*

With digital SLRs, it's easy to adjust manual flash settings by hand and conduct some simple lighting tests. The camera's preview screen is then used to evaluate the results.

9.16.1 Manual flash calculations

Since light output can be measured and falls off over distance in a predictable fashion, it's also possible to perform distance calculations by hand.

Speedlites with manual controls and rear LCD panels can perform these calculations automatically if desired. For completeness, these are the steps to do it, though frankly this functionality is rarely used by most photographers.

- Set the camera to either Av (aperture priority) or M (manual exposure) mode. The camera can be set to other "creative" zone modes, but the aperture symbol will flash to indicate a problem and the picture's flash metering will probably be out.
- Set the flash to manual mode, as above.
- Press the shutter button halfway. The flash will display the current aperture and a distance setting.

- If the camera is in Av mode, the shutter speed will be the camera's X-sync speed and the aperture can be set manually. In M mode, the shutter speed can be any value from 30 seconds to the camera's X-sync, and the aperture can be any setting within the physical abilities of the lens.
- Adjust the settings so that the distance information on the flash matches the number on the distance scale on the lens. If the lens lacks a distance scale, then the distance will have to be estimated or measured.
- Once everything's set correctly, the shutter release can be pushed all the way to take the photo, assuming the "flash ready" lightning bolt is displayed in the viewfinder.

The flash unit can't perform useful calculations if the flash head is in bounce mode—the calculations must be done manually by measuring the flash-to-subject distance. Remember that in bounce mode it's not the distance from the flash to the subject that's important; it's the distance that the light actually has to travel from the flash to the reflecting surface and then to the subject. Light loss from the reflecting surface must also be factored in, which can only really be done by experience or judicious use of a flash meter. The flash unit's guide number is measured in meters and for ISO 100. Additional arithmetic is required when using feet and/or a different ISO.

9.17 Enabling wireless E-TTL flash

Different models have different ways of entering wireless E-TTL, a mode described in detail in section 11.8. Canon identifies wireless E-TTL controls with a Z-shaped icon. The exact configuration of this icon depends on whether the unit is a slave, master, or capable of being both.

A Z with arrows on each end refers to a unit with master/slave capabilities. A Z with an arrow pointing *towards* the flash unit icon means slave mode, and a Z with an arrow pointing *away* from the flash unit icon means master mode. The white wireless icon is not to be confused with the blue PictBridge icon on some digital cameras, which looks very similar.

Master unit

Physical switches

The 420EX, 430EX, 550EX, and 580EX have a convenient physical switch, located at the bottom section of the unit, which reads either "OFF—SLAVE" or "OFF—MASTER—SLAVE". This switch makes it easy to move rapidly from mode to mode, which is of particular importance to news or wedding photographers who need to jump from on-camera flash to wireless flash immediately.

Slave unit

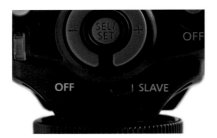

Figure 9-51

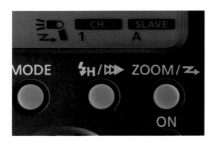

Figure 9-52

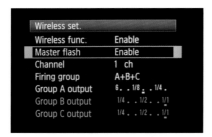

Figure 9-53

Confusingly, "OFF" means wireless mode off, not main power off—it should probably be labeled "SINGLE" or "SOLO" or something descriptive. When the switch is in master mode, the flash unit will send wireless control signals to slave units; when the switch is in slave mode, it will receive wireless command instructions. ● *Figure 9-51*

Push-button controls

The 430EX II and 580EX II, which have camera menu control over Speedlite functions, have a hidden and less convenient push-button control. Pressing and *holding* the "ZOOM/wireless icon" button for two or three seconds will cause the tiny wireless icon to blink. To change a 580EX II from master to slave mode, rotate the control dial after holding the ZOOM button. This allows mode selection. Press the SEL/SET button to confirm the choice. Pressing and holding the ZOOM button puts the 430EX II into wireless slave mode. ● *Figure 9-52*

This awkward push-button method takes a moment to engage and can thus be a problem in fast-moving situations. The ZOOM button is also tasked with controlling quite a few separate features—it would have been simpler for the user had a separate wireless button been added. However, the absence of a physical switch for engaging wireless means that camera menu control will stay in sync with the wireless settings on the flash unit.

Menu controls

Wireless E-TTL on the 430EX II and 580EX II can also be controlled by certain cameras using the flash control menu (section 9.29). The menu is a bit buried but offers a generally more intuitive interface. Nonetheless, these button and menu methods are slow to access, and many photographers still rely on a switch-equipped 550EX and 580EX as their on-camera master. ● *Figure 9-53*

Macro units

The MR-14EX and MT-24EX go into wireless mode when group C is enabled. This is done by pressing the RATIO button until "CH" appears on the LCD.

9.17.1 Changing wireless E-TTL settings

Once slave or master mode is engaged, the user interface for changing wireless settings is not the easiest Canon flash feature to understand. It also varies from model to model.

On flash units with LCD panels, wireless master mode is indicated on the LCD by the ✦z▐ icon or the word MASTER, with the number below CH indicating the current channel. Wireless slave mode is indicated by the word SLAVE, with a letter below SLAVE indicating the current group. On

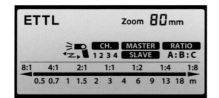

Figure 9-54

flash units without LCDs, groups and channels are indicated by LED lights.
● *Figure 9-54*

9.17.2 Changing channels and groups

Speedlite 420EX
There are separate buttons for changing channels and groups. Pressing each button cycles through the available settings, and an LED will illuminate to indicate the selection. The unit must be in wireless slave mode (the small switch near the flash foot) for these to work.

Speedlites 430EX and 430EX II
These units use the ZOOM button. When the unit is in slave mode, press the ZOOM button until either CH or SLAVE starts blinking. The + and − buttons are then used to select the appropriate channel or group.

Speedlite 550EX
Press the SET/SEL button to cycle through a series of options: flash exposure compensation/flash exposure bracketing/ratios/channels/groups/ master firing on/off. When the CH icon starts blinking, press the + or − buttons to change channels. If the flash unit is in slave mode, SET/SEL will allow the group to be selected. Pressing + or − changes the group, which is oddly marked by the SLAVE icon, not by the word GROUP.

Speedlites 580EX and 580EX II
Pressing (but not holding) the ZOOM button if the unit is in master or slave mode will cycle through a series of options. These options include: zoom setting/ratio (in master mode)/channel/master flash firing (in master mode)/group (in slave mode). If the CH or SLAVE symbols start blinking, turn the control dial to change channels or slave groups.

Macro lites MR-14EX and MT-24EX
These units change channels for external Speedlites in group C. To do so, press the recessed CH button to cycle through the four channels. Groups A and B are assigned to the left and right macro tubes in these units.

9.17.3 Enabling and changing ratios

Wireless E-TTL flash units can be in one of three groups, and it's possible to change the relative output levels of each group. Changing output ratios between the three flash groups is rather confusing and non-intuitive: the relationship between groups A and B is a ratio scale, whereas group C has an exposure compensation (+/−) relationship to groups A and B when taken as a unit.

Enabling ratios

On the 550EX, make sure the unit is in master mode, then press the SET/SEL button repeatedly and cycle through the choices (flash exposure compensation/flash exposure bracketing/ratio/channel/master firing) until RATIO starts blinking. Press +/– to select A:B ratios, A:B C ratios, or no ratios (OFF).

The 580EX and 580EX II have similar controls, only the ZOOM button, not SET/SEL, cycles through the modes (zoom/channel/master firing/ratio). Once "RATIO" starts blinking, rotate the control dial to enable or disable the three settings—RATIO A:B, RATIO A:B:C, and RATIO: OFF.

Figure 9-55
Ratio slider

8:1	4:1	2:1	1:1	1:2	1:4	1:8

The MR-14EX and MT-24EX are actually a lot easier to use, since they have dedicated "RATIO" buttons. Pressing this button once enables A:B (tube left and tube right), and pressing it again enables A:B C (tube left, tube right, and external Speedlite). Pressing it a third time reverts the unit to both tubes and no external Speedlite firing.

Changing A:B ratios

Once ratios are enabled on the 550EX, press the SEL/SET button repeatedly to cycle through the choices until both RATIO and the mark on the A:B slider start to blink (i.e., it isn't possible to adjust the actual ratio setting until the mark itself starts blinking).

On the 580EX or 580EX II, enable ratios as above. Then press the SEL/SET button repeatedly to cycle through the choices: flash exposure compensation/flash exposure bracketing/A:B ratio/C compensation.

Once the *mark* on the slider starts blinking, it is possible to adjust the A:B ratio on the horizontal output A:B display, ranging from a ratio of 8:1 to 1:1 to 1:8. Use the + or − buttons or the dial to move the mark position, indicating the ratio of A to B output. ● *Figure 9-55*

Again, the MR-14EX and MT-24EX are much easier to use, as they have ratio adjustment buttons in addition to a RATIO button. Once the ratio slider is on-screen, simply press the < and > buttons to adjust the slider mark.

Changing C compensation

First make sure that the "RATIO" choice is set to A:B C to enable all three groups.

On 500 series units, press SEL/SET repeatedly and cycle through the choices until "RATIO C" starts blinking. It is then possible to specify the number of stops of compensation for the C group relative to A and B, from −3 to 0 to +3 stops. This is done either by pressing the + and − buttons on the 550EX or rotating the dial on the 580EX or 580EX II.

On the MR-14EX or MT-24EX, use the + and − buttons to add or subtract group C compensation. To get this function once ratios are enabled, press SEL/SET repeatedly to cycle through the choices until "RATIO C" starts blinking.

Flash menu control

If a 580EX II is used on a camera with flash menu control (section 9.29), it's possible to set flash ratios in a much more intuitive fashion by using the on-camera menus. Somewhat inconsistently, the in-camera menu control describes ratios off as "RATIO A+B+C".

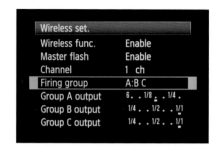

Figure 9-56

9.17.4 Specifying wireless flash output manually

In addition to automatic ratios, wireless E-TTL allows manual flash output power to be set for the three groups separately on all 500 EX units. To do so, press the master flash unit's MODE button until M is displayed. Then enable RATIOs as above. When the flash unit is in wireless mode but with manual metering, the RATIO function allows each of the three lettered flash groups to have its output set manually. This is set from 1/1 (full power) to 1/128, though unfortunately only in full stop increments. The group being set will have its letter underlined. When output power is set by hand, no automatic flash metering is performed.

Individual slave units can also be set to manual mode. The key is to switch the flash unit to slave mode, then press and *hold* the MODE button until M appears. It's even possible to set a wireless slave to MULTI (strobo-scopic) mode this way; additionally, 1/2 or 1/3 stop increments are possible on slave units.

9.17.5 Master flash firing on/off

A 500 series master unit can be instructed not to fire (i.e., not to contribute any scene-illuminating light) while still controlling remote slave units.

On the 550EX, press the SEL/SET button repeatedly and cycle through the options until flash on/off is selected. This is indicated by a blinking icon showing the flash unit emitting light. Press the +/− buttons to change this setting to ON or OFF.

On the 580EX/580EX II, press the ZOOM/⚡ button while the unit is in master mode. The word "ON" and the tiny "flash emitting light" icon should blink on the screen (Figure 9-57). Turn the control dial so that the word "OFF" (it looks a bit like "0 FF" on the 580EX) blinks instead.

While the master unit won't contribute any light to the scene when off, it will still fire a visible preflash to tell the slave units what to do.

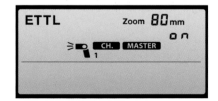

Figure 9-57

9.18 Integrated Speedlite transmitter, or built-in flash as master

Most EOS cameras with popup flash units can't use them as masters in a wireless situation. This has long been a competitive drawback, since the feature is available to many other camera systems. So with the 7D, Canon brought the feature, called an integrated Speedlite transmitter, over to the EOS line. ◉ *Figure 9-58*

At time of writing, the 7D is the sole EOS body capable of controlling wireless slaves without an additional master flash unit, but it seems likely the function will be implemented in future bodies as well.

Figure 9-58

9.18.1 Built-in flash to control one group of slave units

◉ Turn on the camera's built-in flash by pressing the ⚡ popup flash button next to the lens mount. ◉ *Figure 9-59*
◉ Turn on the camera's menu system and select "Flash Control".
◉ Make sure that "Flash firing" is set to "Enable". If it's not, wireless E-TTL won't work. ◉ *Figure 9-60*
◉ Select the "Built-in flash func. setting" menu.
◉ Make sure that "Flash mode" is set to "E-TTL II". It can be set to "Manual" if all-manual wireless flash is desired, but wireless will not work in "MULTI" (stroboscopic) mode. ◉ *Figure 9-61*
◉ Select the "Wireless func." menu item and set it to ⸙🔦. This option will fire remote slave Speedlites, but the built-in flash unit will not contribute light to the scene. ◉ *Figure 9-62*
◉ Choose the desired channel from 1 to 4 using the "Channel" menu item. All slaves have to employ the same channel.
◉ Turn on the slave units and position them as required.
◉ Press the ⸙🔦 button to fire a test flash.
◉ Take the photograph.

Figure 9-59

Figure 9-60

Figure 9-61

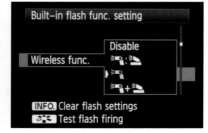

Figure 9-62

9.18.2 Built-in flash and ratios

- The 7D has full ratio support, using the traditional A:B ratio with a separate group C.
- Enable wireless E-TTL as above.
- Choose the desired ratio type from the "Firing group" menu item.
 ● *Figure 9-63*
- If the firing group is set to "A+B+C", then all slave units will fire simultaneously regardless of which group they happen to be in, so long as they're on the same channel.
- If the firing group is set to "A:B", then a ratio between slaves in groups A and B can be set using a slider named "A:B fire ratio". When the marker on the slider is to the left side (e.g., 4:1), then group A will be brighter. If the marker is to the right (e.g., 1:4), then group B will be brighter.
 ● *Figure 9-64*
- If firing group is set to "A:B C" then exposure compensation can be applied to group C as well. ● *Figure 9-65*

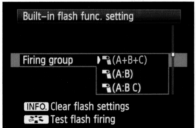

Figure 9-63

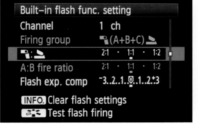

Figure 9-64

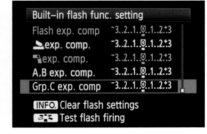

Figure 9-65

9.18.3 Enabling built-in flash to light the scene

The popup flash unit can be set to light the scene as well as to act as a wireless master. However, there is a significant limitation.

When the built-in flash is firing wireless E-TTL commands off to the slave units, it's obviously depleting its capacitor. Since there isn't enough time to recharge the capacitor between issuing wireless commands and the scene-illuminating pulse, there will be considerably less power available to the built-in flash unit. The maximum guide number will drop from 12 to about 4. This limits the built-in flash to adding a catchlight to the subject's eyes or a similar function.

- To allow the built-in flash to contribute light to the scene, choose the appropriate option from the "Wireless func." menu. It's possible to select ⌐ for slave Speedlites only, or two options, including the ⌐ icon, indicating built-in flash.

9.18.4 Wireless all-manual flash

- If "Flash mode" is set to "Manual", then the 7D is capable of using full manual output control for up to three groups of slave units. E-TTL metering is not used.
- If "Wireless func." is set to just ꒳🔦, then all remote slaves will fire at the same power.
- The output power is set via the "flash output" slider. Output values can range from 1/1 (full power) all the way to 1/128. The actual output setting depends on the physical capabilities of the slave unit in question—not all Speedlites can go all the way to 1/128.
- If "Wireless func." is set to ꒳🔦 **(A,B,C)** then up to three separate groups of slave units can be used. The output of each group is adjustable using three flash output sliders. ◉ *Figure 9-66*
- If "Wireless func." is set to ꒳🔦 🔦, then the output of all slaves can be set as one group. The output of the camera's popup flash unit can also be set independently.
- Finally, if "Wireless func." is set to ꒳🔦 🔦 **(A,B,C),** then the output of each of the slave groups and the output of the camera's popup flash unit can be set independently.

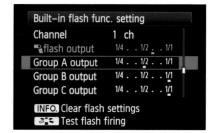

Figure 9-66

9.19 Advanced M (metered manual) ambient metering

In manual exposure mode, the aperture and shutter speed are both set by the photographer, and these exposure settings combined with the camera's ISO or film speed determine how the background (ambient lighting) is exposed. The subject, however, can still be illuminated by the automatic flash metering system since the flash will automatically calculate output levels using TTL or E-TTL metering.

This is how flash works in manual mode. Note that this means the manual exposure mode setting only, which can use automatic TTL flash metering (it will not use A-TTL metering in manual exposure mode). Also, it doesn't refer to setting the output of the flash manually—that's manual flash and a different topic altogether.

- Set the camera to M for manual exposure mode.
- Set the aperture and shutter speed to expose the background correctly.
- Press the shutter button down halfway if the flash unit has a rear-panel LCD, and the flash coupling range will appear. This range is the distance that can safely be covered by the flash. Note that this only works with direct flash. The coupling range is not calculated when using bounce flash, and the range won't necessarily be correct if there's a diffuser on the flash head.

- If the lens has a distance scale, check the current focusing distance to ensure that the distance to the subject falls within this range. Otherwise an estimate is needed.
- If the "flash ready" lightning bolt symbol appears in the viewfinder, press the shutter all the way to take the photo. The flash's TTL or E-TTL system will determine the flash exposure level of the subject.

9.19.1 Meters and feet

The 430EZ was sold in two versions: one in feet for the U.S. market and one in meters for the rest of the world. The distance unit types can't be altered.

The 540EZ and 550EX can display the coupling range in either feet or meters, as determined by a tiny switch in the battery compartment.
● *Figure 9-67*

0.5	0.7	1	1.5	2	3	4	6	9	13	18	m
1.7	2.3	4	5	7	10	15	20	30	40	60	ft

Figure 9-67

The 580EX has a hidden unit-changing feature: press and hold the C.Fn button until "C.Fn" appears on the LCD, then press and hold the center dial button until the units blink on the screen. Use the dial to change units.
● *Figure 9-68*

The 430EX II and 580EX II set measurement systems through the custom function 0, which is also available via the menu system on compatible cameras.

Figure 9-68

9.20 Quick Flash / Rapid-fire mode

Electronic flash units work by charging up a capacitor with electricity, then releasing the stored-up power in a split-second burst of light. The charging process, or "recycle time", takes up to a few seconds on larger units. This can be a problem if several flash photos have to be taken in fairly rapid succession, such as at a wedding.

Many EOS flash units have the ability to be triggered even if not fully recharged, on the theory that there are times when it's better to take a photo without a full flash charge rather than have the flash not fire at all. Flash units capable of this feature have a two-color flash ready ("pilot") light. If the light is red, then the flash is fully charged. If it's green, then the flash is only partially charged but will still fire anyway. The feature is known as Quick Flash or Rapid-fire, depending on when the model was made.

Figure 9-69

This graph shows how a Speedlite will stretch out the flash duration to make up for decreased charge. The example here is at 1/8 power output.

Quick Flash is quite useful. Without it, it's all too easy to take two photos in succession only to find that the flash unit didn't fire on the second shot, which would be completely underexposed.

If a flash unit is fired when not fully charged, it will attempt to lengthen the time period over which the flash pulse is emitted in order to compensate for the lowered output. If this can't be done then its light output will be lower than expected.

Quick Flash will not work if the camera is in continuous shot mode (unless the flash unit has a custom function permitting this to work). It also won't work if the flash is in manual mode at full or half power, in FEB mode, or if the camera is in stroboscopic flash mode at a fairly fast setting. The 430EZ does not work in rapid-fire mode if an external battery pack is used.

9.21 Stroboscopic (MULTI) flash

In "stroboscopic" or "MULTI" mode a 400 EZ series or 500 series flash unit can emit brief rapid pulses of light over the course of an exposure. This permits multiple moments of motion to be captured on a single frame. This type of photography is detailed in section 15.8.

To engage stroboscopy, press the flash unit's MODE button and cycle through the choices until MULTI is displayed on the LCD. This mode is possible with a wireless E-TTL slave unit; the key is to press and hold the MODE button if the unit is performing as a wireless slave.

There are a number of parameters which can be set by pressing either the SEL/SET or MULTI buttons, and then pressing the + or − buttons or rotating the input dial, depending on the model. The settings are as follows:

- The frequency of flashes to be fired per second, specified in Hertz, abbreviated to Hz. 20 Hz means, for instance, that 20 separate pulses of light will fire per second.
- The power output of each burst as a fraction of full power. 1/4 power cannot be exceeded in stroboscopic mode because of the risk of the flash head overheating.
- 500 series units can specify the total number of flash bursts to be fired within pre-programmed safety limits. On a 400 series unit the number of bursts must be calculated by hand from the shutter time and the flash frequency. ◉ *Figure 9-70*

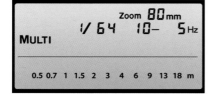

Figure 9-70

When using a 500 series flash unit, the coupling range on the back panel LCD will change as the camera's aperture is adjusted. Adjust the flash unit's power output, the lens aperture, and the camera's ISO (if using digital) so that the coupling range matches the distance to the subject.

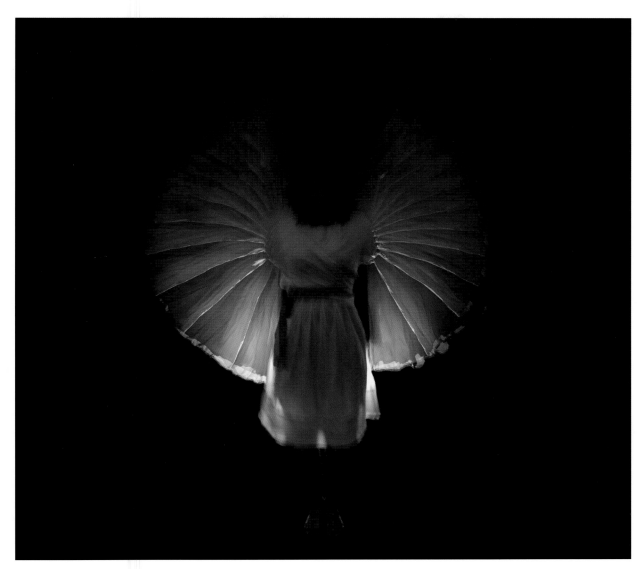

Figure 9-71
A backlit shot. The model raised her arms slowly as the flash unit pulsed light at 5 Hz.

It takes experimentation to determine the ideal number of light pulses to cover the action and the output settings required to expose the subject correctly. Shutter times in seconds can be calculated by taking the total number of flashes and dividing them by the flash frequency. See the final chapter of this book for stroboscopic examples. ● *Figure 9-72*

Consult the flash unit's manual for a table of the total number of flash bursts possible at each frequency/power setting, since each model has

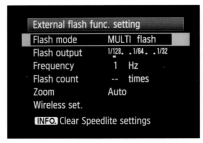

different capabilities. For instance at 1Hz, most 500 models will fire 7 consecutive bursts at 1/4 power, but 100 at 1/128 power. If the number is set to "– –" then the flash unit will fire continuously up to its preset limit, which again varies by model. Note that the 580EX and 580EX II have more conservative restrictions than the 540EZ and 550EX in this regard. The safety limits are there to minimize the risk of damage to the flash head from overheating caused by firing too many stroboscopic sequences in a row.

The EOS 7D can perform stroboscopic flash using its popup flash unit, but the feature is fairly limited due to the low power output of the internal flash.

Figure 9-72

9.22 Flash exposure confirmation LED

Not to be confused with flash exposure compensation, a confirmation light is an LED on the back of most Speedlite flash units. On some units it's labeled "Auto Check", though on most it's not labeled at all. It illuminates for two or three seconds, post-exposure, to confirm that there was sufficient light from the flash to illuminate the subject. Unfortunately, EOS cameras do not have such an indicator in their viewfinders.

The LED will glow even if the image was overexposed, so it's not a guarantee of good exposure. It only indicates that the photo was not underexposed due to being out of range. ● *Figure 9-73*

Figure 9-73

9.23 Range warning

The earliest EOS film bodies (630, 1, RT) could blink the shutter speed and/or aperture values in the viewfinder if the foreground subject was too close to or too far to be illuminated by flash. All other models lack this warning for patent reasons.

The FE lock feature with type A bodies also has a range warning. If the lightning bolt in the viewfinder blinks when the FE lock button is pressed, then there isn't enough flash output to illuminate the subject correctly.

9.24 Modeling flash

Large studio flash units usually have incandescent tungsten bulbs built in alongside the main flash tube or tubes (section 13.2.2). These constant-light bulbs cast light on the subject in much the same way as the actual flash tube would, only much more dimly. This constant light is known as a modeling light, as it allows the effect of the flash to be previewed in

a rough fashion. Flash shadows and reflections can be determined in this way.

The Canon modeling flash simulates the effect of the flash going off before the picture is taken—particularly useful for previewing wireless E-TTL flash ratios. It works by pulsing the flash rapidly (about 70 Hz) for a second, much like high-speed sync mode. This obviously drains the batteries and can overheat the flash unit if triggered repeatedly, so it's best used sparingly.

Speedlites lack a button to activate the feature. Instead, pressing the camera's depth of field preview button fires the modeling light, though this can be turned off with a custom function if it's inconvenient (figure 9-74). Some units must be in wireless slave mode for the modeling light to work. Both a camera and a flash unit that can support modeling flash are needed to use the feature, and the camera must be in a creative zone (letter) mode. Modeling flash won't fire if the camera is in an icon mode or if a digital camera has Live View enabled.

On most cameras, the depth of field button is a small, unmarked button next to the lens mount, positioned immediately below the lens release button (i.e., on the left side of the camera body when looking through the viewfinder). However, for some mysterious reason, the button is located on the opposite side of the lens mount on EOS 1 series cameras. ● *Figure 9-75*

Canon's ring flash units contain small white incandescent bulbs for focus assist and modeling purposes, but these are separate bulbs, not a pulsing of a flash tube.

9.25 Auto Power Off / Save Energy (SE) mode

Most Speedlites turn themselves off (also referred to as "Save Energy" or "Energy Conservation Control") after a set period of time, usually 90 seconds or five minutes, in order to minimize battery drain. Some flash units are always in this mode when powered on.

However, since it can be annoying to have a flash unit turn itself off in the middle of setting up a shot, the ability to override SE mode is very important for wireless flash applications. Accordingly, some Speedlites such as the 550EX have a three-position switch (shown here): off, on, and SE. ● *Figure 9-76*

Additionally, models like the 580EX have custom functions (section 9.28) that extend the time before SE renders the flash quiescent. Many models have a longer timeout period if in E-TTL slave mode.

Pressing the flash unit's test button or the camera's shutter release button down halfway will wake up the flash and recharge it. When using an N-3 equipped EOS camera with the TC-80N3 timer/remote controller, the intervalometer on an EOS 10/10s, a 600-series camera with the Technical

Figure 9-74

Figure 9-75

Figure 9-76

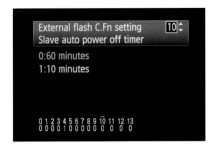

Figure 9-77
Auto power off menu

Figure 9-78
The autoflash sensor is the small round opening on the front of the 580EX II's AF assist panel. It has a coverage angle of approximately 20°.

Back E, or an EOS 1 or 1N with the Command Back E1, the camera will wake up the flash unit a minute or so prior to taking a photo in order to give it time to recharge. ● *Figure 9-77*

9.26 Speedlite autoflash / External flash metering

As discussed earlier in the book, autoflash is a form of flash metering that predates through the lens (TTL) flash metering. The flash unit has a sensor on the front that detects the amount of light reflecting back from the scene being photographed and uses that information to control flash output.

Though seemingly very primitive—easily fooled and incapable of distinguishing between a reflective object nearby and a highly reflective object farther away—autoflash nonetheless can achieve quite good results. Note that the term "autoflash" is sometimes used generically to refer to any form of automatic flash metering, but this book uses the term to mean *automatic flash metering performed by the flash unit itself, and not by the camera.*

Most Canon Speedlite flash units do not support autoflash, with the 480EG and 580EX II being the two exceptions. Autoflash only works on the 480EG if the camera is connected to the flash unit via its PC connector (SYNC socket). The 480EG always uses TTL if the flash is connected via the six-pin hotshoe cable.

9.26.1 580 EX II autoflash

The 580EX II is somewhat complex to use in autoflash mode, which its manual cryptically refers to as "external flash metering". It has two forms: automatic and manual, both engaged by a custom function. Note that when the 580EX II is in autoflash mode, the flash unit's LCD will display either "E" (automatic) or "EM" (manual), and E-TTL metering is disabled.

Automatic external flash metering works only with cameras containing DIGIC III and newer processors, as listed in appendix C. To engage it, set custom function 5 to setting 2. The camera will then feed the current ISO and aperture settings to the flash unit, which performs its autoflash calculations based on that data. However, the flash unit will not fire if it's on an older camera that cannot return ISO and aperture data to the flash unit. ● *Figure 9-79*

To engage manual autoflash, set custom function 5 to setting 3. This mode requires manual input of the ISO and aperture settings. To do this, press the SEL/SET button and enter the appropriate data via the control dial. Manual autoflash mode is compatible with all EOS cameras. Bracketing (FEB) and flash exposure compensation are not possible with autoflash.

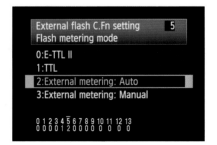

Figure 9-79

Cameras with flash menu systems can also engage autoflash in a more straightforward fashion.

9.27 Optical slave triggers

No Canon Speedlite has built-in optical slave functionality, as opposed to wireless slave functionality. However, the 480EG has a slave socket into which a tiny optional optical sensor, the Slave Unit E, can be plugged. This unusual accessory transforms the 480EG into an optical slave unit which will fire in response to another flash unit firing, but which cannot meter automatically. Some third-party flash units, such as models sold by Sigma and Metz, also support the feature.

For more details on optical slaves, see section 11.7.

Figure 9-80
Slave Unit E for the 480EG.

9.28 Custom functions (C.Fn) on flash unit

Some EX Speedlites have custom functions much like those found on camera bodies. These "functions" (settings or options, really) allow the behavior of the flash units to be altered in certain ways. For example, there are custom functions that switch from E-TTL to TTL flash metering, or which disable the AF assist light. If any custom function is set to a non-default setting then the "C.Fn" icon (or "CF" on older units) will appear on the flash unit's LCD.

Custom functions cannot be set if the unit is in wireless mode, either slave or master.

To alter a custom function, press and hold the "C.Fn" button until "C.Fn" appears on the LCD. Use the +/− buttons or the rotating dial to select a function, and press SEL/SET (or the dial's button) to change the function. When the function information starts to blink, select the function setting and press SEL/SET again. Press MODE to exit the custom function mode. Custom function settings are memorized by the flash unit even when it's turned off. Flash custom functions cannot be set when a camera is in Live View mode.

There is rough consistency between custom functions across later Speedlite models, which is why some units may have certain numbers missing in their selection of custom functions. For example, the 430EX II lacks custom functions 3 through 6, as well as 12 and 13, so that its function numbers match those found on the 580EX II. A full list of flash unit custom functions is included in appendix D.

No current Speedlite has a screen capable of displaying dot matrix text, and so custom functions are not described textually on the flash unit's LCD. However, cameras and flash units with external Speedlite control

Figure 9-81

(see below) have the ability to set flash custom functions through an easy-to-read, full-text menu system. Such cameras can also clear (reset to default settings) the functions on compatible flash units.

9.28.1 Resetting default settings

Some cameras have a button marked CLEAR, or a "Clear all camera settings" menu item, which resets the camera's internal settings to factory defaults. If certain Speedlites are connected and powered on, then performing a "clear' on the camera will also reset the flash unit's internal settings. Custom functions are not reset.

9.29 External Speedlite control

Figure 9-82

Figure 9-83

EOS cameras with DIGIC III and newer processors (appendix C) are able to control certain features of compatible flash units through on-screen menus. When such combinations are used, the option "Flash control" or "External Speedlite control" appears in the camera's menus. ● *Figure 9-82*

If an older Speedlite or a non-Canon flash unit that does not support menu control is attached, an error message will appear. Note that the message only means that the flash unit is not compatible with menu control—it doesn't necessarily mean that the flash unit isn't compatible with EOS cameras. ● *Figure 9-83*

Features that can be controlled from the camera's menus vary from one camera/flash unit combination to another, but include flash mode, first or second curtain sync, FEB (bracketing), FEC (compensation), flash metering, flash firing, manual power output, autofocus assist, and custom functions in full-text form. Even control over such elaborate functions as configuring wireless E-TTL is possible, and in fact the wireless control menus are notably easier to use than the on-flash controls themselves. The menus also allow for configuration of internal flash units on those cameras that have them.

Note that FEC on the flash unit's external controls will take priority if both are set. In terms of custom functions and the like, the flash unit will use whatever setting was last set. Certain camera bodies may need firmware updates to enable full control of recent Speedlite models. The pulsing AF assist light feature of the Speedlite 270EX, for example, requires an update for some camera models, and can only be enabled on cameras with flash menu control.

The feature is sometimes described in printed manuals under the long-winded, yet accurate, name "Speedlite Control with the Camera's Menu System". Consult appendix C, which lists the cameras and flash units that support the function.

9.30 Test flash (manual firing)

Pressing the illuminated "PILOT" light on the back of most Speedlites will fire a test burst, whether on-camera or not. Most flash units will fire at full power, but some have a custom function that allows for a 1/32 low-power burst instead. ● *Figure 9-84*

Speedlites with Quick Flash/Rapid Fire have a two-color LED behind a transparent button. This button will glow green if the unit is charged up enough to fire a partial flash, and red if it's fully charged and able to perform a full-power flash.

The pilot button is also used for waking a sleeping flash unit that's gone into Save Energy mode (section 9.25). If the flash unit is a master wireless E-TTL device, it will command a slave flash unit to fire wirelessly. Of course, the test flash button can also be used for open flash techniques.

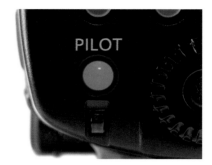

Figure 9-84

9.31 Rear control dial

The 580EX and 580EX II have a rear-panel control dial that can be used for quick and easy control of various settings, such as flash exposure compensation. The dial is activated by pressing the center button. Rotating the dial left or right changes the current settings, and pressing the center button again confirms the settings.

These units also have a custom function which allows FEC to be changed by simply rotating the dial, rather than by pressing the dial's button first and then rotating it. ● *Figure 9-85*

Figure 9-85

9.32 Weatherproofing

All recent Canon professional series cameras and lenses have flexible rubber gaskets around every opening and seam. These weatherproofing seals don't transform the gear into waterproof equipment suitable for diving, but they do repel moisture, dust, and dirt. There is a difference between "weatherproof" and "waterproof".

The 580EX II also has weatherproofing around all seams and connections. However, while many pro-level EOS bodies are weatherproofed, only certain later cameras have a gasket around the hotshoe that can mate with the gasket on the flash unit's foot. ● *Figure 9-86*

The 580EX II's gasket can, incidentally, be installed on the 430EX II. However, it does apply additional pressure to the camera/flash unit connection. If a flash unit is behaving erratically, you might try removing the gasket to see if it improves.

Figure 9-86

With the release of the 580EX II, Canon also updated a number of flash accessories to have similar levels of weatherproofing. The CP-E4 battery pack (section 12.12.1) and the Off-Camera Shoe Cord OC-E3 both have rubber gaskets. The SB-E2 bracket (section 12.10.07) has had its cord replaced with the OC-E3.

9.33 Automatic white balance compensation

The color temperature of a flash tube can vary subtly depending on its precise voltage and pulse duration. The more recent Speedlite EX flash units can monitor battery power levels and communicate with compatible digital cameras to compensate automatically for slight variations in color temperature. For this to work, the camera has to have its white balance set to automatic (AWB) or flash modes. There is no indication of this function on an external control panel—it occurs silently and automatically.

Cameras that support the feature have the phrase "Color temperature information transmission: Provided" or something similar noted in the White Balance section of their Specifications list in the manual. Also, consult appendix C.

9.34 Live View, silent shooting, and flash

A camera's Live View mode, which allows for a live display of video from the sensor chip straight to the back panel LCD (or to a TV set), can cause complications for flash on certain models. E-TTL flash metering occurs when the shutter is closed and the mirror is down because the evaluative light sensor is located inside the prism assembly. But in Live View mode, the shutter is open and the mirror is up so that the camera's image sensor can be exposed continuously to light.

Consequently, a flash photo taken in Live View requires an extra step: the mirror must flip down so the E-TTL preflash can fire, and then the mirror must flip up again for the Live View image to be captured while the subject-illuminating flash is fired. A camera taking a flash photo in Live View mode will make two clicking noises, even though only one picture is taken.

An additional problem is the Silent Shooting mode. In this mode, the camera turns on the image sensor to begin an exposure, a technique known as electronic first shutter, rather than opening the mechanical shutter. Because of timing issues with the CMOS chip architecture, it then closes the mechanical shutter to end the exposure. However, E-TTL flash requires a preflash to be fired with the mirror up, eliminating the usefulness of an electronic first curtain shutter. For this reason, EOS cameras with Silent

Figure 9-87

Shooting will disable the feature when a Canon Speedlite or compatible flash unit is attached and turned on. Since Speedlites can communicate electronically with the camera, it's possible to sense their presence. ● *Figure 9-87*

Cameras with Live View Silent Shooting (see appendix C) do not send sync commands to the PC port or the hotshoe when a non-Speedlite flash unit is used. Therefore, when using a third-party flash unit, such as a studio flash unit, disable Silent Shooting or else the flash won't fire.

Finally, the 500D cannot fire non-Speedlite external flash units when Live View is engaged. ● *Figure 9-88*

Figure 9-88

9.35 Cycle time and high voltage ports

Flash units operate by storing up energy in a capacitor or capacitors, then releasing the power through the flash tube in a burst of light. It takes time to recharge the capacitor, a period known as the cycle (or recycling) time, and which is often accompanied by the rising high-pitched whine of the charging circuitry. The cycle time can range from a fraction of a second to several seconds, depending on the design of the flash unit and also, in the case of battery flash units, on the power level of the last flash burst.

Most battery-powered flash units will only completely discharge (empty) the capacitors when firing a full power burst. When firing a lesser burst, the circuitry cuts off the power to the flash tube after the desired output has been achieved, thus retaining energy in the capacitor. Accordingly the cycle time will be shorter with a partial flash discharge than with a full power burst. (This is not the case with most studio flash units, which adjust flash output by power and not pulse duration.)

Many professionals covering rapid-fire events such as weddings and sports need as short a cycle time possible. They can't risk a lost shot while the flash ponderously charges back up. Unfortunately, most Speedlites are driven by four modest AA cells—not exactly powerhouse technology. Accordingly, there are external battery packs available that reduce the cycle time dramatically (section 12.12).

Canon equips its high-end flash units with high-voltage sockets. These allow external packs to deliver additional high current directly to the flash circuitry, keeping cycle times low. However, the flash unit still needs its AA batteries to work, since the AAs also power the flash unit's digital control circuitry. The high-voltage port simply drives the flash tube output.

The 580EX and 580EX II also have a custom function that controls whether the flash tube is fed power only from the battery pack, or from both the battery pack and the built-in AAs. The former is probably recommended, since recycle time is about the same with either setting, but the flash unit is more useful if its internal batteries aren't drained.

10 Manual Flash Metering

The automatic flash metering technologies described in the previous chapters are quick and easy to use, and are ideal for casual snapshots or quickly changing situations such as those found in photojournalism. But, while computers excel at performing rapid calculations governed by complex software programs, they aren't very good at making artistic judgment calls. Automatic flash metering systems are designed to create flat, even results, which aren't necessarily ideal for every photo.

Figure 10-1
This photo was taken in a simple studio setting. Exposure on the camera was in manual mode, set to 1/50 second at ƒ/5.6. A single Bowens Gemini monolight in a medium-sized softbox, positioned camera left, was used. For more details on these items consult chapter 13: studio photography.

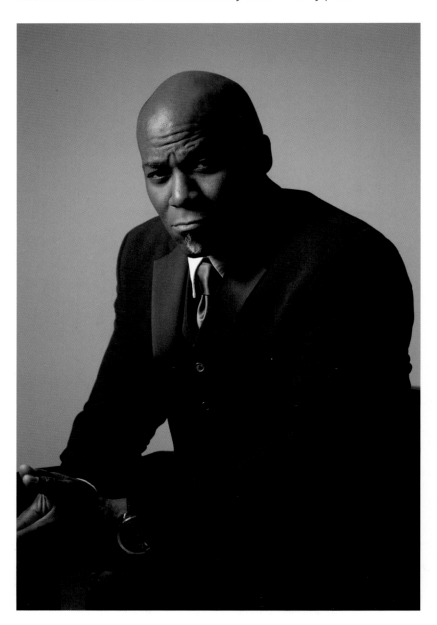

Automatic systems are designed to measure light which is *reflected* off flash-illuminated objects. If light from a flash unit is directly visible—perhaps because a unit is pointing towards the camera or light is reflecting off a shiny surface—then automatic metering will be thrown off and the scene will probably be quite underexposed. This is particularly a problem with on-camera flash when there's a mirror in the frame, or with off-camera flash.

For these reasons, ultimate control over lighting is achieved by using manual flash. "Manual" is quite literally that: the output level of each flash unit is set directly by the photographer, and no automated metering systems are employed. This can be done through use of a handheld flash meter or empirical testing. The flash units are carefully positioned to light the scene, usually augmented with various light modifying devices such as reflectors, umbrellas, or softboxes.

In a sense, manual flash involves stepping back in time to the era when sync (timing of the flash with the shutter opening) was the only real control that the camera had over the flash unit. With automatic flash, the brightness of the flash unit is determined by the camera. With manual flash, it's determined by the photographer at the flash unit.

This sounds daunting, but many developments over the past few years have contributed to the technique's resurgence in popularity.

10.1 Manual flash metering

Manual flash metering is not an obvious technique to master because the effects of a brief pulse of light can't be visualized by the naked eye. Moreover, the ambient light meters built into all EOS cameras can't be used for manual flash metering since they are not designed to do so.

There are essentially two ways of determining correct flash exposure without using automated flash: trial and error, and flash meters.

10.2 Trial and error

This is simply the process of taking a photo, examining the results, then adjusting the flash output by hand. Repeat until good results are obtained.

In the days of film this was an impractical method, since regular film took a lot of money and time to develop and print. Professionals working in a studio would often shoot Polaroid instant photos (frequently using interchangeable Polaroid backs on their cameras) to test out lighting situations, but this was more for testing lighting quality, not for metering.

In today's digital world, trial and error is actually a straightforward and workable option, even though it initially sounds a little crude as a technique.

10.2.1 Manual flash in a digital age

The arrival of digital technology has completely changed everything. Digital cameras boast preview screens, histograms, and EXIF shooting data, all of which simplify manual flash dramatically. It's now possible to tell within a second whether a given manual flash setup has worked or not. If it hasn't, it's easy to fix and reshoot. The feedback loop has been tightened, transforming the technique.

Figure 10-2
A photo taken using two Bowens Gemini R studio flash units, powered by a Travelpak battery. No flash metering was used; output levels were set by hand based on experience and judicious examination of the camera's preview screen.

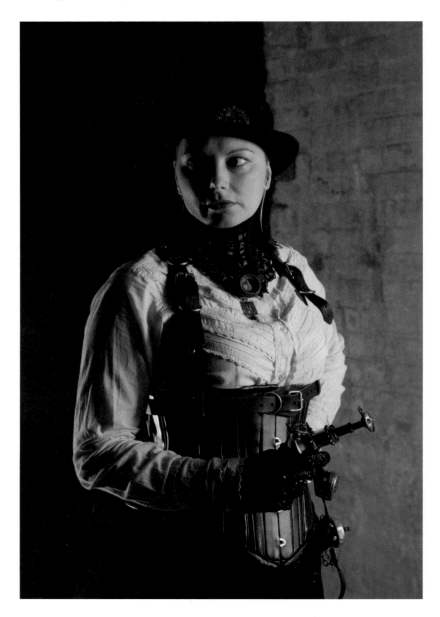

Consulting a camera's LCD after a shot (jokingly known as "chimping") is easy to deride. But it has opened the doors to countless photographers who wouldn't have learned manual flash techniques so easily before. Indeed, this sort of light metering technique may offend photographers trained in traditional methods, since it can be a bit of an intuitive hit and miss. On the other hand, it's also straightforward and effective, even if the photographer may not completely understand the specifics of how flash works. With time, an experienced photographer will learn the most likely flash levels required to illuminate a given scene, and will only need a test shot or two to hone the settings. ● *Figure 10-3*

Figure 10-3

The Internet has also been a driving force in the changing destiny of manual flash metering. In early 2006, photojournalist David Hobby started a modest photographic blog, Strobist.com, which he used as a teaching tool for getting beginners to take their flash units off their cameras. Within a couple of years, the site had become the hugely popular central hub for learning about and evangelizing off-camera flash photography, typically using affordable battery-powered flash units. Now "strobism" is often used to refer to the field in general.

10.2.2 Digital histograms

Histograms are an invaluable tool for determining correct exposure for either ambient or flash-lit photographs. All digital EOS cameras can display these small charts next to an image on the camera's preview screen. The chart can indicate brightness (black and white) or RGB (color)

information, and can show the frequency of occurrence for each pixel level in the image.

Camera histograms are simple bar charts with each bar showing the frequency of a given range of brightnesses—dark to the left and bright to the right. A histogram skewed to the left is a dark image, and a histogram skewed to the right is a bright image. Analysis of a histogram is a sophisticated way to determine how well an image has been exposed. An image with a lot of bars on the left side might require more illumination, for example. Or an image with a number of bars lined up on the right side might be heavily overexposed and blown out.

Figure 10-4
A very dark image. The histogram clearly shows that the bulk of the pixels making up the photo are over to the left, or dark, end.

Figure 10-5
A lighter image. The histogram indicates that a fair number of pixels are essentially pure white, with some midtones (skin color) and dark areas (hair).

10.3 Flash meters

The traditional tools for measuring flash output with control and precision are flash meters. These are handheld devices that can measure the brief pulse of light from a flash unit. They're not inexpensive, but they are an essential tool for studio professionals who need to assure repeatable and accurate results. Flash meters may be overkill for the average hobbyist, but it's useful to know how they work.

A common mode of operation for studio flash is shown in figure 10-6. The meter is held close to the model's face while a test flash is fired. The white dome on the top of the unit picks up the light from the flash, ignoring ambient light levels. This is known as incident flash metering and differs from the reflective meters used inside SLRs such as the Canon EOS line.

Reflective meters, like those in a camera's viewfinder assembly, measure light bouncing back from a subject. Since reflected light has to travel back to the camera from the subject, distance comes into play (see the inverse square law, section 7.14). A highly reflective object far away may meter the same as a darker object closer up. Also, since reflective meters are designed to average everything out to a midtone gray, they can have problems metering very light or very dark subjects.

Modern, sophisticated multiple-zone evaluative light meters are designed to avoid some of these problems but can't eliminate them entirely, since even the most advanced computer program can't know a photographer's creative or artistic intentions. A moodily lit portrait of a person in a dark room, for example, might be overexposed by an automated camera, which tries to bring up the exposure of the dark areas at the cost of correct exposure of the face.

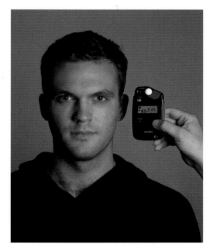

Figure 10-6

10.3.1 Incident light metering

Incident light meters record the actual light falling on the subject. This means that they correctly measure the amount of light required to illuminate the subject and are not fooled by distance or the reflectivity of the subject. The drawback is that they have to be positioned physically by the subject to record the light levels accurately. This is fine in a studio situation, but it could be unworkable for a photograph of a vast landscape.

One of the key advantages of incident meters is that they can be used to measure the amount of light falling on different parts of a scene. Take, for instance, the example of a person in front of a white background. The background should be pure white, but if it were to be excessively lit, then light would spill over onto other areas. By using a light meter, it's possible to measure (in *f*-stops) the difference in illumination between the background and subject. Then, assuming the background and subject are lit by different lamps or flash units, the output of those devices can be adjusted precisely. For this reason, cinematographers and studio photographers often walk the set to check light levels before shooting. Light meters also make it straightforward to determine light output from more than one flash unit.

Of course, many meters are multipurpose in nature. The Sekonic flash meter shown in figure 10-7 can also measure ambient lighting, either incident or reflective spot, as well as flash. It can even display flash levels as a percentage value compared to the ambient light levels. Ambient metering is essential for metering exposures with older film cameras that lack internal light meters, such as many view cameras. Finally, this Sekonic model has a built-in PocketWizard transmitter (section 11.10.1), which means that it's easy to fire compatible radio-equipped flash units right next to the subject.

Figure 10-7
Sekonic flash meter

10.4 Choosing a manual flash unit

Quite simply, any flash unit with manual output controls will work. Some units have sliders, some have knobs, and some have buttons. A manual flash can be anything that permits the amount of light produced by the device to be adjusted at will. It can be an old battery-powered hotshoe flash unit from the 1970s, a brand new manual-capable unit designed for a different camera system, or an AC powered studio unit (section 13.1). All that's needed is manual control and some way to connect a sync cable or other trigger so that the unit fires when the camera takes a photo.

Figure 10-8
This studio unit, a Bowens Gemini monolight, has two dials on the side that are used to set the light output.

Wholly automatic flash units generally aren't useful for this technique; they will probably just fire at full power when triggered by hand, which affords little control over manual flash.

Figure 10-9
This shot was lit by two flash units, both controlled by sync-only optical triggers. One was a Speedlite 580EX II, located camera left. The other was the Bowens Gemini monolight shown above, located on the floor behind the mannequins.

Manual flash begins with connecting a flash unit to the camera or to a triggering device. In the case of a hotshoe flash unit, this can be done by sliding the device into the camera's hotshoe. In the case of off-camera flash or studio equipment, it can be done via an electric cord, a light sensor, or a wireless controller. But before anything is physically connected to the camera, the matter of trigger voltages must be addressed.

10.5 Trigger voltages

Electronic flash units work by pumping high voltage electricity through their flash tubes. These powerful electrical discharges are fired by a triggering voltage, and many older flash units connect the trigger circuitry directly to their controlling switches. That means when a camera's flash contacts close, there may easily be anywhere from 50 to 200 volts flowing through them. This isn't a problem restricted to AC powered studio flash—even battery-powered flash units have high-voltage internal circuits. The battery units use special step-up circuitry to transform the low voltage from the batteries into the high voltage needed to power the flash tube.

Old mechanical cameras handle such high voltages with aplomb, but many EOS cameras employ delicate flash sync contacts. Some EOS shutter switches are only rated to six volts and can be destroyed by high voltages. The damage isn't usually instantaneous but cumulative with repeated use, as arcing and pitting slowly destroy internal components. So it's vitally important to check both the trigger voltage of a flash unit and the maximum trigger voltage of a camera before plugging in any non-Canon flash unit in.

10.5.1 Measuring the trigger voltage

Measuring a flash foot is quite simple. First, fully charge up the unit by turning it on and waiting for its flash ready light to glow. Then take a voltage-measuring device, such as a simple multimeter or multitester, and set it to measure DC volts. Touch the black (negative) probe of the multimeter to the side connector of the flash unit's foot and the red probe to the foot's center contact. The meter will display the trigger voltage. ● *Figure 10-10*

If the trigger voltage exceeds the camera's limits, then a voltage-limiting device can be used. These accessories sit between the camera and the high-voltage flash, keeping things at a safe level. ● *Figure 10-11*

Trigger voltage mismatches aren't a universal problem, particularly with most 1-series cameras and recent digital EOS bodies. Instead of fragile electric switches, these cameras use semiconductor switches that can withstand up to 250 volts. Consult appendix C for a table of models that

have this capability. Conversely, most flash units on the market today are designed with low trigger voltage circuits because of this issue; it's mainly older models that can be a problem.

But to be honest, it's simpler just to use an optical or radio trigger, which bypasses the whole trigger voltage problem altogether and eliminates the hassle of using a cable. See chapter 11 on off-camera flash.

Figure 10-10
This old Vivitar flash unit built in the 1980s has a trigger voltage of just over 8 volts. Whether this is safe or not on a camera rated for 6 volts is something of a judgment call. It's probably fine, as a 2-volt difference isn't that significant, but anything much higher should probably not be connected directly.

Figure 10-11
A Wein SafeSync. While somewhat crude-looking, this device can save a camera's shutter from flash-derived destruction. It fits into a camera's hotshoe and also allows PC cables (section 11.4) to be plugged into cameras that lack PC sockets.

Figure 10-12
This Nikon shoe is not compatible with EOS cameras.

10.6 Incompatible shoes

Generally, hotshoe connectors designed for other camera systems are completely incompatible with EOS cameras. This is because they use different pin configurations. ● *Figure 10-12*

Some devices have all-metal cold shoes for accessories, or hotshoes with incompatible pin configurations. These could be a problem if they inadvertently short out any of the four small data contacts on EOS cameras or flash units.

Of particular concern are cheap flash units with large, crude central hotshoe contacts. If such a contact were to touch one of the four EOS data contacts, damage could occur if the device has a high trigger voltage.

10.7 Autoflash metering

It's worth mentioning the earliest form of automatic flash metering: "autoflash", exemplified by the venerable Vivitar 283/285 hotshoe battery units introduced in the early 1970s. These flash units are self-metering, and the only control the camera has over the flash unit is a sync signal.

Autoflash units contain small light sensors on the front which monitor the amount of light reflecting back from the subject when the flash fires. The process can be likened to filling a car's empty fuel tank and stopping when the numbers on the pump hit a predetermined point.

Once a reasonable exposure is determined by these sensors, an electronic component known as a thyristor is used to shut off power from the flash tube, immediately "quenching" the light. There is a relationship between the duration of the flash pulse and the distance from the subject, with longer pulses generally needed to illuminate subjects further away. Autoflashes are sometimes referred to generically as "thyristor" flash units, though this is inaccurate since many flash units are thyristor-based but are not autoflashes.

Figure 10-13
A classic Vivitar 285

Autoflash works surprisingly well despite its simplicity. In fact, many experienced wedding photographers and photojournalists still rely on autoflash units in today's digital age, since the units behave fairly predictably once one is trained in their use. However, an autoflash is easily fooled by dark areas or highly reflective surfaces, can't distinguish between light reflecting back from objects outside the frame of the photo, and can't be used as a fill flash very easily. It's also generally designed to meter for the typical area covered by a normal lens, so it will meter inaccurately if used with a long telephoto or a very wide lens.

Autoflash requires more knowledge on the part of the photographer and really only works in single-light setups. Most autoflash units require the ISO/film speed to be set along with the lens aperture. Based on these two pieces of data, an autoflash will attempt to meter correctly using the built-in sensor on the front of the unit.

Autoflash has never really been a part of the EOS technology lineup, and at time of writing only three EOS-era Speedlite flash units use it: the discontinued 480EG; the recent 580EX II (section 9.26.1); and the tiny Speedlite 200M, designed for the EF-M manual focus camera. Some third-party manufacturers, notably Metz, manufacture autoflash units that can be used with EOS cameras.

11 Off-Camera Flash

Probably the only time we see the world illuminated by a beam of light emanating from our foreheads is when we're wearing head-mounted lamps, such as the ones on caving helmets. Headlamp lighting is not, it has to be said, a particularly natural way to see the world. Accordingly, camera-mounted flash units, whether built-in or clip-on, inevitably produce rather flat and uninspiring photographs, particularly when the flash unit is the primary source of illumination.

So the first step in improving the quality of flash photography is to get the flash off the camera. There are seven basic ways to control a flash unit that is located remotely.

11.1 The Seven Basic Methods for Off-camera Flash Control

The first way is to fire the flash manually, with no automatic control. But if synchronization is needed, then three fundamental methods are available: a physical cord, wireless light commands (optical), and wireless radio. Each of these methods can be used to send either sync-only commands or full metering instructions.

11.2 Off-Camera Method 1—Open flash

The simplest way to trigger a flash unit off-camera harkens back to the introductory chapter and the techniques used by Victorian photographers: just fire a flash unit by hand when the shutter is open. This is open flash, and it involves no automation of any kind for either synchronization or metering. It basically means that the shutter has to remain open long enough for the flash to be set off.

For the example in figure 11-1, a camera was attached to a sturdy tripod and the lens prefocused. The camera was set to ISO 100 with an aperture of f/5.6 and an exposure time of 30 seconds. The shot was triggered using a wired remote control to avoid bumping the camera. Exposure settings were based purely on previous experience. This is an area where light meters aren't much help—long exposure photography is all about trial and error, as well as consulting preview screens and EXIF data.

Since the photo was taken facing a pre-dawn sky under very low light, the trees essentially ended up as black silhouettes. The human eye could make out details in the trunks, but the camera lacked the dynamic range to do so. Two handheld bursts from a 580EX II filtered with a half CTO filter brought out the missing detail.

Figure 11-1

Dawn over bristlecone pines. Schulman Grove, Inyo National Forest, White Mountains, California, USA. Dendrochronology (tree ring counting) has established that some gnarled and ancient trees in this grove have been growing continuously for over 4,000 years, with the oldest specimen over 4,700 years old. The sprightly young trees in this photo are a fraction of that age.

11.3 Off-Camera Methods 2 and 3—Wired cords

The easiest way to control a flash unit remotely in a synchronized fashion is to use a physical cable between camera and flash unit. This isn't always the most practical method, as wires can be pretty inconvenient sometimes. They tangle, restrict the range, and generally get in the way. But they fire flash units pretty reliably and are usually inexpensive.

11.4 Off-Camera Method 2—Wired sync-only: PC cords

If all that's needed is a way to fire a flash, and automatic metering or any other advanced functions are not required, traditional PC cords may fit the bill. These are simple electric cords that can carry a synchronized trigger signal but don't carry metering data or any other information. They can't be used to adjust or specify the flash unit's power output.

The coaxial (cylindrical) design of 3.5 mm PC plugs dates back to at least the early 1950s. PC stands for "Prontor-Compur", two types of leaf shutters used in older cameras, which is why it's sometimes called a "German" socket. It does not stand for "personal computer": a PC cable can't plug into a computer.

Canon has never really promoted the PC cable solution, since it can't support flash metering. Few Speedlite flash units have PC connectors. However, most midrange and high-end EOS cameras have PC sockets. These are intended primarily for connecting to studio flash systems, though they can of course be used with battery flash units.

> • **KEY POINT**
>
> Sync-only means a camera can send a simple "fire now!" command to a flash unit but can't specify any other information, such as output levels.

Figure 11-2

A PC socket on a camera body, or the answer to the question "Why does my camera have a socket marked with a flash icon that doesn't connect to anything I own, including my flash unit?"

Figure 11-3

LumoPro "Universal Translator". This adapter has a foot, a hotshoe, a PC socket, and a 3.5 mm minijack, allowing it to connect to all kinds of things.

PC cables can still be used on EOS cameras with no PC ports by using a hotshoe adapter, such as one shown above. These adapters take the sync signal from a PC cable and connect directly to the central point, the sync contact, on the camera's hotshoe. ● *Figure 11-3*

 Two other issues to consider are PC connector polarity and trigger circuit voltage. Most flash units have a positive tip and negative sleeve, but a handful of devices have the polarity reversed. Certain EOS models are incompatible with positive sleeves. And, as noted in section 10.5, some flash units have dangerously high flash trigger voltages that can damage cameras.

Figure 11-4

This studio portrait was taken using a pair of monolights in softboxes. One was synchronized to the camera using a PC cable. The other was triggered optically using a slave cell.

11.4.1 PC connector problems and other sync plugs

While ubiquitous, PC connectors have a famously unreliable mechanical design, leading many people to joke that the acronym should really be "Poor Connections". The tiny friction-fit sleeve has to conduct electricity, which it does fairly well, but it also has to hold the plug in place physically, which it does quite badly. PC plugs are notorious for falling out at the slightest provocation. The problem is exacerbated when people attempt to tighten the plug by squeezing it with pliers (or even their teeth), which just worsens the poor contact by making the sleeve go out of round. ● *Figure 11-5*

Figure 11-5
Standard PC plug

There are three approaches to the PC problem. First are plug conditioners, which are simple metal tools used to tighten and round the metal sleeve. They can mitigate damage but don't address the underlying weakness of the plug design.

Second, there are threaded "screwlock" PC plugs which fit most PC sockets, but which also have sturdy threaded collars that hold the plugs securely in place when used with compatible screwlock PC sockets. Canon and Nikon both use the screwlock PC connector on their digital SLRs and some flash units. Oddly enough, while many devices use threaded PC sockets, the actual screwlock PC cables are difficult to find and are never included with any kits. The one shown here is from FlashZebra. ● *Figure 11-6*

Finally, other sync-only plug types can be used to avoid the weakness of the PC connector.

Figure 11-6
Screwlock PC plug

Figure 11-7
3.5 mm (1/8") minijack

A 3.5 mm (1/8") minijack is a mono version of the standard plugs used for the headphone jacks of MP3 players and the like. These are seen on various devices, from PocketWizard remotes (section 11.10.1) to Elinchrom D-Lite flash units (section 13.1.5). They are cheap, readily available from electronics stores, and reliable. One minor drawback is that they can short briefly when unplugged, causing misfires. ● *Figures 11-7, 11-8, 11-9*

Figure 11-8

1/4" audio jack. Similar to the minijack, but the large size seen on full-sized headphones. These are frequently seen on U.S. and U.K.-built studio flash units.

Figure 11-9

Elinchrom Amphenol. Large sturdy connector used on some Swiss-built Elinchrom studio equipment. Reliable, but too big to be used on cameras or portable flash units.

Figure 11-10

Household bladed plug

Figure 11-11

An adapter that goes from a non-screwlock PC plug to a 3.5 mm minijack.

"Household" bladed plugs, with two flat blades, are the same as those used for ordinary household power in North America and Japan. In my opinion they are a poor choice for safety reasons. It would not be a good thing for a child to plug a bladed plug into a power outlet if the other end were to be connected to a camera. Why take a pointless risk when perfectly functional and safer alternatives exist? Bladed plugs are also not polarized, making it easy for a plug to go in the wrong way around, with the result that a polarity-dependent camera may not fire a flash unit. ● *Figure 11-10*

11.4.2 Speedlites and PC cables

Manual control over the flash output is also required for a PC-triggered flash unit to be useful. For this reason older Canon Speedlites are actually less useful for all-manual flash than units from other makers, since they usually lack PC sockets and sometimes lack manual output control. Speedlites may also suffer from the SCR lockup problem described in section 11.7.6.

 Though few of Canon's flash units have PC sockets, simple and inexpensive adapter blocks that attach to the foot of a flash unit are readily available from other vendors. ● *Figure 11-12*

Figure 11-12

This foot adapter from FlashZebra uses a 1/8" or 3.5 mm minijack instead of a less reliable PC connector.

11.5 Off-Camera Method 3—Wired with automatic metering: Canon flash cords

There are two extension cord systems from Canon. The first supports all automatic flash metering options on nearly all cameras, whereas the second only supports TTL for film cameras. Neither uses sync-only PC connectors. ● *Figure 11-13*

Figure 11-13

11.5.1 The Off-Camera Shoe Cord

A shoe cord is a coiled extension cable that links a flash unit's foot to a camera's hotshoe, up to a stretched-out distance of about two feet. The cord preserves all Canon flash functions, including TTL and E-TTL, since the camera doesn't actually know that the flash unit isn't residing in the hotshoe. There have been three versions of the cord.

OCSC is the original cord from the 1980s, and it has just a rotating pressure ring to keep it on the hotshoe. The flash shoe has a plastic screw socket compatible with a regular 1/4–20 tripod bolt. However, it lacks the grooves that would let it fasten to a cold shoe.

OCSC 2 is the same as above but with the addition of a spring-loaded, locking hotshoe pin. The flash shoe end also has grooved sides compatible with a cold shoe, making it more useful for portable umbrella setups than its predecessor.

OC-E3, the Off-Camera Shoe Cord 3, is basically a heavier OCSC 2 with a metal foot, a lever lock instead of a pressure ring, and a metal bushing for the tripod socket. It also has rubber gaskets that mate with those found on weatherproofed EOS bodies and Speedlite flash units, reducing the risk of dust or water contamination.

While an essential tool for any EOS user, the cords are fairly short, since they are basically intended for attaching a Speedlite flash to a flash bracket. The Canon E-TTL flash system presumes that longer off-camera distances

Figure 11-14
Clockwise from top left: an OCSC 2, an original OCSC, generic clone copy of the OC-E3 (note thinner cord), and a Canon OC-E3.

will be handled wirelessly. It's possible to connect two together for a little more distance, but Canon does not recommend this practice since the electrical impedance (internal resistance) changes and reliability decreases. Third-party manufacturers also make compatible cords with longer wires.

Somewhat obscurely, the earliest EOS film cameras—the EOS 630 and RT—are not compatible with shoe cords, and there are governmental licensing issues caused by radio emissions when a cord is used with the 10/10S (not 10D).

11.5.2 Multiple TTL flash cords for film cameras

Before the advent of wireless E-TTL, Canon sold a corded system that supported TTL flash on film cameras only. The system is based around the camera-mounted TTL Hot Shoe Adapter 3, which is powered by a small lithium CR-2025 battery. This adapter connects via 60 cm and three-meter connecting cords to the feet of remote Speedlites via Off-Camera Shoe Adapters (OA-2) and a round TTL distributor that lets one camera link up to three flash units. Each device uses a Canon-proprietary plug similar in shape to a mini-DIN connector.

Figure 11-15
Canon TTL Cable components

While TTL metering works with this system, many advanced features are disabled because the control signals are all sent down one line; they would result in contradictory instructions from multiple flash units. Disabled features include adjustable ratios, A-TTL, E-TTL, preflash, second curtain sync, camera DEP mode, camera program shift, automatic flash head zooming, and aperture and coupling range data.

Lighting ratios between the individual flash units in TTL multiflash mode cannot be adjusted—all flashes will fire at the same time and shut off at the same time. Any flash on manual will disable TTL flash for all of the flash units; manual flash cannot be combined with automatic TTL flash.

The TTL cord system, initially developed for the T90 camera back in the mid-1980s, has few advantages today and is superseded by wireless E-TTL. It can be used as a sync-only corded system but has few benefits over regular PC cords in that respect. ● *Figure 11-16*

Figure 11-16

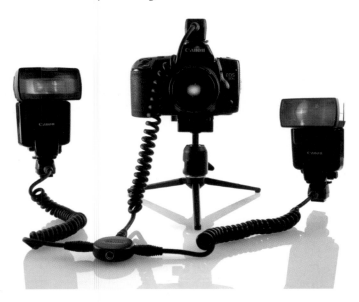

11.6 Off-Camera Methods 4 and 5—Wireless optical control

There are times when wires are inconvenient, awkward, or inflexible. A studio full of cables can be a trip hazard, and it doesn't take much to send a top-heavy monolight or stand-mounted flash unit crashing to the floor. For these situations, wireless, either optical or radio, is a great option.

Optical devices use simple pulses of light to encode commands. Just as Boy Scouts can turn flashlights on and off to signal each other at night, optical transmitters send information to compatible receivers by brief blinks of light. The light can be visible to the human eye, or it can be infrared energy that behaves just like light (except for the fact that people can't see it) at certain wavelengths.

Optical signaling has the advantage of being free of regulatory restrictions. It's easy to block an optical transmitter—just cover it up with a hand or a piece of tape. Governments don't place legal restrictions on optical devices. Unlike radio transmitters, they don't share a finite frequency band.

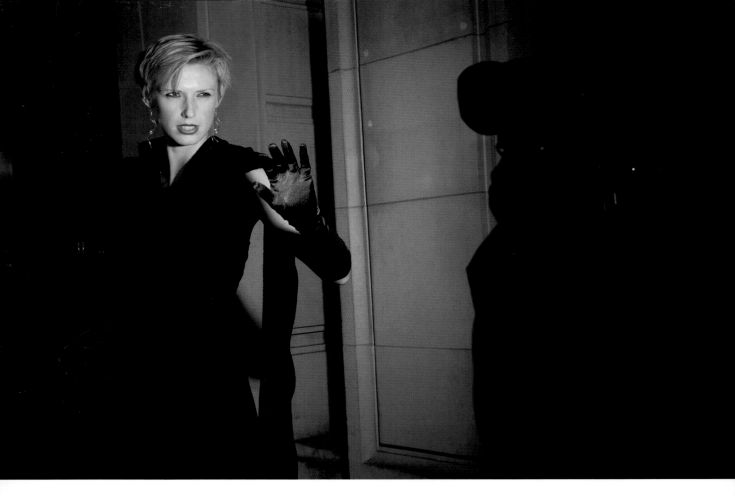

Figure 11-17
Photographers often joke that asking someone to hold a flash unit is using a "voice activated light stand". Here the model playing the paparazzo is doing just that. The camera visible in the frame is of course a prop, but the Speedlite 480EG flash unit is actually providing the bulk of the light for the scene. It's triggered optically using the small green sensor on the back of the unit. The master flash is a 580EX II on the camera used to take the photo, dialed down to 1/64 manual so it contributes relatively little light.

Accordingly, a manufacturer can make an optically triggered device and sell it around the world without dealing with regulatory paperwork.

Unfortunately, optical devices have one significant limitation: beams of light are blocked by opaque objects and have limited distance ranges.

11.7 Off-Camera Method 4—Wireless optical, sync-only: optical slaves

The simplest method to sync a flash unit wirelessly, if automatic metering is not required, is to use an "optical slave" light sensor. These sensors are quiescent when incoming light is at ordinary ambient levels, but respond to the bright pulse of light from a flash unit. They then trigger the attached flash unit.

Because optical slaves react so rapidly, the triggering is effectively instantaneous. A group of flash units triggered optically can be thought of as firing in unison, though of course there's actually a miniscule fraction of a second delay between the triggering (master) flash unit firing and the responding (slave) flash units firing. Any number of flash units equipped with optical slave sensors can be set about a scene for complex lighting scenarios. There are no limits other than budget and physical space.
● *Figure 11-17*

Some flash units have optical slave capabilities built in. Most studio flash units, for example, have basic optical triggers. A few third party battery-powered units, such as the Sigma EF-530 DG Super, also contain optical slave sensors. No Canon E-series Speedlite has one, though an optional add-on slave sensor was sold for the 480EG (section 9.27).

Slave sensors for battery-powered flash units are usually small plug-in devices that attach to a flash unit's foot, a PC socket, or a similar connector. They typically do not require batteries.

Optical slaves are a great solution for low-cost wireless triggering but do have a number of limitations.

11.7.1 Line of sight and range

Optical sensors must obviously be able to see the pulse of light from the triggering flash unit. Small or medium-sized rooms, particularly with light-painted surfaces such as walls or ceilings, rarely pose a problem since light bounces around everywhere. But outdoors, or in large indoor venues, optical slaves can be of limited value. Range depends on the sensitivity of the slave and the power output of the triggering flash unit.

11.7.2 Misfires from other units

Standard optical slaves are difficult to use outside the controlled environment of the studio, since they cheerfully respond to any flash unit that happens to fire nearby. This can be a real nuisance for wedding photographers who find their carefully configured flash units suddenly firing every time Uncle Bob takes a photo with his flash-equipped point-and-shoot. There's no way for a simple optical slave to discriminate between one triggering flash and another.

Short of banning the ubiquitous Uncle Bob, public situations like this call for wired solutions or wireless triggers with some form of digital encoding. Canon wireless E-TTL and most radio triggers are two options.

11.7.3 Optical slave E-TTL misfires

All EOS digital cameras, and most later film cameras, use E-TTL flash metering, not TTL. E-TTL sends out a low-powered preflash for measuring purposes before the shutter opens. Then, when the shutter opens, it sends out the actual subject-illuminating flash.

Unfortunately, the initial preflash is bright enough to trigger "dumb" optical slaves. As a result, photos rarely work out when an E-TTL flash unit

Figure 11-18

Two low-cost optical slaves: a Hama Synchromat (left) and a Sonia slave from FlashZebra (right). The generic Hama device, available from online auctions, does not work properly with Speedlites—see section 11.7.6 on SCR lockup. The Sonia unit is compatible with Speedlites. It's the tiny device encased in clear plastic resin, shown here plugged into a hotshoe adapter. The adapter in turn fastens to the flash unit's foot, though it can be plugged directly into any flash unit with a compatible minijack socket.

• KEY POINT

Simple optical slaves are not compatible with E-TTL flash.

triggers an optical slave. Either the picture is completely dark, because the subject-illuminating flash has already ended by the time the shutter opens, or the picture is quite dimly lit because only the tail end of the slaved flash unit has been recorded. The time between the preflash and the main flash firing is too brief for most flash units to recharge and trigger a second time.

This misfire issue is a particular problem with the popup flash. Since most EOS digital cameras use E-TTL to control their built-in flash units, these cameras can't use popup flash to trigger most studio units. The exception at time of writing is the EOS 7D, which is the first EOS body to permit optional all-manual control over the output of the built-in flash.

An inconvenient workaround is to press the * (autoexposure lock/AEL) or FEL (flash exposure lock, if the camera has a separate FE lock button) button to fire the E-TTL preflash first; wait a moment, then take the photo. Since the preflash must be fired before each photo, this isn't a very practical solution.

Some optical slave units intended for use with digital point-and-shoot cameras are designed to ignore preflashes, but these are less common. Some sensors on more advanced studio units can also be programmed to ignore a certain number of prefires before the subject-illuminating flash.

11.7.4 Disabling E-TTL on Speedlites

A better approach than using FE lock is to disable E-TTL on the Speedlite altogether. Most advanced Speedlites have a custom function or mode selector that puts the device into TTL mode only. However, not all digital cameras will fire a flash unit when it's in TTL mode, so this may not work. Also, a flash firing in TTL mode will work as a trigger, but it might end up contributing more light to the scene than is really desired. Angling the flash head away from the scene, or putting an infrared filter (see below) over the head can help. Dialing in the maximum amount of flash exposure compensation can also work.

The ideal solution is to put the unit into manual flash mode and specify a low power output, such as 1/64 or 1/128. The low power is enough to trigger the optical slave without contributing much actual light to the scene. Unfortunately, not all flash units have a manual mode, so this option may or may not be available. See appendix C for a list of Speedlites that can operate in manual mode.

Another option is to use a thin piece of plastic to cover the four small pins on the camera's hotshoe. This forces the flash unit to revert to all-manual behavior, though most will fire at full power only in this case.

A final complication involves built-in flash. All EOS digital bodies and a few EOS film bodies rely on E-TTL only for their internal flash units and can't

use TTL or manual flash. For that reason, built-in flash (except the 7D in manual mode) is not useful for triggering optical slaves.

11.7.5 Light and infrared

Sometimes light originating from the triggering flash unit is highly undesirable for the composition of a scene. Usually dialing down flash output and angling the flash head away is enough, but in some cases a truly invisible optical slave trigger is needed.

A good way of preventing the flash-triggering pulse from recording in the final photo is to install an infrared-passing filter over the flash head. An infrared-passing filter is an opaque black filter that blocks visible light but lets infrared (IR) through. Flash tubes generate infrared energy as well as visible light, and most optical slaves can detect infrared, so this trick works quite well—though, of course, at the cost of some range. In fact, commercially available optical slave triggers are nothing more than low-powered flash units with their flash tubes masked by infrared-passing filters.

Figure 11-19

Prolinca (left) and a Kenro/Interfit (right) flash transmitters, both of which are basically small flash units with plastic infrared filters. They work quite well as flash triggers, though their cycle time of a second or two is slower than radio. The Kenro unit has an energy-saving sleep feature that can't be disabled, making it less convenient in studio settings.

Sheets of light-blocking IR-passing material can be purchased from more comprehensive photo shops. Failing that, sandwiching together red, green, and blue gel filters is a reasonable approximation. In a pinch, a piece of unexposed but developed slide (E6 transparency) film will work.

Infrared filters are also a way to use a flash unit which only fires at full power as an optical slave trigger; note that this isn't an optimal solution since flash units firing at full power tend to take a few seconds to recharge. Additionally, a larger flash tube firing at full power can cause a filter to melt or fade.

11.7.6 Compatibility problems (SCR lockup)

Canon Speedlite flash units are incompatible with many simple optical slave triggers, such as the Hama unit shown in figure 11-18. Such optical slaves can fire a Canon Speedlite only once, and then the flash unit will unhelpfully lock up. It will not respond until it's turned off and turned back on again. The problem doesn't seem to harm the Speedlite at all, but obviously limits its usefulness with optical slaves. When shopping for an optical slave device, be sure to buy one designed to work with Canon Speedlites.

Technical note: This problem is sometimes referred to as "SCR lockup" since it's caused by a silicon-controlled rectifier (SCR) in the optical slave that does not reset. This appears to happen because the Speedlite's trigger circuit does not drop to zero volts.

11.8 Off-Camera Method 5—Wireless optical with automatic metering: Canon wireless E-TTL

E-TTL is the automatic flash control system used by nearly all EOS cameras since 1995. E-TTL's primary innovation was improved metering over TTL, but wireless capabilities were a key feature as well.

Wireless E-TTL is pretty well identical to regular E-TTL from the point of view of the user, the main difference being that the control signals are sent through the air from camera to flash unit by rapid pulses of light. No wires are required, just a visible line of sight between the devices (or reflective surfaces).

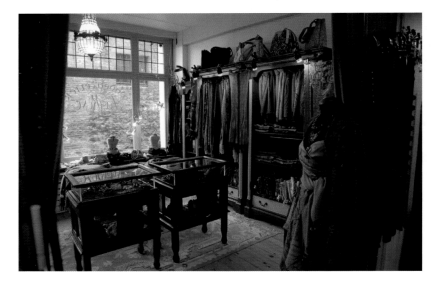

Figure 11-20

This photo of a small boutique in Bruges, Belgium, illustrates how relying on available light alone can be a problem. The ceiling light fixture and window are both overexposed to allow for adequate exposure of the interior. In addition, the room in which the camera is located, visible to the right side, is not as brightly lit as the main room. EOS 5D, 1/6 sec at f/4, ISO 100, 24 mm.

Figure 11-21

This photo is lit by an on-camera 580EX master flash unit which has its head angled to the ceiling. This illuminates the belts on the wall to the right and controls the slave unit. The 420EX slave is positioned in the other room, camera left. In addition to improving the interior lighting, the use of flash permits a lower overall exposure setting, bringing the outside to a more reasonable level. Note one drawback: the belts to the right and the bags on the top right shelf have some unfortunate flash shadows. EOS 5D, 1/8 sec at f/8, ISO 100, −1 FEC, 24 mm.

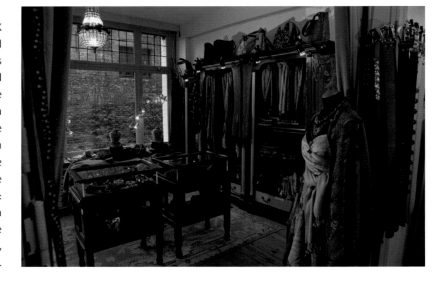

The simplest technical comparison is a TV remote control. In the case of TV remotes, small infrared (IR) LEDs send rapid-fire, digitally encoded pulses of invisible energy bouncing around the room. A receiver built into the TV set receives the signals, decodes them, and responds accordingly, perhaps by changing channels or muting the volume. In other words, the remote can be used to send a variety of different instructions to the TV set, not just "turn on now". The fact that the remote transmits invisible IR energy and not radio waves is easily demonstrated by simply covering over the LED or panel on the remote's front to interrupt the signal.

Flash units employ a conceptually similar system, but instead of infrared LEDs, ordinary xenon flash tubes produce rapid-fire bursts of digitally encoded light. These precisely timed pulses can be interpreted by fast-reacting computers and decoded in a fashion analogous to Morse code. The preflashes instruct the remote flash units when to fire and at what brightness. In other words, both sync *and* metering are fully supported in a transparent way.

Camera manufacturers are the primary makers of these light triggers for flash units. Canon, Nikon, Sony, Olympus, and Pentax all employ incompatible, but technologically similar, light-based flash controllers in their SLR lineups. Canon's system, known as wireless E-TTL, is built into most Speedlites sold today.

11.8.1 How wireless E-TTL works

Canon's wireless system requires at least two wireless-capable flash units. A *master* flash unit is attached to the camera and any number of *slave* flash units are set up to illuminate the scene as desired. At time of writing, only the EOS 7D can use its internal flash unit as a wireless E-TTL master. All previous EOS models require a separate master device.

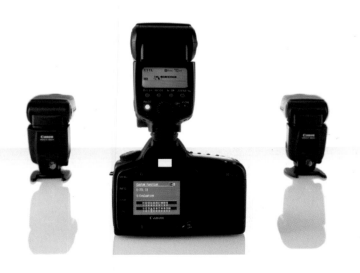

Figure 11-22

An EOS 5D equipped with a 580EX II serving as a master Speedlite. The master sends control signals to the two slave units in the front. Note how the flash heads on the slaves are rotated 180° so that the wireless sensors on the fronts of the units face the master.

As a side note, it has long been a convention in engineering circles to refer to a device that issues commands as a "master" and a device that receives such commands as a "slave". This unidirectional design is in contrast to a "peer-to-peer" model in which either device can send or receive commands. Obviously the words "master" and "slave" have regrettable historical meanings. But, since Canon and other manufacturers have used these terms to refer to the design of their remote flash systems, they are also used here in lieu of other popular synonyms (e.g., commander/remote, transmitter/receiver, etc).

Any 500 EX series flash unit can serve as a master, either directly on the camera's hot shoe or using an Off-Camera Shoe Cord (section 11.5.1). EX macro flash units can also serve as masters, though only under special circumstances described in "Macro ratios" (section 11.8.6). The master unit can be set so it contributes light to the scene, or it can be set simply as a controller unit. There is also the Speedlite Transmitter ST-E2, a special master-only unit that lacks a scene-illuminating flash tube and is thus a dedicated flash controller.

Any 400 EX or 500 EX series flash unit can serve as a slave flash unit. A number of flash units built by third-party manufacturers are also compatible with Canon's wireless system. The remote units must be set to slave mode, in which their front-mounted optical sensors dutifully sit and wait for pulsed signals of light from the master unit. The commands are so rapid that, to the human eye, they look like a single brief flash, but in fact complex messages and instructions are sent out. Virtually every standard E-TTL function is supported wirelessly through these control commands. One notable exception is second curtain sync.

There is no limit, other than physical space and budget, to the number of slave flash units that can be used. No two-way communication occurs between master and slave units. Each slave simply responds to commands, and the master only knows what slave units exist in terms of whatever light they produce during the prefire stage.

Canon's wireless system needs an E-TTL camera to be really useful. When used with older type B film cameras, Canon wireless flash works sync-only but can't support any form of automatic flash metering, including TTL or A-TTL. In such cases, the flash units will only fire at full power, or, in the case of units with manual output control, at whatever output level is manually set.

11.8.2 Line of sight

Wireless E-TTL is ideal for quick, portable, and flexible flash setups in smaller spaces. However, optical signals have two significant restrictions. First, optical signals are thwarted by walls, tables, people, and other opaque

barriers. Second, the range is limited; flash units can't be triggered remotely from great distances, such as from the other side of a stadium or even across a large ballroom.

Figure 11-23
This photo of Kikunoya guest house in Kanazawa, Japan, is lit by available light only. The garden is lit by sunlight, and the room interior is lit by fairly low tungsten light.

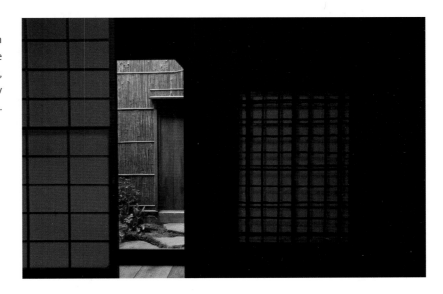

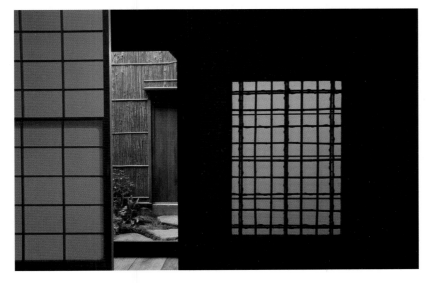

Figure 11-24
The same scene as in figure 11-23, shot with an ST-E2 as an on-camera master and a 420EX as a slave. The 420EX was on the other side of the right-hand screen in the hallway area, but enough of the ST-E2's control signal passed through the shoji rice paper screen to trigger it correctly.

Each slave must be positioned such that the wireless sensor on its front can see the master's signals, either directly or reflected. When shooting indoors with many light-reflecting surfaces (walls, ceilings, etc.) a slave can often detect a master's control signals even if the two units aren't set up to point at one another. But outdoors or in a non-reflective indoor setting (vast

Figure 11-25

The dark panel above the Canon logo on this 430EX II conceals the wireless flash sensor.

ballroom, black-painted nightclub, coal mine, etc.), the slave unit's sensor must be able to see the front of the master unit.

The sensor is behind a dark plastic cover on the front of the unit's body. Slave-capable flash units have rotating heads, so it may be necessary to turn the flash head so that it points in a different direction from the body. The master unit can also be put on an off-camera shoe cord rather than directly onto the camera body if necessary. Each slave must see the master directly; there is no capacity for relaying with intermediate devices.

There is a common perception that wireless E-TTL masters transmit invisible infrared signals, like the aforementioned handheld remotes used to control TV sets. This actually depends on the master unit used. All EX series master units, such as the 580EX or the MT-24EX, pulse their subject-illuminating flash tubes to send commands; they use white light and IR, since the tubes produce both. However, the ST-E2 master-only unit (section 9.7.7) transmits discreet invisible infrared.

Command transmission distance depends partly on the angle at which the master is transmitting relative to the slave, whether the signals are direct or are bouncing off surfaces, and which master unit is used. EX units, with their powerful flash tubes, have a greater transmission distance than the tiny ST-E2.

11.8.3 Channels and groups

There are four different data "channels" for flash control, and each slave unit can also be put into one of three "groups", sometimes referred to as "slave IDs". The numbered channels (1–4) allow up to four cameras to use wireless E-TTL in the same physical location without conflicting with each other. They're named by analogy to radio or TV channels but don't actually use different transmission frequencies—each slave detects all incoming commands, but only responds to those on the channel to which it's set.

It's often not desirable to have all slave units fire at precisely the same power or output level, unless multiple slaves are being used in combination to produce lots of light. Thus the three groups or slave IDs (A through C) permit independent flash output ratios to be specified within a given channel when used by most cameras. In other words, all slave flash units set to the same channel will always fire simultaneously. But the different groups allow finer control over the units by letting the photographer specify relative brightness of the flash units in the groups. For more information on this feature, please see the next section on ratios.

It's possible to check whether the slave units are within transmission distance or not by pressing the test ("pilot") button on the master flash unit. The camera will instruct all the slave units to emit a flash of light in sequence. First the A group units will flash, then B, and then C. If the camera

has modeling flash capabilities (section 9.24), then a quick preview of the final scene can be viewed.

11.8.4 Wireless E-TTL ratios

As noted earlier, there would be little value in being able to control multiple groups of flash units if they all fired at the same power level anyway. Consequently, most E-TTL capable cameras can specify the output levels of up to three separate groups of remotes.

The primary means of control is the ratio of light produced by groups A and B. Confusingly, this A:B ratio can be set from 8:1 to 1:1 to 1:8 in half-step or third-step increments, which yields a total of 13 steps or a 6-stop range (e.g., 1/8 of the light is −3, stops and 8x the light is +3 stops). More specifically: 1:1 means both A and B groups fire at the same power; 8:1 means that the group A units put out much more light; and 1:8 means that the group B units put out much more light.

Ratio	8:1	4:1	2:1	1:1	1:2	1:4	1:8
Stops	3	2	1	0	1	2	3

If a 500 series EX unit is the wireless master, then its internal flash tube defaults to group A. To control the ratio of slave unit output to master unit output, be sure to put the slave units into group B. Note that wireless flash ratios are unrelated to fill flash ratios between flash and ambient lighting.

EX master units can also specify flash compensation for a third and completely independent group: group C. Group C units do not fire unless the ratio setting has been set to "A:B C". Unlike A:B ratios, compensation of group C is adjusted from −3 to +3 stops relative to the A:B ratio, in third-step increments. Group C can't be adjusted relative to group A or B only, since it's assumed that group C is used primarily for background lighting. The ST-E2 transmitter is unfortunately unable to control group C.

Figure 11-26

The first generation of type A (E-TTL capable) film cameras does not support wireless E-TTL ratio control, and all flash units on the same channel will fire at the same power. When using a 500 series unit as a slave, there is a partial workaround: flash exposure compensation can be specified manually using the flash unit's controls.

Regrettably, Canon wireless E-TTL does not let the camera set exposure values for each group or turn specific groups on and off. Automatic control is restricted to ratios, an A:B ratio and a compensation for C separately. This system assumes a main, fill, and background flash lighting model, which isn't necessarily what's needed in every situation.

11.8.5 Manual wireless E-TTL control

Although the ratio system is a bit limiting, wireless E-TTL does permit manual control. To access it, press and hold the MODE button on the master unit until M appears. It's now possible to control slave flash units manually by dialing in the desired power output, such as 1/4 or 1/16. This will instruct all slave units to fire at whatever power output they produce for that fractional setting.

It's also possible to control the three groups separately using manual control. Put the master unit into M mode, then select the RATIO option as described above and choose A:B:C. The flash output power for each of the three groups can now be specified manually, though of course it's technically not a ratio at all. This system lets a photographer set arbitrary power output levels for each of the three groups (e.g., fire group A at full power, group B at 1/2 power, and group C at 1/8 power).

11.8.6 Macro ratios

The MR-14EX and MT-24EX macro units can both serve as master units in wireless E-TTL setups, though not in the way one might expect. One of the two flash tubes on the macro head is assigned to group A and the other to group B (the tubes are labeled). The controls on the flash unit can specify the output ratio between the two tubes when used with a ratio-capable camera. The controls can also be used to make only one tube fire if desired. Figures 11-28 through 11-32 demonstrate different set-ups using the MR-14EX and the MT-24EX.

Figure 11-27
The Speedlite MT-24EX has two separate flash heads, which can be positioned independently or clipped to the end of a macro lens, for flexible closeup lighting control.

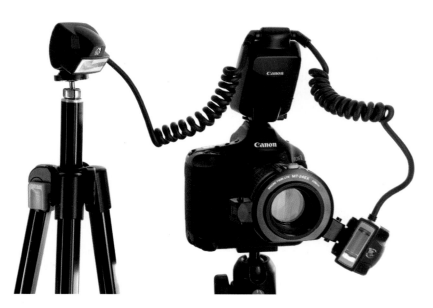

Magnesium refining can produce strange-looking crystal nodules as seen here. This lightweight metal is used to build many modern EOS cameras.

Figure 11-28
A Speedlite MR-14EX set to a 1:1 ratio. This means both tubes fire at the same level, for flat and even lighting.

Figure 11-29
The MR-14EX set to an 8:1 ratio. Left-hand tube A is 3 stops brighter than right-hand tube B. (4:1 would be 2 stops brighter, and 2:1 would be 1 stop brighter.)

Figure 11-30
The MR-14EX set to a 1:8 ratio. This is the reverse of the previous example, with tube B brighter than A.

Figure 11-31
Here the MR-14EX is firing normally, but with group C enabled. A 580EX II slave is firing through a clear red plastic cup behind the nodules.

Figure 11-32
This shot was lit with an MT-24EX. Its movable flash heads were positioned far to either side, giving a more sculpted look.

Figure 11-33
An MT-24EX with group C enabled and the same 580EX and cup arrangement as 11-31.

Slave flash units are assigned to group C, so that flash exposure compensation of the slaves can be set relative to the two macro unit tubes, an ideal situation for background illumination of macro shots. A custom function on the flash unit can be set to assign slave units to groups A and B, but then their output is linked to the internal tubes.

11.8.7 Speedlite Transmitter ST-E2

Figure 11-34

The ST-E2 is a compact unit powered by a 2CR5 non-rechargeable lithium battery that fits onto a camera's hotshoe. It's a wireless E-TTL master and so can control external wireless Speedlite flash units, but it doesn't produce any scene-illuminating white light of its own. ● *Figure 11-34*

The ST-E2 actually contains an ordinary small flash tube which it uses to send the control signals to other flash units; however, the tube is covered by a light-blocking filter so that most of its output is invisible infrared (IR) energy. Since the human eye can't detect IR, the ST-E2 is more discreet in operation than a normal flash unit when controlling slave units. It also has AF assist LEDs on the front, making it a useful adjunct for cameras with poor low-light autofocus abilities.

Although conveniently small and portable, the ST-E2 has a number of limitations that affect its usability. The ST-E2 can't transmit its control signals as far as, and its coverage angle is narrower than, the 500 EX series units, which really restricts its operating range to medium-sized rooms or studios. The ST-E2 supports only groups A and B and A:B ratio control; and mysteriously, it cannot control group C. The ST-E2 also does not support flash exposure bracketing (FEB), lacks flash exposure compensation (FEC), and can't control manual or stroboscopic slave units. 500 series units are larger and more expensive, but also much more capable E-TTL master units.

11.8.8 Third-party support

A number of companies make equipment that is compatible with Canon's wireless E-TTL.

Quantum QNexus

Figure 11-35

Quantum makes add-on devices, QNexus modules, which can interpret optical signals intended for Canon wireless E-TTL units and translate them for the company's Qflash series of battery flash units. All E-TTL functionality, with the exception of high-speed sync flash, is supported transparently. From the camera's point of view, a QNexus-connected flash unit is just another Speedlite, albeit one that can pump out a lot of light. The usual groups and channels can be specified. ● *Figure 11-35*

Qflash units are high-output flash units powered by battery packs. They bridge the gap between Canon Speedlite-type units powered by AA cells and the big studio flash units powered by battery packs the size of car batteries. This makes them ideal for wedding photographers and other professionals who need lots of light in reasonably portable fashion. Although Qflash units lack zooming flash heads, they have glass-encased tubes to which a wide variety of light-modifying devices, such as reflectors and softboxes, can be attached.

Sigma

Sigma produces flash units that have wireless functions compatible with Canon's. They support the same four channels and groups as Canon, though Sigma numbers the groups 1 to 3 rather than labeling them A through C. Ratios and other features are also fully supported.

Figure 11-36
The Sigma EM 140 DG macro flash in wireless mode.

The EF 530 DG Super can operate with Canon wireless E-TTL as both a master and a slave unit. The EM 140 DG macro flash can operate as a wireless E-TTL master. The EF 530 DG ST does not support wireless E-TTL.

The EF 530 DG Super is an affordable alternative to Canon units, though two points need to be kept in mind. First, wireless operation is somewhat difficult due to the DG Super's confusing user interface. Second, while it's mostly compatible, it can occasionally yield inconsistent metering.

Metz

Some Metz flash units are compatible with Canon wireless E-TTL, though the company also has its own wireless system, that isn't compatible with Canon's. The units that support wireless E-TTL are generally "System Flash" units.

11.8.9 Drawbacks of wireless E-TTL

On the whole, wireless E-TTL is a useful system but not without drawbacks. By far, the biggest problem is line of sight and range. Outdoors, in dark-painted rooms, in huge rooms such as theaters or hangars, or in situations where there's powerful backlight from the sun, wireless E-TTL simply doesn't work very well, especially when compared to radio systems.

The ratio system for the three wireless flash groups is not very useful. First, it's confusing because groups A and B are controlled as ratios to each other, whereas group C is controlled with exposure compensation over the combined A+B groups. Second, there's no way to simply specify the output of each group in EV or other units, and there's no way to turn specific groups on or off.

11.9 Off-Camera Methods 6 and 7— Wireless, radio frequency (RF)

The most reliable way to transmit flash-triggering information wirelessly is by radio frequency (RF). There are a number of reasons why most professionals rely on wireless flash control that employs radio commands.

11.9.1 No line of sight requirement

The primary advantage is that radio signals can pass unhindered through many visually opaque barriers, and so are immune to the line of sight and distance limitations imposed by optical systems. That doesn't make them invulnerable; signals can be blocked by metal objects, or at certain frequencies, by water-filled objects such as plants or people. Dense materials such as stone walls or stucco walls with embedded metal mesh can present a barrier. Other nearby devices transmitting on the same frequencies can also interrupt a signal.

But in most cases, radios can transmit signals to flash units on the other side of walls, tucked around corners, hidden behind backdrops, and so on.

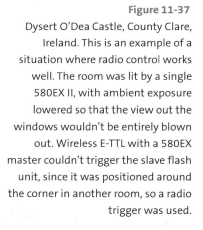

Figure 11-37
Dysert O'Dea Castle, County Clare, Ireland. This is an example of a situation where radio control works well. The room was lit by a single 580EX II, with ambient exposure lowered so that the view out the windows wouldn't be entirely blown out. Wireless E-TTL with a 580EX master couldn't trigger the slave flash unit, since it was positioned around the corner in another room, so a radio trigger was used.

11.9.2 Enhanced range

RF controllers can usually operate at greater distances than optical controllers, though the range obviously depends on the product and general conditions. Advanced professional RF units such as non-TTL PocketWizards can

work up to 1500 feet in open air, though cheap products might have a range of only around 30 feet. Professional RF transmitters hold great benefits for sports photographers who need to trigger large flash units at the other side of a hockey arena, or wedding photographers who want to trigger flash units in a large ballroom for a couple's first dance.

Note one unintended consequence of using radio to control E-TTL devices: with regular light-based wireless E-TTL, it's usually not possible to control a flash unit so far away that the camera's evaluative metering can't see the unit's preflash. But with radio signaling it becomes entirely possible. This isn't an issue when controlling remote flash units sync-only: if they're within radio range, the flash units will fire at whatever output level is specified.

Note also that it's wise to interpret the manufacturer's published range somewhat conservatively. Like fuel economy ratings for cars, transmitter range numbers are often somewhat optimistic in nature.

11.9.3 Digital coding

Most RF systems use some form of digital coding in their transmissions. This serves two functions. First, digital coding can reduce the risk of misfires caused by random radio noise. Very simple low-cost transmitters may transmit uncoded triggering commands, or may support just four different pulse-modulated commands. Such systems can be fooled by bursts of radio static, whereas more expensive transmitters employ digital error correction to ensure that an incoming signal is genuine. This is one of the reasons why cheap transmitters can misfire—they're more vulnerable to accidental triggering by noisy radio devices in the vicinity.

Second, most flash transmitters send coded signals (much as a garage door opener is coded for security) so that more than one transmitter of the same brand can operate in the same area. They may also transmit on different radio frequencies, again reducing the risk of misfires caused by signals from other compatible devices. ● *Figure 11-38*

But even professional devices have a finite number of channels or codes available, making conflicts inevitable in busy areas or when using a device with great range. Sports or political photographers covering a big event, for example, may find their flash units firing inadvertently when another photographer is shooting. Well-organized professionals covering an event may actually sit down and allocate channel or code numbers to each other in advance to avoid this problem.

Figure 11-38
Tiny slide switches used to specify security coding on a transmitter.

11.9.4 Multiple receivers

Most radio systems support any number of receivers. When the transmitter broadcasts a signal, any receiver in range which is programmed or designed to respond will do so. A single transmitter can control complex studio setups with dozens of flash units.

11.9.5 Regulatory issues

The biggest drawback of radio systems is that radio waves have a habit of wandering off wherever they want. They don't respect walls or arbitrary human barriers, and they can interfere with other devices. The radio spectrum is a finite natural resource which is highly regulated by governments.

Local radio frequency laws can mean that an RF device legal in one country may not be legally imported, sold, or even used in another. RF devices must be approved by the Federal Communications Commission (FCC) in the U.S., have CE (Conformité Européenne) certification in Europe, Industry Canada approval for Canada, carry the C-Tick mark in Australia and New Zealand, and have VCCI approval in Japan. ◉ *Figure 11-39*

In short, governments don't want imported products that can interfere with radio products sold legally. There have never been harmonized global rules for radio frequencies; for example, a band of the spectrum reserved for emergency services in one country might be open to general use in another.

This lack of regulatory coordination explains the variety of incompatible devices available in different markets, a frustrating problem for the traveling photojournalist. For example, U.S. FCC PocketWizard transceivers operate on a different frequency range than European CE models. A U.S./Canada RadioPopper PX uses the same frequency range as GSM-900 cellphones elsewhere in the world. It also takes time to get licensing approval, so some markets may see long regulatory delays.

At time of writing, the Elinchrom Skyport and Paul C. Buff CyberSync systems use the 2.4 GHz band shared with Wi-Fi computer networking and Bluetooth devices. This has the advantage of using an open global standard. On the other hand, the 2.4 GHz band is packed with device transmissions and has a range limit compared to lower frequency signals.

Figure 11-39

11.9.6 Latency

Radio triggers often advertise a very high maximum shutter speed which is not always achievable. Sometimes this is because of the X-sync problem with all SLRs, in which case the maximum shutter speed is going to be determined by the camera. In other cases, the flash transmitter itself introduces signaling delays, something engineers call latency.

In other words, it can take a fraction of a second for the transmitter to take the signaling information and broadcast it, and then for the receiver to decode it. This delay can be long enough to lower the maximum shutter speed. It's worth testing any new product to find out what its real-life values are going to be.

11.9.7 No cross-manufacturer support

There are no universal standards for radio trigger communications, so a product made by one manufacturer probably won't work with a product made by another. The investment in a given product line is not typically transferrable.

Occasionally, companies will license another firm's technology—such as Profoto and Bowens flash units, which support PocketWizard receivers—but this is not the norm. In fact, sometimes two products made by the same manufacturer won't work together.

11.9.8 Battery drain while idling

Transmitter batteries are usually small and last a long time because most transmitters only send brief bursts of commands when a photo is taken. Receivers, on the other hand, have to sit and wait for incoming commands, and therefore require larger batteries.

11.10 Off-Camera Method 6—Radio, sync-only

A whole host of companies sell radio frequency (RF) transmitters that can be used to sync off-camera flash units but that don't offer any metering capabilities.

The best-known product line in North America is probably the LPA PocketWizard system, whereas in Europe the Elinchrom Skyport and Bowens Pulsar systems are popular. Other radio remotes of note include Microsync Digital, Cactus V2/V4, AlienBees/Paul C. Buff CyberSync (not discussed in this book), and Yong Nuo CTR-301P.

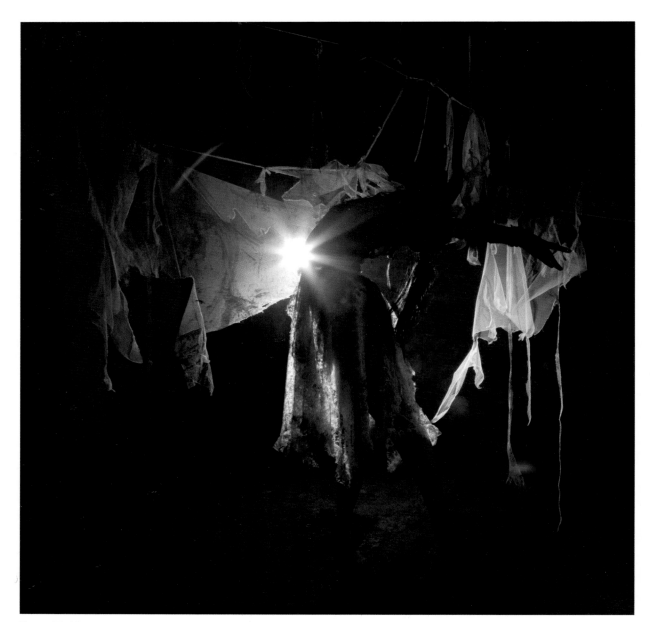

Figure 11-40

When using sync-only radio transmitters, there are three basic ways to adjust exposure. If time isn't an issue, just run back and forth and adjust flash output manually. If depth of field isn't an issue, adjust the aperture. If noise isn't an issue, adjust ISO when shooting digital.

11.10.1 PocketWizard MultiMAX and Plus II

The PocketWizard system has long been the studio professional standard for radio remotes in North America. The transceivers, while expensive, have a reputation for solid reliability and long operating ranges. PocketWizards have error detection systems to avoid misfires and are rated at distances up to 1600 feet in open air, which is adequate even at a vast sports arena or Olympic venue.

The classic PocketWizard sync-only devices are black plastic boxes, about the size of a deck of cards, that attach vertically to a camera's hotshoe. They are transceivers, meaning that each device can serve as either a transmitter or a receiver. The two current models are the Plus II, which is a simpler device with no screen, and the MultiMAX, which is a more sophisticated device with an LCD panel. They are both powered by two AA cells.
● *Figure 11-41*

The Plus II model is auto-switching and decides whether to transmit or receive based on what device it's plugged into. If it's attached to a camera's hotshoe, it will transmit a sync signal when the shutter is fired. If it's attached via a cable to a flash unit, it'll receive the signal and trigger the flash unit. It supports four different digital channels and can also be used to fire cameras remotely. This latter function is popular with sports photographers and photojournalists, who sometimes hide remote cameras in interesting or inaccessible locations for unusual shots.

The MultiMAX is considerably more feature-laden. While the same size as the Plus II, it includes a small LCD panel. It supports 32 digital channels, time lapse, second curtain sync, and other functions. It's also possible to purchase a custom digital ID number for the MultiMAX. This essentially gives pro photographers their own private transmission ID so that their flash units don't get triggered by anybody else's, even other photographers who use the same products and frequencies.

The MultiMAX in particular is packed with more features than any photographer is likely to ever use, offering tremendous flexibility for remote camera triggering, interval timing, and so on. A unique function is the ability to connect an optional light sensor, which allows a receiver to send a message back to the transmitter confirming that the flash unit actually fired.

Conveniently, other companies produce receivers compatible with PocketWizard signaling, making it a useful product ecosystem. For example, Profoto and Bowens both make optional add-on units that transform some of their studio flash units into PocketWizard devices. This saves the trouble of external boxes, cabling, and separate batteries for the receiver. Sekonic also sells light meters with built-in PocketWizard-compatible transmitters, making it easy to walk around a set lit by remote-operated flash units and test the lighting. ● *Figure 11-42*

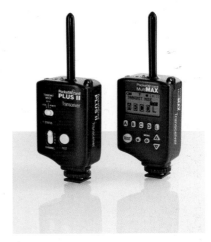

Figure 11-41

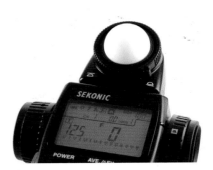

Figure 11-42

The primary drawbacks of the PocketWizard sync-only devices are cost, size, and complexity. They're fairly large and have a tall vertical orientation which blocks sight over the top of the camera (figure 11-43). They also have an extremely long auto power-off setting of 40 hours. This means that they don't turn themselves off in the middle of a shoot, but it also means it's easy to forget to turn them off, draining batteries.

There are also different versions produced for different markets. As described above, these versions transmit on different radio frequencies and are therefore incompatible. The North American PocketWizards operate at 340 at 354 MHz, the European models at 433 MHz, and the Japanese versions at 315–317 MHz.

In short, PocketWizards are a professional studio basic. They work well for any situation in which reliable radio sync, but not metering, is required.

11.10.2 Elinchrom EL Skyport

Swiss studio flash manufacturer Elinchrom produces a line of portable radio triggers for its flash units. They come in two forms: the EL Skyport Universal, which can perform sync-only triggering with almost any make of flash unit; and the EL Skyport RX, which can also adjust the power output of Elinchrom RX studio flash units. ● *Figure 11-44*

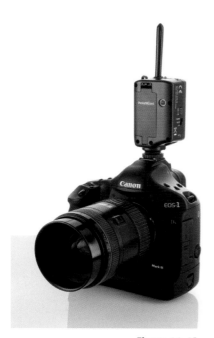

Figure 11-43

Figure 11-44
Three EL Skyport devices:
the Skyport USB Transceiver,
the Skyport Transmitter, and the
Skyport Universal Receiver.

EL Skyport Universal
The Universal models are sync-only radio triggers that consist of transmitter/receiver pairs operating at 2.4 GHz, the same radio frequency used by Wi-Fi personal computer networks. They support eight different frequencies and have an official open-air range of about 400 feet. Digital error correction is supported. The transmitters attach directly to a camera's hotshoe and are powered by a small lithium button cell. They're very small, low-profile devices that don't block the view over the top of the camera.

The receivers are powered by an integrated rechargeable battery pack, like a mobile phone, for about 24 hours of use on a single charge. They also

have auto power-off after a number of hours. On the one hand, the built-in battery means no batteries to throw away or lose. On the other, it means that it isn't possible just to replace the battery on a shoot if it runs out unexpectedly. Still, the receiver can continue to function while it's recharging.

Four different groups are supported, and the transmitter can fire specific groups or all groups at once. This allows for different lighting setups to be configured and tested.

EL Skyport RX

The RX-capable Skyports add the ability to transmit power output information, though only to Elinchrom RX studio flash units. They are *not* able to handle automatic TTL-style flash metering—they simply enable the photographer to perform manual output control wirelessly, in 1/10 stop increments, without the bother of walking over to each flash unit. In this, they excel. The ability to adjust the output of multiple flash units right on-camera is great time saver in the studio. It also makes it easy to adjust the power output of a monolight in an inaccessible location, such as on a high light stand or on a boom.

The RX system also has a version with a computer USB interface. This transmitter plugs into a Mac or Windows computer and comes with downloadable software that supports a wide range of controls. Intended for professional studio settings, the software can store commonly used settings and configurations for later retrieval. ● *Figure 11-45*

Figure 11-45

While versatile and useful, the advanced functionality of the RX units does not work with any flash units other than Elinchrom RX devices. But in a

studio equipped with compatible units, the ability to adjust multiple flash units directly from the camera is extremely handy.

11.10.3 Bowens Pulsar

Figure 11-46

British flash manufacturer Bowens sells hotshoe-mounted radio transceivers known as Pulsars. Each transceiver can transmit (TX) or receive (RX) sync commands at 433 MHz, depending on the position of the power switch. The devices run off two ordinary AAA cells, though a power socket is available for continuous studio use. They are oriented horizontally and so block less of the view along the top of the camera. ● *Figure 11-46*

The transceivers have two output jacks, one PC and one 3.5 mm minijack. The PC socket is used for flash sync, and the minijack is used for firing a flash unit or for triggering a camera's shutter release.

One useful feature of the Pulsar is its ability to handle multiple channels simultaneously. Up to four separate channels can be enabled and triggered independently, and an "all" setting lets a transmitter fire any device on any of the four channels at once. This makes it very useful for testing flash ratios and the like. The Pulsar can also transmit on any one of five separate frequencies via a switch labeled "Studio".

Another advantage is that small radio receivers can be installed in many newer Bowens studio flash units. These don't run off battery power and can't be lost, making them a very convenient radio triggering solution for Bowens users. As with the stand-alone transceivers, the built-in receivers support sync-only.

11.10.4 Microsync Digital

One of the smallest radio solutions is the Microsync Digital from US camera bag maker Tamrac. This is a transmitter/receiver pair that operates on 433 MHz. The transmitter is an incredibly tiny unit that sits in a camera's hotshoe, powered by a lithium coin cell. The receiver is larger, as it accommodates two AA cells. ● *Figure 11-47*

There are actually two models of the receiver, both geared to the North American market. One has a large 1/4" plug and the other a two-bladed "household" plug. These plugs allow the receivers to be plugged straight into many North American studio flash units. Adapter cables are required if a given flash unit doesn't have these two connectors. The cables can be a little bulky, since both 1/4" plugs and household plugs are large. Note the safety risk of the bladed version. Keep it well away from children, since the bladed receiver could be plugged straight into a power socket.

Figure 11-47

Figure 11-48

The Microsyncs do not have any advanced features, such as the ability to transmit on multiple channels for ratios. They also cannot sync at shutter speeds higher than about 1/180 sec.

Only four channels are available, and channel selection on either device is awkward. The transmitter has a tiny hole in the side, into which a bent paperclip must be inserted to cycle through the channels. The receiver will sync itself to the transmitter if the paperclip is pushed in within 10 seconds of powering on the receiver. In a studio setting where the channel is rarely changed, this shouldn't be a problem. However, photographers who shoot in the field might find it an issue. ● *Figure 11-48*

The Microsync's primary selling point is the extremely small transmitter. The product is basically optimized for a small studio setting where channels are infrequently changed but an unobtrusive flash sync solution is needed. It's less suited for photojournalist or field use, particularly if battery-powered flash units are used.

11.10.5 Quantum FreeXwire

U.S. flash manufacturer Quantum offers a number of radio solutions for remote triggering. The simplest is the Radio Slave 4i, which is a basic sync-only radio transmitter. A more advanced system with eight separate channels is the FreeXwire system. This can support full-metered TTL commands also transmit sync-only signals. ● *Figure 11-49*

The basic FreeXwire Digital Transmitter can be fastened directly to the camera's hotshoe with the FW12 hotshoe adapter. The FW12 doesn't, unfortunately, support TTL signals in any way, so it doesn't take full advantage of the transmitter's capabilities. However, it is simple to use.

The FW9T transmitter, powered by a pair of AAA cells, sends radio commands at 434 MHz to a compatible Quantum receiver on a Qflash battery flash unit. ● *Figure 11-50*

Figure 11-49

Figure 11-50

The Quantum system includes other devices as well. For example, in addition to a FreeXwire receiver, there's also a transceiver which can serve as either a transmitter or receiver, and which can actually extend the range of a signal by acting as a repeater. The Quantum system is extremely versatile, but also difficult to understand because of the vast range of products and all their permutations.

11.10.6 Cactus / Gadget Infinity V2 / V2s / PT-04

These simple units from Hong Kong's Gadget Infinity are widely available from Internet auction sites and are sold under different brand names. They're extremely low cost and so form a good basis for students and other beginners on tight budgets. The V2s version is apparently certified by the FCC (US) and CE (Europe), which is unusual for an inexpensive product. However, different variants of this product are *not* interoperable, and so two units may not work together even though they look the same. The units shown here are the older PT-04 model. ● *Figure 11-51*

The Cactus V2 consists of two devices: a shoe-mounted transmitter and a clip-on receiver. The transmitter is powered by a small 12-volt battery of the type commonly used in household smoke alarms. There is a single test firing button, a 3.5 mm minijack socket, and two tiny DIP switches for setting one of four codes.

Figure 11-51

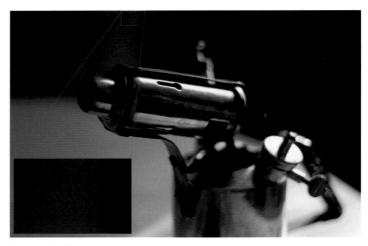

Figure 11-52

The codes must match those found on the receiver, a rectangular box that fastens to the shoe of a flash unit. The receiver is powered by a non-rechargeable lithium CR2 battery, an expensive choice since receivers must be left on for extended periods while the unit's radio waits for incoming

transmissions. The receiver has a crude metal bracket, tilt-adjusted by a thumbscrew, for attachment to a tripod or cold shoe. This delicate component is one of the weak spots of the product. The receiver also has a PC socket and a transmission confirmation LED.

On the whole, the V2 fits its amateur market well because it is inexpensive. However, it's prone to triggering failures and is not a reliable professional product. Its range is also limited to about 30 feet. The earlier versions suffer from the SCR lockup problem (section 11.7.6), but the later V2s are compatible. ● *Figure 11-52*

Some transmitters may cause banding (zigzag lines caused by radio interference) on the EOS 5D, as shown in figure 11-52. Interference is most common at high shutter speeds with low ISO, and is worsened by hobbyist antenna modifications to the transmitter for boosting range.

11.10.7 Cactus / Gadget Infinity V4

The V4 is another hobbyist product but a significant improvement from the V2 design. The units have four DIP switches for a total of 16 different codes. ● *Figure 11-53*

Although they transmit on the same 433 MHz frequency band as their predecessors, the increased number of codes means they are not compatible with the V2 line. Anyone upgrading to the V4 will have to abandon the previous devices. Since the V2 devices aren't all interchangeable anyway, this may not be an issue.

Figure 11-53

The transmitter has a swiveling, albeit delicate, antenna and some cosmetic changes. The receiver has the biggest improvements. First, the weak rotating bracket is omitted since the device is now a simple base upon which the flash unit rests. It also operates on a pair of ordinary AAA cells, which are cheap, widely available, and made in rechargeable versions. Range is extended and officially goes up to 100 feet in open air.

The receiver has a couple of practical limitations. First, the on/off switch is blocked by the front edge of many flash units, meaning that the flash unit has to be removed to turn off the receiver. This, and the fact that the switch position is hard to see, makes it likely that the unit will be left on inadvertently, draining the batteries. Second, the receiver isn't wide enough to serve as a reliable stand, though it can be loosely attached to a normal Speedlite clip-on stand for better stability. The battery door also tends to fall off. Finally, the same interference issues on the EOS 5D can occur.

Figure 11-54
One advantage of an inexpensive transmitter: here, a group of old industrial ovens is lit by separate flash units, each controlled by a low-cost Cactus V4.

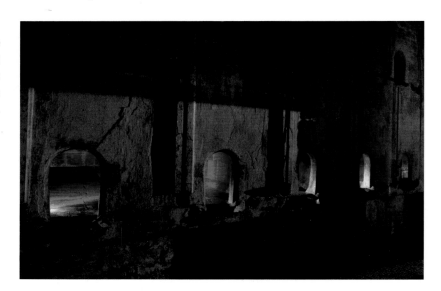

The V4 addresses many of the drawbacks of its predecessor while remaining affordable enough for a hobbyist. It lacks the reliability and range of the high-end professional products, but then it doesn't really compete with them.

11.10.8 Yong Nuo CTR-301P

A competitor to Cactus in the hobbyist field, the Chinese-made Yong Nuo trigger is a similar low-cost receiver/transmitter product. With blocky styling resembling the Cactus V4 line, the CTR-301P also transmits at 433 MHz but employs four codes only. Range is officially 30 feet.

The transmitter is a small box equipped with a test button and powered by a 12-volt 23A battery. It has a very thin contact on its foot that is likely to scratch the camera's central hotshoe stud. ● *Figure 11-55*

The Yong Nuo receiver is intended to serve as a flash base, though most flash units are too heavy for the small area and so will topple over. Fortunately, there is a tripod thread on the bottom. An easily-bumped power

Figure 11-55

switch enables "W" mode for wireless, and also engages an unusual "L" mode that turns the unit into an optical slave. Unfortunately, the receiver uses expensive, non-rechargeable lithium CR2 batteries, making it costly to use if it's left on accidentally.

The non-P version had a simple test button on the receiver, but on the P model this is replaced with a socket—incorrectly labeled "PC" since it's actually a 3.5 mm mono jack, which is the device's sync connector.

Yong Nuo devices are sensitive to unusually low trigger voltages and can fail to work reliably if the batteries in the flash unit are partly drained.

11.11 Off-Camera Method 3—Radio with automatic metering

The most technically complex form of off-camera flash control is radio with automatic output control. There are a number of incompatible systems from different manufacturers that bring E-TTL capabilities to the wireless world.

Figure 11-56
The cockpit of the Raygun Gothic Rocketship (section 6.15). This photo is lit by a mixture of daylight coming through the portholes, tungsten lamps on the simulated displays, the glowing video monitor, and a blue-gelled 580EX Speedlite controlled by a RadioPopper wireless remote on the next floor down.

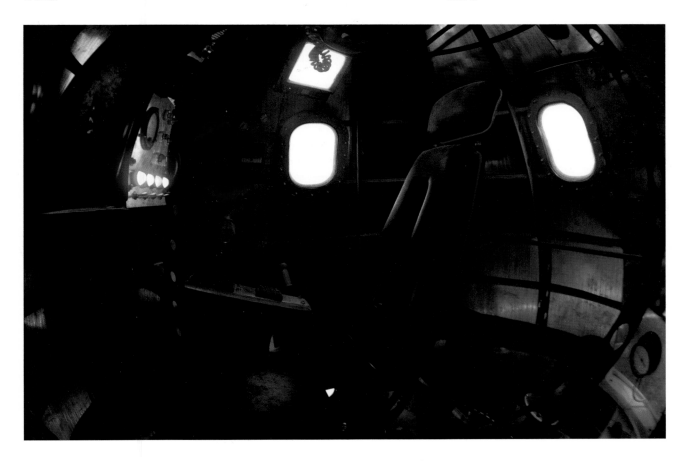

11.11.1 Quantum Q-TTL

Quantum's Q-TTL system is the oldest radio-frequency wireless flash triggering system on the market today that supports automatic power output levels on Canon cameras. It consists of a number of different products that interoperate in different ways, all based around the FreeXwire transmitter.

Quantum has decoded the flash-related commands sent by Canon cameras and produces a hotshoe attachment, the Quantum TTL Adapter, that can interpret those signals. The attachment connects to the FreeXwire transmitter and sends flash sync and metering information by radio to FreeXwire receivers. These receivers can attach directly to the side of Quantum Qflash units. The radios use eight different frequencies and transmit up to 1000 feet. Each flash unit can be in one of four zones, which can be turned on and off directly from the transmitter.

Figure 11-57

Quantum flash units are somewhat similar to Canon Speedlites in that they're battery-powered portable flash units, but they differ in that they have very high light output levels and require external battery packs. Instead of swiveling or zooming flash heads, they have bare flash tubes, protected by clear glass shields, to which various light-altering devices can be attached. They support simple metal reflectors, small softboxes, and other accessories. In short, they are high-output portable devices meant for professionals, such as wedding photographers.

11.11.2 RadioPopper PX

The RadioPopper PX, successor to the P1, takes an interesting approach to handling wireless signals. Instead of interpreting commands directly from the camera, the RadioPopper intercepts optical signals sent by a master Canon flash unit. It reads those instructions, converts them to radio signals, and transmits them to a receiver. The receiver then sends the instructions back to the slave unit using infrared. Essentially the RadioPopper PX is a radio bridge or translation system, and thus it automatically supports all wireless E-TTL functions.

Figure 11-58

RadioPopper PX comes in matched transmitter/receiver pairs. The transmitter has a small pickup, like a tiny version of the coils used in electric guitars, which detects the magnetic burst produced by a flash unit when it fires. Its small fixed antenna sends commands using one of 16 separate radio frequencies. The transmitter must be fastened to the flash head of a Canon-compatible master device, such as any 500 series EX unit or the ST-E2, using tape or Velcro.

The receiver has no pickup, just a single, directional antenna that can be rotated to receive the signals from the transmitter. Additionally, it has an infrared diode on the back that plays IR signals back to a Speedlite. For all

this to work, the receiver must be attached very carefully, since the slave won't respond if it can't see the RadioPopper's IR output. Also, if a slave flash unit receives optical signals from the master flash unit as well as radio-bridged RadioPopper signals from the RadioPopper receiver, things can get confused.

RadioPopper advantages

The strength of the RadioPopper system is that it fully and transparently supports all wireless E-TTL features without modification, since it's simply bridging the normal optical communications system used by the flash units. All 500EX and 400EX series Speedlites are supported, as is the ST-E2 transmitter. Attach RadioPoppers to a set of flash units and a very convenient automatic system becomes possible. No need to walk over to each slave unit to adjust its output: this can all be controlled from the master flash unit. The PX system has a good working range of about 300–1500 feet.

Of particular note is that radio-controlled high-speed sync flash is possible, up to the camera's highest shutter speed. This was a technical innovation introduced with the original RadioPopper P1.

PX devices are small, lightweight, and easy to use. They allow for the convenience of E-TTL without short distance and line of sight restrictions. They can also work with sync-only RadioPopper JrX units. ● *Figure 11-56*

RadioPopper limitations

The RadioPopper system's main advantage—a radio bridge to wireless E-TTL—is also its main weakness. It requires full wireless E-TTL capable master and slave units, making it expensive for hobbyists. It isn't intended for use with simple manual flash triggering, and can't extend E-TTL's capabilities (e.g., second curtain sync is not supported). RadioPoppers can be used in conjunction with Nikon cameras and flash units, but note that all devices have to work on the same system—Canon E-TTL or Nikon iTTL. The RadioPopper can't translate Canon commands into Nikon commands or vice-versa.

Another key point is that the small, flat RadioPopper boxes must be attached to sending and receiving flash units somehow. This can be done semi-permanently with double-sided tape, Velcro hook and loop fasteners, or an optional RadioPopper mounting bracket. Regardless of how it's done, the result is a small box that sticks out from the side of the flash unit. This can be a little awkward, particularly on flash units with curved fronts like the 580EX, and it can cause reliability problems if the RadioPopper receiver is bumped out of alignment with the wireless E-TTL receiver window.

The PX devices are fairly minimalist. Both components are small, lightweight, thin-walled plastic boxes. They have a very terse screen and input system which consists of two seven-segment LED numerals, two LED lights, and two push buttons. Configuring the devices involves cycling through

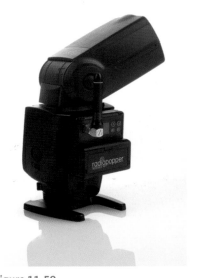

Figure 11-59

A RadioPopper PX receiver attached to a 580EX II slave

various two-letter menu choices, and it's essential to have the manual on hand to know how to work it. For this reason, it's best to configure and test the devices prior to a shoot. It also lacks a test button, which makes setup testing somewhat inconvenient. The RadioPoppers do not have any way for firmware updates to be uploaded. If the unit goes into P1 clone mode, for compatibility with a previous RadioPopper model, it can seem unresponsive.

RadioPoppers built for the North American market transmit from 902–928 MHz. This means they operate on the same frequency band as GSM-900 mobile phones used almost everywhere in the world except for North America and Japan.

11.11.3 PocketWizard ControlTL devices

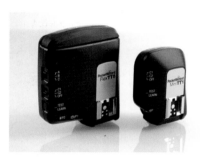

Figure 11-60

The last of the three radio transmitter systems that supports power output levels is from LPA Design. Best known for its sync-only PocketWizard devices (section 11.10.1), the company has produced some highly programmable and compact hotshoe adapters that enable a wide range of advanced Canon E-TTL features wirelessly.

Like the Quantum devices, the ControlTL devices don't bridge E-TTL commands from a master flash unit, but connect directly to the camera and interpret the commands it would normally send to a flash unit. Radio waves are then used to transmit sync, metering, and other data. ● *Figure 11-60*

At time of writing the product line consists of two devices: the MiniTT1 and FlexTT5. The MiniTT1 is a very compact transmitter, powered by a CR2450 lithium coin cell which fastens to the camera's hotshoe. It has an integral antenna, a few switches and buttons, and a pass-through hotshoe attachment on the top which connects to a flash unit's foot. The hotshoe allows for a flash unit and a MiniTT1 to be attached to the camera simultaneously if desired, but it does not let the unit act as a receiver. ● *Figure 11-61*

Figure 11-61

The FlexTT5 is a noticeably larger device that can act as either a transmitter or receiver. Since it needs to sit and wait for radio signals when it's in receive mode, it's powered by two AA cells. The receiver connects to a camera via a hotshoe, adds a couple of sockets for controlling external flash units or remote cameras, and has a swiveling antenna.

Both devices are available in Canon and Nikon versions, but the two product lines are dedicated to one manufacturer only and do not interoperate or translate one maker's TTL commands to another's.

Basic features

Like other radio remotes, the two devices can be set up in simple master/slave fashion. The MiniTT1 attaches to the camera's hotshoe and transmits sync and metering data wirelessly by radio to the FlexTT5, which then commands any flash unit connected to it to fire.

Alternatively, one FlexTT5 can be used as a master and another as a slave. The system is compatible with many aspects of Canon's E-TTL; it supports flash metering, ratios, high-speed sync mode, and flash exposure compensation set on-camera. E-TTL ratios are supported, though they're referred to as "zones" and not "groups".

At time of writing, stroboscopic mode, flash bracketing (FEB), menu control of flash units, and some other functions are not supported by ControlTL devices.

Up to 26 different transmission frequencies are available to reduce the chance of channel conflict with another photographer's PocketWizard devices. The FlexTT5 can also be used to trigger a remote camera as well as a remote flash unit.

Figure 11-62
MiniTT1 on-camera

Compatibility with sync-only PocketWizards

The ControlTL devices can transmit on the same frequencies as regular sync-only PocketWizard devices. This allows photographers who have an investment in the older system to use the devices as sync-only receivers with a MiniTT1/FlexTT5 transmitter. Note that all devices must be designed for use in the same region in order to interoperate, for the regulatory reasons mentioned earlier.

Manual output controlled by the 580EX II

When a 580EX II is connected to a ControlTL device's hotshoe, it's possible to control the manual output of three separate groups ("zones") of flash units. Power output is specified in fractions, not ratios as is normal for E-TTL.

Upgradeable via USB port

Devices such as the ControlTL are little computers driven by software. Many such hardware devices are difficult or impossible to reprogram, but the MiniTT1 and FlexTT5 have mini USB type B ports for connecting to a personal computer. When LPA Design releases new firmware, it's easy for users to download updates from the Internet. The company has introduced a number of firmware updates that fix problems and add new features this way.

Figure 11-63
PocketWizard menu

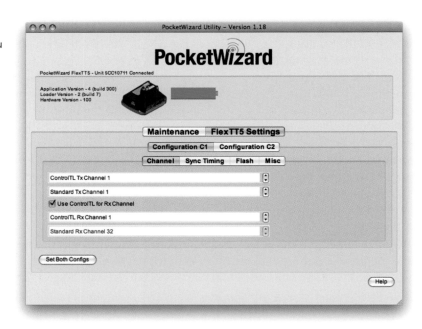

Advanced features

Because they talk directly to the camera and flash unit, the ControlTL devices offer some interesting and unusual features. Most notable, perhaps, is the fact that the maker has released software upgrades that add a variety of new functions, such as more efficient high-speed and second curtain sync and more powerful preflashes (in addition to fixing other problems).

Higher efficiency sync

Normally, Canon high-speed sync flash starts pulsing the flash tube a bit before the shutter actually opens. The ControlTL devices, since they control the flash unit directly, have tightened up this flash trigger timing so that the tube begins pulsing closer to the shutter opening and closing times. This can mean increased high-speed sync output on some camera models, which translates to greater light output and decreased battery usage.

A similar trick is employed in the ControlTL version of second curtain sync. Flash timing is moved closer to the actual second curtain closing, resulting in less blurring at the front edge of a moving object.

HyperSync

Perhaps the most interesting feature is a function called "HyperSync", which gives the ControlTL boxes the ability to exceed the camera's X-sync speed without using high-speed sync at all.

As noted in section 7.11, flash units can't expose the full frame of a focal plane camera if the shutter speed goes too high. The usual solution to

the problem is to pulse a flash tube very rapidly, enabling high-speed sync. ControlTL devices support regular high-speed sync but add another way to exceed a camera's X-sync.

HyperSync takes advantage of the fact that the light produced by a flash tube drops off gradually if the tube is fired at full power. If fired at partial power, most battery-operated devices cut off power to the tube sharply, and the light drops pretty well immediately. But at full power, the light output has a long "tail" as it decreases. HyperSync fires the flash tube *before* the sync command is sent, and thus before the shutter actually opens. Then, as the light output gradually drops off, a full frame can be exposed at a high shutter speed.

HyperSync requires very precise timing over flash firing relative to the shutter opening, and each camera mechanism has slightly different time requirements. For that reason, the Windows or Mac OS X software included with the ControlTL hardware allows the timing to be adjusted in minute increments. Through trial and error, it's possible to squeeze the most performance out of each flash unit/camera combination, thus getting the highest shutter speed possible while maintaining full flash exposure and avoiding the black bar problem. It's also possible to specify the shutter speed at which the ControlTL device will transition from HyperSync to regular Canon E-TTL high-speed sync. ● *Figure 11-64*

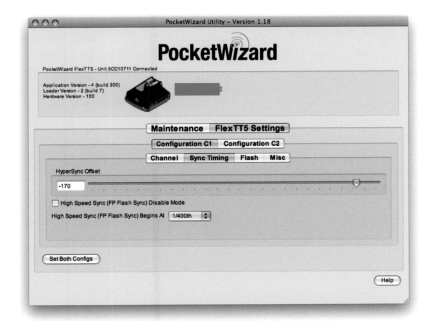

Figure 11-64

Range limits

The biggest weakness of the ControlTL system springs from one of its advantages. For compatibility, the devices transmit on the same frequency range as their predecessors, so they can trigger a Plus II or MultiMAX remote. Unfortunately, it so happens that certain Canon Speedlites emit radio-frequency noise in the same band when they fire. This noise is well within legal limits, but it interferes with the PocketWizard radio transmission. For this reason, ControlTL performance with certain Canon Speedlites is severely curtailed. Range may drop to 30–800 feet, compared to the 1500-foot expected distance range from regular PocketWizard products.

The problem is severe with ControlTL units sold in North America, which operate on a frequency band from 340 to 354 MHz. Units sold in Europe operate at 433–434 MHz for regulatory reasons, and therefore have greater range. However, the CE-certified products are not available for sale in the U.S. and Canada.

The problem does not occur with non-ControlTL PocketWizard devices because they are usually situated a short distance from the flash unit when operating as receivers. ControlTL units, however, generally clip directly to the flash unit's hotshoe.

Various approaches to mitigating the effect of this interference are available, including using off-camera shoe cords to connect the receivers to the flash units (rather than connecting the receivers directly to the flash feet), adding noise-shielding ferrite clamps to these cables, or adjusting antenna orientation. But these measures obviously represent something of an inconvenience. The official PocketWizard solution is to provide a "sock" of noise-blocking metallic fabric, the RF Soft Shield, which can be wrapped around an offending Speedlite.

The Speedlites that produce the most noise, and thus have the shortest range, are the 430EX, 580EX, and 580EX II. The Speedlites 550EX, 420EX, and 430EX II produce the least amount of noise.

Not compatible with entire Canon range

ControlTL devices are not compatible with all Canon cameras and flash units. Specifically, they're compatible with most Canon digital SLRs since the 20D, and most Speedlite EX models and the ST-E2. Earlier cameras, including all film models, and TTL-only flash units are not supported.

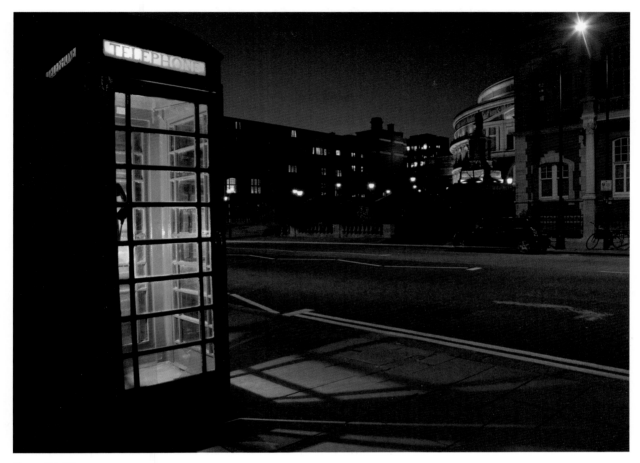

Figure 11-65

Avoiding the hassle of wires, radio remotes are ideal for triggering flash units placed in unusual locations, such as this phone booth near the Royal Albert Hall in London . A high-powered Quantum Qflash unit was used, triggered by a FreeXWire radio remote. EOS 5D, 2.5 sec at *f*/8. ISO 100, 24mm.

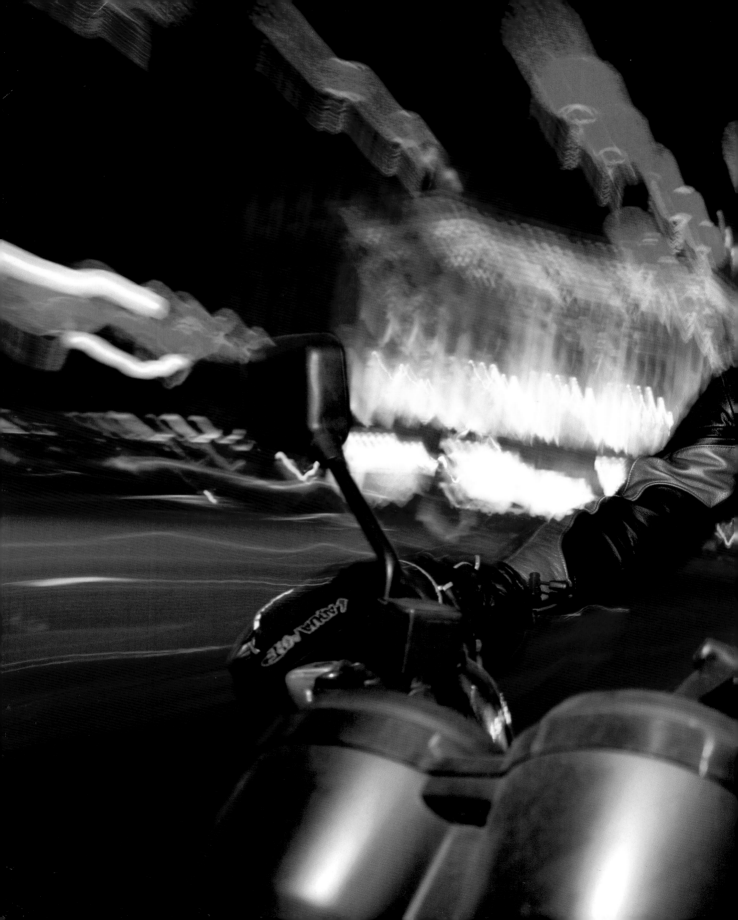

12 Flash Accessories

Camera shops and the Internet are filled with countless flash accessories vying for customer attention. Some are indispensable; others could be charitably described as possessing limited value. This section describes some of the more interesting light-modifying add-ons for small portable flash units.

The majority of these accessories are designed to do one basic thing: enlarge the surface of the light-producing area relative to the subject. This softens and tames the harsh light of a flash, as detailed in the chapter on basic technique. Some of the other accessories restrict the light or alter its color.

One point to keep in mind is that flash compensation should not need adjusting when using a diffuser in any automatic flash-metering mode that works through the lens. The camera will adjust automatically for the stop or two that the diffuser costs, up to the limits of the flash unit's light output. Of course, when using manual flash metering mode, it will be necessary to factor in the reduced light output manually through testing.

So, are these diffusers useful? The answer is a qualified yes. They can definitely help in certain specific situations, and so they have a following in the professional market. But they are not a panacea for flash problems in general. There is no such thing as a universal magic flash accessory that covers all situations. Simply slapping one of these devices onto a flash unit will not automatically yield awesome photos. An on-camera flash unit, utilizing accessories or alone, is no substitute for skilled use of off-camera flash.

Another key point to remember is that diffusers behave differently when used in different spaces. A common trap for beginners is to test out a new diffuser at home in a white-painted living room, then try it out in a vast wedding hall. The reflective properties of the room are critical to the way that most diffusers work.

This is also important when viewing the sample photos in this book for diffuser comparisons. They were taken in a small studio with light-colored walls. Therefore, they do not accurately convey the likely results of taking a photo with a given product in a large hall. This chapter is intended to serve as a guide, but you should always research these items yourself before buying.

12.1 Flash diffusers

There are all sorts of add-on flash diffusing attachments out there that clip or tape onto the flash head. They usually cost a stop or two of light, easily halving the range. There are two basic types: small light diffusers and small panels.

12.2 Small diffusers

Small diffusers do little to enlarge the size of the light source, and so do not, in themselves, soften the light very much. What they actually do is redistribute the flash unit's light output so there's more light scattering around, bouncing off walls and ceilings and so on. They help to reduce the "black hole" effect of flash photography by distributing light more evenly and thus providing illumination to the background scene. They also soften the light a little for foreground subjects.

Small diffusers are best suited for small interior spaces or for macro photography shot without a macro unit. They are less useful when shooting outdoors or in dark interior spaces, where there's no way to bounce the light. In such situations they simply cut down usable range, waste power (plus batteries and money) and increase flash cycle time. They're also problematic when the walls or ceilings are painted bright colors, as the light bouncing off those surfaces will have a color cast. Small diffusers also offer less control, as they just basically spray light around. But all this aside, they can be very useful, particularly for fast-moving journalist or wedding situations.

12.2.1 Sto-Fen Omnibounce

Milky white, open-ended plastic boxes that fits snugly over the flash head, Omnibounces approximate the way bare tube studio lights radiate light outwards in a near sphere. For this reason they're very useful with wide angle lenses. ● *Figure 12-1*

Photojournalists often have these accessories permanently fastened onto their flash units, since they can help even out the spread of light when used indoors. Yellow and green versions are also available to help color-correct for tungsten and fluorescent lighting situations. Because of their tight-fitting design, Omnibounces must be designed specifically for each flash unit model and are not available in generic one-size-fits-all versions.

Figure 12-1

12.2.2 Gary Fong Lightsphere

The Lightsphere is a heavier and larger diffuser popular with wedding photographers. Because a larger device such as this puts out more light, and because its significant bulk and weight can be a problem for the hinges on smaller flash units, it works best with larger hotshoe flash units. This particular Lightsphere is a cloudy white plastic, though more specular versions made of clear plastic are also available. These accessories attach onto the end of a flash unit using fabric straps. ● *Figure 12-2*

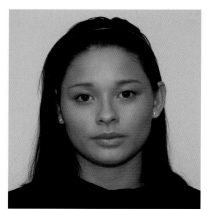

Figure 12-2

12.2.3 Demb Flash Diffuser

This product consists of two layers of translucent plastic attached via rivets to a strap, which allows the diffuser to be tilted forward or back to govern the amount of light hitting it directly from the flash head. It's designed to be used in conjunction with the Flip-It! reflector in the next section, though it can also be used alone. ● *Figure 12-3*

Figure 12-3

12.2.4 Speedlight Pro Kit Flexi Bounce

This fold-out diffuser, from Speedlight Pro Kit, combines a translucent diffuser made of flat polypropylene sheeting with three stippled reflective silver reflectors. The result is a device that reflects some light forward and causes the rest to bounce outwards. When used in a small to average-sized

room with neutral-colored walls and ceiling, the light will bounce around and reduce the black hole effect. ● *Figure 12-4*

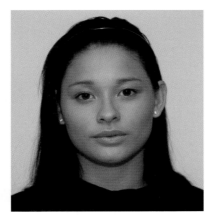

Figure 12-4

12.2.5 Harbor Digital Design Ultimate Light Box

This modestly-named translucent plastic box fastens to the end of a flash unit's head, so it must be bought with the correct attachment mount for a given unit. It's like a larger version of the Omnibounce with a detachable translucent front. It also has an optional black plastic box to restrict side bounce and direct more light forward. In fact, various combinations of pieces can be snapped together, and color filters can be added. It is reasonably flexible in design, but the main box is somewhat bulky and awkward to pack when traveling. ● *Figure 12-5*

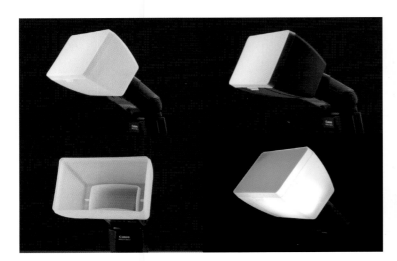

Figure 12-5

12.3 Small reflectors

These accessories enlarge the surface area of the flash a small amount, but also reflect light towards any nearby wall or ceiling. They're adjustable on small hinges, which allows a good deal of control. The reflectors can also be mounted on the long edge or the short edge of the flash head, depending on the orientation of the unit relative to the subject and the desired reflected direction. They don't work as well outdoors or in a large dark room, where they soften the light on the foreground somewhat but do little to affect the background.

12.3.1 Demb Flip-It!

The Flip-It! is one of the oldest products in this market, dating back to the 1990s. This panel, white on one side and black on the other, straps onto the top of a flash head with Velcro and is on a movable hinge. This allows more or less light to be reflected forward at any arbitrary angle. It easily attaches to either the long side or the short side of a flash head. A Flip-It! is shown here with the optional Demb Flash Diffuser. ● *Figure 12-6*

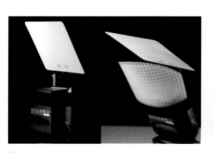

Figure 12-6

12.3.2 PRESSlite VerteX

This accessory ships as a small bag of components which must be assembled before use. It differs from the other two reflectors in that it has two separate halves that can be tilted independently. One side can reflect light forward, for example, while the other reflects light upward. One half can have a white matte card installed, and the other a mirror-like silver sheet.

It's quite versatile, but at a cost: it takes some practice to understand the ways in which the device reflects light, both directly and off nearby surfaces. Its rectangular rubber frame is also a difficult fit on larger flash units such as this 580EX II. ● *Figure 12-7*

Figure 12-7

12.3.3 Hanson Fong Skin Glow

This accessory (unrelated to Gary Fong products) is a double-sided reflector. It's similar to the Flip-It, but one side is pure white and the other is colored a subtle warm tint. It has a slightly wider hinge, which is sturdy but also difficult to fasten to curved flash heads like the 580EX II. It is shown here attached with a Honl Speed Strap in both long side and short side positions. ● *Figure 12-8*

Figure 12-8

12.4 Medium-sized reflectors

These mid-sized reflector panels essentially enlarge the light output area of the flash, softening the edges of shadows. Unlike small devices, these larger accessories aren't as reliant on white surfaces to bounce light and thus are of more value outdoors or in dark churches, large banquet halls, and so on. However, they're really meant for close-range shooting—they won't help much when taking pictures at a distance and indeed will hinder the process, as they cut the range of a flash unit by at least half and again. After all, a mid-sized panel some distance away becomes a small light source relative to the subject. ● *Figure 12-9*

Figure 12-9
A classic difficult situation for a photographer: an aisle shot taken in a large abbey with a high, dark ceiling. There were no surfaces for bounce flash, and it was too dark to rely entirely on ambient light. Since things were moving rapidly, and a large reflector on a stand wouldn't work, a flash unit with a LumiQuest Quik Bounce was used.

12.4.1 LumiQuest Quik Bounce

This scoop-shaped vinyl device is angled forward slightly, to catch most of the light thrown upwards by the flash head. It thus increases the area of the light-producing surface. It attaches to a camera's flash head with the usual Velcro strips, though it's shown here with a Honl Speed Strap.

As it's reasonably large for a portable reflector, it offers a decent surface area for portrait shots, though does tend to stick out vertically quite a bit. For added flexibility, the Quik Bounce has a pair of doors or flaps that can be held open with Velcro dots. The opening allows more light to escape upwards for situations in which a bounce flash is possible. ● *Figure 12-10*

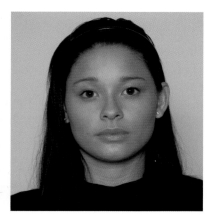

Figure 12-10

12.4.2 LumiQuest Softbox III

This unit is a collapsible, vinyl, pyramid-shaped accessory that fastens onto the flash head with double-sided Velcro tape. It has a double-thickness oval patch in the center to reduce the hotspot effect caused by proximity to the flash head. The Softbox III is shown here attached to a Honl Speed Strap, to avoid the messiness of Velcro tape. It's effective for close-range work, though a little heavy for its size. It also blocks a flash unit's autofocus assist light when directed forward, as it normally would be used. It flattens to a thin square for easy transportation. ● *Figure 12-11*

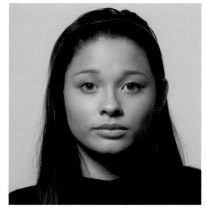

Figure 12-11

12.4.3 Westcott Micro Apollo

This diffuser is essentially a fabric bag with folding metal frame. It has a white fabric front and silver-lined black sides to reduce spill. The frame has Velcro attachments so it can fasten to the sides of a flash head. It's fairly lightweight, sturdy, and folds flat for easy transport. It expands the size of the light-producing area, but only to about the size of a paperback book. Since it directs all its light forward, it's intended for close-range use in portraiture. It's a little awkward in operation compared to similar add-on panel devices. ● *Figure 12-12*

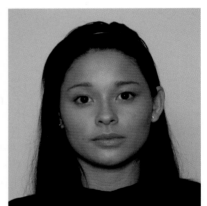

Figure 12-12

12.4.4 Speedlight Pro Kit Reflectors

This is pair of reflectors (the 4 model and the 6 model) that ship as flat-pack kits containing numerous wedge-shaped panels. Their flat sides clip together to form pyramid-shaped flash diffusers. Notably, the reflectors can be accessorized with corrugated plastic grids and the like as they direct all their light forward. They break down easily for packing, but can easily come apart if bumped. ● *Figure 12-13*

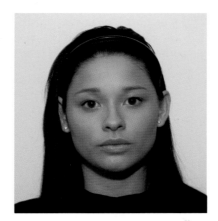

Figure 12-13

12.4.5 Generic vinyl diffuser

This cheap, semi-transparent bag, bought from an Internet auction site, is frankly useless and makes no difference whatsoever in the quality of light. It does, however, amuse onlookers who may ask what the inflatable pillow is for. ● *Figure 12-14*

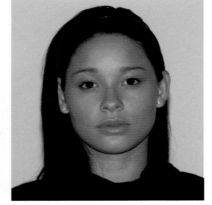

Figure 12-14

12.5 Large portable diffusers

Large diffusers offer softer light solutions but generally with less portability than small modifiers. Many are smaller or stripped-down versions of the light modifiers used in studios.

Figure 12-15
This picture was taken in direct sunlight with a California Sunbounce reflector positioned camera left. Note that a gold and silver striped surface faces the model for a slightly warmer color of light.

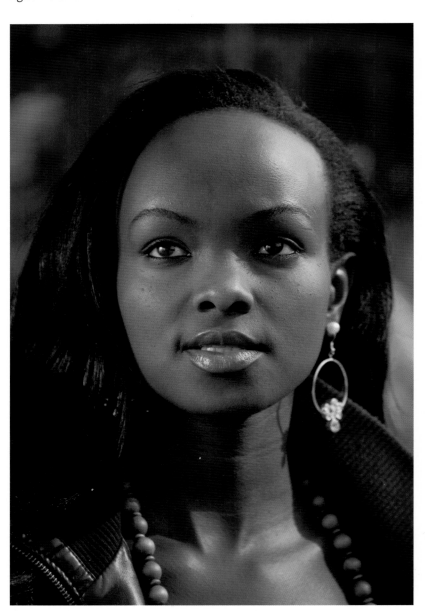

12.5.1 Umbrellas

The classic solution for increasing light-producing surface area in order to soften the light, umbrellas come in a variety of sizes. They can be reflectors (silver umbrellas) or diffusers (shoot-through translucent umbrellas). Most are intended for studio use, but some collapsible models are particularly useful for location work. Collapsibles have struts that fold in half, making them quite small and portable.

Consider the photograph of ancient Noh theatre masks at the start of chapter 9. These masks were lit with a Speedlite bouncing off a collapsible silver umbrella. They would have been better lit by a softbox, as light hotspots are visible in shiny areas, but the portability of the umbrella meant it was possible to take these images on location at a private Noh theatre in Tokyo. ● *Figure 12-16*

There is an important point about using a portable flash unit with an umbrella. In the photo below, the flash head has not been set to cover the entire surface area of the umbrella, which can lead to a hotspot, or brighter area in the center. This may be intentional, or it may be better to zoom the flash head out to provide more even coverage.

For more details on umbrellas, please consult section 13.4.2.

Figure 12-16

Figure 12-17

Figure 12-18

12.5.2 Umbrella brackets

Umbrella brackets are simple metal or plastic brackets that allow a Speedlite-type flash unit and an umbrella to be attached to a light stand. These

tilting brackets have small holes with thumbscrews to fasten the shaft of the umbrella, and a cold shoe on the top for the flash unit. ● *Figure 12-17*

A more flexible bracket is one made entirely of metal, with a small ballhead that lets the flash be pointed in any direction. ● *Figure 12-18*

12.5.3 Lastolite Ezybox

This portable fabric softbox pops open from a flat disc form, somewhat like a self-standing tent. It has a metal ring at the back to which a portable flash unit can be attached, though there's no light seal around the edges of the opening. This softbox is ideal for positioning a soft light source close to a person's face for on-site portraits. It's somewhat larger and heavier than most of the previous accessories, but its larger surface area means it can provide a much softer form of light. ● *Figure 12-19*

It has an optional extending handle for handheld use, though this is awkward without an assistant and a light stand may be easier when shooting solo. The hotshoe attachment takes a little practice to use effectively, though it has the advantage of leaving the flash unit's controls fully accessible.

Figure 12-19

12.5.4 Westcott Mini-Apollo

The 16-inch Mini-Apollo is a sort of hybrid between a softbox and an umbrella. It has a flat fabric diffuser front like a softbox (only one layer of white fabric), but conveniently collapses like an umbrella for easy transportation. It's a lightweight and portable solution for improving flash quality. ● *Figure 12-20*

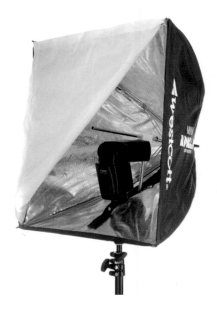

Figure 12-20

Unfortunately, the Mini-Apollo is a little awkward to set up and use. It has a loose-fitting metal rod between the umbrella shaft and the flash unit that tends to wobble. The flash unit controls are not accessible without removing the diffuser fabric, so it's vital to disable auto power-off. Oddly, the instructions show the flash unit facing forward, which defeats much of the purpose of a softbox. Facing backward loses power but increases the softness of the light.

12.5.5 Westcott Recessed Front Apollo

The 28-inch Apollo is the Mini-Apollo's much bigger brother. It's also a square softbox design with an umbrella frame, so it takes up very little space when collapsed. ● *Figure 12-21*

Unlike its smaller sibling, however, the 28-inch Apollo relies on a fairly standard umbrella bracket to support a flash unit, avoiding the loose support system of the Mini-Apollo. This design is fairly sturdy, though it has the drawback of positioning the flash head rather far up the softbox. ● *Figure 12-22*

Given its size, this modifier really needs a high-powered flash unit to work effectively. In fact, it's roomy enough to accommodate up to four battery-powered Speedlite-type units, given proper mounting brackets such as those from Denis Reggie (two-way) and Lastolite (three-way). This allows for highly portable softbox lighting with full support for high-speed sync.

Figure 12-21
A pair of Apollo softboxes in their collapsed form: the Mini-Apollo is on the left, and the 28-inch Apollo is on the right.

Figure 12-22
A Westcott Recessed Front Apollo
shown with the diffuser cloth rolled up.

12.5.6 California Sunbounce Micro Mini

The Micro Mini, from German maker California Sunbounce, consists of a lightweight H-shaped metal frame over which reflective fabric is stretched. An adjustable arm holds the flash unit, which bounces light off the fabric onto the subject. A sturdy and well-engineered reflector, it rolls up into a reasonably compact, though somewhat long, bundle.

The primary advantage of the reflector is that light is bounced back off a relatively large surface area, making the light very soft for portraiture. Its primary drawback is its size and the fact it can catch the wind when outdoors. It's shown here attached to a light stand with a Manfrotto Superclamp, but it's also designed to be held by an assistant—or by you singlehandedly, if you're comfortable operating the camera with the other hand. ● *Figure 12-23*

The name "Micro Mini" might seem a little strange for one of the largest products in this section, but that's because Sunbounce specializes in large professional products for commercial photography and TV and film production. By comparison, this is quite a small reflector. The model shown here has a silver-white surface on one side for neutral lighting and a gold-silver zigzag stripe ("zebra" pattern) on the other for warmer light.

Figure 12-23
The California Sunbounce Micro Mini

12.6 Other flash accessories

In addition to devices for softening light output, there are various accessories available that can modify or shape light in different ways. These tools perform very different functions.

12.6.1 HonlPhoto Speed Strap

This is a convenient strap for attaching accessories to flash heads. Most add-ons require Velcro adhesive pads to be added to the sides of the flash head, which inevitably look a bit untidy and leave a sticky residue. Instead, this strap is a pressure/friction fit rubber and Velcro strap that can be added to the end of a flash unit and quickly removed when it's no longer needed. One minor drawback is that it has a rubber tag with the manufacturer's name that can get in the way of some flash attachments. Nonetheless, it's a flexible solution that's compatible with most of the add-on accessories in this section. ● *Figure 12-24*

Figure 12-24

12.6.2 HonlPhoto Speed Grid

This plastic grid fastens onto the end of a flash unit with a required Speed Strap and restricts the output of a flash unit to a narrow pool. Two versions are available: one with a 1/4" grid and one with a 1/8" grid. The latter offers a smaller area. While a useful accessory, the grid is larger than most portable flash units and thus doesn't fit neatly over the head. ● *Figure 12-25*

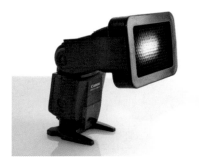

Figure 12-25

Figure 12-26

Note how grids work. They essentially direct a beam into a straight line by blocking sideways reflection. Figure 12-26 shows a pair of grids straight on and at a slight angle, showing how effectively they block off-axis light.

12.6.3 Speedlight Pro Kit snoot with honeycomb

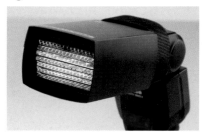

Figure 12-27

This unassuming grid is made of layers of corrugated plastic inside a rectangular sleeve. While rather low-tech, it's lightweight and convenient to use—a bit less crush-resistant than the Speed Grid, but quicker to attach. The grid section can also be moved within the sleeve for limited adjustment. Inexpensive and recommended. ● *Figure 12-27*

12.6.4 HonlPhoto snoot

Figure 12-28

A snoot is a simple cone or cylinder that attaches to a flash unit and restricts light to a narrow area. Studio flash snoots tend to be metal cones, but HonlPhoto products are fabric panels. They attach to the flash head using Velcro and can be shaped into cylinders or cones as required. Simple, but versatile and useful for keeping light away from areas it shouldn't be illuminating. ● *Figure 12-28*

12.6.5 Walt Anderson Better Beamer flash extender, from Arthur Morris / Birds as Art

Most flash units don't zoom farther than about 105 mm, so they scatter and waste a lot of light when used with very long focal length lenses. This can be a problem for nature photographers and others who habitually use telephoto lenses. At the distances they shoot, every drop in flash power is important.

The Better Beamer is a Fresnel lens mounted on a lightweight folding frame that attaches to a flash head with Velcro. The extender concentrates the light from the flash tube, giving more reach when using telephoto lenses 300 mm or longer. These devices are invaluable for nature photographers who often need to add a little fill flash to wildlife located a considerable distance away. The Better Beamer packs down to flat components for easy portability. ● *Figure 12-29*

Figure 12-29

12.7 Ringflash adapters

Ringflashes are ring-shaped flash units that fit around the end of a camera lens. They can be fairly small and low-powered, such as those used for macro photography (the Canon MR-14EX is a typical example), or they can be large studio units (section 13.1.3).

Studio ringflash is commonly used in fashion photography, yielding a characteristic flat look to the light with no shadows on the foreground subject. Subjects lit with ringflash tend to cast a signature dark halo shadow onto background surfaces. Ringflashes are expensive, large units. Macro flash units are portable but don't offer much light output.

A number of companies have introduced plastic light-guiding adapters that transform an ordinary shoe-mount flash unit into a ringflash. These adapters fit around the lens and contain various guides and baffles to provide a reasonably even light output. Neither is a full substitute for a true ringflash, but they do offer relatively flat and shadow-free on-axis lighting for portable situations. They're just somewhat awkward to use. ● *Figure 12-30*

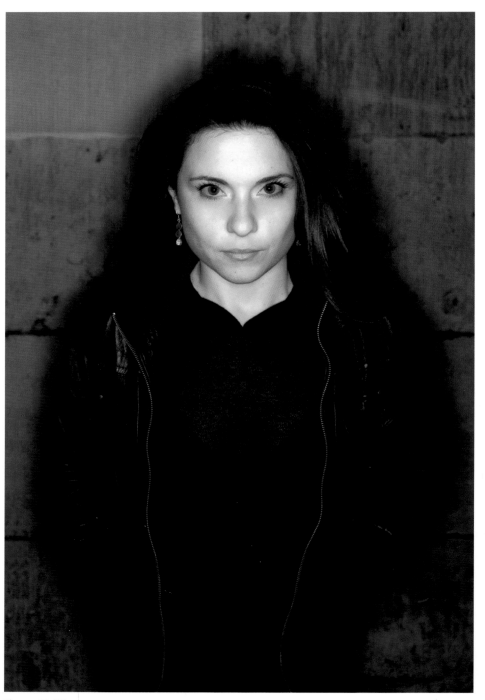

Figure 12-30
This photo was taken using an orbis ringflash adapter. Note the flat lighting and the characteristic dark halo around the model. Color was desaturated for a vampiric look.

12.7.1 Rayflash

The first ringflash add-on commercially available, this unit requires a 500 series flash unit attached to the camera's hotshoe. The adapter fits onto the end of the flash head and angles downwards 90° to the ring itself. ● *Figure 12-31*

There are no supporting structures to keep the ring parallel to the image plane, so it tends to sag a little inwards from the weight. The adapter must be matched to a specific flash model—a single adapter won't fit all flash units. The unit costs a bit over a stop of light.

It works reasonably well, though the weight of the device does seem to put some strain on the flash unit's hinge. It also blocks the AF assist light on the front of the flash unit, making it very difficult to use in low-light situations.

Figure 12-31

12.7.2 orbis

The orbis adapter is similar in concept but different in execution. The adapter slides directly into the flash unit, which does not sit on the flash shoe. Instead, the adapter has to be held by hand around the lens, though the company does sell an optional bracket. ● *Figure 12-32*

The primary advantages of the orbis are that less light is lost down a vertical tube of plastic, and the adapter does not block the flash unit's AF assist light. However, these advantages may be somewhat theoretical, as the orbis doesn't seem that much brighter than the RayFlash. Also, the latter point is fairly moot since the whole rig must be held at a very specific angle for the AF light to line up properly with the focus points.

The orbis is a bit trickier to use off-tripod, since both hands are busily occupied holding things. The flash unit could be attached to a light stand if necessary and mounted vertically, which would make things a little less cumbersome. Its light also has a notch cut out of the end where the flash unit attaches; it doesn't project a perfect circle.

Figure 12-32

12.8 Filter gels

The most commonly available and affordable filters for light sources are paper-thin flexible plastic sheets known as "gels". In years gone by, gel filters were made from animal gelatin, hence the name. Today gels are made from sheets of polyester or polycarbonate in a dizzying variety of colors. They aren't as optically perfect as filters intended for lenses, for the simple reason that they're tools for modifying light output.

Figure 12-33

Gels are usually sold in rather large sheets. They're commonly used for theatrical and cinematic lighting, where big sheets are positioned in front of large hot lamps. Gels have a pretty short lifespan when used in this way, since continuous lighting will fade or even melt gels quite rapidly. Flash is usually less stressful to the filter dyes and material, as flash bursts are so short, but filters still need to be replaced from time to time in situations where precise color accuracy is needed.

Larger flash units, such as studio flash, require big gel sheets cut to size. Since portable flash units are much smaller, huge gel sheets can seem like overkill. A great way to alter the light color from a small flash unit on the cheap is to go to a theatrical lighting store and pick up a gel swatch booklet, such as these from Lee Filters and Rosco Laboratories. ● *Figure 12-33*

Swatch booklets are bound collections of gel filter samples—each coincidentally just large enough to cover the lens of a typical small flash unit—with paper slips describing the exact lighting properties of each gel. The booklets are often available for free, but don't be surprised to be charged for a booklet. Shops and filter makers aren't too keen on subsidizing their use on small flashes these days.

12.8.1 Gel holders

Canon Speedlites do not have built in filter holders, so it's necessary to use either strips of Velcro, or bits of gaffer tape, or attach some sort of holder to contain any filter gels in use. Here are three filter holders for small battery-powered flash units.

LumiQuest FXtra

The LumiQuest FXtra is a vinyl filter-holding pouch that attaches to a flash head using adhesive hook and loop tape. It includes a small storage flap that can hold additional rectangular filters, and the product ships with a useful basic selection.

The holder is a great way to change the color of the flash in moments. The primary drawback is that it isn't wide enough to fit larger flash heads. The diffuser panel bulge on the top of the 580EX II, for example, prevents the FXtra from fitting properly. It's also easy to crease the filters, as it's tricky to slide them into the tight clear filter holder. ● *Figure 12-34*

HonlPhoto Filter Kit

The Honl filter system takes a different approach in that it doesn't use rectangular, sample-sized filters. Instead, it's a collection of Lee gel filters cut down to size and equipped with hook and loop strips. These strips are intended to fasten onto a Honl Speed Strap, which is not included.

Figure 12-34

The filters curve over the head, as shown here. They don't look great, but they offer full coverage of the flash head and easily fit any common portable flash unit. No carrying pack is supplied. ● *Figure 12-35*

GelHolder.com

The Gel Holder is a piece of clear acrylic plastic, folded permanently into an L shape. It attaches to a flashhead using hook and loop fasteners, and can also attach to other products such as the Honl Speed Strap.

The Gel Holder is designed to contain a sample-sized sheet gel. Its hard surface protects the gel well, and it's easy to slide the gels in and out. A simple and straightforward design, though one which lacks any storage options for carrying gels around. It doesn't fit flash heads with curved tops, such as the 580EX II, quite as well. ● *Figure 12-36*

Figure 12-35

12.9 Do it yourself!

The products listed above include a lot of popular tools used by professional photographers. For pros, time is money. They need convenient and reliable solutions that work the first time. A photojournalist might be a bit self-conscious gaffer-taping a cereal box snoot to a flash head in front of a paying client. A lot of effort goes into designing a solid product, but hobbyists have the luxury of time for experimentation, and the option of spending less money. There's no need to impress anyone. So experiment and be resourceful!

A box lined with foil for a reflector. Black straws stacked together to make a grid. Plastic pipes and white nylon for a diffusion panel. A salad bowl for a beauty dish. A translucent milk jug for a small diffuser. An index card strapped to a flash head with a rubber band for a bounce card. Cardboard and black gaffer tape for a flag. A Fresnel reading magnifier to extend a flash unit's reach. These homebrew light-modifying solutions may not be terribly rugged, but they may produce results similar or equal to expensive commercial products.

Figure 12-36

Most traveling photographers also have their own favorite solutions for mounting flash units on location. Some screw coldshoes to sturdy painter's clips. Some use thin-bladed palette knives or trowels and slide the metal piece in a doorframe or a shelf. And then there's the infinitely flexible human light stand... ask an assistant or a passerby to hold the flash for you.

12.10 Supports

There are countless ways to mount and attach battery-powered flash units. Here are some common accessories to do the job.

12.10.1 Plastic foot stand

Inexpensive plastic stands are included with all slave-capable Speedlites. They're nothing more complicated than a plastic base with a slide-in bracket, but they're very effective for setting a remote flash on a flat surface. They can be stored in the flash unit's carrying case. Extra stands are readily available from Internet auction sites at very low cost. ● *Figure 12-37*

12.10.2 Light stand

Light stands are telescoping metal supports for lighting equipment. They come in a variety of heights and sizes, usually consisting of a central column with three folding legs located some distance down. This design makes them less study and more prone to wobbling than camera tripods, but also makes them more portable. It's easy to attach a coldshoe to the top of a small stand for a convenient, portable solution. ● *Figure 12-38*

Figure 12-37
A Sigma flash unit on its stand

Figure 12-38
A pair of Manfrotto Nano light stands

Most light stands are fairly large and heavy affairs, but the Manfrotto Nano stands shown here have legs that fold upwards into the main shaft, resulting in a very small and portable unit. It is only 19 inches when folded, yet can reach six feet when fully extended. Stands like this are a mainstay of photojournalists who need lightweight, portable lighting.

Figure 12-39

12.10.3 Joby Gorillapod

The Joby Gorillapod is engineered with an ingenious set of three flexible jointed plastic arms. The plastic "tentacles" can be wrapped around any convenient object, allowing cameras and flash units to cling to all manner of things. Shown here is the Gorillapod SLR model with optional add-on flash shoe, which is sturdy enough to support the weight of this Speedlite 580EX II. Smaller versions are available to support pocket cameras, and larger Gorillapods can handle even sizable SLRs.

They're particularly useful when working outdoors, where there are often few convenient flat or even surfaces. A camera or flash unit can grip onto a tree branch quite easily. A Gorillapod can't reliably support the weight of a flash unit with a heavy modifier, like a softbox.

Figure 12-40

12.10.4 Justin Clamp

Figure 12-40 shows a Manfrotto "Justin" clamp (named after Justin Stailey, who designed it for photographer Joe McNally). It's a metal clamp with rubber pads in its jaws and a tiny ballhead topped with a coldshoe. The clamp also has a 5/8" stud on the side.

The clamp allows a flash unit to be attached to all kinds of surfaces—tables, doors, shelves—and the ballhead lets it point in any direction required. Very versatile, especially for indoor shoots, though the awkward size and shape means it's a little bulky for traveling.

12.10.5 MagicArm

A Manfrotto MagicArm is an indispensable piece of equipment for location photographers and filmmakers. It's a sturdy articulated metal arm with screw-in points for clamps and brackets. It may be overkill for the typical flash unit, but it can be used in countless ways. The motorcycle shot at the start of this section, for example, was taken using a camera fastened to a MagicArm. ● *Figure 12-41*

Figure 12-41
A MagicArm with optional flash hotshoe attachment.

12.10.6 Kacey pole adapter

Painters and window washers frequently use very long, sturdy, telescoping metal poles in their line of work. On the end of these poles is a standard tapered broom handle thread, onto which paint rollers, squeegees, and other tools can be screwed.

These poles haven't gone unnoticed by photographers, who are always looking for ways to put cameras and light sources into new and interesting places. Such poles can serve as high-vantage-point camera mount and can yield some interesting shots. They aren't perfect, as the poles may flex; therefore, high shutter speeds are needed.

Although photographers have had to homebrew their own rigs for this in the past, the Kacey pole adapter is another solution. It's simply a turned piece of aluminum with a broom handle compatible socket on one end and a 5/8" stud on the other. As shown here, it allows a flash unit to be raised quite high and in a very portable fashion. Unfortunately, it lacks a 1/4" thread. ● *Figure 12-42*

12.10.7 Flash brackets

Large metal brackets for mounting external flash units to a camera are commonly used by wedding photographers and the press for reducing the redeye effect. However, they serve other purposes as well. ● *Figure 12-43*

By raising the flash above the lens, ugly flash shadows cast onto walls behind a subject are less visible. The shadows still occur; they're simply below the subject and may not appear in the final picture. Many flash brackets also have rotating attachments that keep the flash centered above the lens at all times—rather than having it on the side when taking photos in portrait orientation rather than landscape. This can involve flipping or rotating the camera rather than the flash unit.

The primary drawbacks of flash brackets are that they're very large and cumbersome. They transform a camera into a gigantic rig, which can frighten human subjects or make them feel much more self-conscious than they would normally. Another drawback involves AF assist lights. A flash unit raised off the camera may have an assist light that no longer lines up correctly with the camera's focus points, thanks to simple geometry.

Canon makes the Speedlite Brackets SB-E1 and SB-E2 for use with 430EX/II and 580EX/II flash units only. This simple horizontal bracket attaches to the mounting socket on the side of those flash units, providing sturdy and secure two-point mounting. The only difference between the SB-E1 and E2 is that the latter includes a weatherproofed off-camera shoe cord. The SB units have no rotating function and position the flash unit to the side of the camera, not above it, making them more suitable for portrait use than landscape.

Figure 12-42

A Kacey pole adapter, shown here with a tilting flash bracket and a Speedlite.

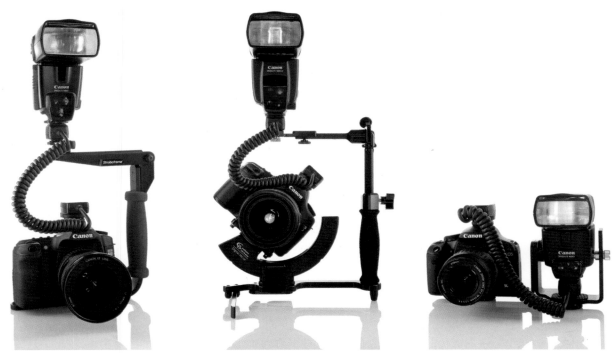

Figure 12-43
From left to right, a Stroboframe Quick Flip 350, a Custom Brackets Digital Pro-M, and a Canon Speedlite Bracket SB-E2. The Quick Flip allows the flash unit to be rotated above the camera. The Digital Pro-M takes a different approach; the flash remains stationary and the camera turns on a rotating bracket. The Canon Speedlite Bracket is compact but has no provision for flash unit or camera movement. It requires a special mounting socket which older Speedlites lack.

12.11 Batteries

Not really an accessory as such, the humble battery is a vital consideration with any electronic device. After all, dead batteries transform a working tool into a useless paperweight. Most Canon flash units use four standard AA penlight cells.

Of the various battery chemistries available, NiMH and NiMH hybrids are the best choice. Disposable batteries are costly over time, and more importantly, are unnecessarily wasteful and harmful to the environment. A set of NiMHs with a good charger has a higher initial investment that will pay for itself over time, and the lowest environmental impact of current battery technology. Higher capacity batteries (NiMH capacities range from about 1600 to over 2850 mAh, or milliamp hours) are most convenient.

Note that AAs consist of a single electrical unit and thus are technically cells and not batteries. However, "cell" does sound a bit pedantic.
● *Figure 12-44*

Figure 12-44

12.11.1 Standard AA (zinc carbon / zinc chloride / manganese oxide)

Pros: Generic, cheapest batteries sold, based on chemical designs over a century old. Ubiquitous—readily available at a drugstore or corner shop in an emergency.

Cons: Don't contain much power. Can't be recharged; wasteful. Fairly high internal resistance and slow to recharge between shots. Particularly vulnerable to leaking and corrosion when dead.

12.11.2 Standard AA alkaline (LR6)

Pros: Alkalines are cheaply and readily available anywhere. Store a lot of power and go a reasonably long time between replacements.

Cons: Last much longer than carbon zincs but otherwise have the same disadvantages. Can't be recharged; wasteful. Recycle time to full power can range from 6–20 seconds, depending on how new they are. Not as effective as NiMHs in high-drain devices.

12.11.3 Rechargeable nickel-cadmium (NiCad/NiCd)

Pros: Relatively inexpensive, rechargeable hundreds of times. Fairly low internal resistance and so decrease the recycle time the flash unit will take to recharge to full power to 4–6 seconds.

Cons: NiCad cells are hazardous household waste (cadmium is a toxic heavy metal) and should never be thrown into the garbage. Limited capacity and thus short runtime between charges. NiCad cells can drain dead ("self-discharge") within a few weeks after charging. Some have non-standard casings that don't maintain reliable electrical contact. Can't maintain a full charge if recharged before being fully discharged, a voltage depression phenomenon sometimes called the "memory effect".

12.11.4 Lithium AA (FR6)

Pros: AA cells using lithium chemistry. Store a lot of power, have long shelf lives, and recharge the flash at roughly the same rate as alkalines. Noticeably lighter in weight than other AA types.

Cons: Expensive and not rechargeable (unlike the lithium ion and lithium polymer batteries used in cameras and computers). Steep death curves: will work fine and then suddenly run out of power. Cannot be mixed with other battery types. Older flash units are not compatible with lithium AA cells due to power issues and might be damaged by them. The 540EZ and all EX series flash units can safely use lithium cells; earlier Canon flash units cannot.

12.11.5 Rechargeable nickel metal hydride (NiMH/HR6)

Pros: Affordable and rechargeable hundreds of times. Higher capacity NiMHs approach the runtime of alkalines. Less hazardous to the environment than NiCads. Similar rapid flash recycle time as NiCads: around 4–6 seconds. Not affected by the so-called memory effect.

Cons: Must be charged before first use, because they self-discharge quite rapidly, especially at warmer temperatures. Require different chargers from older NiCad chargers. Heavier than most other AA batteries. Deliver consistent output during use, but drop rapidly when empty.

12.11.6 Hybrid/low self-discharge NiMH

Pros: All the advantages of NiMH, since they're a refinement of the NiMH design ("hybrid" is a bit of a marketing misnomer in this respect). Arrive from the factory conveniently precharged, and their low self-discharge rate also makes them more useful for occasional use. Most are billed as being able to be recharged 1000 times. Similar rapid flash recycle time to regular NiMHs.

Cons: Same as regular NiMHs. Relatively new technology, not yet proven in the marketplace. Slightly lower maximum capacities than regular NiMHs.

12.11.7 NiMH Chargers

Chargers for NiMH batteries come in three basic varieties.

Figure 12-45

Cheap chargers (left) are not computer controlled and simply pump power into the cell. They usually have safety cutoff circuits that prevent over-charging, but tend to shorten battery lifespan because they can't charge cells at rates appropriate to the condition of the cell. Not recommended, especially older model chargers designed for NiCad cells, which can damage NiMH cells.

Smart chargers (center) contain computers that charge cells at different rates depending on the state of the cells (e.g., ramping up a charge versus topping up a charged cell). Unfortunately, the unit shown can only charge cells in pairs, which means that charge rates can't be optimized for each individual cell. However, it's ideal for traveling, since it doesn't require a separate power brick.

Advanced smart charger/conditioners (right) also contain small computers, but the unit shown here can optimize the charge for each cell individually, something most chargers can't do. Each charge rate can be manually adjusted, from slow (better for improved longevity of the cell) to fast (better when in a hurry). Larger models are available that can charge more than four cells at once.

12.11.8 Other battery tips

Many batteries can leak corrosive liquid if fully discharged. It's wise to remove batteries from any device that won't be used for a length of time.

Some flash units can behave erratically when battery power is low. Weak batteries normally result in long recycle times, but can also result in the flash triggering randomly, the zoom motor buzzing at odd intervals, etc. Similar symptoms occur if the flash unit isn't firmly seated in the hot-shoe, or if the battery contacts are dirty or corroded.

As batteries are nothing more than chemical reactions contained in metal cans, they lose power when they become cold. They resume normal performance when warmed up again.

12.12 External battery packs

While portable and convenient, AA batteries are quite small and don't have much capacity. This can be a real problem for working professionals who need to take large numbers of photos in a day. Cycle time is also critical, and anything that can reduce the time between flash shots can be very useful.

Most of Canon's high-end flash units have sockets on the side that can accommodate external high-voltage (270 volts) battery packs. All Canon packs use the same proprietary connectors which fit any Canon high-voltage compatible flash unit. Canon does not sell AC adapters for its flash units. ● *Figure 12-46*

Figure 12-46

The packs have two basic functions: they speed up the flash's recycle time between shots to a second or two (critical for news or wedding photography) and extend the runtime between changing batteries. They can also be useful in cold weather, since the pack can be stuffed inside a jacket to keep the cells warm.

268
PART C EQUIPMENT
CHAPTER 12 FLASH ACCESSORIES

Figure 12-47

12.12.1 Battery pack types

The largest and oldest Canon pack is the Transistor Pack E, which takes six C batteries with the battery magazine. It can also take the optional NiCad Pack, which has its own special charger. This large bulky pack was the usual power supply for the Speedlite 480G.

Far more convenient is the Compact Battery Pack E, which takes six regular AA alkaline, NiCad, or NIMH batteries. The Compact Battery Pack CP-E2 can also accept lithium AA cells. Either compact pack can be attached to the bottom of a camera using the tripod mounting screw.

The slightly larger Compact Battery Pack CP-E3 uses eight AA cells. The Compact Battery Pack CP-E4 is similar as well as weatherproof when used with a weather-sealed unit such as the Speedlite 580EX II.

These packs have plastic battery holders called magazines. Additional magazines can be bought and preloaded with sets of batteries, allowing rapid reloads when on a shoot. The TP-E, CP-E, and CP-E2 have different sized magazines. The CP-E3 and CP-E4 have incompatible magazines because of the latter's weatherproofing. ● *Figure 12-47*

A number of other companies also sell high-power battery packs compatible with the Canon Speedlite high-voltage connector, though special adapter cables are normally needed. These products include Quantum Instruments' Turbo (lead-acid) and Turbo Z (NiCad), Lumedyne's Cycler, and Dynalite's Jackrabbit. These high capacity packs are fairly large and heavy. They also don't use standard batteries and must be recharged when depleted. ● *Figure 12-48*

Figure 12-48
A Canon CP-E4, A Quantum Turbo 2x2, and a Quantum Turbo SC. The Canon pack contains AA cells, whereas the Quantum packs are sealed, rechargeable units with no user-replaceable cells.

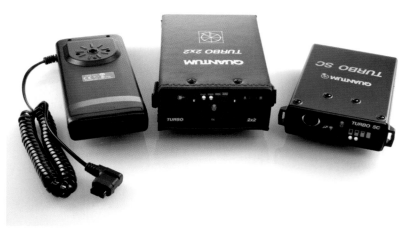

While a necessary evil in many circumstances, packs are fairly heavy, bulky, and inconvenient (especially the huge Transistor Pack E and third-party

products); they also require that the flash unit be tethered to the battery pack via a coiled cord. Note that flash units will not work with a high-voltage external pack if the flash unit's internal AA batteries are dead or missing. The high-voltage power is used solely for recharging the unit's capacitors, not for powering its control circuitry.

A number of manufacturers also sell low-power battery packs (such as the Quantum Bantam), which can be connected to most AA-powered EOS flash units, even those that don't have special power sockets. They work by replacing the AA batteries with a dummy plastic shell and running a cord to the power pack. Such packs require small notches to be cut out of the battery door to run the wire. A notched door on a used flash unit is a pretty good sign that it was used by a professional photographer. These packs aren't high-power and therefore can't speed up the recycle time as dramatically—they're more useful for increasing the number of shots between battery changes.

Keep in mind that portable flash units were not designed for continuous high-power use. It's easy to damage a flash unit if too many high-power bursts are fired in a short period of time, something an external battery pack may make possible. Try not to fire flash bursts for longer than a few seconds, especially at full power manual or small aperture TTL firing. Smoke emerging from a flash unit is universal shorthand for "stop immediately!"

13 Studio Flash

> **• KEY POINT**
>
> Automated TTL or E-TTL metering cannot be used with studio flash equipment. Manual metering is the order of the day.

Figure 13-1
A flash tube: the heart of any studio flash system.

While any kind of flash equipment can be used in a studio setting, the term "studio flash" generally refers to large, non-portable flash equipment that is powered by household AC current. Large, expensive, and daunting, studio gear has always represented something of an impenetrable barrier between the amateur and the professional. The jump from battery-powered flash to studio flash has traditionally been one fraught with mystery and governed by studio apprenticeships. Equipment was expensive, difficult to use, and hard to learn.

Aside from the cost, the biggest stumbling block to using studio flash has been the fact that it's almost always metered manually. But, as discussed in section 10.2.1, digital cameras have made manual metering much easier to learn and master. With many companies introducing affordable, low-end studio flash units for the advanced amateur market, there's never been an easier time to make the transition to studio lighting. ● *Figure 13-1*

So, why use studio lighting at all? There are a number of reasons why studio flash is used almost exclusively by professional photographers, despite the lack of automatic metering.

- ● **Power:** Small flash units powered by AA cells don't have anywhere near the light output produced by the typical studio flash unit. This matters when photographing larger scenes and when stopping down lens apertures. Studio equipment exists to light entire automobiles or even larger objects.
- ● **Speed:** Good quality studio lighting can recharge very rapidly between shots, especially if it isn't being taxed and set to full power. In contrast, lights powered by AAs can take quite a few seconds between each take, limiting their utility for professional shoots.
- ● **Repeatability:** With no batteries to drain, quality studio units can be used day in, day out. Better units are engineered for very accurate power output levels and flash color.
- ● **Versatility:** The range of light-modifying devices and tools for studio equipment is endless.

The rest of this chapter describes some of the common flash-based lighting equipment found in typical studios. Obviously, the specific type of gear will vary depending on what the studio is used for. A small portrait studio will be arranged differently from a huge space used for photographing cars, or a studio used for photographing commercial packaging or food. The equipment described in this chapter is frequently used for basic applications.

Figure 13-2
A digital chip and circuit board from the interior of a Speedlite 580EX flash unit. A pair of monolights in studio softboxes was used to provide bright, even illumination. EOS 5D Mark II, 1/50 sec at *f*/11, ISO 100, 100 mm macro with 20 mm extension tube.

13.1 Types of studio lights

The huge number of firms manufacturing studio flash units includes Balcar, Bowens, Broncolor, Paul C. Buff (AlienBees/White Lightning), Dynalite, Elinca/Elinchrom, Hensel, Interfit, Norman, Novatron, Paterson, Photoflex, Photogenic, Profoto, and Speedotron. Regardless of the maker, studio flash units generally come in one of two configurations: monolight, or pack and head.

13.1.1 Monolights

Monolights are self-contained units that include both the flash tube and the power circuitry needed to drive it. They tend to be roughly cylindrical devices with a tube and reflector mounted on one end and a small control panel on the other. They plug directly into AC power and are known in the UK as "monoblocs". Most have built-in fans for internal cooling. ● *Figure 13-3*

Figure 13-3

Pros:
Monolights each contain their own power supplies, so failure of one unit won't take down an entire setup. They are also relatively inexpensive, allowing beginners to buy their way gradually into a system, component by component. Monolights come in a wide range of sizes and power outputs. Monolights from different manufacturers can be used together if necessary, though they may differ in terms of performance, subtle color output, and so on. ● *Figure 13-4*

Cons:

Since the transformers and capacitors for each flash head must be installed inside the monolight's body, the units can be a little top heavy. In a sophisticated studio environment with multiple flash units, they can be inconvenient, since each unit must have its power output adjusted manually, one by one (except for advanced models with computer interfaces).

Figure 13-4
This simple portrait was taken using two low-cost monolights. One was inside a softbox, positioned close to the model, camera right. The other was on the other side of the room. It had no modifiers and was set to provide subtle outlining to the model's left shoulder and hair.

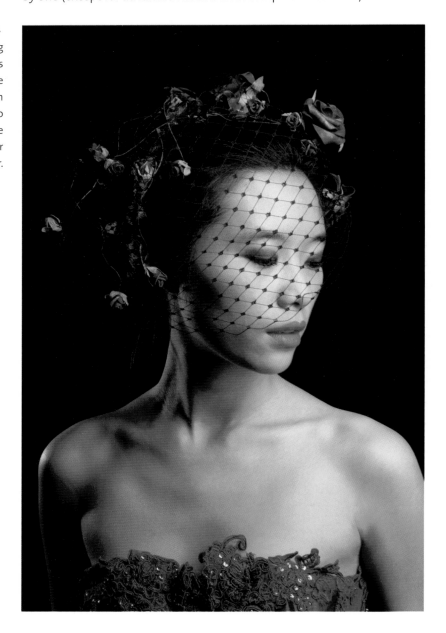

Analog monolight controls

Traditional monolights contain analog electronics to control the power output, using a dial or a slider like a household dimmer switch. The back-panel controls on a monolight vary from one manufacturer and model to another, but they typically look something like this classic Elinchrom studio unit. ⬤ *Figure 13-5*

Figure 13-5

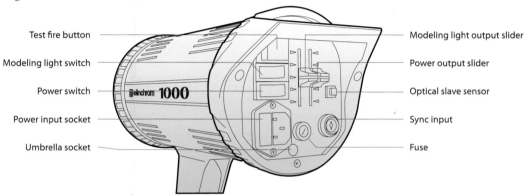

Test fire button
Modeling light switch
Power switch
Power input socket
Umbrella socket

Modeling light output slider
Power output slider
Optical slave sensor
Sync input
Fuse

Power input socket. This is usually a standard female IEC connector so the power cable can be detached for travel and storage.

Power switch. Power for the overall unit. The power rating may be listed here. Most studio units are localized to the region of sale (e.g., 110 VAC for North America, 100 VAC for Japan, and 240 VAC for most of the rest of the world), though increasingly more units are sold with universal power supplies.

Modeling light switch. This enables or disables the tungsten modeling lamp.

Test fire button. This may also illuminate to indicate that the unit is fully charged and ready to go.

Fuse. Some units contain a circuit breaker.

Modeling light output slider. This slider sets the brightness of the tungsten modeling light.

Power output slider. This slider sets the output of the flash tube itself.

Optical slave sensor. This unit has a combined sensor for the optical slave and a push button switch to enable or disable the slave. Some units have white half-dome covers over the light sensors.

Sync input. This is an input socket for an external sync cable. This particular model uses an unusual manufacturer-proprietary plug, but other makers use 3.5 mm audio plugs and the like.

Digital monolight controls

More recent monolights are controlled by digital electronics. This doesn't mean that they necessarily can interface with a personal computer or can have their output levels controlled automatically, though some do. Instead, it means that a specific numeric value can be punched in, making output levels easily repeatable. Some digital monolights use up/down pushbuttons, and others use dials or sliders like traditional analog units. Either way, there'll usually be a small readout panel showing the current output setting. This panel may show the output in stops or may use an arbitrary numbered scale. It won't necessarily display the power output in an absolute form, so it's rarely possible to compare the power output of two different units.

Figure 13-6 shows the key controls of a modern digital unit from Bowens:

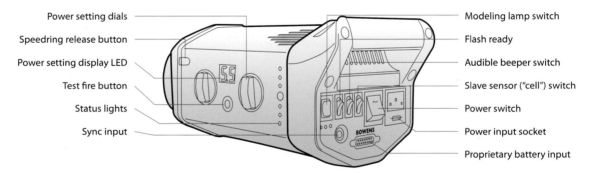

Power setting dials
Speedring release button
Power setting display LED
Test fire button
Status lights
Sync input

Modeling lamp switch
Flash ready
Audible beeper switch
Slave sensor ("cell") switch
Power switch
Power input socket
Proprietary battery input

Figure 13-6

Power input socket. The usual IEC connector.

Power switch. This particular unit has a three-position switch: off, on using AC power, and on using battery power.

Modeling light switch. This switch turns on the tungsten modeling lamp.

Flash ready. This switch controls the way the unit powers on the modeling lamp to indicate that the flash tube is ready to fire.

Audible beeper switch. Engage an audible signal for flash ready.

Slave sensor ("cell") switch. Turn on the slave sensor.

Sync input. A 1/4" plug for sync input.

Proprietary battery input. A proprietary jack for supplying power from an external battery pack.

Power setting dials. This unit has an unusual system. The left hand dial controls the power level in stops. The right hand dial controls the level in tenths of a stop.

Power setting display LED. This display shows the power setting in stops.

Test fire button. The green light indicates the unit is ready to fire.

Status lights. Various LEDs show the status of different functions.

Speedring release button. Used to unlock the unit's speedring.

13.1.2 Pack and head lights

The alternative to monolights is pack and head, whereby a single large power pack supports multiple flash heads linked by heavy cables. The packs, sometimes called generators in the UK, vary in size and capacity, but all tend to be fairly expensive. They can have a symmetrical design where all heads get an equal amount of power, or an asymmetrical design where one or two heads receive higher power output levels.

Pack and head lights are the workhorses of many large professional studios, though separate monolights are frequently used as supplementary lighting when required. Recent digital pack and head units have USB interfaces for personal computers and can be controlled remotely using special software. These programs set up a sort of virtual interface on-screen for configuring complex lighting setups. The settings can be saved to disk and restored later. Of course, the physical equipment has to be moved and positioned on the set by hand, but at least power output settings can easily be accessed. ● *Figure 13-7*

Figure 13-7

Pros:
A single pack can power multiple heads, so it's simple and quick to adjust the output of each head without a lot of walking around. The output controls are centralized on the pack. The heavy and bulky transformers and capacitors are also located in the pack, so heads can be relatively lightweight and small. ● *Figure 13-8*

Cons:
The systems can be quite costly. Cables to the heads can be fairly heavy and usually involve proprietary connectors, making it expensive to have long cable runs (a 15-foot cable for one proprietary system costs as much as an entire entry-level monolight). Failure of a pack will take down the whole system. One generally can't mix and match heads and packs made by different manufacturers. ● *Figure 13-9*

Figure 13-8
Compact and rugged, Swedish-built Profoto units are popular with pro rental companies.

13.1.3 Ringflash

Ringflash units are specialized heads that employ large ring-shaped flash tubes. Like smaller macro rings, studio ringlights fit around the end of a lens, but they provide considerably more power output. The result is flat, even lighting with essentially no shadows on the foreground subject. However, if the subject is close to a wall then there will be a characteristic dark halo shadow pattern. ● *Figure 13-10*

Studio ringlights are a popular tool for fashion photography because of the punchy look they produce. Used more subtly, they can also provide shadowless fill.

Figure 13-9

Figure 13-10

Studio ringflashes usually work on the pack-and-head principle because a full power source built around the tube itself can be heavy. The ring attachments often have optional reflectors or diffusers on the front to control the quality of the light, and they typically include a bracket assembly to which a camera can be attached by its tripod mount socket. ● *Figure 13-11*

Figure 13-11
An EOS 5D bolted into a Bowens
Ringflash Pro.

13.1.4 Battery packs

Professional location work, outdoors or in remote settings, often calls for portable high-power solutions, or at least flash units bigger than a Speedlite. Consequently, many makers sell portable packs containing large rechargeable batteries, usually lead-acid gel batteries similar to those used in electric wheelchairs. The packs naturally follow a pack-and-head model, and some can be recharged using a car adapter. They are specialized professional tools and are priced accordingly.

They are extremely useful for documentary and fashion photography, as they permit full studio power basically anywhere without the inconvenience and expense of noisy portable generators. Of course, generators are still used for lavish expedition-type photo shoots, where there's a budget for a dozen assistants and an air-conditioned trailer for the talent, but battery packs are suitable for more modest shoots. ● *Figure 13-12*

Figure 13-12
Elinchrom Ranger Quadra, Bowens Explorer 1500, and Bowens Travelpak battery packs.

The packs also range in size. The Elinchrom Ranger Quadra, for example, is extremely light and portable as this type of equipment goes. At seven pounds, it wouldn't be fun to wear on one's shoulder for extended periods, but it's eminently doable. It uses tiny flash heads that can be adapted to standard Elinchrom speedrings if necessary. In the photograph that opens this chapter, the small size of the Quadra flash head was ideal for concealing inside a foam sphere.

In contrast, the Bowens Travelpak is the size of a small car battery and isn't wearable, but it can power a pair of full-sized Bowens Gemini monolights that support any traditional Bowens S-type speedrings. Two capacities of interchangeable, rechargeable batteries are available. Additionally, the Bowens Explorer 1500 can deliver 1500 watt-seconds of power, but it's the size and weight of a large car battery.

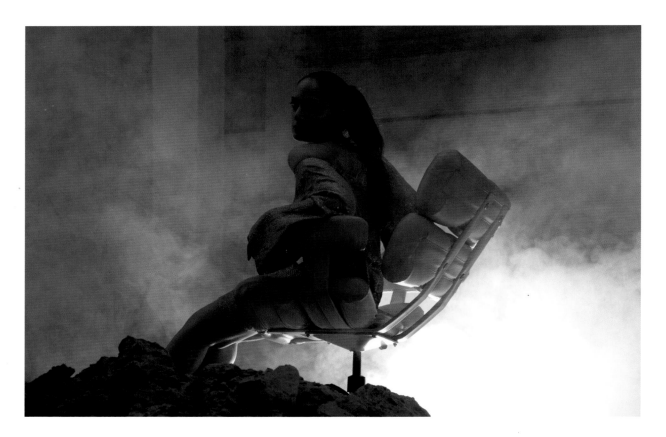

Figure 13-13

This photo was taken in a rubble-strewn, condemned warehouse. It was lit mostly by a Bowens Gemini R flash unit powered by a Travelpak battery. An on-board flash unit was used as an optical trigger and added a subtle catchlight to the model's eyes.

13.1.5 Inexpensive gear

Professional studio equipment can be very expensive, prohibitively so for a beginner. Even renting the gear adds up quickly, so the rock-bottom lights sold on Internet auction sites are very attractive. The question is, are they worth it?

Well, like anything, that depends on priorities. The drawbacks of inexpensive equipment are obvious. The products tend to be low-powered, have long recycle times, produce inconsistent light output or color, tend to be considerably less rugged than name-brand gear, have non-replaceable tubes with short lifespans, may be difficult or prohibitively expensive to repair if they go wrong, and finally have the unknown factor that they may not have had proper safety approvals.

On the plus side, they're cheap! And since any collection of monolights can be mixed and matched as long as precise color temperature isn't a concern, cheap lights can be a good way for a casual amateur or a student on a tight budget to get started.

The key is not to start too low-powered for most applications. A flash unit billed at, say, 150 watt/seconds is very low powered, particularly since manufacturers tend to be a bit generous in their ratings. There's no point in getting something so weak that it can't be used for portraiture in a medium-sized room. So don't buy a unit advertised as under 200 or 300 w/s. Note that these units are often sold in kits with a load of cheap accessories and listed by their combined light output. For example, 450 w/s might sound great, but not if it's a group of three 150 w/s units. ● *Figure 13-14*

Having said all this, it's also worth thinking about future growth possibilities. Does it make sense to invest in something of disposable quality? Or does it make more sense to buy something a bit more expensive but with higher build quality and more growth potential? After all, quality gear tends to hold its value in the used market fairly well.

Some brand name manufacturers also sell introductory-level gear at lower prices, such as this Elinchrom D-Lite unit. This equipment isn't up to the build or power standards of their professional equipment, but it's largely compatible with the rest of their product line. ● *Figure 13-15*

Figure 13-14

Cheap and cheerful. A generic low-powered AC flash unit. This particular product isn't all that more powerful than a couple of battery-powered Speedlites. It's adequate for close-up portraits.

Figure 13-15

Other products sold to beginners are screw-in light bulb flash units. These devices are the size and shape of regular light bulbs, housing instead a tiny flash unit and an optical slave trigger. They screw into an ordinary light socket and fire in response to any other flash unit going off. They can be useful on location for adding a bit more light from existing light fixtures (just replace the bulb with the flash), especially if flash color temperature is needed. They can also be useful for accent lights. However, they're weak, slow, and aren't adjustable in any way, making them pretty limited.

Figure 13-16

13.2 Basic flash unit features

These days most studio units have a fairly standardized shopping list of features.

13.2.1 Flash heads and speedrings

The business end of the flash unit. The most common flash tube design is an omega loop, or near circle. The tube may be tinted a very pale yellow color to warm its light slightly. Positioned at the center of the tube is an incandescent light bulb, used for modeling as described in the next section. ● *Figure 13-17*

Figure 13-17

The tube and bulb are mounted in front of a metal reflector. The end of the head is frequently equipped with a mounting ring known as a speedring, to which various light-modifying attachments can be fastened. Speedrings are manufacturer-specific and conform to no particular universal standard, though sometimes a smaller flash unit maker will adopt the speedring system used by a popular manufacturer. ● *Figure 13-18*

Figure 13-18
Elinchrom (left) and Bowens (right) speedrings.

Figure 13-19
This studio unit is equipped with a heat-resistant Pyrex glass dome.

Optionally, the tube and bulb are covered by a heavy-duty glass dome, mainly to protect the delicate lamps but also to minimize the risk of injury. Some Pyrex domes have a clear UV-blocking coating for improved color accuracy, since ultraviolet energy shows up blue on film and image sensors. ● *Figure 13-19*

Figure 13-20

13.2.2 Modeling lights

Studio lights usually have tungsten or tungsten halogen light bulbs mounted within or next to the flash tube. These continuous lights are used to preview the effect of the light on the scene. They make it easier for a photographer to predict how multiple-light setups will work and to see where shadows are cast. Another useful function in smaller studios is that they can contribute to overall room lighting during setup without adversely affecting lighting during a shot. This is handy to avoid the problem of models with gigantic pupils from sitting in a dark room. ● *Figure 13-20*

Some flash units shut off the modeling lights when firing the flash (to prevent them from contributing light to the scene) and others do not. A common feature on better flash units is proportional modeling lights, where the brightness of the tungsten lamp matches the relative brightness of the flash output setting for a more accurate preview.

The primary issue with tungsten modeling lights is their heat output. Some smaller enclosed light modifiers, such as softboxes, can cause a flash unit with a modeling light to overheat. In such cases, it's best to use the lights only sparingly. There is also a very real risk of fire from high-wattage modeling bulbs (section 7.22.1).

Modeling lights pose a problem for battery units because of their heavy current draw. Some battery systems omit modeling lights, and others put them on brief countdown timers. ● *Figure 13-21*

A recent innovation is a white LED modeling light that draws relatively little power despite a high light output. Such lights can serve as a modest continuous light source for portable video if the camera is set to a high ISO. ● *Figure 13-22*

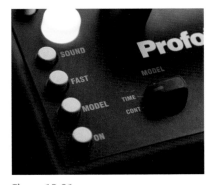

Figure 13-21

Some Profoto battery packs have timer options for the modeling lights to keep battery drain to a minimum.

13.2.3 Optical slaves

As discussed in the chapter on off-camera flash, it's very common for studio flash units to contain optical slave sensors or "photocells", which trigger the flash unit in response to a pulse of light from another flash unit or from an infrared trigger (section 11.7). This is a low-cost yet effective way of synchronizing multiple units with the camera.

Figure 13-22

This compact Quadra Ranger portable flash unit employs a high-intensity LED module.

Figure 13-23

The hemispherical white dome covers the light sensor used by an optical slave.

Since they can be a liability in public settings, where anyone else's camera flash can set off a slave inadvertently, optical slave sensors can usually be turned off (switches are often marked "CELL"). Sensors are typically positioned on the back panel of a monolight, which is sometimes a bit inconvenient as the sensor may not always face the triggering flash unit. ● *Figure 13-23*

Another issue is that optical slaves can be set off prematurely by automated flash units with prefire, such as that used by E-TTL. A recent innovation on a few digital monolights is the ability to ignore preflashes and only trigger when the final flash goes off.

13.2.4 Trigger voltage

The issue of high trigger voltages has been discussed earlier (section 10.5), but it's worth reiterating. Many older studio flash units use very high trigger voltages that can damage a camera. Always confirm that the camera is able to connect to high trigger voltages before using a direct cable. Alternatively, it's usually safer and more convenient to use optical or radio triggering instead.

13.2.5 Duration versus output

Speedlite-type, battery-powered flash units vary the light output by varying the *duration* of the pulse. The longer the pulse, the more light hits the film or sensor. Conversely, for lower power outputs, the flash duration is shortened.

Most studio flash units, however, maintain more or less constant flash durations but alter the *amount of power* being delivered to the flash tube. In other words, when a studio unit fires it usually "dumps" its entire capacitor charge in one go. If a partial output is required, the unit simply doesn't charge up its capacitor fully before dumping.

The pulse lengths also tend to be longer than those on small hotshoe units, making the majority of studio flash units less effective at freezing motion. One exception is when studio flash units are billed specifically as being high-speed capable, which means they often use the duration-altering technique.

13.2.6 Audio confirmation (beepers)

Many flash units contain small beepers or "sounders" that emit a tone when a flash is fired, making it easier to know if a given unit is working or not. Some have different tones or numbers of beeps, so it's possible to tell if a flash in a specific group has fired. ● *Figure 13-24*

Figure 13-24

13.3 General studio gear

The well-equipped photographic studio is overflowing with all kinds of specialized tools and equipment. The most common items are described here.

13.3.1 Light stands

Since it wouldn't be a good idea to have the typical flash-illuminated scene lit by units resting on the floor, light stands are an essential part of any studio. They are similar to tripods in that most have three-legged bases, but they differ in that the majority of the vertical height is a single tube (i.e., the legs join the vertical tube lower down, rather than higher up, as is the case with tripods). This is because rock-steady stability is less of an issue with light stands than with tripods. As long as the stand is fairly sturdy, it doesn't matter if it wobbles a bit when bumped, something that wouldn't be acceptable for a camera tripod. ● *Figure 13-25*

Most light stands are made of aluminum tubing, painted black to minimize unwanted reflections. They generally have telescoping segments and foldout legs at the base. A particularly sturdy design with rotating legs is known as a "C-stand", or "Century stand," and is common on movie sets.

Better quality studio light stands have internal baffles or air piston systems known as air cushioning, which slows the speed at which the collapsing tubes can descend. These are very useful for preventing delicate flash equipment from being severely jolted if a clamp on a light stand's tube is released unexpectedly. It's worth investing in solid light stands rather than going for lightweight versions. Very inexpensive stands are not stable enough, which puts heavier studio gear at risk of toppling.

Light stands generally don't work very well on uneven ground. The legs are joined and designed to work on flat surfaces. Some stands have a "lazy leg", which is a leg of adjustable length to compensate for slight unevenness of surface.

Figure 13-25

13.3.2 Booms

A common attachment to heavier duty lightstands is the boom. Booms are cantilevered or counterbalanced extension arms that can hold equipment at some horizontal distance from the stand. They're useful for holding lights above a subject's head as a hair light, for example, or for positioning small light heads or monolights in tight quarters. Booms often have clips on the end for attaching sandbag weights so that they don't topple over. ● *Figure 13-26*

Figure 13-26

13.3.3 Light stand attachments

Most light stands have turned brass fittings on the top known as "spigots" or "male studs" (yes, really). These are simple turned brass rods, 5/8" in diameter, to which most studio flash units attach. These studs are not threaded, and rely mainly on gravity to hold the unit in place. The flash unit also has a locking handle that tightens up the connection to prevent accidental dislodging. ● *Figure 13-27*

Some light stands may have 1/4" or 3/8" tripod-style threaded bolts for attaching smaller battery-operated Speedlite flash units and other accessories.

Figure 13-27

13.3.4 Ceiling support systems

While light stands are ubiquitous in any studio, they can obviously get in the way, particularly in smaller spaces. For this reason, many professional studios use ceiling-mounted tracks to hang lighting equipment. The tracks may have pantographs or scissor mechanisms so that the flash units can be moved easily from one vertical position to another.

13.3.5 Backdrops

Portraits and product shots often benefit from simple, uncluttered backgrounds. While bare walls can be used, it's often easier to hang a backdrop behind the subject for a clear, unmarked surface.

Canvas and muslin

Fabric, sometimes painted or patterned, has been used for studio backdrops since Victorian times. In those days, portraits were usually taken in front of heavy canvas sheets, frequently painted like the stage flats used in theatres. In keeping with the style of the age, these paintings often had neoclassical themes, such as columns and Grecian urns. Today it's more common to see blotchy, abstract patterns that produce broad washes of color when thrown out of focus by narrow depth of field.

The main issue with fabric is that it must be carefully rolled for storage to avoid unsightly creases. Thinner muslin can be steamed and ironed. Alternatively, fabric can be deliberately crumpled so that it yields random patterns when kept out of focus.

Seamless paper

Though painted fabric has its place, creases are difficult to avoid. For that reason, simple, wide rolls of paper are a very common studio backdrop. These large rolls of seamless paper, white or black or a solid color, are rolled out from a support crossbar. They hang straight down, meeting the floor in a smooth sweep or scoop that eliminates an ugly join. Once the paper gets dirtied, it can be torn off and a clean piece unrolled. ● *Figure 13-28*

Seamless paper must be stored carefully—either vertically or else on a proper rack. If it's stored horizontally in a box, it can develop flat sections on the bottom of the roll, which results in creases.

Figure 13-28

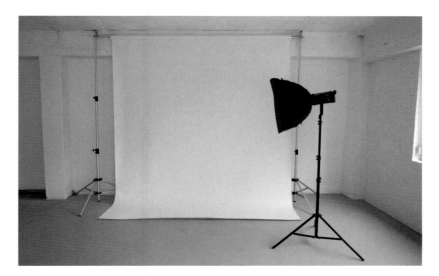

Backdrop supports

Stands, racks, and poles are commonly used to support backdrop materials. Stands usually consist of a pair of light stands with a horizontal crossbar and are ideal for portable setups.

Other solutions include permanent wall racks with hand-operated or motorized chain drives to allow the material to be easily adjusted. Vertical poles extend from floor to ceiling, typically with adjustable spring mechanisms to press firmly upwards. Clamps and crossbars are then attached to the poles to hold the rolls of paper or fabric.

13.3.6 Radio control

Some flash units contain built-in radio receivers, simplifying their use in a multiple-flash radio setup (section 11.9). They may be radio systems proprietary to the maker of the unit, such as the Elinchrom Skyport or Bowens

Figure 13-29

Pulsar, or they may rely on a third-party radio system such as PocketWizard. Some may support both. Recent Bowens lights, for example, support plug-in receivers the size of a matchbook. Receivers compatible with both Bowens Pulsar and PocketWizard are available. ● *Figure 13-29*

Such integrated receivers are very handy since they don't need separate batteries and can't get lost. Of course, they're only useful when used with a compatible transmitter. Most radio systems are sync-only, though some companies such as Elinchrom and White Lightning are transitioning to systems that can specify output power levels.

13.3.7 USB/Infrared control

More advanced digital units may have built-in remote control, accessed via USB cables or infrared signals. These controls may permit the unit to be controlled or adjusted by a remote device or computer program. For example, custom software running on a personal computer might allow a photographer to adjust and save various preset output configurations for a group of flash heads.

13.4 Studio light modifiers

Here one can go on forever. There are countless types of light modifiers for studio gear, though the most common fall into the categories listed here.

Figure 13-30

A studio portrait setup. The primary light source is a beauty light with a diffusing fabric "sock" located on a light stand at camera right. The background is a self-illuminating Lastolite HiLite box. To the front is a Lastolite Trilite/Triflector reflector panel, a three-lobed arrangement that bounces light upwards.

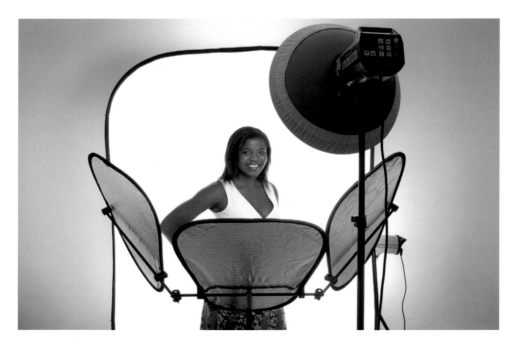

13.4.1 Flash head reflectors

These are metal dishes or open cylinders that fit around the flash tube and direct light outward. A flash unit fired without a reflector sprays light in a complete hemisphere, a situation known as "bare bulb" flash. A reflector guides the light forward, narrowing its angle of coverage and improving its efficiency.

Flash head reflectors are usually described in terms of the number of degrees of coverage that they offer, and are sometimes called "spill kill" reflectors since they keep light from spilling out everywhere. ◉ *Figure 13-31*

One special type of reflector is the background reflector. This unusual shape directs light from a floor-located flash unit up towards a backdrop, creating an oval-shaped pool of light. These reflectors usually have metal clips so that colored plastic gel sheets can be attached. ◉ *Figure 13-32*

Figure 13-31

13.4.2 Umbrellas

The unassuming umbrella is one of the oldest photographic light modifying devices. Like an ordinary rain umbrella, it's a curved round fabric surface supported by metal struts. When not needed, it can be collapsed and put away. Umbrellas are popular because they're convenient and portable, making them ideal travel solutions. In fact, collapsible umbrellas with telescoping shafts and folding struts can fold up into very small tubes.

Umbrellas come in two basic types: reflective and shoot-through. Regardless of which umbrella type is used, umbrellas have a signature scalloped circle catchlight. Often the umbrella struts themselves can be seen, though some have fabric-covered struts to reduce this effect. Most studio flash units have spring-loaded holes to accommodate umbrella shafts, which typically have diameters of around 8–9 mm. It should be noted that Elinchrom units have an unusually narrow hole diameter of 7 mm that isn't compatible with all umbrellas.

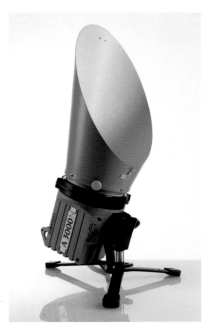

Figure 13-32

While umbrellas are affordable, lightweight, and portable, it is difficult to control the light they produce, particularly shoot-throughs which tend to send out light in every direction. They're great for quick grab-and-go shots with limited setup time, for hobbyists on a tight budget, or for relatively uncritical commercial applications such as school photos.

Figure 13-33

Figure 13-34

Reflective umbrellas

Reflective umbrellas have interiors lined with white, silver, or gold fabric, and are designed to serve as a large area from which light can be bounced. In this configuration, the flash unit sits between the subject and the umbrella, pointing *away* from it. Reflective umbrellas are relatively light efficient, since they are reflectors and not diffusers. They're often backed with black fabric to reduce the amount of backspill caused by light passing through the umbrella's fabric. ● *Figure 13-33*

However, they do have a couple of disadvantages. First, because all the light-producing gear sits between the subject and the umbrella, it's not possible to get the umbrella very close. The farther the light-emitting surface is from the subject, the harder it is to light the subject. Second, though they increase the light area, they don't diffuse or soften it that much.

Shoot-through umbrellas

Shoot-throughs are umbrellas used as diffusers rather than reflectors, made of translucent fabric with no backing material. They are, in effect, foldout diffuser panels. Shoot-through umbrellas can be very soft light sources, since it's easy to position them extremely close to the subject—the flash unit sits on the opposite side of the fabric from the subject, giving more clearance. However, they do consume a lot of light, reducing the overall flash range. They're also not as even as softboxes in their lighting; they tend to produce brighter areas (hotspots) at the center. Despite these drawbacks, they're cheap, portable, and commonly used. ● *Figure 13-34*

13.4.3 Softboxes

Softboxes are so called for two reasons. First, they're capable of producing extremely soft "wraparound" light, making them ideal for portraiture. Second, they're constructed from fabric held together with thin rigid metal rods, like a tent. They are essentially pyramid-shaped constructions. Heavy, black synthetic material prevents light from leaking out the back and sides. The large, flat, face of the box is fronted by at least one, but usually two, layers of translucent white cloth to diffuse and soften the outgoing light. The interior of the softbox is lined with stippled silver metallic fabric. The back of the softbox has a metal ring, a speedring compatible with the studio flash unit to which it's attached. The light from the flash tube radiates out into the box, bounces around, and leaves via the front diffuser panel. ● *Figure 13-35*

Softboxes are collapsible and fairly portable, though most can be time-consuming and inconvenient to reassemble because of the tight-fitting metal support struts. Photojournalists and others who do on-location

Figure 13-35
A typical softbox, with its front diffuser fabric removed to reveal the stippled interior, speedring, and metal support rods.

portraiture use collapsible sprung softboxes, which are considerably easier to open and repack.

Many softboxes have a black fabric lip that extends around the edge, thus blocking some stray light from leaving the sides. Some also have Velcro fasteners that permit the attachment of fabric grids. Fabric grids, similar to the small hard plastic grids for battery units discussed in section 12.6, can direct light outwards with relatively little spill on the sides.

Most softboxes are rectangular, but some have square or octagonal front faces. The shape governs the coverage area of the light as well as the shape of the catchlight in the eye. For example, 3/4 portraits are often best served by rectangular softboxes rather than square ones. ● *Figure 13-26*

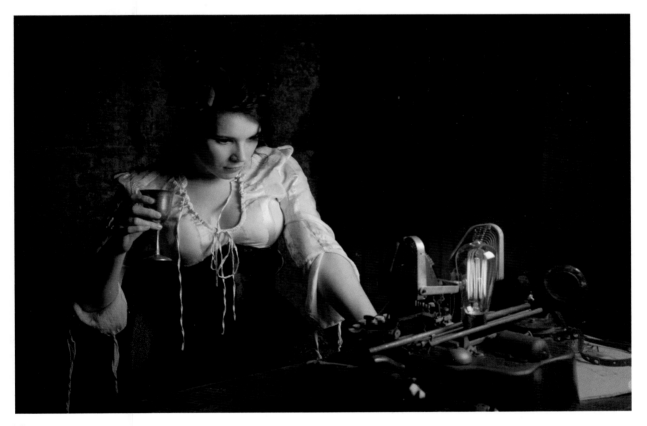

Figure 13-36
This portrait was lit with a single softbox, camera right, as the catchlights in the light bulb and wine bottle reveal.

13.4.4 Striplights

Striplights are essentially very narrow rectangular softboxes. They are used as sidelighting in portraiture in order to give a glowing outline to a subject. They are also commonly used in product photography to emphasize the shape of objects, such as bottles. Striplights were used extensively for the product photography in this book, providing an outlined look for the black plastic devices. ● *Figure 13-37 and Figure 13-38*

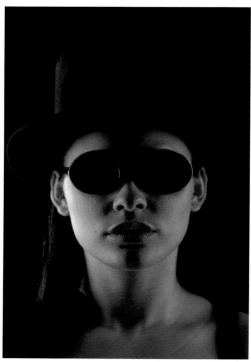

Figure 13-37

Figure 13-38
This shot was lit by two striplights, one on each side of the model.

13.4.5 Beauty dishes

Beauty dishes are shallow, dish-shaped pans. They attach to a flash unit's speedring and are typically bare, silver-colored metal or painted white. The opening for the flash tube is capped by a small metal plate that reflects the light back into the dish and out towards the subject. This plate is either silver or gold for warmer light. ● *Figure 13-39*

 Beauty dishes offer very direct lighting and are frequently used for portraits of young people with smooth, flawless skin. They don't always provide

the most flattering illumination, though the addition of a fabric diffuser can soften the light slightly. The dishes are often used as an overhead light on a boom. ● *Figure 13-39 and Figure 13-40*

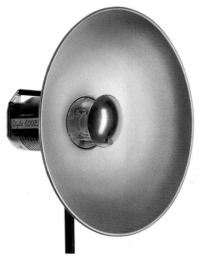

Figure 13-39

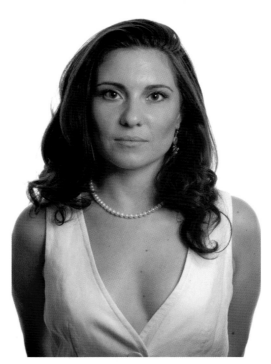

Figure 13-40

13.4.6 Self-illuminated panels

Large, self-supporting fabric panels are available for backdrop purposes. They light up pure white when the head of a flash unit is inserted into a hole in the side. They're ideal for taking high key portraits (section 14.2.1) and 3/4 body shots, since the self-illuminated design prevents the appearance of shadows behind the subject. This makes them great for small spaces, such as passport photo applications, since the subject can stand quite close to the panel without shadowing. The panels can also serve as huge softboxes.

Their main drawback is that full-body portraits can be a problem, since there will always be a visible join between the self-illuminated backdrop and the non-glowing floor. The panels should not be used with an incandescent modeling light, or only if the light is carefully positioned to avoid touching the flexible plastic of the panel, because of a serious risk of fire.

Figure 13-41

Most of the product photos in this book were taken using the Lastolite Hi-Lite panel shown here. This provided a pure white background in a small studio with a minimum of post-production cleanup. ● *Figure 13-41*

13.4.7 Reflecting panels

Simple reflecting panels are bits of fabric stretched over a frame. They come in all shapes and sizes, and mainly serve one function: they bounce light back to fill in shadowed areas. Some, like the Sunbounce described in section 12.5.6, use frames that are slotted together. Others employ sprung metal frames, so they can be stored in a package the size of a plate, yet pop open in moments.

Reflecting fabric may be silver, gold, or alternating gold and silver stripes for different color warmths. Gold panels are often too warm for general use, so the "zebra" stripes are a useful middle ground. Panels may also be black (sometimes called "negative reflectors") to absorb light where necessary. ● *Figure 13-42 and Figure 13-43*

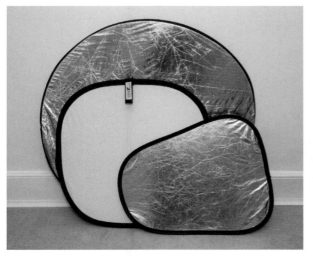

Figure 13-42

Figure 13-43

13.4.8 Snoots

Snoots are simple metal tubes, often with stepped sides, used to turn the light into a beam shape. They concentrate light in a spotlight-like fashion, though not as sharply and at considerably less expense. ● *Figure 13-44*

Figure 13-44

13.5 Hot lights

After talking about flash all the way through this book, what about hot lights? It seems obvious that regular incandescent or fluorescent lighting should make perfectly good light sources for photography.

It's true that hot lights can be used for most forms of photography. Prior to the invention and widespread use of flash equipment, most studio

Figure 13-45

This scale model of the Apollo 11 lunar lander was lit using a pair of tungsten photoflood bulbs in reflectors. Note, however, that the bottom of the model is backlit with a subtle bluish light. This was actually a flash, with its higher color temperature, fired manually beneath the model during the exposure. No filtration was put on the flash head in order to highlight the color difference.

portraits were done with continuous forms of electric light. Hollywood glamour photos of the 1940s, for example, were done using large 8 x 10 glass plate negatives on sets lit by the same huge Fresnel lens spotlights that were used on movie sets of the age.

Most beginning photographers start out using regular home improvement warehouse halogen lamps on telescoping stands. That is, of course, a perfectly reasonable way to go on a tight budget. Another option is blue-coated "photoflood" light bulbs—high-output tungsten bulbs that are deliberately overdriven to produce a whiter light at the cost of a shorter lifespan. ● *Figure 13-45*

Continuous lighting is considerably cheaper even than inexpensive flash equipment. However, flash offers a number of advantages in key areas of photography.

13.5.1 Heat

Hot lights are, well, hot. A studio full of thousands of watts of continuous tungsten lights can get extremely hot. This can cause models to sweat, flowers to wilt, and fire risks to increase. Flash units generate heat mainly from their modeling lights; they generate very little warmth when they fire, simply because the light duration is so short.

Fluorescent tubes are one way to avoid the heat issue—though not all fluorescent lamps are suitable for color photography, since many don't output particularly pure white light. Even fluorescent tubes billed as "full spectrum" can produce slightly greenish light, requiring pale magenta filters to correct.

13.5.2 Power consumption

Tungsten light consumes a lot of electricity. This isn't environmentally friendly; it's also quite expensive and requires a reliable power supply with adequate circuits to handle the load. A studio with permanent continuous light may need its supply circuits upgraded for safety.

13.5.3 Fewer light modification options

The heat output of an incandescent bulb places limits on the types of light modifiers that can safely be used. Softboxes for constant lights do exist, but they must be much more rugged and heat resistant than an ordinary flash-safe softbox. Plastic gel filters on hot lights must be used with care, as they can melt or catch fire.

13.5.4 No freezing of motion

Because flash durations are short, they can be used to effectively freeze motion. At an extreme, they can be used for dramatic motion-freezing shots, such as the splashing raspberry on the cover of this book. The brief exposure duration is useful for ordinary portraits as well. A shot taken with flash is often sharper and crisper than a portrait taken with continuous light.

It takes a surprising amount of continuous light to illuminate a scene, so exposure durations can be quite long when not using flash. This increasing the risk of motion blur, particularly if the subject is moving or the camera isn't on a tripod.

13.5.5 Limited filtration requirements

Figure 13-46
This photograph of the Clockwork Quartet was deliberately lit with continuous tungsten lighting to convey a feeling of Victorian gaslight. The drawback is that the long exposure has caused some band members to blur slightly over the long exposure.

Flash produces light of the same approximate color temperature as daylight. In contrast, tungsten light always has a much lower color temperature and is thus a fairly orange light. When using daylight-balanced film this means that blue filters are needed to match colors. Tungsten-balanced film exists but offers far fewer choices.

This isn't such an issue with digital photography, since DSLRs can be adjusted to any white balance setting required; but mixing and matching light sources of different color temperatures can be an issue.

13.5.6 Inconsistent color temperature

A flash tube fired repeatedly at precisely the same power output will produce light of the same color temperature over and over. Tungsten lights, however, start to age the moment they're turned on. As the filaments burn and age, the tube interiors slowly blacken, resulting in a gradual yellowing of the light. Many photographers throw out older photoflood bulbs long before they're actually burned out, since the color output shifts with age. Flash photography is thus a better way to assure consistent color, which is critical for commercial applications.

13.5.7 Easily adjustable power output

It's easy to adjust the power output from a flash tube by adjusting its power usage or pulse duration. However, tungsten lights change color temperature radically when dimmed, becoming quite orange. Fluorescent tubes are difficult to dim, and many can't be dimmed at all.

13.6 Cheap vs. expensive

Newcomers to photography are often flabbergasted at both the high cost of studio gear and the range of pricing. A pair of monolights, seemingly identical in terms of specifications, might be tremendously different in price. Why are some products so costly?

In photography, as in many things, it's often a matter of getting what you pay for. The question is whether the price is worth it. Here are some key areas to consider.

13.6.1 Reliability and repeatability

For a working professional, reliable and repeatable results are essential. A typical example is a radio trigger for a flash unit. A professional photographing an expensive model or actor, or covering a one-off event such as a wedding or news story, can't afford a flash misfire. An amateur, on the other hand, probably won't mind the occasional blank frame when the flash didn't go off, because they can simply try again. There may be a tenfold difference in price between an auction site garage door opener special and the best sync-only flash trigger, but that difference is relatively unimportant to a professional on a commercial budget, particularly compared to the cost of a missed shot.

Another example is the heat generated by a monolight. A professional doing an assembly-line shoot of children's school portraits, for example, will need to take thousands of photos a session, day in and day out. The flash must fire uncomplainingly every single time. But someone taking a few casual shots on the weekend probably won't need this sort of solid reliability. It's little more than an inconvenience to an amateur if a flash head overheats and shuts down until its thermal safety cutout cools; but such a failure can directly hit a professional's wallet.

13.6.2 Power and color consistency

Catalogue photos need to be precisely color-matched. Color variance can be extremely costly to a retailer, primarily in the form of lost revenue from customer returns. Someone photographing clothes for a catalogue, therefore, needs extremely accurate and repeatable color results. Not all flash units are capable of pumping the precise amount of electricity repeatedly through a flash tube to guarantee color accuracy, so the color temperature of a tube can vary slightly from shot to shot. Likewise, the brightness of the flash unit must be as consistent as possible for commercial work.

Again, this is an area that is largely irrelevant to the amateur. Color and brightness differences may be difficult to spot on consumer monitors, and can be adjusted out in software after the fact anyway.

13.6.3 Unique features

Pro gear may have other specific features to address professional requirements. For example, some studio flash units have very brief light pulses to freeze motion as much as possible. Others may have expensive computer interfaces to make it easier to adjust power output from a central location. Still others may have massive power output capabilities to light a huge studio set.

There are many reasons why pro gear is so costly. But the point here is not that affordable equipment is necessarily of poor quality. It's simply a matter of having realistic expectations, and of matching budget to equipment requirements as much as possible.

PART D: TECHNIQUE

14 Basic Technique

A ll of the detailed technical discussion of the previous two sections is ultimately in the service of one thing: taking great photographs. Photos are nothing more than recorded patterns of light. The trick has always been to combine light and shadow in a way that's evocative, informative, moving, or simply interesting.

Flash photography is about taking control of shadows and light. Ambient or available light photography is about taking advantage of existing light conditions; but with flash, deliberate and very conscious decisions have to be made about what sort of photograph is wanted.

There are arguably four fundamental aspects of light that matter to a photographer: direction, intensity, quality, and color. The tools and technologies described thus far are ways of guiding photons to do your bidding in those four basic terms. This is obviously a vast topic, and one that can fill many books, so the discussions of technique herein really just serve as an introduction to the basics of lighting with flash.

14.1 Direction

The first basic property of light is direction, or simply where the light comes from. In everyday life, we're used to light from overhead sources—the sun or a ceiling fixture. We may want to simulate that effect in a photograph. Or we may want to avoid it altogether and go for something quite different. Take this sequence of photos on the next page.

This is a series of photographs of a model lit by a single studio flash unit. The distance between the light and the model never varied. The brightness remained the same. The only difference was the physical position of the light source, yet the mood changes completely from picture to picture.

The full-on frontal lighting shows the model's face well but has a very flat effect. The backlight results in a silhouette, emphasizing the form but losing the model's face. Side lighting brings a sense of dimensionality and drama at the cost of hard shadows. Top-down and bottom-up lighting tend to look exaggerated and unrealistic. Each direction brings a certain look to the fore, and whether that look is good or bad depends on the photographer's goals and priorities. ● *Figure 14-1 and Figure 14-2*

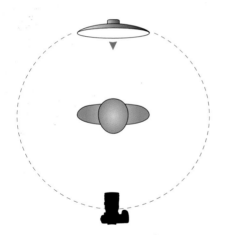

Figure 14-1

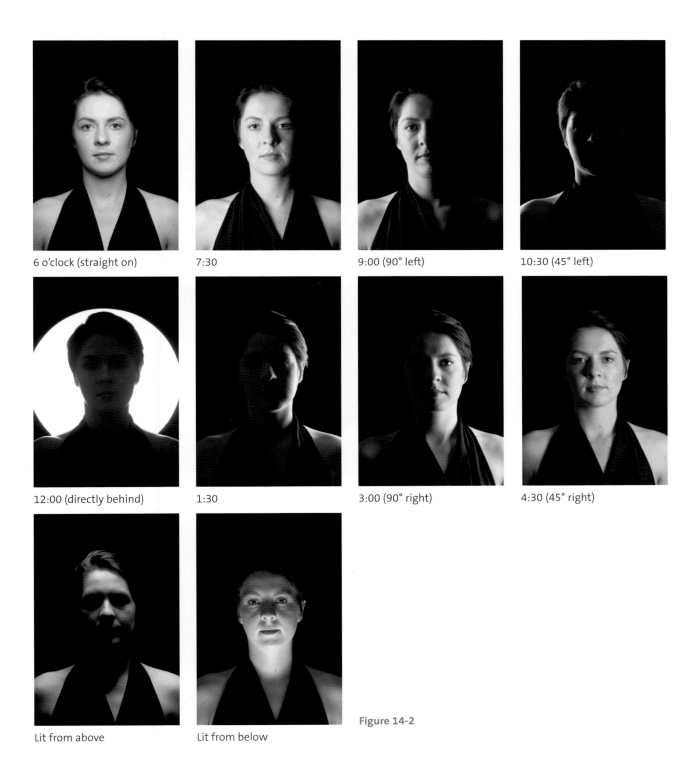

6 o'clock (straight on)

7:30

9:00 (90° left)

10:30 (45° left)

12:00 (directly behind)

1:30

3:00 (90° right)

4:30 (45° right)

Lit from above

Lit from below

Figure 14-2

14.1.1 Short and broad lighting

Two common approaches to lighting a person's face, when the person is not angled directly at the camera, are to position the key light source on the side facing the camera, or to position it on the side away from the camera.

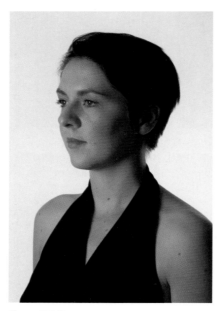

Figure 14-3

Figure 14-4

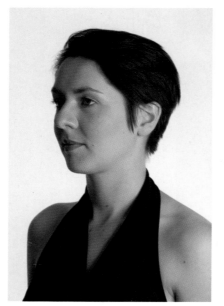

Figure 14-5

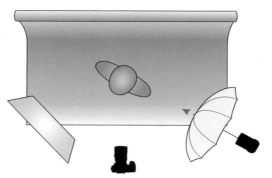

Figure 14-6

Short or narrow lighting refers to a key light positioned to illuminate the side of the face turned away from the camera. This tends to emphasize the shape of the face and is very common in studio portraiture. ● *Figure 14-3 and Figure 14-4*

Broad lighting refers to a key light illuminating the side of the face that faces or is closest to the camera. This can tend to make faces look wider and broader, so it is more often used for people with narrower faces. ● *Figure 14-5 and Figure 14-6*

14.1.2 Multiple light sources

Naturally, multiple light sources can be combined from various angles to produce specific effects. This actor's headshot, for example, uses two light sources and one reflector. The key light is positioned slightly above camera left. A reflector is positioned below his face to fill in shadows. A small unit is positioned behind him to outline his hair and shoulders, in order to separate them from the black background. ● *Figure 14-7*

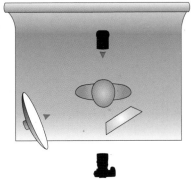

Figure 14-7　　　　　　**Figure 14-8**　　　　　　**Figure 14-9**

Incidentally, this "rim" light has one side effect in this shot: tiny white dots that will need to be painted out in an editing program. These white dots are not, Internet rumor notwithstanding, spiritual orb entities, but simply specks of dust lit by the flash. They're most apparent in backlit situations with dark backgrounds, or when using built-in flash at night in dusty or rainy conditions. ● *Figure 14-9*

14.2 Intensity

Intensity is the brightness of the light. Most cameras are designed to meter everything to a mid-toned grey, but of course that isn't always what's needed for a photograph. The exposure for an image is as much an artistic decision as it is a technical one. Is the goal to create a bright, cheerful mood? A dark, somber one?

Two particularly pronounced examples of light intensity are high key and low key lighting. The key light is the main light in a given photo.

14.2.1 High key

High key refers to lighting that's bright and even, with a light or white background. It's used a good deal in advertising to convey feelings of youth, friendliness, happiness, and so on. Medical and health advertising often uses high key to indicate healthiness and cleanliness. ● *Figure 14-10 and Figure 14-11*

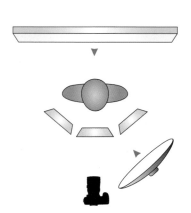

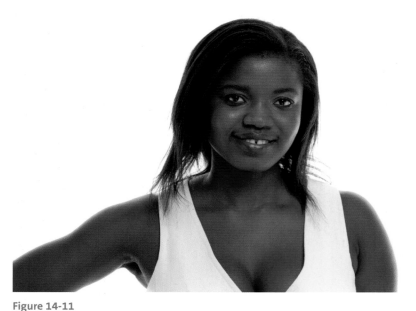

Figure 14-10

Figure 14-11
EOS 5D Mark II, 1/100 sec at *f*/6, ISO 100, 110 mm. The lighting arrangement for this shot is also seen in section 13.4.

14.2.2 Low key

Low key lighting, on the other hand, is darker and moodier. It's not simply a photo with the brightness turned down. Rather, it's a photo that emphasizes shadows and the shapes cast by them. Light is often used to paint the edges of things rather than fill them in. Film noir detective movies from the 1940s are classics for their mastery of low key lighting. ● *Figure 14-12 and Figure 14-13*

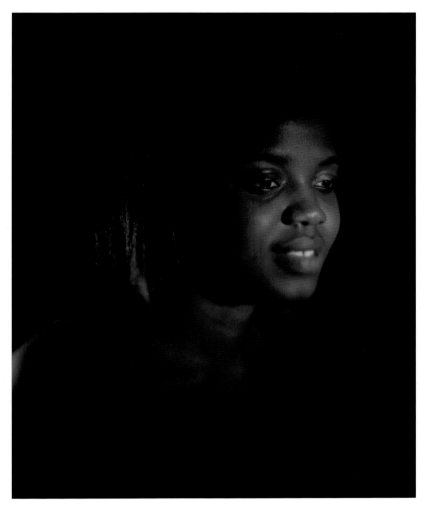

Figure 14-12
EOS 5D Mark II, 1/100 sec at *f*/2.8, ISO 100, Hartblei 80 mm Super-Rotator tilt/shift lens, 8° tilt. Speedlite 430EX with 1/2 CTO, camera left behind model. Speedlite 580EX with 1/2 CTO and Honl grid, camera right.

Figure 14-13

14.3 Quality

Quality of light refers not to the cost of the equipment, but basically to the hardness or softness of the light. Consider these photos of a naturally occurring pyrite cube formation from Navajun, Spain. ● *Figure 14-14 and Figure 14-15*

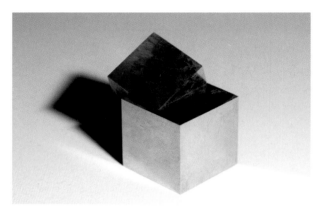

Figure 14-14

Figure 14-15

The image on the left is lit by a flash unit located on the other side of the room. The light source is quite small relative to the subject, so it yields very sharp-edged, high-contrast shadows. Hard lighting is light in which the beam is tight and fairly parallel, with minimal spreading as it moves farther from the source.

The image on the right is lit by the same flash unit, but now the light is positioned close to the minerals behind a sheet of ordinary paper. The result is a larger area of light, so the shadows are much more softly defined. Soft light spreads out widely and bounces off everything.

Another classic example demonstrating the quality of light is the sun. Although the sun is incredibly big, it's also incredibly far away. As a result, it doesn't fill a very big area of the sky when seen from our planet. On a bright cloudless day, particularly at high altitudes, the sun is almost a point light source, emitting directional light and casting very sharp-edged, high-contrast shadows. But on an overcast day, the entire sky becomes a giant softbox. Light is almost shadowless, since it's striking everything from multiple directions at once.

Take the two photos on the next page. The latest space probe photos of one of Saturn's moons? No, just the end of an ordinary chicken egg. ● *Figure 14-6*

The left-hand shot was taken using a bright studio flash unit reflecting off a white ceiling. The entire ceiling thus became a reflective surface, resulting in soft lighting.

However, the right-hand shot was taken with a small Speedlite flash unit, zoomed out to 105 mm and positioned camera left. The result is a hard and intense light, sometimes called a "raking" light, which brings up the interesting texture on the egg's surface. Photographers of ancient manuscripts and archeological artifacts often use raking light to reveal otherwise unnoticed surface detail.

Figure 14-16

Hardness or softness of light significantly affects all types of photography. It's particularly an issue for portraiture. Hard light emphasizes slight facial blemishes, and is one reason why snapshots taken in restaurants and pubs aren't desirable for user profiles on social networking sites.

14.3.1 Achieving soft light

Portable camera flash units are essentially designed to work like spotlights and have small light-emitting areas—about one-third the size of a playing card. This is partly for portability reasons, and partly because flash units are designed to achieve the maximum distance range possible by concentrating their light output with a reflector and lens. Any softening of the light necessarily involves a reduction in efficiency and range.

There are two basic ways to soften light: reflect it off a large surface, or diffuse it through a large surface. Either way some light will be lost, but the tradeoff comes in light quality.

When using a battery flash unit, bouncing light off large white surfaces such as white walls or ceilings is one way to use the first technique. Remember that colored surfaces will add a color cast to the light—something to be aware of when bouncing light in interior spaces. A blood-red wall will reflect red light onto the subject, which may or may not be the desired effect.

Figure 14-17

This photo was lit by a medium-sized softbox with an Elinchrom monolight camera right. A reflector under the model's chin filled in the shadow.

Many of the large flash diffusers described in section 12.5 employ the second technique, increasing the size of the light-producing area. Studio softboxes and shoot-through umbrellas also use this method. They must be positioned close to the subject to provide truly soft light, however. A large softbox positioned a long way from the subject will provide light that's as hard as a smaller light source close at hand.

Of course, having said all that, hard flash lighting isn't some pernicious evil forever to be eschewed. It's just good to start with the benefits of soft light, then move into mastering hard light later, as discussed in the next section. ● *Figure 14-17*

14.4 Color

Contemporary photography is usually about color, black and white having lamentably fallen into the niche fields of art and education in the 1980s. As discussed in the section on color temperature (section 7.18), there are many complex subtleties about white light and the way it's perceived by the human brain.

Flash units are designed to produce a fairly neutral white light similar in color to daylight. Portable units like Canon Speedlites typically have a color temperature of around 5500K. Studio lights sometimes have slightly bluer light, up to 6000K or so. Regardless, the light is quite blue compared to ordinary tungsten lights and compact fluorescents meant to simulate tungsten.

Figure 14-18

CTO (orange) filters are needed to get the blue-white light of a flash unit to match the warm light from the practical on-set tungsten and candle lighting.

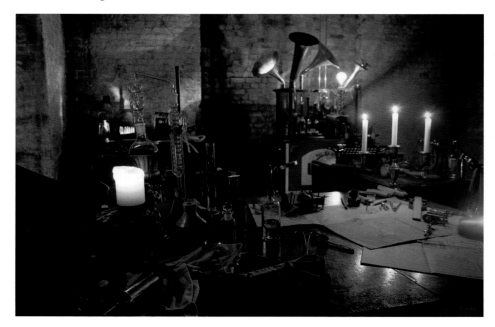

Accordingly, it's important to keep light source differences in mind when shooting. The preview screen on digital cameras, while not a perfect rendition of the finished results, can be a useful tool for checking how the camera sees the scene compared to the way the eye sees it. This is particularly important for long shutter times. ● *Figure 14-19 and Figure 14-20*

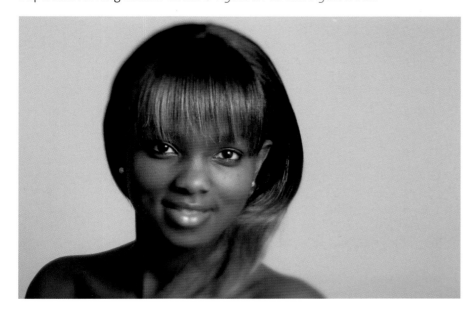

Figure 14-19
Cooler.

Figure 14-20
Warmer. Which shot is better is a matter of opinion. The blurring effect was created by a Hartblei manual focus tilt-shift lens set to maximum tilt (8°).

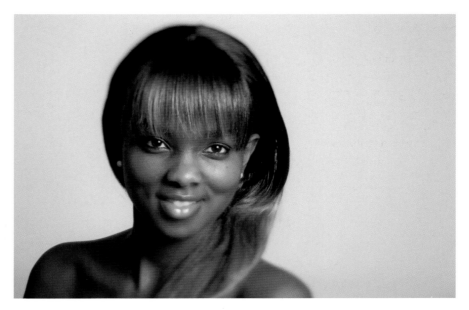

14.5 Basic Speedlite portrait photography

This sequence of photographs shows different approaches to lighting a person using a single flash unit.

Figure 14-21

This photo was taken using an EOS 50D's built-in flash, which resulted in harsh, unflattering light and a sharp-edged flash shadow.

Figure 14-22

The next step was to add a shoe-mount flash unit. Here a 580EX II was used on the same 50D. It isn't vastly better.

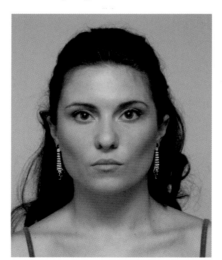

Figure 14-23

Next, the flash unit was angled upwards to bounce light off the ceiling. The room had eight-foot ceilings painted white. Accordingly, enough light bounced around the room to fill in the shadowed areas

14.5.1 Bounce flash

Direct flash—a flash unit pointing straight ahead—is an efficient means of illumination, but it is rarely flattering. The light is harsh because it originates from a very small area relative to the subject. Fortunately, most Speedlites have the ability to tilt and swivel the flash head independently of the flash body. This can send light bouncing off walls, ceilings, reflectors, bystanders, etc. Bouncing light in this way means that the light reaching the subject originates from a larger area than the flash head and is therefore softer. ● *Figure 14-24*

Bounce flash can soften light nicely but has disadvantages. For one, it obviously isn't possible to bounce flash outdoors without a reflector or something that can serve as one, so the technique is most immediately useful in interior spaces. Some interiors, in fact, aren't much good either if they have really dark surfaces or high ceilings. Another drawback is that colored surfaces (such as painted ceilings or walls) can end up tinting the light from the flash, resulting in unwanted color shifts.

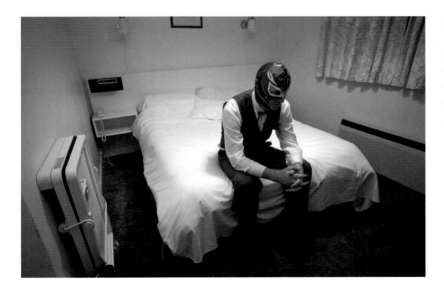

Figure 14-24
Bounce flash off the ceiling can produce a soft and consistent look, which is often a good thing. Here the flatness of bounced light is used to emphasize the drabness of the hotel room.

Relying purely on ceiling bounce flash can result in unattractive shadows appearing under the eyes and nose, sometimes referred to as "raccoon shadows". The traditional approach to filling in these shadows has been to elastic-band an index card around the back of vertically-pointing flash heads in order to bounce a bit of light forward. Some Speedlites, in fact, have built-in, pull-out catchlight cards.

Finally, bouncing the light reduces the amount of light hitting the subject, and this easily costs about half the range. For this reason, it's sometimes necessary to use a higher ISO setting or a larger lens aperture with

bounce flash. Remember that increasing the shutter speed won't help at all, since flash durations are too brief to be affected by shutter time.

14.6 Building a studio portrait

Bounce flash with a single flash unit is a useful technique for quick photos on the go, but it doesn't yield much control over lighting a scene. The traditional studio portrait, in contrast, has long been a structured, multiple-light affair. Here is one approach to building a studio portrait using only Canon Speedlites.

14.6.1 External flash off-camera with shoot-through umbrella diffuser

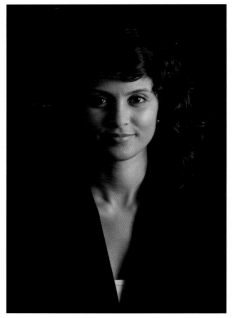

Figure 14-25 **Figure 14-26**

The flash unit is moved off-camera onto a light stand. It's a 580EX II assigned to group A, and it's fired using wireless E-TTL by an ST-E2 transmitter located on the camera. The flash unit is set to fire into a shoot-through umbrella to camera right, at about a 30° position. This is the dominant light for the photo, known as the "key" light.

14.6.2 Two off-camera flash units with shoot-through umbrellas

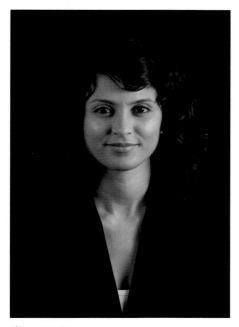

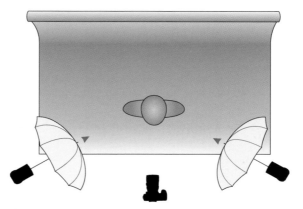

Figure 14-28

Now the model is lit by a pair of shoot-through umbrellas, one located on either side of the camera. One has a 580EX II assigned to group A; the other has a 580EX assigned to group B. Both are still controlled by an ST-E2. The second light fills in the shadows so that they aren't too dark, and therefore is known as the fill light.

Figure 14-27

14.6.3 Two off-camera flash units with shoot-through umbrellas, one background light

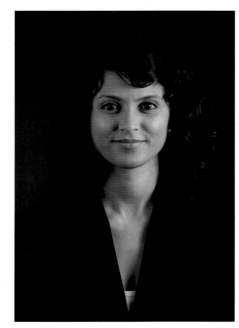

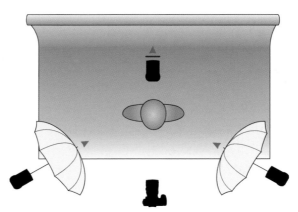

Figure 14-30

Same as above, but a third Speedlite is added immediately behind the model, illuminating the backdrop. This helps add contrast between the subject and the background, providing a little dimensionality. Since the ST-E2 can't control group C, this flash unit has its output set manually. Additionally, it has a blue filter, but no diffuser or umbrella.

Figure 14-29

14.6.4 Two off-camera flash units with shoot-through umbrellas, one background light, one hair light

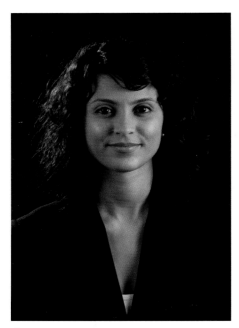

Figure 14-31

Figure 14-32
Finally, a fourth Speedlite is added to skim the model's hair. This is a 430EX II, also set manually and zoomed out to 105 mm.

14.7 Experimenting with light

The traditional approach to taking a photo uses three-point or four-point lighting. While it yields perfectly nice results, ready for the corporate bio or the school yearbook, it's fair to say that the portraits in figure 14-29 and 14-31 won't win any prizes for original lighting. Sometimes simpler can be more interesting. Take, for example, these two photos on the next page.
● *Figure 14-33 and Figure 14-35*

The two images were taken one after the other with lights positioned in identical locations. The image on the left has a large softbox camera left, a light with a small diffuser camera right, and a self-illuminating Lastolite backdrop. The image on the right is identical, only the backdrop and camera right lamps are switched off. Just one softbox, with a little spill onto the white backdrop, turning it gray. Yet the photo is arguably more flattering to the subject and certainly more dramatic.

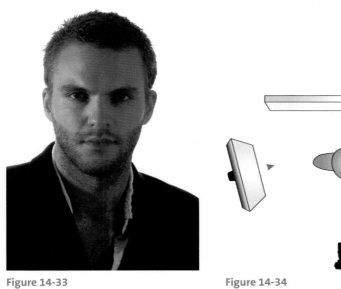

Figure 14-33

Figure 14-34

Figure 14-35

Figure 14-36

This shot was even simpler to set up. The key light is a Speedlite 580EX zoomed out to 105 mm, with no modifiers, positioned on a stand camera right. It was triggered manually at quarter power using a generic radio remote. A tungsten bulb positioned camera left provides a small amount of subtle fill. That's it: the Speedlite lit the model's back and the red-paneled wall, resulting in a silhouette of her face.

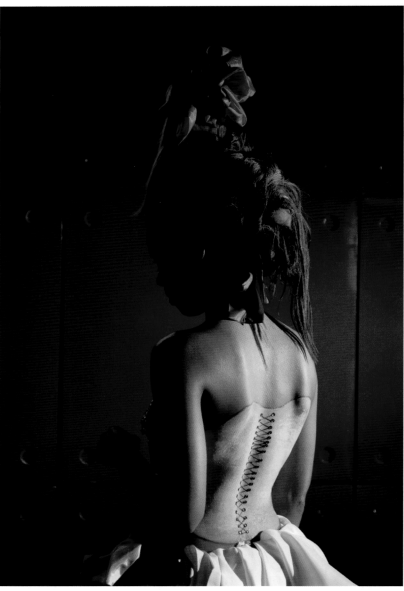

Figure 14-37

Figure 14-38

A slightly more complex shot, this photo used wireless E-TTL and three Speedlite flash units. A 580EX was used on-camera as the controller but did not contribute light to the scene. A 580EX II was positioned camera right on top of a six-foot light stand with its flash head set to 105 mm. This created a spotlight effect shining downwards. A 430EX, also set to 105 mm zoom, was positioned camera left in front of a cardboard grid to create patterns on the wall.

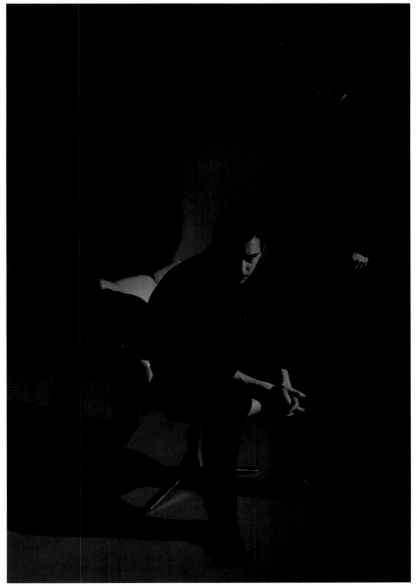

Figure 14-39

Figure 14-40

Figure 14-42 mixes hard light with soft light. A large softbox positioned camera right, provides soft key lighting for the portrait. Camera left, however, had a studio flash unit with a simple "spill kill" reflector and no light modifiers for a deliberately hard form of lighting.

Figure 14-41

Figure 14-42

Figure 14-43

Figure 14-44

This last shot combines Speedlite and studio flash. The portrait employs foreground fill from an on-camera Speedlite 580EX firing manually. A large Bowens studio unit (with a simple spill kill reflector but no modifier) was positioned behind the model and the gate, and was triggered optically by the onboard flash. A haze machine was used to lower the contrast and diffuse the backlighting.

The key to effective lighting is always to experiment with different lighting positions and types. The next section has some other starting points for more creative exploration.

15 Advanced Techniques

The previous chapters of the book deal with figuring out the fundamentals of flash photography. This final section is a compendium of ideas for exploring other directions in flash.

15.1 Slow shutter sync and motion

Slow shutter sync and its usefulness for exposing a background correctly with low light levels were discussed early on in this book. Also mentioned was the importance of using a tripod to reduce motion blur in areas not illuminated by flash.

The same principle can be deliberately exploited to take advantage of motion blur for dynamic effect. Essentially, a photo taken with flash and a slow shutter speed can provide an interesting mix of frozen flash-illuminated subject and ambient-light-illuminated motion blur. The effect isn't always easy to predict, but it can be very striking and exciting when it works.

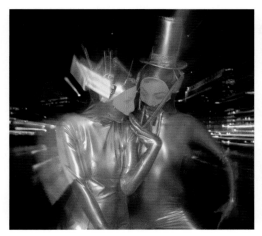

Figure 15-2

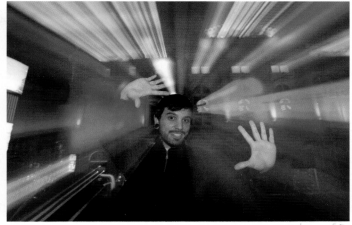

Figure 15-3
Another trick is to adjust the position of the zoom lens during the course of a slow sync exposure. In Figures 15-2 and 15-3, flash is used to freeze the foreground, and the zoom motion causes dynamic blurring outwards.

Figure 15-4
A classic use of slow shutter sync is this shot of a car interior. A flash, carefully positioned so as not to distract or blind the driver, was used to illuminate and freeze the car interior. The two-second exposure nicely blurred the lights visible through the windshield.

15.2 Hard isn't all bad

Introductory material for beginning photographers can make it sound as if hard light is malevolence in photon form, and that professional studios have nothing but huge softboxes in them. This isn't the case, of course. Light that's too soft can be boring and flat. Shadows define a picture as much as light, and skillful photography is as much a matter of choosing and positioning good light sources as it is composing the elements that make up the shot.

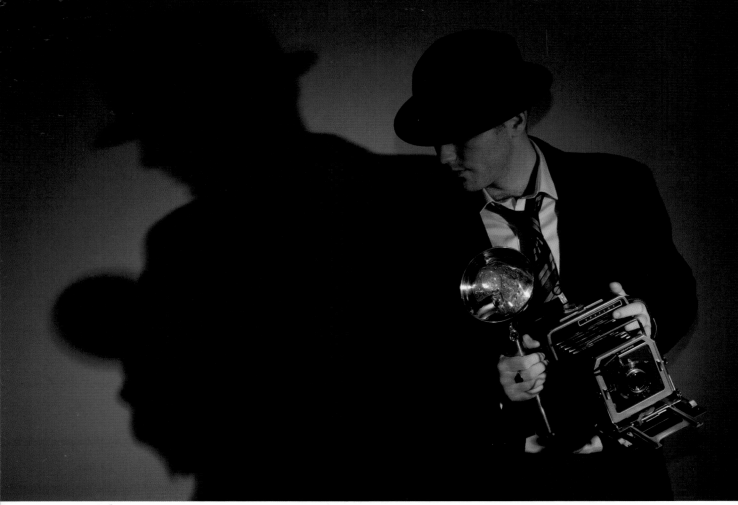

Figure 15-5
Hard light can impart a bold and dramatic look to an image, casting sharp shadows for strong graphic forms. This photo, for example, was taken with a single flash unit to camera right. The Elinchrom Style 600 had a snoot installed (section 13.4.8) which projects a circle of light, almost like a spotlight.

Figure 15-6
Direct flash is also useful for illuminating iridescent insects. This male banded demoiselle damselfly (*Calopteryx splendens*) was photographed with on-board direct flash mainly to help freeze motion, since I was in a bobbing rowboat at the time. However, the direct flash also helped bring out the insect's magnificent metallic sheen.

Figure 15-7
A group of masks from Jiichi Asami's working collection of Japanese Noh theatre masks. The masks were side lit by a single 580EX II Speedlite.

Figure 15-8
This photo of author Cory Doctorow at his desk was taken using two 580EX Speedlites triggered by an ST-E2. One 580EX was filtered 1/2 CTO and positioned camera left to rake along the bookcase. The other was filtered blue and positioned on the floor to illuminate his handcrafted raygun, which he uses to defend Earth from malevolent space invaders. No light modifiers were used other than the filters.

15.3 Narrowing down the light

Standard automatic flash lighting systems emphasize getting as much light all over the scene as possible. Yet this often yields rather flat, dull photos. Spots or patches of light can make for much more interesting pictures. Think of the dark chiaroscuro or tenebrist paintings of 17th century artists such as Caravaggio: shadowed scenes with pools of light gathered around, or hinting at, mysterious narratives.

The zooming mechanism in most portable flash units is a great tool for narrowing down the cone of light from the flash head. Many people often think of the zoom more as a "portable snoot" than something used to compensate for focal length. Naturally, the zooming mechanism has to be under user control; fortunately, most Speedlites these days have manual override on zoom position.

Add-on flags (light-blocking panels), snoots, and grids are also useful tools for keeping the light focused in one place.

Figure 15-9
This shot was taken with two lights. One was a large Elinchrom studio flash unit inside a large Lastolite HiLite box (section 13.4.6). This provided a silhouette of the subject, since there was no foreground lighting. The second light was a 580EX in manual mode, equipped with a Speedlight Pro Kit add-on grid. The Speedlite was aimed by hand at the subject's neck in order to focus an oval patch of light on his tattoo.

Figure 15-10
This photo used a Honl grid to concentrate the light from a Speedlite 580EX II onto the nautilus shell

Figure 15-11
This shot of ceramic artist Andreas Alefragís used a single CTO-filtered Speedlite 580EX II, positioned camera right and shooting through a large sheet of transparent bubblewrap. This created the effect of the photo being taken in late evening light.

15.4 Backlighting and flash in the frame

One of the first rules that beginning photographers are taught is never to point a camera towards the light source. While this is an understandable rule, strictly following it means passing up too many photographic opportunities. Lights facing the camera can achieve all kinds of interesting effects.

Figure 15-12

Mobius Arch, Alabama Hills, California. This photo is a two-minute exposure taken at moonrise. A 580EX II was fired from behind the arch to outline its inner edge and provide an unusual burst of light. The tall mountain visible through the arch is Lone Pine Peak. The mountain to the very far right is Mount Whitney, the tallest mountain in the contiguous United States.

Figure 15-13

This picture was taken using two Speedlites mounted back-to-back on a light stand. One had a red filter and was pointed at a white wall. The other faced the camera and backlit the model, creating a silhouette with an outline of white.

Silhouettes are a particularly dramatic way to light something. Even show-ing the flash in frame can yield interesting results. Positioning a light to the side of the subject, but behind it, can give an attractive halo of light, help-ing separate the subject from the background. This technique lends itself to manual metering, however. Automatic metering tends to underexpose badly if the flash unit is visible to the lens.

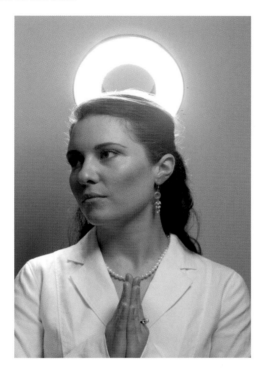

Figure 15-14
This portrait is lit by a beauty dish, out of frame, and a Bowens ringlight with translucent glass diffuser, very obviously in frame.

15.5 Kill the ambient

As discussed in section 6.3, each flash exposure is essentially a double ex-posure—there's the subject lit by flash, and the background which may be lit by ambient light. In the case of night or other low-light conditions, it's fairly easy to reduce shutter times to minimize the amount of light contrib-uted by ambient without affecting flash. But in daylight, this becomes trickier, because the X-sync limit puts an upper ceiling on the maximum attainable shutter speed.

Fortunately, the arrival of high-speed sync means that X-sync is no longer the barrier that it was. This makes it much easier to set high shutter speeds to keep ambient exposures low while exposing the foreground normally using flash. This technique can create moody atmospheres under what appear to be fairly uninteresting or banal lighting conditions.

Figure 15-15
This shot was lit by a 580EX firing into a California Sunbounce reflector. As can be seen by the dark shadow to the model's right side, she is lit primarily by flash.

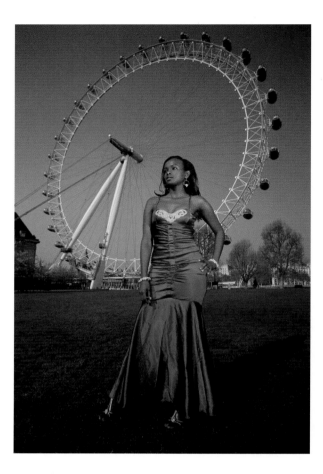

Figure 15-16
You knew it was coming, didn't you? What book on flash photography would be complete without a picture of somebody pointing a flash unit at his own head? This off-camera 420EX was triggered by an on-camera 580EX II using ordinary wireless E-TTL. High-speed sync was used for a shutter speed of 1/400 sec at f/6.3 despite the bright sunlight. The camera was an EOS 5D Mark II, which has a maximum X-sync of 1/200 sec.

15.6　Cookies

A basic lighting tool for cinema and stage is the "cookie", short for "cucoloris". The best part about "cucoloris" is that nobody seems to know where the word comes from. Whatever its etymological origin, a cookie is simply a flat board with holes cut into it. Or a piece of mesh with fabric leaves stuck on to it. Or a bunch of branches. Or a glass of water. Or anything, really, used to break up light into interesting shadows.

Speedlite-type flash units are ideal for working with cookies because the hard-edged light from a battery unit automatically wants to cast sharp shadows.

Figure 15-17
This photo is simply a blank white wall with a houseplant positioned to the left, out of frame. A blue-filtered Speedlite 430EX was put behind that.

Figure 15-18
Here's a portrait taken in front of the same wall. The filter was changed to red to match the model's corset, and a beauty light was used camera right as the key light.

Figure 15-19
What appears to be the shadow of a mighty bird is actually an ordinary household electric fan positioned in front of a Speedlite 580EX II. A straw-colored filter was used to give the feeling of late afternoon light.

15.7 Open flash

A fun way of taking interesting photos in the dark is to use open flash, which is described in sections 5.5 and 11.2. This is the most direct way to apply light to a scene.

The basic technique is to lock the camera to a solid tripod, find a location with little or no ambient light, and then open the camera's shutter in "bulb" mode. This is best done with a remote that can be locked in the open position. Then it's just a simple matter of walking around the scene, firing the flash by hand to illuminate areas of interest. Colored gels can be taped over the flash head to illuminate the photo with different colors of light.

The Neverwas Haul shown in figure 15-20, a self-propelled three-story art vehicle in the form of a Victorian house, was created by the Neverwas team. In this shot, the Haul is lit primarily by the full moon, camera left. The lengthy exposure, nearly a minute and a half, made the picture look like it

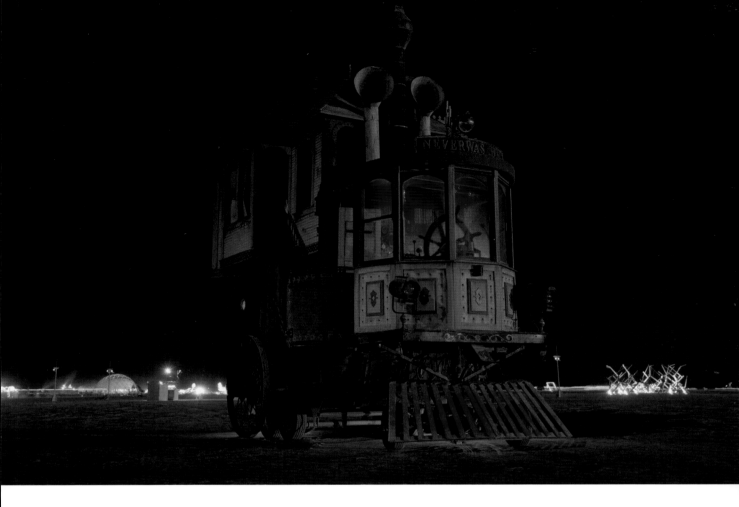

might have been taken in late evening light. The keen-eyed observer will notice that there are two shadows cast by the vehicle, hinting that there was also a large work light camera right, positioned some distance away.

The vehicle is outlined by handheld flash triggered manually. A 580EX II was fired at full power at various positions around the vehicle and through its port-side windows to backlight its steering wheel. The flash was colored using red and blue filters for effect. More subtly, there was also a single half-power burst fired onto the left side of the vehicle, with a 1/4 CTO filter, to fill in the shadowed areas by the wheels and the staircase. EOS 5D Mark II. 70 seconds at f/7.1, ISO 100. 35mm.

Canon Speedlites with manual controls or old flash units with manual metering are ideal for this application, since the output power can easily be adjusted. It helps to wear dark clothing and point the flash away from one's body. Naturally, a flash unit isn't the only tool for doing this sort of photography. People often take outdoor night scenes using high-powered flood-lamps, or indoor photos with small flashlights (electric torches) or blinky light toys.

Figure 15-20
The Neverwas Haul

Figure 15-21
By comparison this snapshot was taken using direct on-board flash. The image looks flat and lifeless, and dust motes in the air are illuminated.

Figure 15-22
It's been done before, but it's still a lot of fun. This picture of the windmills in Oia Santorini, Greece, had a very long shutter setting to record the faint light of dusk. Then I took a 580EX II with a blue gel and ran past the right-hand windmill, firing the flash once by hand as I jumped. EOS 5D Mark II. 10 seconds at f/6.3, ISO 200, 45 mm.

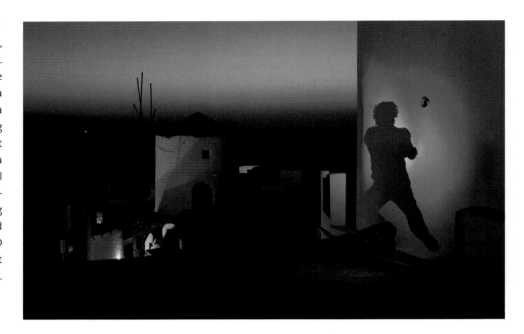

15.8 Stroboscopic (MULTI) flash

"Stroboscopic" photography is the process of firing a sequence of brief flashes during the course of a single photographic exposure. The result can capture the steps of a dancer in motion or the swing of a golfer, like the classic photographs that Harold Edgerton took in the 1940s and 50s. Each frozen moment is recorded on the same frame, like a multiple exposure.

The ingredients required to take a stroboscopic photo are a Speedlite (or other flash unit) with stroboscopic capabilities, a very dark background, and a relatively light-colored moving subject. Reflective or light backgrounds don't usually work because the multiple pops of light will build up cumulatively to overwhelm the foreground subject. Put the camera on a tripod, install fresh batteries in the flash unit, use either M (metered manual) or Bulb modes, and ideally use a remote shutter release. Stroboscopic mode is not compatible with second curtain sync or high-speed sync, but it can be activated in wireless E-TTL mode. ● *Figure 15-23 and 15-24*

The 400EZ series and all 500 series Speedlite flash units have built-in stroboscopic flash capabilities, known in the Speedlite menu as "MULTI". All models can specify the number of flash pulses per second (i.e., the frequency in Hertz), as well as the length of time the flash unit will fire. Some can also specify the total number of shots to be taken per exposure, but older models require this to be calculated by hand. The full details for engaging stroboscopic flash are described in section 9.21.

Figure 15-23
The complex motion of an aikido throw, captured as a sequence of freeze frames.

Figure 15-24
A 580EX II pulsing at a relatively slow one-flash-per-second (1 Hz) was used to capture the movement of the dancer's fans. The flash head was zoomed to 105mm to create a spotlight effect.

Note that there are some practical limits posed by stroboscopic lighting. First, a flash unit can only fire a certain number of times before it overheats, so it can't be pressed into service as a disco strobe light at your next party. It also can't fire full-power pulses very rapidly, since the unit needs time to recharge its capacitors. For this reason, Speedlites are pre-programmed with flash frequency and power limits.

15.9 High-speed photography

While flash units are used today mainly as a photographic light sources, the flash tube was originally used as a device for stopping time—at least, photographically speaking. In the mid-1920s, MIT's Harold Edgerton was studying the behavior of synchronous electric motors. He had made some calculations predicting their performance and built a mercury arc lamp that could photograph the spinning motors as they were put under load, thereby testing his theories. Over the next few years, he generalized the concept for photographic applications, eventually switching to xenon gas in the tubes.

Edgerton was thus following in the footsteps of photographic pioneer William Henry Fox Talbot, who in June 1851 used an electric spark to freeze the motion of a sheet of paper fastened to a rotating disc.

Today, the same photographic flash units that are used for snapping photos can be used for freezing motion. The duration of a flash pulse can be set in the milliseconds, making it much faster than a mechanical shutter. Since the light pulses are so brief, exceeding the highest shutter speeds of most cameras, the field is often called high-speed photography. There are a few basic points to keep in mind.

First, the faster the object motion that needs to be stopped, the briefer the flash of light needed to freeze it. Ordinary subjects, such as people and cars, can easily be frozen by the pulse of light from a regular flash unit. For this reason, portraits and similar shots always look sharper when taken with flash. However, really fast-moving objects such as water drops, hummingbirds, and bullets need extremely brief light pulses.

Second, AC powered studio gear is usually not the best option for freezing motion. Most studio units control the brightness of light output by changing the *amount of power* discharged through the tube. They often have long "tails" as light output drops off. In contrast, battery-powered flash units control overall light output by altering the *duration* of the flash pulse. A full power pulse from a Speedlite-type unit is actually not all that brief—values of 1/700 sec to 1/1000 sec are typical. But at low power settings, the light produced by battery units is extremely brief, since power to the tube is cut off very rapidly. Therefore, high-speed photography is best performed with ordinary battery flash units at low power settings, or

studio units designed specifically for motion-freezing purposes. If the light from one unit is insufficient, then multiple units can be set up to fire simultaneously. Note also that many flash units will extend the duration if power is low, and the fastest flash bursts will be from fully charged units.

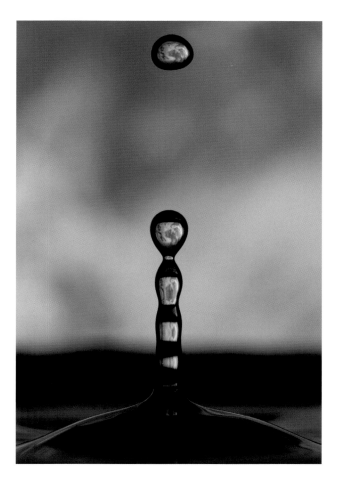

Figure 15-25
The world in a drop of water. The tiny liquid droplets act as lenses, showing the photo of Earth that was taped to the wall behind the container of water. Triggered using a StopShot timer (see overleaf).

Third, high-speed photography that uses flash to freeze motion requires low ambient light levels so the flash is the dominant, if not only, source of light. That means it's easiest to use open flash techniques, just like in the days before flash sync. The shutter is opened under low light conditions, the flash fired, then the shutter closed again. ● *Figure 15-26*

Finally, assuming the third point, synchronization of the flash burst during high-speed photography is a matter of syncing the flash to a given event, not to the shutter opening. This can be a matter of trial and error. For example, the raspberry photo on the cover was done entirely by hand. I simply set up a camera with an ST-E2 transmitter, putting a 580EX II behind a translucent screen and a 420EX to camera right. FEC was dialed down a

stop to shorten flash duration. I then dropped the raspberry into a wine glass filled with water and pressed a wired shutter release manually. It took quite a few drops to get the timing just right, but no other special equipment was used.

Figure 15-26

The complex curl of smoke from a stick of incense, frozen by a burst of flash from a 580EX II.

15.9.1 High-speed photography timers

Manual timing is pretty tedious work, so a flash trigger timer is highly recommended for high-speed photography. These electronic devices can fire a flash after a beam of light is broken (a falling water drop, say) or after a microphone hears a sound (perhaps a balloon popping). Variable time delays can then be set so that the flash fires at the perfect moment to capture the action.

Many people build their own high-speed triggers, so this has become a popular photographic hobby. However, people low on electronic skills or time can also purchase advanced computerized flash triggers such as the ones shown opposite. ● *Figure 15-27*

The left-hand device is the deceptively simple looking Universal Photo Timer from UniversalTimer.com. While compact and equipped with a simple LED display, it has five basic functions.

It can perform time lapse photography and other timed work as an infrared remote; it can trigger cameras and flash units in response to external events such as water drops and the like; it can work as an optical slave for a flash unit; it can perform stroboscopic flash; and it can operate as a remote shutter release. It has two sockets for controlling two separate flash units.

The right-hand device, the StopShot timer from Cognisys, has an advanced LCD screen with control over three separate output devices plus timing and intervalometer options. It supports conditional triggers for crossed beams (e.g., a flying insect will only trigger a shot if two beams are broken, not just one) and can memorize preset configurations. The maker also sells a variety of input devices, such as laser sensors.

Figure 15-27

Figure 15-28

This image of a light bulb hitting a piece of polished black slate was taken using a Universal Photo Timer.
The timer's built-in microphone was used as the trigger, and a few millisecond delay was required. Two 550EX flash units, one to either side of the bulb, were fired at 1/128 power to immortalize the bulb's demise.

15.10 Cross-polarizing

A common photographic problem is taking a photo of something made of reflective material, such as an oil painting or anything under a sheet of glass. Art documentation has to deal with this problem on a regular basis. The usual suggestion is to put a polarizing filter on the lens. This helps, but any reflected light sources still appear in the photo. A solution? Cross-polarizing.

Cross-polarizing involves putting a sheet of polarizing plastic over a light source, such as a flash unit, as well as placing a polarizing filter over the lens. The lens filter is then rotated so that it's aligned at 90° to the material on the light. When a photo is taken, non-polarized light will record as usual, but polarized light such as direct reflections will almost completely vanish.

Figure 15-29

Figure 15-30

This work by street artist SNUB23 demonstrates the technique. Since the art was made using enamel spraypaint, it was very difficult to photograph without getting rogue hotspots and reflections. Additionally, the art was located in a narrow stairwell, which limited lighting choices considerably. The photo to the left has a very objectionable hotspot. The photo to the right was taken from the same position with the same lighting, but with a polarizer placed over the lens and a sheet of polarizing plastic over the flash head. The polarizer was rotated until the hotspot vanished.

This technique is also useful for nature, wildlife, and food photographers who photograph wet or moist surfaces such as the eye of a fish or a sliced piece of fruit. It can also reveal interesting structures in minerals or reflective surfaces.

Figure 15-31
Eye of a rainbow trout, shot normally (left) and cross-polarized (right).

Incidentally, cross-polarizing can also reveal stress lines within transparent plastic objects made using injection molding. The normally transparent items suddenly burst forth into a rainbow of stress patterns. (Though to be honest, the easiest and cheapest way to photograph these patterns is to put a clear object in front of a polarized light source, such as ordinary LCD monitor, and put a polarizer on the lens.) ⊜ *Figure 15-32*

Figure 15-32

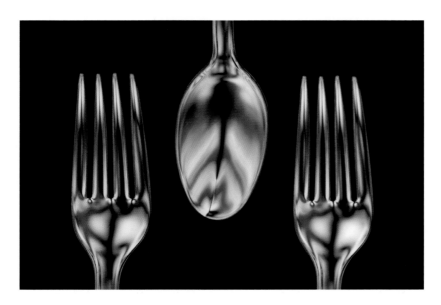

15.11 Learning from the masters

There is much to be learned by studying the works of great painters. They only had oils and canvas rather than CMOS image sensors and xenon flash tubes, but they sure knew a thing or two about light. One painter whose techniques are of great value to portrait photographers is Rembrandt van Rijn.

Many of Rembrandt's paintings are lit predominantly from one side. This effect can be reproduced photographically by positioning a key light to one side of the subject, fairly high up. The other side is filled in by either a lower powered light or a reflector. The result is a simple and elegant portrait, with the shadows providing a dimensionality to the face. A key hallmark of the Rembrandt technique is that the side of the face in shadow typically has a downwards-pointing triangle of light on the cheek, under the eye.

While the formula doesn't have to be strictly followed to work, it can be a useful starting point for basic portrait photography, as shown here.

Figure 15-33

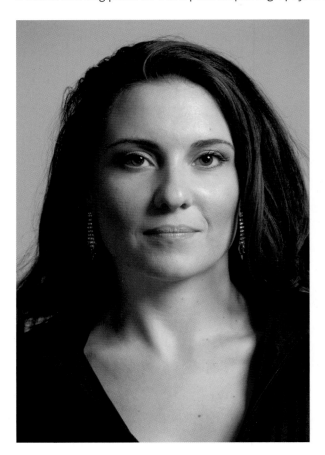

Figure 15-34

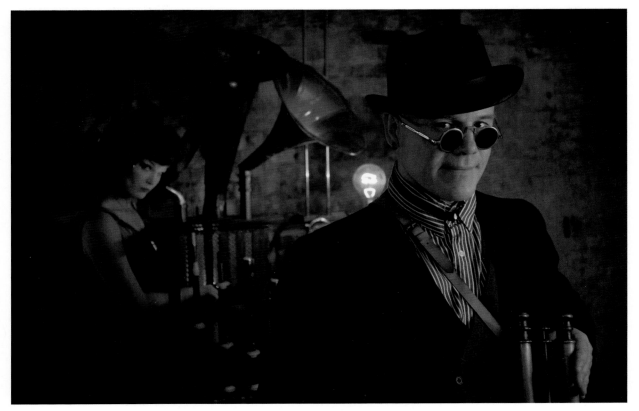

Figure 15-35
Musician, producer and entrepreneur Thomas Dolby.

Conclusion

This book, although it strives to be one of the most comprehensive books published to date on the subject of flash photography, just scratches the surface. Lighting with flash offers tremendous creative and practical solutions, from the affordability and flexibility of off-camera hotshoe flash to the dizzying choices and budget-straining options of professional studio gear. And the fundamental principles of flash technique can be applied across all forms of short-duration photographic lighting: an expensive studio box really isn't that much harder to use than a small Speedlite.

This book is frozen in time to the year 2010, but who knows what technological innovations the future will bring? Maybe we'll see flash units with integrated radio controllers providing full metering support, radio frequency distance measurement to remote flash units, and stepless zooming with wireless control. Or infinitely variable on-demand color filters using transparent LCDs, tighter preflash timing to reduce blinking eyes, flash output zone control using a touch-screen interface on the camera LCD, and true continuous modeling lights employing high intensity white LEDs. Perhaps someday high efficiency lights will supplant xenon tubes altogether.

But whatever technical improvements may come, the basic principles of using bright flashes of light to capture still photos will doubtless continue. And hopefully, this book has set some useful starting points for exploring creative lighting solutions. Have fun!

APPENDICES

Appendix A:
Flash Units for Canon EOS

Speedlites for film and digital cameras (E-TTL)

These flash units are compatible with all Canon EOS type A cameras that support E-TTL and E-TTL II metering. All but the 270EX can also be used with older film cameras in legacy TTL mode.

Speedlite 220EX

The E-TTL successor to the Speedlite 200E has slightly greater range and a few E-TTL functions. It's a tiny portable flash unit for cameras that lack built-in flash. It can neither tilt nor swivel, nor can it serve as a wireless E-TTL slave. Fixed 28 mm coverage, and the red AF assist light covers the center point only. This model has been discontinued.

220EX

Speedlite 270EX

The 220EX's replacement has a tilting head and a two-position hand-operated zoom. It supports E-TTL but is the first Speedlite to drop support for legacy TTL metering. Unfortunately, it lacks a red AF assist light and instead pulses its main tube annoyingly in low light conditions. It uses only two AA batteries, so it's quite compact.

Unfortunately many of the 270EX's features are only available on cameras that have Speedlite menu control. It's therefore much more suited to recent digital models and less suited to earlier cameras.

270EX

Speedlite 380EX

An early EX flash unit, the 380EX has three restrictions that make it of limited value today. First, while it can tilt its zoomable head, it can't swivel. Second, it can't use wireless E-TTL. And third, it has no flash exposure compensation adjustment for cameras that lack FEC. For these reasons, it is better to buy a used 420EX or 430EX.

Other than those limitations, it's a mid-sized flash unit with the usual E-TTL abilities. Its red AF assist light covers the central point only. It has no manual controls of any kind, so it can't be used for manual flash work. This model has been discontinued.

380EX

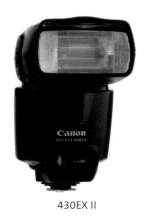

420EX 430EX 430EX II

Speedlite 420EX

The first affordable EX unit with wireless slave capabilities. The 420EX lacks a screen or manual control but can zoom, tilt, and swivel and supports most E-TTL functions. Its red AF assist light covers seven focus points, and it has modeling light support. It also lacks on-board controls for flash exposure compensation, which means FEC will not be available on those camera bodies that also lack control over FEC. Frequently confused with the older 420EZ.

No manual controls of any kind, for either flash output or zoom, so not useful for manual flash work. This model has been discontinued.

Speedlite 430EX

A definite upgrade to the 420EX, the 430EX brings a proper LCD display, manual controls (output, zoom, and curtain sync), a pull-out diffuser panel, single-button tilt and swivel, and custom functions. In addition to all wireless slave functions, it has modern digital features such as sensor size compensation and white balance adjustment.

A good value for the money, its only real drawbacks compared to the 580EX are no wireless master capabilities, no stroboscopic operation, no weatherproofing, no battery pack socket, and lower power output. Its red AF assist covers up to nine focus points. Frequently confused with the older 430EZ. Full manual controls. This model has been discontinued.

Speedlite 430EX II

The 430EX II adds a metal foot with quick-release lock and the ability to be controlled by the menu of newer digital EOS cameras. It's also quieter and a bit faster at recycling than its predecessor. Its main drawback for busy

550EX

580EX

580EX II

photographers is that engaging slave mode requires time-consuming menu button presses, rather than the simple switch on the 420EX or 430EX.

The 430EX II is a great product, though not inexpensive. Full manual controls.

Speedlite 550EX

The 550EX was the first flagship flash unit of the E-TTL era. It introduced full wireless E-TTL control, and it can serve as a master or a slave unit. It's the largest and heaviest of all the 500 series flash units, a sturdy workhorse with full wireless E-TTL capabilities and stroboscopic control. No custom functions. Full manual controls.

It's somewhat bulky and noisy in operation, and its buttons are recessed and awkward to operate. This model has been discontinued.

Speedlite 580EX

The most compact of the 500 series units, the 580EX also introduces an improved interface with easier to operate buttons, custom functions, and a dial configuration. It's a nice upgrade from the rather chunky and blocky 550EX. Like its predecessor, it has a quick and easy physical switch for engaging wireless master and slave modes, making it a popular buy on the used market. Full manual controls.

It has the old-style rotating wheel foot rather than a quick-release clamp, and it does not have the ability to be controlled by a camera's menu system. This model has been discontinued.

Speedlite 580EX II

A revision of the 580EX, the 580EX II adds weatherproofing compatible with 1 series cameras, a new quick-release foot design, advanced digital capabilities that permit full Speedlite menu control from compatible cameras, single-button tilt and swivel, and silent recycling. It's only slightly larger than the 580EX. Full manual controls and a PC socket.

Its main drawback is that engaging its wireless mode requires fiddly and time-consuming button holds rather than the simple switch found on its predecessors. Some users also report intermittent contact issues with the flash foot, particularly if the camera is in portrait mode.

Speedlite Transmitter ST-E2

The ST-E2 is a compact master transmitter for wireless E-TTL, which fits onto a camera's hotshoe. It does not have the ability to produce scene-illuminating light. It's useful for controlling slave units in small rooms, but is severely limited by its weak range and its inability to control units in group C. It has a red AF assist light for low-light autofocus. Powered by a disposable lithium 2CR5 battery. For more information, see section 11.8.

ST-E2

Macro flash

There are three Speedlites designed uniquely for macro (closeup) photography.

Speedlite ML-3 Ring Lite

This film-only macro unit comes in two pieces joined by a detachable cable. The body fits on the hotshoe, and the head fits around the end of a lens. The two tubes are curved but do not cover a full 180°. Because of the modeling lights, each tube has an arc of roughly 150°. It fits directly onto Canon 50 mm 2.5, 100 mm 2.8 macro, 100 mm 2.8 USM macro, and MP-E 65 mm lenses. An adapter ring is needed for the 180 mm 3.5L macro. It does not fasten onto the filter threads, and so is not directly compatible with third-party macro lenses or other non-macro lenses.

ML-3

Unfortunately, the ML-3 is only useful for film camera (TTL) users. Since it has no manual controls, it's of very limited value for digital bodies. Additionally, there is no way of adjusting the power ratios between the two tubes, though it is possible to specify left or right tube only. Its only other features are a test flash button and a button to enable a pair of white incandescent focus assist bulbs. This model has been discontinued.

Speedlite MR-14EX Ring Lite

The MR-14EX is similar to the ML-3, but updated for E-TTL control. It has a non-detachable cable between control unit and head. It's also vastly more advanced in terms of controls, as the control panel and display are similar to the 550EX. Like the 550EX, it has awkwardly recessed buttons, and like the ML-3, it has true curved flash tubes covering about 150° each.

In addition to support for E-TTL metering, it supports high-speed sync, stroboscopic output, and full manual control. It supports A:B ratios between the two tubes and can also support a slave unit in group C for background lighting.

MR-14EX

Speedlite MT-24EX Macro Lite

The MT-24EX has a very similar body/control unit as the MR-14EX, but instead of a ring, it has two separate and detachable flash heads. Each head can clip onto a rotating ring that fits Canon's standard macro lens lineup. The heads are all adjustable and tiltable, and put out a bit more power than the MR-14EX.

Whereas ringlights create very flat macro lighting, the MT-24EX allows for a slightly more sculpted look by making it easier to cast shadows across the subject. Very expensive.

MT-24EX

Speedlites for film cameras (TTL)

The flash units in this section are TTL-only devices and so cannot meter with digital bodies. Note that in TTL mode, flash units will fire at full power on some digital bodies and won't fire at all on others. They are thus only useful if they have manual controls. All TTL-only flash units have been discontinued.

160E

Speedlite 160E

The smallest and least powerful Speedlite ever made, the 160E is a tiny add-on for EOS film cameras that lack built-in flash. The 160E is absolutely minimalist: it has an autofocus assist light, a two-color flash ready ("pilot") light, and nothing else. It doesn't have a power switch but instead automatically powers up when the camera's shutter release button is pressed halfway.

On some digital bodies, it misfires continuously during long exposures. It's the only Speedlite to use expensive lithium 2CR5 batteries, the kind used in most EOS film cameras. No manual controls.

200E 200M 300EZ

Speedlite 200E

The 160E's successor. Slightly larger, slightly more powerful, the 200E uses 4 AAs and has a power switch and a locking foot. TTL only with fixed coverage, though an optional clip-on plastic panel takes the coverage to 28 mm with some loss of power. No manual controls.

Speedlite 200M

This flash unit was made uniquely for the film-based Canon EF-M, which was an EOS Rebel/1000 with autofocus, TTL flash metering, and the top deck LCD removed. A strange little 35mm camera, not to be confused with the older Canon EF, it was sold as a manual-focus body that could take any EOS lens.

The Speedlite 200M was a 200E with TTL functionality removed and a simple autoflash sensor added. It should work with any EOS body if its front switch is set to "A" (the other option, "M", simply fires at full power when triggered). Metering is performed by the flash body itself using a sensor eye in the front panel. A table printed on the back indicates its flash working range for some apertures and film speeds. No manual controls.

Speedlite 300EZ

Probably one of the least useful early Speedlites, the 300EZ supports TTL and A-TTL. It has an automatic zooming flash head which adjusts from 28 mm to 70 mm. Oddly, the only switch on the back, aside from the power switch, is a slider which sets first or second curtain sync. The biggest limitation of the 300EZ is that its head will neither tilt nor swivel despite its size, restricting it to direct flash only. No manual controls.

300TL

420EZ

430EZ

Speedlite 300TL

This flash unit doesn't quite belong here, since it was designed for the Canon T90, a renowned manual-focus predecessor to the EOS system. However, the 300TL is compatible with EOS film bodies in basic TTL mode. Certain advanced features, such as FE lock and second curtain sync, work only with the T90.

It isn't very useful as a manual flash as it only has two output levels— low and high. It has a manual zooming head, which means the top of the head is moved back and forth by hand to adjust the zoom position. Tilt and swivel capabilities.

Speedlite 420EZ

The first high end tilt/swivel flash unit in the EOS lineup, the 420EZ is of limited value today. It has a zooming flash head, but it does not have flash exposure compensation controls and can't be used with a high voltage pack. Supports A-TTL in P, Av, and Tv modes, though in bounce mode the 420EZ fires annoying visible light flashes whenever the shutter release is pressed halfway.

The 430EZ or 540EZ are better choices for EOS film users. The 420EZ is mainly useful today for someone looking for an affordable unit with manual flash controls and stroboscopic output of up to 5 Hz (pulses per second). Often confused with the newer 420EX.

Speedlite 430EZ

An upgraded 420EZ equipped with flash exposure compensation buttons, improved back panel LCD, and a standard Canon socket for a high-voltage pack. The stroboscopic function is improved, with a maximum speed of up to 10 Hz. Supports A-TTL in P, Av, and Tv modes, though in A-TTL bounce

mode, the 430EZ fires annoying visible light flashes whenever the shutter release is pressed halfway. Two versions were sold, with the US model displaying manual distance information in feet and the international model displaying meters. Often confused with the newer 430EX.

The 430EZ is available quite inexpensively and is a reasonable flash unit for all-manual operation.

Speedlite 480EG

Sometimes jokingly referred to as a hammerhead or potato masher, the 480EG was Canon's only grip-style flash unit for EOS cameras. A heavy and powerful unit with a built-in bracket to which a camera can be fastened. Its guide number of 48 doesn't sound like much, but this is without a zooming flash head—it reaches GN 48 via two flash tubes with a fixed 35mm coverage.

The unit has TTL control for film cameras, a basic form of manual control (full, 1/4, and 1/16 power, limiting its utility for modern digital shooters), and unusually, autoflash.

It's often available on the used market with components missing. Crucially, the 480EG's grip is filled with a large capacitor: it does not have a battery compartment and must be plugged into a Transistor Pack E to work. The power connector is compatible with Canon compact battery packs, but this is not recommended because of slower cycle times and lower power output. It also requires either the Shoe Cord E, which attaches to a film camera's hotshoe and provides TTL metering, or the Synchro Cord 480 that connects to a camera's PC socket for autoflash or manual operation. Both cords are very difficult to find these days. The Shoe Cord E uses a proprietary connector, but the Synchro Cord 480 can be replaced with an ordinary PC cable if necessary.

480EG

Other accessories sold for the 480EG included the Panel Adapter 480 with Wide (28 mm coverage) and Tele (135 mm coverage) panels and the Slave Unit E, a simple optical trigger that could be plugged into the back. The telephoto attachment gives the unit a guide number of 68 at 135 mm, so the 480EG's guide number is sometimes listed as 68.

Speedlite 540EZ

The pinnacle of TTL flash technology, the 540EZ also supports A-TTL, though only in P mode direct. Does not fire visible light pulses in bounce mode, since it reverts to TTL. Flip-out diffuser panel and support for up to 100 Hz in stroboscopic mode.

Fairly bulky and quite noisy in operation, since its multiplexing circuitry produces a whine that varies in pitch. Its buttons are recessed and awkward to operate. Makes a good manual-only flash unit, though there is no sync socket.

540EZ

Third-party flash

As discussed in the section on dedicated flash, a number of companies have produced flash units that are compatible with Canon EOS cameras. None are officially sanctioned by Canon, so they're built by "reverse-engineering" the Canon control language for flash. This means that there is no guarantee of compatibility, though units by well-known makers are reasonably reliable.

The following products were examined and tested for inclusion in this book. It's not an exhaustive list by any means. Some makers, notably Sunpak and Metz, did not participate, though a Metz distributor did provide some non-system units.

Sigma

Sigma of Japan is best known for its extensive lineup of lenses, which are made to fit all the popular Japanese SLR systems. The firm also produces a few flash units, which again are produced in different versions for each major camera system. Be sure to buy one marked "EO E-TTL II", indicating compatibility with Canon EOS evaluative metering.

The Sigma products are mainly cost competitive and are not differentiated in terms of features unavailable in the Canon lineup. Of the three units produced at time of writing, the EF-530 DG Super has a very competitive price/performance ratio. Older Sigma flash units, particularly those that lack the DG designation, are not fully compatible with recent Canon EOS digital cameras.

Sigma EF-530 DG ST

EF-530 DG ST

This unit is functionally analogous to the Speedlite 380EX, with greater power output and much larger physical size. However, certain important features are missing: there's no support for second curtain sync, wireless E-TTL, or high-speed sync flash; it has no rear-panel LCD; and its AF assist light covers just the central point.

While it has manual controls, they are not useful since the unit can fire either at full power or 1/16 power only, and the unit will not fire if the center pin alone is grounded (i.e., it's not compatible with sync-only triggering devices). In short, it has a number of limitations compared to a used EX series Speedlite. However, as an on-camera device, it produces quite a lot of light, has full bounce and tilt capabilities, and is quite affordable.

Sigma EF-530 DG Super

While the same size and shape as the EF-530 DG ST, the similarly-named Super is much more advanced. It offers most of the functionality of the Canon Speedlite 550EX at considerably less cost. It offers good output, has a flexible zooming/tilting/rotating flash head, supports advanced features such as second curtain sync and stroboscopic flash, has full manual output control, and is compatible with wireless E-TTL both as a master and a slave (though confusingly, it refers to groups A, B, and C as 1, 2, and 3). It also has a built-in optical slave, which is a feature no modern Speedlite has. It will work as an ordinary manual slave unit with sync-only flash triggers, but needs to be set to slave (SL) mode for this to work correctly. Slave mode also disables the power-saving standby function, which can be a nuisance for remote flash operation.

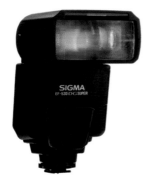

EF-530 DG Super

Its primary drawbacks are lighter build quality, an AF assist light which only covers the center focus point, longer recycle time, no custom functions, no high voltage port, and an awkward menu system that's difficult to navigate. It also has minor issues such as an inconvenient high-speed sync mode which disengages whenever the shutter speed drops below X-sync, and a lack of recent Canon Speedlite features such as white balance compensation and menu control from the camera.

If the limitations above are not an issue, and if there's a photocopy of the manual in your camera bag for times when you need to figure out how to use the wireless modes, the EF-530 DG Super is excellent value for money. However, some users have reported inconsistent exposure when used with a Canon master.

Sigma EM-140 DG

This is a macro flash unit, roughly equivalent to the Canon Speedlite MR-14EX, which also comes in two sections joined by a non-detachable cable. The body is the same size and shape as the EF-530 DG Super, and the tubes are mounted in a ring-shaped casing. However, unlike the MR-14EX, the tubes are not curved and thus the unit is really more of a double-head macro flash than a true ring. It fastens onto the filter threads of a lens and ships with 55 mm and 58 mm adapter rings. Additionally, 62, 72, and 77 mm rings are available. It has a pair of white incandescent bulbs for focus assist, and modeling lighting via pulsed output of the main tubes is also possible.

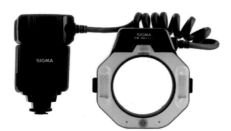

EF-530 DG Super

Controls are almost identical to the EF-530 DG Super and similarly awkward to use. However, a wide range of features is supported, including tube ratios, second curtain, stroboscopic flash, manual output control, and wireless E-TTL control of a slave in group C. The same issues with the EF-530 DG Super apply to this model.

Metz

Metz, a respected German flash manufacturer, produces four categories of flash units that work with Canon EOS, all sold under the "Mecablitz" product name ("Blitz" is German for "lightning" or "flash").

1. "System flash" units are those models dedicated to a specific camera manufacturer. Thus, a system flash such as the Mecablitz 58 AF-1 that works with Canon EOS cameras will not work with Nikon cameras. At time of writing, there are three Metz flash units dedicated to Canon EOS.
2. "SCA" units are not dedicated to any one-camera system. Instead, add-on adapters must be installed between an SCA flash unit and the camera. These SCA adapters, which support various forms of automated metering, can be exchanged and replaced as necessary. The Metz website has a compatibility feature which displays all the complex permutations of compatibility between different SCA flash units, SCA adapters, and camera models.
3. "Automatic" units are autoflash-only models. These units have built-in photocells for autoflash metering and do not support any form of camera-controlled TTL automatic metering. They work with any camera.
4. "Slave" units are small portable units that are designed to be triggered by a master flash unit or an on-camera flash.

The Metz range is much more extensive than Canon's, and Metz offers features that Canon units do not—such as flash units with memory settings, built-in secondary flash tubes, clip-on colored filters, USB ports for upgrades, and audio warning beepers. Note that some of the terms used in Metz's advertising and documentation have been translated from German and differ from Canon's terminology. A "lighting control indicator" is what Canon calls a "flash exposure confirmation" light, for example. An "AF measuring beam" is the confusing name for an "AF assist light" or "AF auxiliary light".

Mecablitz 15 MS-1 macro slave flash

The 15 MS-1 is a unique and innovative product. It's a tiny ring-shaped macro unit that's automatic and self-powered by two AAA cells (i.e., it doesn't have a separate control box). It can be controlled by a variety of wireless masters, including Canon E-TTL masters, or can be controlled manually.

A black plastic ring in shape, it fits around the end of most ordinary camera lenses, fastening to the filter threads. Note that although the device is ring-shaped, its tubes aren't. The flash tubes are short straight

15 MS-1 macro slave flash

tubes located 180° across from each other and do not curve around the lens like a true ring flash.

Unfortunately, through no fault of Metz, the unit is less useful for most cameras in the EOS system than cameras from other makers. At time of writing, only the EOS 7D can use its built-in flash unit as a wireless master. On older models, the slave-only 15 MS-1 requires a master device such as an ST-E2 or 500 series flash unit in order to function using automatic metering, adding to the cost and bulk of the solution.

Without a master unit, the 15 MS-1 functions in manual mode only. It has learning capabilities and can be taught to ignore the metering preflashes used by E-TTL, allowing it to sync correctly with an E-TTL flash unit such as the built-in flash on EOS digital cameras. However, its power output must then be set by hand.

Mecablitz 76 MZ-5 hammerhead

This flash unit is a large and heavy grip design, favored by press and wedding photographers. Its chief benefit is that it's capable of producing a tremendous amount of light: its guide number at 105 mm is 76. It can speak E-TTL through the add-on SCA 3002 adapter, though it also supports manual control and autoflash.

One interesting feature is its secondary flash tube, somewhat misleadingly referred to as a second "reflector". This is a tube on the handle that is independent of the main flash tube. If the flash head is tilted up for bounce lighting, this small secondary tube can provide some frontal fill flash.

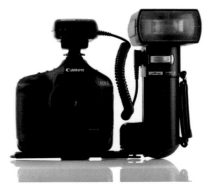

76 MZ-5 hammerhead

Quantum

Quantum Instruments is the U.S. manufacturer of an unusual line of flash units. The Qflash products are either large, battery-powered units or small studio units, depending on your point of view. Either way, they bridge the gap between sophisticated, computerized, but low-powered Speedlites and technically simpler but higher-powered studio units. They also produce a dizzying array of accessories, adapters, and interfaces to allow their Qflash units to work with cameras from Canon and other makers.

The basis of the Quantum line is the Qflash series. The main units at time of writing are the T5d-R and X5d-R units, which are both high-powered units with parabolic reflectors rather than zooming heads like a Speedlite. The units alone are a bit bigger than a Speedlite, not including the large and bulky battery pack that's required to power them. Qflash units are designed for portable applications and do not plug into AC sockets.

Qflash units can be fired sync-only via cables or Quantum's FreeXwire radio system, or they can connect directly to a Canon camera via a special

Quantum Qflash T5d-R

E-TTL hotshoe adapter. These adapters permit the transmission of radio signals compatible with Canon preflash E-TTL metering. Additional adapters, the QNexus line, allow Qflash units to serve as wireless E-TTL slaves.

The company also makes a shoemount flash unit, the Qflash Trio. This is a dedicated hotshoe unit of similar size and shape to the rest of the Qflash line. It supports regular E-TTL metering and contains a built-in, Quantum-compatible radio transmitter. Unlike a Canon Speedlite, the Trio requires an external battery pack.

Quantum products are very popular with wedding photographers and others who need large amounts of portable light for location shoots. Another advantage for wedding and sports photographers is that the Qflash units recycle very quickly, thanks to their external Turbo battery packs. The principal drawbacks of the product line are the cost and the frankly confusing range of different adapters and accessories.

A Quantum Qflash equipped with a collapsible softbox, FreeXwire radio receiver, and Quantum Turbo battery pack.

Nissin

Nissin Digital (no relation to Nissin, the cup noodle manufacturer or Nissan, the car company) produces a number of hotshoe flash units, all of which are available as Canon-only models and Nikon-only models.

Nissin Di866

Di866

The Di866 is quite an unusual third-party flash unit. Most makers of such products generally focus on replicating the name brand's key features at a lower price, but the Di866 introduces a number of new features not found elsewhere in a hotshoe flash unit powered by four AAs.

The Di866 is roughly analogous to the 550EX in terms of its basic functionality, though it doesn't offer the exact set of features as the Canon unit. Standard features include E-TTL/E-TTL II compatibility, a swivel/tilt/zoom head, a retractable wide-angle diffuser and bounce card, stroboscopic flash, wireless master/slave, and a high-voltage socket for a Nissin-proprietary battery pack.

Unusual features include a secondary fill flash tube, a color display on the back with a menu system, rotation detection, a removable battery magazine, a USB port, and a guide number of 60 (meters, ISO 100) at 105 mm. It also produces strange intermittent beeping noises while idling, as though it is communicating with the mothership, and sports an uncomfortably bright pilot LED. This latter feature is a real nuisance when using the unit on-camera in low light conditions, as the LED is positioned right by the viewfinder.

The secondary front-mounted tube, like those found on some Metz units, allows for a tiny bit of frontal fill flash at GN 12 when the main flash

head is in bounce mode. The output of this "sub" flash is set manually through a hidden menu option. The color display allows for an icon-driven graphical user interface, and rotation detection allows the screen to rotate when the camera is turned to portrait mode. The 4xAA battery magazine, like those found in old Vivitar units, allows for rapid pack changes in the field. There is a USB port for downloadable upgrades from the Internet if the company releases any. And the high GN is primarily there for bragging rights, since it's not much higher than a 580EX or a Nikon SB900.

In short, it's not a replacement for Speedlite 500 series units, as certain pro features are incomplete or missing. However, it's a sturdy-feeling basic flash that also pioneers some clever and innovative functions.

Di866 LCD

Nissin Di622

The Di622 is a low-to-midrange unit, roughly equivalent to a 380EX in the Canon lineup. It has limited onboard controls and no LCD. It's compatible with E-TTL and E-TTL II only, and therefore will not work with film bodies. In fact, it isn't compatible with all digital bodies. At time of writing, it will not work with the 5D Mark II or any 1 series model.

Its swiveling, tilting, and zooming flash head covers focal lengths from 24 mm to 105 mm, with an optional diffuser for 20mm coverage. It also has a retractable catchlight card.

The unit has an optical sensor that lets it serve as a manual optical slave unit. Unfortunately, while it has manual output controls to 1/32 power, it will not fire if the center pin alone is grounded, making it incompatible with most sync-only remotes.

The Di622 has a service port for firmware upgrades, but it's not a standard USB port. This means that upgrades for compatibility with future cameras are possible but not installable by the customer. The manufacturer or distributor is likely to charge a fee for applying the upgrade. Unlike the Di866, the Di622 has little advantage other than price over similar Canon products.

Di622

Nissin Di466

The Di466 is a very basic introductory-level unit. It has four operating modes: automatic E-TTL, manual with six steps to 1/32, optical slave which ignores preflash, and regular optical slave. It does not support wireless E-TTL and is not compatible with all EOS bodies.

It's primarily suited as a portable low-power unit for beginners and is a bit like a bulkier Speedlite 270EX in this regard, having a tilt-only head. However, it also has a zooming head and controls on the back for flash exposure compensation.

Di466

While it makes a fine low-cost optical slave unit, it can't be fired by sync-only radio triggers, since it doesn't rely on the center pin only to fire. Its pilot LED is also blindingly bright.

Marumi

Marumi is a manufacturer of low-cost photo accessories. The company has a line of affordable flash units that are billed as being compatible with Canon EOS cameras. They include the D35AFC and D728AFC hotshoe flash units and the DRF14 macro ring flash unit, which are also branded under other names such as Phoenix, Dot Line, and Bower (not to be confused with Bowens).

Unfortunately, while the units are very inexpensive, they have some compatibility issues with various camera bodies. The units tested would not fire consistently or at all on some newer EOS cameras. Some had auto-focus assist lights that would not go out.

The D35AFC is roughly equivalent to the 380EX. It has E-TTL compatibility, a hand-operated manual zoom, full tilt and swivel, and AF assist. The unit has no manual controls. Unfortunately, while the tested unit metered reasonably well on an EOS 10D and a 5D, it fired late on a 1Ds Mark III, resulting in only half the frame being exposed even at shutter speeds well under X-sync. It wouldn't fire at all on a 50D or a 500D/Rebel T1i. Its E-TTL status light is an excessively bright orange light positioned very close to the viewfinder.

The D728AFC fared better and fired on all cameras tested, though its output was a little inconsistent. This unit is similar to the D35AFC, but with lower power output.

The DRF14 is a small macro ring light with automatic controls only. The unit tested would not power on.

D35AFC

D728AFC

DRF14

Generic flash units

Be extremely wary when considering a generic flash that's branded as Canon EOS compatible. Many older, cheap flash units are TTL only, which means they won't work on a Canon EOS digital camera. Some of them are merely simple autoflash units with neither TTL nor E-TTL support, despite their misleading packaging. This is a classic situation of buyer beware, particularly when purchasing something online, sight unseen. This isn't to say that lesser-known brands are necessarily poor quality, just that it's essential to test their products on-camera first.

Some of these lesser-known brand names include Achiever, Bower (not to be confused with Bowens), Carena, Cullmann, Dörr, Dot Line, Emoblitz, FalconEyes, Opteka, Phoenix, Promaster, Quantaray, Rokinon, Sakar, Soligor, Starblitz, Tumax, and Vivitar. Many of these brands are distributors and marketers that resell products made by others under their own nameplates.

All-manual battery flash

The following are some all-manual battery-powered flash units. All operate on four AA cells, have some form of manual control over output power, and lack modern features such as TTL metering or LCD panels. Some also have autoflash capabilities.

So why buy them at all? Quite simply, with digital the possibilities of manual-only flash have become quite accessible. See chapter 11, "Off-Camera Flash", for details.

Vivitar 285

The Vivitar 285 is a classic flash unit originally released in the early 1970s. The unit shown here is over 20 years old but still works well, using either manual or autoflash (section 10.7) metering. These units were rugged workhorses for many years.

The 285, its predecessor 283, and its successor 285HV have limitations—they're quite bulky and noisy, have only four manual output power choices, have a non-standard sync socket, are slow to recharge, and lack an optical slave trigger. The 285 and 285HV have three-position manual zooming heads. Some early models have a very high trigger voltage, in the double digits (see next section).

Additionally, production of these units took place at different factories around the globe over the years, and the final production runs have a reputation for poor build quality. Vivitar as a separate entity is no longer in business, but at time of writing Cactus/Gadget Infinity has resurrected

Vivitar 285

and rebranded the 285HV as the KF36. Vivitar is now a marketing brand used by accessory company Sakar, which sells inexpensive camera products under the name. The Vivitar DF383, for example, is not related to the older generation of flash units in any way.

LumoPro LP120

Yong Nuo YN460

Nikon SB-800

LumoPro LP120

LumoPro is the house brand for U.S. retailer Midwest Photo Exchange. The LP120 is an all-manual flash stripped down to the basic elements for an off-camera flash user on a budget: manual control in six steps to 1/32, two sync ports (a PC socket and a 3.5 mm minijack), a built-in optical slave, and a manually zooming head that can bounce and swivel. There's a wide-angle diffuser panel, but it's clip-on and not integral. This is easy to lose but harder to break.

That's it. No bells, no whistles (literally—it's quite quiet). It's not perfect—the limited number of power steps means a big jump between full and half power; the two-switch power output control is quite bizarre and arranged backwards from what one might expect; the build quality is quite light; and the zooming head only goes to 85 mm—but it's very affordable and straightforward. Modest power: GN 30 at 50 mm, and a bit slow to recycle.

Yong Nuo YN460

This is another very inexpensive and moderately sized unit designed specifically for the amateur strobist. It's of fairly light build quality, and the user interface consists of a series of rear-panel LEDs. The manual control is quite simple and easy to read, with a pair of + and − buttons beneath a

simple seven-light output scale, from full power to 1/64. No zooming flash head, though it does have a delicate flip-down diffuser for 18 mm coverage and a small bounce card. Full tilt and swivel. Somewhat noisy when charging or idling.

It has a 30-minute energy-saving timeout, which is not adjustable but a reasonable length of time. It has a regular optical slave sensor and the ability to ignore preflashes. Unfortunately, the slave sensor is positioned inside the flash head, despite the unused red window on the front. No sync socket, oddly enough.

Nikon Speedlight SB-800

It may seem surprising to mention Nikon products in a book on Canon flash, but Nikon has produced many high quality battery-powered flash units over the years. While Nikon TTL, D-TTL, and i-TTL automatic metering is, of course, incompatible with Canon cameras, Nikon Speedlights (note the spelling) often have manual controls, making them excellent remote devices for manual flash work. Some, such as the SB-800, also have PC sockets (section 11.4) for connecting directly to a camera or remote trigger.

Appendix B: Choosing a Flash Unit

Choosing the right flash unit for a job depends on a host of factors. There is no one perfect flash unit for all purposes.

Before shopping for a flash unit, consider how it's likely to be used. Is it needed just for occasional snapshots? For heavy use out in the field? For indoor amateur studio work? What about size and weight? The 500 series units work fine with lightweight consumer cameras but are about as big as the camera itself. What budget restrictions are there? Are there any plans to expand into a wireless system, or is a single on-camera flash unit adequate?

Here are a few suggestions for various types of flash usage.

A flash unit for casual and occasional use with a Canon digital camera or a type A film camera

Recommended:

- The 430EX and the 430EX II are both great for general purpose, fully automatic flash photography. They're surprisingly capable, with full manual controls and a rear LCD, and can serve as a wireless E-TTL slave for future expansion. The 430EX II offers a few new features, such as quiet recycling and camera menu control, but the 430EX does quite well also.
- The pocketable 220EX and 270EX may be acceptable for very occasional snapshot use, but not much more since they are low powered. The 270EX can't be fully controlled by cameras that lack flash control menus.

Not recommended:

- The 380EX lacks swivel and wireless slave capabilities. The 420EX lacks manual controls and has no FEC on some consumer bodies, but might be adequate if it's a good deal.
- The 500 EX units are quite large and expensive, and may be overkill for casual use.
- Rock-bottom cheap flash units billed as "Canon compatible" should always be considered with caution. Never buy one without testing it first, as many have compatibility issues.

Advanced use with a Canon digital camera or a type A film camera

Recommended:

- The 580EX and 580EX II are quite powerful and can do anything a portable flash unit can be expected to do. The 580EX has much more convenient wireless master controls, and its price holds up on the used market.
- A used 550EX may be a good choice if priced low, but it's bulky and noisy.

Not recommended:

- Avoid any flash units that lack wireless controls and manual output, as they place limits on future expansion.

A flash system for wireless E-TTL

One's first inclination might be to buy a 500 series unit as a master and a 400 series as a remote slave. The trouble is, in terms of power output, it often makes more sense to have them arranged the other way around. This way the master provides on-camera fill and the slave provides the main light. With time, the limitations of a lower-powered slave often become increasingly apparent.

Recommended:

- Two 500 EX series units, each of which can serve as either master or slave. 400 EX series units are okay as additional adjunct units. The Sigma EF 500 DG Super is a more affordable wireless unit, particularly as a slave.

Not recommended:

- The ST-E2 places many limits on wireless control. It has a limited control range and, most problematically, can't control group C flash units. It's fairly cheap but in the end can be a false economy.

A flash unit for all-manual work, Strobist-style

Here, it all depends on one's priorities. Is the goal to use manual flash uniquely, or is it to build a system that can be used both automatically and manually? Relatively few of Canon's flash units are suited solely for manual work, simply because they're optimized for automatic use.

Recommended:

- Any battery-powered flash unit from any manufacturer works well, as long as it has manual output controls. However, a built-in sync port, the ability to recycle the unit quickly, and a zooming flash head are very useful features. The 580EX II is fine for this, but an expensive choice unless it's also being used for its automatic capabilities.

Not recommended:

- A fully automatic flash unit that lacks manual controls is useless.
- A flash unit with auto power-off which can't be overridden, especially if the power-off timer is less than 5 minutes.
- An older unit with high voltages on its flash foot can sometimes damage cameras or wireless triggers.
- Any third-party flash unit that can't fire when the center pin is triggered.

A flash unit for macro photography

While specialized macro units are very handy tools, it's possible to use regular flash units as well. Any flash unit positioned off-camera with a suitable diffuser can serve as a good macro flash unit; it's simply more awkward to use.

Recommended:

- The MR-14EX is good if a ring-type flash unit is needed, though its flat light isn't suitable for all subjects. The MT-24EX is expensive, and its ability to move flash heads independently is valuable for some types of photography but not others.

Not recommended:

- The ML-3 is TTL only and lacks manual controls, making it useless for digital cameras. The Sigma EM-140 DG is not a true ring flash, and doesn't offer significant enough savings to make it a better choice than the MR-14EX.

A flash unit for use with a type B film camera; no plans to buy a type A film or digital camera in the future

In this case, it's best to stay with an E or EZ series flash unit, since buying an EX unit means paying for extra features that don't work with a type B camera. Also, since EZ units are all discontinued and incompatible with digital, they can be purchased on the used market very cheaply.

Recommended:

❯ The 430EZ and 540EZ are fairly large but offer a full range of features. Most importantly, they both offer tilt/swivel and the ability to apply flash exposure compensation. The 540EZ doesn't emit irritating pulses of white light when metering in bounce mode.

Not recommended:

❯ The E units are compact, but very underpowered and not very versatile. The 300EZ lacks tilt and swivel, and the 420EZ lacks flash exposure compensation. There's no real advantage to buying a third-party unit in this situation unless it offers some unusual features, such as some of the more advanced Metz units.

Appendix C: Features Table

	Medium*	Year introduced	Month	Maximum X-sync	TTL metering	TTL zones	A-TTL metering	E-TTL metering	E-TTL II metering	Evaluative zones	Red AF assist	White AF assist	Pulse AF assist
EOS 650	35mm	1987	March	1/125	●	1	●			6			
EOS 620	35mm	1987	May	1/250	●	1	●			6			
EOS 750/750QD	35mm	1988	October	1/125	●	1	●			6	●		
EOS 850	35mm	1988	October	1/125	●	1	●			6			
EOS 600/630	35mm	1989	April	1/125	●	1	●			6			
EOS 1	35mm	1989	September	1/250	●	1	●			6			
EOS RT	35mm	1989	October	1/125	●	1	●			6			
EOS 10/10S/10QD	35mm	1990	March	1/125	●	3	●			8	●		
EOS 700	35mm	1990	March	1/125	●	1	●			6	●		
EOS 1000/Rebel	35mm	1990	October	1/90	●	1	●			3			
EOS 1000F/Rebel S	35mm	1990	October	1/90	●	1	●			3	●		
EOS 100/Elan/100QD	35mm	1991	August	1/125	●	1	●			6	●		
EF-M	35mm	1991	September	1/90						3			
EOS 1000N/Rebel II	35mm	1992	March	1/90	●	1	●			3			
EOS 1000FN/Rebel S II/1000S QD	35mm	1992	March	1/90	●	1	●			3	●		
EOS 5/A2/A2E/5QD	35mm	1992	November	1/60–1/200	●	3	●			16	●		
EOS 500/Rebel X/Rebel XS/Kiss	35mm	1993	September	1/90	●	3	●			6		●	
EOS 1N/1N HS/1N RS/1N DP	35mm	1994	November	1/250	●	3	●			16			
EOS 5000/888	35mm	1995	January	1/90	●	3	●			6		●	
EOS 50/Elan II/50E/Elan IIE/55	35mm	1995	September	1/125	●	3	●	●		6		●	
EOS 500N/Rebel G/New Kiss	35mm	1996	September	1/90	●	3	●	●		6		●	
EOS IX/IX E	APS	1996	October	1/200	●	3	●	●		6		●	
EOS IX 7/IX Lite/IX 50	APS	1998	March	1/125	●	3	●	●		6		●	
EOS 3	35mm	1998	November	1/200	●	3	●	●		21			
EOS 3000/88	35mm	1999	March	1/90	●	3	●			6		●	
EOS 300/Rebel 2000/Kiss III	35mm	1999	April	1/90	●	3	●	●		35			●
EOS 1V	35mm	2000	March	1/250	●	3	●	●		21			
EOS 30/Elan 7E/33/Elan 7	35mm	2000	October	1/125	●	3	●	●		35			●
EOS 3000N/Rebel XS N/66	35mm	2002	February	1/90	●	3	●	●		6		●	
EOS 300V/Rebel Ti/Kiss 5	35mm	2002	September	1/90	●	3	●	●		35			●
EOS 3000V/Rebel K2/Kiss Lite	35mm	2003	September	1/90	●	3	●	●		35			●
EOS 30V/Elan 7NE/33V/Elan 7N/7S	35mm	2004	April	1/125	●	3	●		●	35			●
EOS 300X/Rebel T2/Kiss 7	35mm	2004	September	1/125					●	35			●
EOS DCS 1	digital	1995	December	1/250	●	3				16			
EOS DCS 3	digital	1995	May	1/250	●	3				16			
EOS D2000/Kodak DCS520	digital	1998	March	1/250				●		12			
EOS D6000/Kodak DCS560	digital	1998	December	1/250				●		12			
EOS D30	digital	2000	October	1/200	Doesn't fire			●		35		●	
EOS 1D	digital	2001	December	1/500	Full power			●		21			
EOS D60	digital	2002	March	1/250	Doesn't fire			●		35		●	
EOS 1Ds	digital	2002	November	1/250	Full power			●		21			
EOS 10D	digital	2003	March	1/200	Doesn't fire			●		35			●
EOS 300D/Digital Rebel/Kiss Digital	digital	2003	September	1/200	Doesn't fire			●		35			●
Kodak DCS Pro SLR/c	digital	2004	March	1/180				●		8			
EOS 1D Mark II	digital	2004	April	1/250	Full power				●	21			
EOS 20D/20Da	digital	2004	September	1/250	Doesn't fire				●	35			
EOS 1Ds Mark II	digital	2004	November	1/250	Full power				●	21			
EOS 350D/Digital Rebel XT/Kiss Digital N	digital	2005	March	1/200	Doesn't fire				●	35			●
EOS 1D Mark II N	digital	2005	October	1/250	Full power				●	21			
EOS 5D	digital	2005	October	1/200	Full power				●	35			
EOS 30D	digital	2006	March	1/250	Doesn't fire				●	35			●
EOS 400D/Digital Rebel XTi/Kiss Digital X	digital	2006	September	1/200	Doesn't fire				●	35			●
EOS 1D Mark III	digital	2007	March	1/300	Full power				●	63			
EOS 40D	digital	2007	September	1/250	Full power				●	35			●
EOS 1Ds Mark III	digital	2007	November	1/250	Full power				●	63			
EOS 450D/Digital Rebel XSi/Kiss X2	digital	2008	March	1/200	Full power				●	35			●
EOS 1000D/Digital Rebel XS/Kiss F	digital	2008	June	1/200	Full power				●	35			●
EOS 50D	digital	2008	September	1/250	Full power				●	35			●
EOS 5D Mark II	digital	2008	November	1/200	Full power				●	35			
EOS 500D/Digital Rebel T1i/Kiss X3	digital	2009	March	1/200	Full power				●	35			●
EOS 7D	digital	2009	August	1/250	Full power				●	63			
EOS 1D Mark IV	digital	2009	October	1/300	Full power				●	63			

| | Medium | Year introduced | Month | Maximum X-sync | TTL metering | TTL zones | A-TTL metering | E-TTL metering | E-TTL II metering | Evaluative zones | Red AF assist | White AF assist | Pulse AF assist |

For an enlarged PDF view of these tables, please visit the publisher's website at rockynook.com. Choose "Mastering Canon EOS Flash Photography" and then select "Look Inside/Add Ons".

Speedlite AF assist	Disable Internal	Disable Speedlite	Disable assist	Speedlite red/pulse	Built-in flash	Built-in flash GN	Flash coverage	Flash zooms	Flash auto raises	Flash auto lowers	Tall flash	Popup flash manual	Popup flash stroboscopic	Redeye reduction
•					•	12	35mm		•	•				
•														
•														
•														
•														
	•				•	12	28mm		•	•				
					•	12	35mm		•	•				
•					•	12	28mm							•
•	•	•			•	12–17	28, 50, 80mm	•	•					•
•	•													
•					•	12	28mm		•					•
			•		•	13–17	28, 50, 80mm	•	•					•
•					•	12			•					•
•					•	12								•
•	•	•			•	13	28mm		•					•
•					•	12			•					•
•					•	11	22mm		•					•
•					•	10	22mm		•					•
•		•	•											
•					•	12								•
•			•		•	12	28mm		•					•
•		•												
•	•				•	13	28mm		•					•
•					•	12	28mm							•
•					•	12	28mm		•		•			•
•					•	12	28mm		•		•			•
•	•		•		•	13	28mm		•					•
•	•		•		•	13	28mm		•		•			•
•														
•														
•	•	•			•	12			•					•
•		•												
•	•	•			•	12			•					•
•		•												
•	•	•	•		•	13	18mm		•					•
•	•	•	•	•	•	13	18mm		•		•			•
•		•												
•	•	•			•	13	17mm		•		•			•
•		•												
•	•	•	•		•	13	17mm		•		•			•
•		•												
•	•	•	•		•	13	17mm		•		•			•
•	•	•	•		•	13	17mm		•		•			•
•	•	•			•	13	17mm		•		•			•
		•									•			
•	•	•	•		•	13	17mm		•		•			•
•	•	•	•	•	•	13	17mm		•		•			•
•	•	•			•	13	17mm		•		•			•
•		•												
•	•	•	•		•	13	17mm		•		•			•
•	•	•	•	•	•	12	15mm		•		•	•	•	•
•		•												

| Speedlite AF assist | Disable Internal | Disable Speedlite | Disable assist | Speedlite red/pulse | Built-in flash | Built-in flash GN | Flash coverage | Flash zooms | Flash auto raises | Flash auto lowers | Tall flash | Popup flash manual | Popup flash stroboscopic | Redeye reduction |

	Wireless E-TTL	Wireless ratios	Popup flash master	Internal FEC	External FEC	FEC in viewfinder	Flash micro adjustment	FEL controls	FEL in viewfinder	Modeling flash	FEB	Subframe adjust.	Flash cust. function	Auto fill red.
EOS 650														
EOS 620														
EOS 750/750QD														
EOS 850														
EOS 600/630					•									
EOS 1					•									
EOS RT					•									
EOS 10/10S/10QD					•									
EOS 700					•									
EOS 1000/Rebel					•									
EOS 1000F/Rebel S					•									
EOS 100/Elan/100QD				Internal only	•								•	
EF-M														
EOS 1000N/Rebel II					•									
EOS 1000FN/Rebel S II/1000S QD					•									
EOS 5/A2/A2E/5QD			•		•								•	•
EOS 500/Rebel X/Rebel XS/Kiss					•									
EOS 1N/1N HS/1N RS/1N DP				•	•	•			•					•
EOS 5000/888					•									
EOS 50/Elan II/50E/Elan IIE/55	•			•	•									
EOS 500N/Rebel G/New Kiss					•									
EOS IX/IX E	•				•	•								
EOS IX 7/IX Lite/IX 50	•				•									
EOS 3	•	•			•			Dedicated	•	•			•	
EOS 3000/88					•									
EOS 300/Rebel 2000/Kiss III	•				•						•			
EOS 1V	•	•		•	•			Dedicated	•	•			•	•
EOS 30/Elan 7E/33/Elan 7	•	•		•	•				•	•			•	
EOS 3000N/Rebel XS N/66	•				•	•								
EOS 300V/Rebel Ti/Kiss 5	•				•					•				
EOS 3000V/Rebel K2/Kiss Lite	•				•					•				
EOS 30V/Elan 7NE/33V/Elan 7N/7S	•	•		•	•			•	•				•	
EOS 300X/Rebel T2/Kiss 7	•				•					•				
EOS DCS 1				•	•									
EOS DCS 3				•	•									
EOS D2000/Kodak DCS520	•	•		•	•									
EOS D6000/Kodak DCS560	•	•		•	•									
EOS D30	•	•		•	•			AE lock		•			•	
EOS 1D	•	•		•	•	•		Dedicated	•	•	•			•
EOS D60	•	•		•	•			AE lock		•				
EOS 1Ds	•	•		•	•	•		Dedicated	•	•	•			•
EOS 10D	•	•		•	•			Assist button		•	•		•	•
EOS 300D/Digital Rebel/Kiss Digital	•	•		•										
Kodak DCS Pro SLR/c	•													
EOS 1D Mark II	•	•		•	•	•		Dedicated	•	•	•			
EOS 20D/20Da	•	•		•	•			AE lock	•	•	•	•		•
EOS 1Ds Mark II	•	•		•	•	•		Dedicated	•	•	•			
EOS 350D/Digital Rebel XT/Kiss Digital N	•	•		•	•			AE lock	•	•	•		•	•
EOS 1D Mark II N	•	•		•	•	•		Dedicated	•	•	•			•
EOS 5D	•	•		•	•			AE lock	•	•	•			•
EOS 30D	•	•		•	•			AE lock	•	•	•		•	•
EOS 400D/Digital Rebel XTi/Kiss Digital X	•	•		•	•			AE lock	•	•	•		•	•
EOS 1D Mark III	•	•		•	•	•		Dedicated	•	•	•			•
EOS 40D	•	•		•	•			AE lock	•	•	•		•	•
EOS 1Ds Mark III	•	•		•	•	•		Dedicated	•	•	•			•
EOS 450D/Digital Rebel XSi/Kiss X2	•	•		•	•			AE lock	•	•	•		•	•
EOS 1000D/Digital Rebel XS/Kiss F	•	•		•	•			AE lock	•	•	•		•	
EOS 50D	•	•		•	•			AE lock	•	•	•		•	•
EOS 5D Mark II	•	•		•	•			AE lock	•	•	•			•
EOS 500D/Digital Rebel T1i/Kiss X3	•	•		•	•			AE lock	•	•	•		•	•
EOS 7D	•	•	•	•	•			M-Fn button	•	•	•	•		•
EOS 1D Mark IV	•	•		•	•	•	•	Dedicated	•	•	•	•	•	•
	Wireless E-TTL	Wireless ratios	Popup flash master	Internal FEC	External FEC	FEC in viewfinder	Flash micro adjustment	FEL controls	FEL in viewfinder	Modeling flash	FEB	Subframe adjust	Flash cust. function	Auto fill red.

PC socket	Ignores PC polarity	250v trigger	Second curtain sync	SCS internal	SCS external	Weather-proofed	CPU type	Ext. menu control	Automatic autoflash	Color temp.	Auto ISO, bounce	Live View	Live View silent mode	LV, no ext. flash
			•											
			•											
	•	•	•											
			•											
			•											
			•											
			•											
			•	•										
			•											
•			•	•	•									
			•											
•	•	•	•											
			•											
			•		•									
			•											
			•											
•	•	•	•		•									
			•											
•	•	•	•		•									
			•											
			•											
			•											
			•	•	•									
			•											
•	•	•	•											
•	•	•	•											
•	•	•	•											
•	•	•	•											
•			•	•	•		Unnamed							
•	•	•	•		•		DIGIC							
•	•	•	•	•	•		Unnamed							
•			•		•		DIGIC							
•	•		•	•	•		DIGIC							
			•		•		DIGIC							
•			•											
•	•	•	•		•		DIGIC II							
•	•	•	•	•	•		DIGIC II				•			
•	•	•	•		•	•	DIGIC II							
	•	•	•	•	•		DIGIC II				•			
•	•	•			•	•	DIGIC II				•			
•	•		•		•		DIGIC II				•			
•	•	•	•	•	•		DIGIC II				•			
	•	•	•	•	•		DIGIC II				•			
•	•	•	•		•	•	2 DIGIC III	•	•	•		•		
•	•	•	•	•	•		DIGIC III	•	•	•		•	•	
•	•	•	•		•	•	2 DIGIC III	•	•	•		•		
	•	•	•	•	•		DIGIC III	•	•	•		•		
	•	•	•		•		DIGIC III	•	•	•		•		
•	•	•	•	•	•		DIGIC 4	•	•	•		•	•	
•	•	•	•		•	•	DIGIC 4	•	•	•		•	•	
	•	•	•	•	•		DIGIC 4	•	•	•	•	•		•
	•	•	•	•	•	•	2 DIGIC 4	•	•	•	•	•	•	
•	•	•	•		•	•	2 DIGIC 4	•	•	•		•	•	
PC socket	Ignores PC polarity	250v trigger	Second curtain sync	SCS internal	SCS external	Weather-proofed	CPU type	Ext. menu control	Automatic autoflash	Color temp.	Auto ISO, bounce	Live View	Live View silent mode	LV, no ext. flash

	160E	200E	200M	300TL	300EZ	420EZ	430EZ	480EG	540EZ	ML-3
Max guide number, meters	16	20	20	30	30	42	43	48	54	11
Max guide number, feet	52	65	65	98	98	137	140	156	176	36
GN at 14mm										
GN at 17mm or 18mm									16	
GN at 24mm				25		25	25		28	
GN at 28mm					22	27	27		30	
GN at 35mm	16	20	20	30	25	30	30	48	36	
GN at 50mm				35	28	35	35		42	
GN at 70mm					30	40	40		46	
GN at 80mm				40		42	43		50	
GN at 105mm									54	
Year introduced	1988	1990	1991	1986	1987	1987	1989	1993	1994	1989
Year discontinued	1990	1996	?	?	1995	1989	1994	?	1998	2001
Physical										
Width/height/depth in mm	59x83x52	64x104x41	64x104x41	81x119x94	66x89x100	75x122x106	75x122x106	98x257x114	80x138x112	74x61x107
Ring/heads width/height/depth										106x123x25
Weight without batteries	85g	130g	130g	395g	215g	365g	365g	715g	415g	365g
Foot material	Plastic	Plastic	Plastic	Plastic	Plastic	Plastic	Plastic	Plastic	Plastic	Plastic
Foot lock type	No lock	Slide lock	Slide lock	Wheel	Wheel	Wheel	Wheel, pin	None	Wheel, pin	
Weatherproofing										
Socket for SB-E bracket										
Controls										
Back panel LCD, illuminated						●	●		●	
Coupling distance scale on LCD									●	
Custom functions and settings										
Control dial										
Power										
Battery type	2CR5 lithium	4xAA	4xAA	4xAA	4xAA	4xAA	4xAA	External pack	4xAA	4xAA
Lithium AA supported	n/a							n/a	●	
High voltage port							●	●	●	
Auto Power Off/Save Energy (SE) mode	15 sec	None	None	5 min	5 min	5 min	90 sec	None	90 sec	5 min
Power switch SE override				●					●	
Custom function SE override										
Automatic metering										
TTL (film only)	●	●		●	●	●	●	●	●	●
A-TTL (film only)			with T90 only			●	●			
E-TTL and E-TTL II										
Autoflash			●					●		
Manual flash output control										
Manual output controls on unit				●		●	●	●	●	
Output controls on compatible camera										
Illuminated test button ("pilot")				●	●	●	●	●	●	●
Number of output levels				2		6	6	3	8	
Lowest output level				1/16		1/32	1/32	1/16	1/128	
Increments										
Feet/meters user-configurable								No	Switch	
Optical slave capabilities								Optional		
PC socket								●		
Tilt and swivel										
Tilt, up/down	Fixed head	Fixed head	Fixed head	90°U	Fixed head	90°U	90°U	90°U	90°U, 7°D	
Swivel, left/right				180°L, 90°R		180°L, 90°R	180°L, 90°R	180°L, 105° R	180°L, 90°R	
Single-button tilt/swivel release										
Pull-out catchlight card										
Flash head coverage (for 35mm frame)										
Fixed flash head coverage	35mm	35mm	35mm					35mm		
Optional clip-on panels		28mm	28mm					20, 135mm		
Hand-operated zoom head positions				4						
Motorized zoom head positions					4	6	6		7	
Zoom head focal range				24–85mm	28–70mm	24–80mm	24–80mm		24–105mm	
Zoom setting LEDs				●	●					
Zoom setting on LCD						●	●		●	
Manual control of motorized zoom						●	●		●	
Sensor size compensation										
Pull-out diffuser panel; coverage									18mm	
	160E	200E	200M	300TL	300EZ	420EZ	430EZ	480EG	540EZ	ML-3

220EX	270EX	380EX	420EX	430EX	430EX II	550EX	580EX	580EX II	MR-14EX	MT-24EX	ST-E2
22	27	38	42	43	43	55	58	58	14	24	
72	88	124	137	140	140	179	189	189	46	78	
				11	11		15	15			
						15					
		21	23	25	25	28	28	28			
22	22	23	25	27	27	30	30	30			
		28	31	31	31	36	36	36			
	27	31	34	34	34	42	42	42			
		33	37	37	37	46	50	50			
				40	40	50	53	53			
		38	42	43	43	55	58	58			
1996	2009	1995	2000	2005	2008	1998	2004	2007	2000	2001	1998
2009	Current	2001	2005	2008	Current	2004	2007	Current	Current	Current	Current
65x92x61	64x65x73	75x114x104	72x123x99	72x122x101	72x122x101	80x138x112	76x134x114	76x137x117	74x126x97	74x126x97	62x51x80
									113x126x26	235x90x49	
160g	145g	270g	300g	320g	320g	405g	375g	405g	430g	585g	100g
Plastic	Metal	Plastic	Plastic	Plastic	Metal	Plastic	Plastic	Metal	Plastic	Plastic	Plastic
Slide lock, pin	Slide lock, pin	Wheel, pin	Wheel, pin	Wheel, pin	Quick release	Wheel, pin	Wheel, pin	Quick release	Wheel, pin	Wheel, pin	Slide lock, pin
								●			
				●	●		●	●			
				●	●	●	●	●	●	●	
						●					
				6, 12	9, 20		14, 28	14, 32	7, 14	9, 18	
							●				
4xAA	2xAA	4xAA	4xAA	4xAA	4xAA	4xAA	4xAA	4xAA	4xAA	4xAA	2CR5 lithium
●	●	●	●	●	●	●	●	●	●	●	n/a
						●	●	●	●	●	
90 sec	90 sec	90 sec	90 sec	90 sec	90 sec	90 sec	90 sec	90 sec	90 sec	90 sec	
						●					
		●					●				
●		●	●	●	●	●	●	●	●	●	●
●	●	●	●	●	●	●	●	●	●	●	●
								●			
				●	●	●	●	●	●	●	
	●										
●		●	●	●	●	●	●	●	●	●	
	7			7	7	8	8	8	7	7	
	1/64			1/64	1/64	1/128	1/128	1/128	1/64	1/64	
				1 stop	1/3 stop						
						Switch	Button	C.Fn			
Fixed head	90°U	90°U	90°U	90°U	90°U	90°U, 7°D	90°U, 7°D	90°U, 7°D			
	No swivel	No swivel	180°L, 90°R	180°L, 90°R	180°L, 90°R	180°L, 90°R	180°L, 90°R	180°L, 180°R			
				●	●		●	●			
							●	●			
28mm	28mm, 50mm										
	2										
		6	6	7	7	7	7	7			
		24–105mm	24–105mm	24–105mm	24–105mm	24–105mm	24–105mm	24–105mm			
		●	●								
				●	●	●	●	●			
				●	●	●	●	●			
				●	●		●	●			
				14mm	14mm	17mm	14mm	14mm			
220EX	270EX	380EX	420EX	430EX	430EX II	550EX	580EX	580EX II	MR-14EX	MT-24EX	ST-E2

	160E	200E	200M	300TL	300EZ	420EZ	430EZ	480EG	540EZ	ML-3
Autofocus assist										
Red LED; points covered	1	1			1	1	1		5	
Red LED range, center	1–5m	1–5m			0.9–6m	0.9–8m	0.9–10m		0.5–15m	
Red LED range, periphery										
White incandescent										•
Pulses flash (with compatible bodies)										
Flash exposure lock (FEL)				with T90 only						
High speed sync/FP mode										
High speed sync control										
Flash exposure bracketing (FEB)										
Flash exposure compensation (FEC)							Buttons		Buttons	
FEC in 1/3 increments										
Second curtain sync (SCS)										
SCS enabled by switch				with T90 only	•					
SCS enabled by +/– buttons						•	•		•	
SCS via camera C.Fn/menu										
Recycling										
Approx recycle time, alkaline AAs	0.3–1.7 sec	0.3–1.7 sec		0.2–13 sec	0.3–8 sec	0.2–13 sec	0.2–13 sec	0.2–17 sec	0.2–13 sec	0.2–13 sec
Flashes per charge, alkaline AAs	400–4000	400–4000		100–700	200–2000	100–700	100–700	100–700 (TP3)	100–700	100–1000
Rapid fire/Quick Flash capability	•			•	•	•	•		•	
Rapid fire with high voltage port									•	
Silent recycling										
Stroboscopic flash rate						1–5 Hz	1–10 Hz		1–100 Hz	
Number of repeated flashes									1–100	
Flash exposure confirmation LED								•	•	•
Wireless E-TTL										
Master capable, groups										
Wireless feature enabled by:										
Slave capable										
Flash A/B ratio displayed on LCD										
Flash A/B ratio LEDs										
Visible light or infrared signals										
Control signal range, center										
Control signal range, periphery										
Control signal angle										
Modeling flash										
Modeling flash in slave mode only										
Automatic WB compensation										
External (camera) menu control										
	160E	200E	200M	300TL	300EZ	420EZ	430EZ	480EG	540EZ	ML-3

220EX	270EX	380EX	420EX	430EX	430EX II	550EX	580EX	580EX II	MR-14EX	MT-24EX	ST-E2
1		1	7	9	9	45	9, 45	9, 45			45
0.7–5m		0.7–10m	0.7–7m	0.7–7m	0.8–7m	0.6–10m	0.6–10m	0.6–10m			0.6–10m
			0.7–5m	0.7–5m				0.6–5m			
									•	•	
	•										
	•	•	•	•	•	•	•	•	•	•	
•	•	•	•	•	•	•	•	•	•	•	•
Button	Camera menu	Switch	Switch	Button	Button	+/– buttons	Button	Button	+/– buttons	+/– buttons	Button
						•	•	•	•	•	
				Buttons	Buttons	Buttons	Dial	Dial	Buttons	Buttons	
				•	•	•					
				•	•	•	•	•	•	•	
•	•	•	•	•	•	•	•	•	•	•	•
0.1–4.5 sec	0.1–3.9 sec	0.1–7.5 sec	0.1–7.5 sec	0.1–3.7 sec	0.1–3.7 sec	0.1–8 sec	0.1–6 sec	0.1–5 sec	0.1–7 sec	0.1–7 sec	
250–1700	100–680	260–1800	200–1400	200–1400	200–1400	100–700	100–700	100–700	120–800	120–800	1500
	•					•	•	•			
						•	•	•			
					•			•			
						1–199 Hz	1–199 Hz	1–199 Hz			
						1–100	1–100	1–100			
•		•	•	•	•	•	•	•	•	•	•
						A, B, C	A, B, C	A, B, C	C	C	A, B
			Switch	Switch	Button/Menu	Switch	Switch	Button/Menu	Switch	Switch	
				•	•	•	•	•			
						•	•	•	•	•	
											•
						Visible	Visible	Visible	Visible	Visible	Infrared
						10–15m	10–15m	10–15m	3–5m	5–8m	8–10m
						8–12m	8–12m	8–12m			
						80° H, 60° V	80° H, 60° V	80° H, 60° V	80° H, 80° V	50° H, 70° V	40° H, 30° V
	•		•	•	•	•	•	•	•	•	
			•	•	•	•					
	•			•	•			•			
	•				•			•			
220EX	270EX	380EX	420EX	430EX	430EX II	550EX	580EX	580EX II	MR-14EX	MT-24EX	ST-E2

Key to Appendix C: Features Tables

Model name. If multiple model names are listed, it's because the same camera is sold under different names in different regions. For example, the camera known as the 500D in Europe and most of Asia is sold under the name Digital Rebel T1i in Canada and the U.S., and under the name Kiss X3 Digital in Japan. There are rarely any major differences between variants.

Medium. Recording medium: 35mm film, APS film, digital.

Year introduced. The year in which the camera was announced.

Maximum X-sync. The highest shutter speed at which normal (non high-speed sync) flash photography is possible. See 7.11.

TTL metering. Whether TTL (through the lens) flash metering is supported. TTL flash metering is a film-only feature, and is never supported on digital bodies. Some digital cameras will fire TTL or A-TTL flash units at full power, whereas other digital bodies will not fire them at all. See 7.2.

TTL zones. The number of metering zones used by TTL or A-TTL. See 7.9.3.

A-TTL metering. Advanced TTL, a film-only variant of TTL metering. See 7.3.

E-TTL metering. Evaluative TTL, a flash metering system used by later film and all digital EOS bodies. See 7.4.

E-TTL II metering. An improved version of E-TTL. See 7.5.

Evaluative zones. The number of metering zones employed by the camera's evaluative metering system. See 7.8.5.

Red AF assist. The camera has a built-in red LED to help autofocus perform in low light conditions. See 9.7.1.

White AF assist. The camera has a bright white lamp to help autofocus perform in low light conditions. See 9.7.4.

Pulse AF assist. The camera pulses its popup flash unit in order to help autofocus perform in low light conditions. See 9.7.5.

Speedlite AF assist. The camera is able to use a directly connected Speedlite's autofocus assist light. See 9.7.

Disable Internal. The camera can disable its internal AF assist. See 9.7.6.

Disable Speedlite. The camera can disable an external Speedlite's AF assist.

Disable assist. The camera can disable autofocus assist altogether.

Speedlite red/pulse. The camera can distinguish between Speedlites with red AF assist lights and those that pulse the main tube for AF assist.

Built-in flash. The camera has a built-in popup flash unit. See 8.1.

Built-in flash GN. The metric guide number of the internal flash. See 7.15.

Flash coverage. The coverage of the internal flash unit, equivalent to the focal length of a lens. In the case of cropped image sensors, the actual focal length supported is used. See 9.5.

Flash zooms. The internal flash unit has a motorized zooming head.

Flash auto raises. The internal flash unit can pop up automatically if light levels are low and if the camera is in an icon mode which uses flash.

Flash auto lowers. The internal flash unit has a motorized system for lowering the flash unit (no need to push it down manually).

Tall flash. The internal flash unit is on a longer strut system to raise the flash head farther from the center of the lens, thus reducing redeye slightly.

Popup flash manual. The internal flash unit can have its output settings specified manually. See 9.16.

Popup flash stroboscopic. The internal flash unit can pulse stroboscopically. See 9.21 and 15.8.

Redeye reduction. The camera has some form of redeye reduction system, typically a bright light to cause a person's pupils to contract. See 9.8.

Wireless E-TTL. The camera can support Canon's wireless E-TTL flash metering system, which uses pulses of visible light or infrared energy to send signals. See 9.17 and 11.8.

Wireless ratios. Support for A, B, and C wireless ratios. See 11.8.4.

Popup flash master. The camera's built-in flash unit can control remote wireless E-TTL slave units. No additional hardware is required. See 9.18.

Internal FEC. The camera has on-board controls for flash exposure compensation. See 9.9.

External FEC. The camera supports flash exposure compensation on an external Speedlite if FEC controls are built into the flash unit.

FEC in viewfinder. The camera displays FEC settings in the viewfinder.

Flash micro adjustment. The camera can bias normal flash exposure settings. See 9.9.1.

FEL controls. The camera has a means for flash exposure lock (e.g., a separate FEL button, or the function is tied to AE lock). See 9.10.

FEL icon. The camera displays FEL information in the viewfinder.

Modeling flash. Support for simulated modeling lights with external Speedlite flash units. See 9.24.

FEB. Support for flash exposure bracketing. See 9.13.

Subframe adjust. A digital camera can instruct an external Speedlite that a subframe image sensor is in use and compensate accordingly. See 9.5.4.

Flash cust. function. The camera has custom functions for flash control.

Auto fill red. The camera can disable auto fill flash reduction. See 9.12.

PC socket. The camera has a socket for external sync-only flash. See 11.4.

Ignores PC polarity. The camera doesn't care about the polarity of a PC connector (i.e., whether the tip is positive or negative).

250v trigger voltage. The camera's hotshoe, and PC socket if present, can withstand up to 250 volt flash trigger circuits. See 10.5.

Second curtain sync. The camera is capable of supporting second curtain sync with directly connected Speedlite flash units. See 7.13.

SCS internal. The camera has internal controls (a menu item or a custom function) for enabling or disabling second curtain sync.

SCS external. The camera supports or honors any second curtain sync controls on an external Speedlite.

Weatherproofed. The camera has some form of sealing (rubber gaskets and so on) to protect it against dust or inclement weather. See 9.32.

CPU type. The type of internal digital image processor used by the camera.

Ext. menu control. The camera can control a compatible Speedlite via a menu system. Various flash unit settings can be adjusted. See 9.29.

Automatic autoflash. The camera can send ISO and aperture data to a 580EX II flash unit if it's in autoflash mode. See 9.26.1.

Color temp. data. The camera can receive data from a compatible flash unit for minor color adjustments. See 9.33.

Auto ISO and bounce. The camera can tell if the Speedlite is in bounce mode and, if so, increases auto ISO settings to compensate. See 9.4.

Live View. The camera can display live video from the sensor chip directly on the camera's preview screen. See 9.34.

Live View silent mode. The camera can use electronic first curtain in Live View for quieter performance. Silent mode is not compatible with flash.

LV, no ext. flash. The camera cannot fire studio flash units (ie: non-Speedlite sync-only flash units) when in Live View mode.

Appendix D: Custom Functions

Recent EOS cameras with Speedlite menu control have the ability to display and set custom functions on version II Speedlites in a full-text form. Older cameras and flash units do not, so it could be useful to put a photocopy of this page in your camera bag for easy reference.

Speedlite 430EX

1	Auto power off	on/off
2	Power-off in slave mode	60 min / 10 min
3	Automatic compensation for subframe digital cameras	on/off
4	AF-assist beam	on/off
5	Modeling flash	on/off
6	LCD when shutter release pressed halfway	maximum range / aperture

Speedlite 430EX II

0	Distance display	meters / feet
1	Auto power off	on/off
2	Modeling flash	on: DOF button/on: test button/on: both buttons/off
7	Test firing	1/32 power/full power
8	AF-assist beam	on/off
9	Auto-zoom for subframe digital cameras	on/off
10	Slave unit auto power off	60 min / 10 min
11	Cancelation of slave's auto power off: can be canceled by master within	8 hours / 1 hour
14	LCD when shutter release pressed halfway	maximum range / aperture

Speedlite 580EX

#	Function	Options
1	Automatic cancellation of FEB after three frames	on/off
2	FEB sequence	normal – + / – normal +
3	Flash metering	E-TTL / E-TTL II / TTL-only
4	Slave unit auto power off	60 mins / 10 mins of inactivity
5	Cancelation of slave's auto power off: can be canceled by master within	1 hr / 8 hrs
6	Modeling flash	available / not available
7	Flash recycling when using high voltage port. Note that flash needs working internal batteries to run, even if it's connected to a battery pack.	Use both internal batteries and high voltage port / use high voltage port only
8	Quick flash with continuous shooting	on/off
9	Test firing	1/32/full output
10	Modeling flash with test button	disabled / enabled
11	Automatic compensation for subframe digital cameras	enabled / disabled
12	AF assist beam off	disabled / enabled
13	Flash exposure compensation	dial and button / dial only
14	Auto power off activation	on/off

Speedlite 580EX II

#	Function	Options
0	Distance display	meters / feet
1	Auto power off	on/off
2	Modeling flash	on: DOF button/on: test button/on: both buttons/off
3	Automatic cancellation of flash exposure bracketing (FEB) after three frames	on/off
4	FEB sequence	normal – + / – normal +
5	Flash metering	E-TTL/E-TTL II/TTL-only / external metering auto / external metering manual
6	Quickflash with continuous shot	disabled / enabled
7	Test firing with autoflash	1/32 power / full power
8	AF assist beam	enabled / disabled
9	Automatic compensation for subframe digital cameras	enabled / disabled
10	Slave unit auto power off	60 min / 10 min
11	Cancelation of slave's auto power off: can be canceled by master within	8 hours / 1 hour
12	Flash recycling when using high voltage port. Note that flash needs working internal batteries to run, even if it's connected to a battery pack.	Use both internal batteries and high voltage port / use high voltage port only
13	Flash exposure compensation	dial and button / dial only

Appendix E: Sequence of Operation

E-TTL (film and digital) sequence of operation

The usual E-TTL sequence of operation, not counting the optional flash exposure lock (FE lock) feature or wireless operation, is as follows:

- When the shutter release is pressed halfway, the current ambient light levels are metered by the camera as usual. Shutter speed and aperture are set by the camera or user depending on the current mode: PIC (icon) modes or P, Av, Tv, or M.
- When the shutter release is pressed all the way, the flash unit immediately fires a low-power preflash from the main flash tube (i.e., white light).
- The reflected light from this preflash is analyzed by the same evaluative metering system that the camera uses for metering ambient light levels. The appropriate power output (i.e., flash duration) of the flash is determined by an internal computer which subtracts the ambient light level. The entire sensor area is evaluated and compared to the ambient metering, and the area around the active focus point is emphasized. The value of the required power output is stored in memory. If manual focus mode is used, then either the central focus point or averaged metering is used.
- If the photo is being taken under bright lighting conditions (10 EV or brighter), auto fill reduction is applied (unless it has been disabled by a custom function, as is possible on some bodies), and the flash output is decreased by anywhere from 0.5 to 2 stops. Canon has not published details of the E-TTL auto fill reduction algorithms, and they vary from model to model.
- The mirror flips up and the shutter opens, exposing the film or sensor chip.
- The flash tube is then fired at the previously determined power level to illuminate the scene. Start time of the flash burst depends on whether first or second curtain sync has been set. The OTF sensor in the camera, in the case of most EOS film cameras, is not used in E-TTL mode.
- The shutter stays open for the full duration of the shutter speed time.
- The shutter closes and the mirror flips back down. If the flash unit has a flash exposure confirmation light, and if the flash metering was deemed sufficient, the light glows.

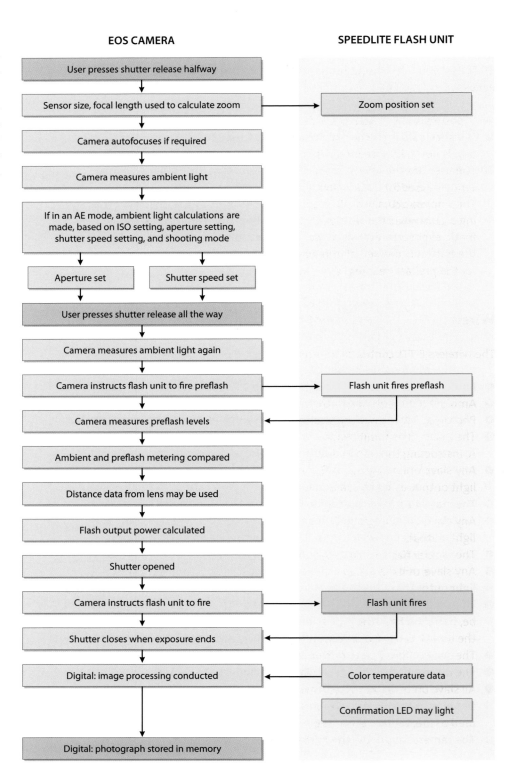

Figure E-1
Basic E-TTL II sequence, not including user-selectable options such as sync timing (first, second, high speed), metering types, and flash exposure compensation.

EOS CAMERA

SPEEDLITE FLASH UNIT

User presses shutter release halfway

Sensor size, focal length used to calculate zoom → Zoom position set

Camera autofocuses if required

Camera measures ambient light

If in an AE mode, ambient light calculations are made, based on ISO setting, aperture setting, shutter speed setting, and shooting mode

Aperture set Shutter speed set

User presses shutter release all the way

Camera measures ambient light again

Camera instructs flash unit to fire preflash → Flash unit fires preflash

Camera measures preflash levels

Ambient and preflash metering compared

Distance data from lens may be used

Flash output power calculated

Shutter opened

Camera instructs flash unit to fire → Flash unit fires

Shutter closes when exposure ends

Digital: image processing conducted ← Color temperature data

Confirmation LED may light

Digital: photograph stored in memory

E-TTL II sequence of operation

E-TTL II is similar to E-TTL in terms of the basic sequence. The primary differences are as follows:

- Exposure is not biased to any focus point.
- Distance data from the lens is factored into the calculations if the flash unit is not in bounce mode or wireless.
- The user has the ability to specify whether evaluative or averaged metering is used for the ambient light.
- The camera actually performs ambient metering twice. The first reading occurs when the shutter release is half-pressed and is used for automatic exposure settings as normal. The second reading occurs when the button is pressed all the way and is used as a point of comparison for the preflash reading. ● *Figure E-1*

Wireless E-TTL sequence of operation

The wireless E-TTL control sequence is as follows:

- Photographer presses the shutter release button halfway.
- Ambient light metering of the scene is conducted.
- Photographer presses the shutter release all the way.
- The master flash unit sends a wireless signal to all slave units in group A, instructing them to issue a low-power preflash.
- Any slave units in group A fire a preflash, and the camera records this light output using its evaluative meter.
- The master flash instructs group B slaves to issue a preflash.
- Any slave units in group B fire a preflash, and the camera records this light output.
- The master flash instructs group C slaves to issue a preflash.
- Any slave units in group C fire a preflash, and the camera records this light output.
- The camera calculates what the final flash output for the scene should be, based on both the preflash data from each slave group (if any) and the user-defined group ratios/flash exposure compensation settings.
- The camera flips up the mirror and opens the shutter.
- The master flash instructs all slave units to fire simultaneously.
- All slave units fire at whatever level the master unit has told them to. If the master flash unit is flash-capable (i.e., not an ST-E2) and is configured to fire, then it too will do so.
- The camera flips down the mirror and closes the shutter.

Figure E-2
Wireless E-TTL sequence with
all three slave groups in use.
(See rockynook.com
for a PDF of this table.)

There are, of course, differences in the timing of some of these events if AE lock or flash exposure lock (FE lock) are used, but this is the basic work flowchart. The command pulses and prefires occur at an extremely rapid rate. They'll register with a human observer but occur far too quickly to be interpreted as much more than a flash burst. They also occur prior to the shutter opening and so should not light the scene.

TTL (film only) sequence of operation

- When the shutter release is depressed halfway, the current ambient light levels are metered by the camera as usual. Shutter speed and aperture are set by the camera or user depending on the current mode: P, Av, Tv, M, or icon mode. In P mode and most icon modes, the camera sets the shutter speed to a value between 1/60 and X-sync. In the other modes it meters normally (except on certain cameras that have a custom function that can lock the camera to X-sync in Av mode).
- When the shutter release is pressed all the way, the camera flips up the mirror and opens the shutter, exposing the film.
- If second curtain sync is used, the shutter stays open for nearly the full duration of the shutter speed time.
- The flash unit sends power to the flash tube, illuminating the scene. The start time of the flash triggering depends on whether first or second curtain sync has been set. First curtain: immediately after the shutter opens. Second curtain: shortly before the shutter closes.
- Duration of the flash pulse is determined by the off-the-film (OTF) flash sensor, which meters for an average scene. If the photo is being taken under bright lighting conditions (10 EV or brighter), auto fill reduction is applied, unless it has been disabled by a custom function as is possible on some bodies. This can reduce the flash output by anywhere from 0.5 to 1.5 stops.
- As soon as the flash unit determines that the foreground subject has been adequately lit (by realtime measurement of flash-derived light reflecting off the surface of the film), it cuts off the power to the flash tube. The light from the flash unit is immediately quenched.
- The shutter remains open for the full duration of the shutter speed time in the case of first curtain sync.
- The shutter closes and the mirror flips back down.
- If the flash unit has a flash exposure confirmation LED, and if the flash metering was deemed adequate, then the light glows.

A-TTL (film only) sequence of operation

The A-TTL sequence of operation is as follows:

- When the shutter release is depressed halfway, the current ambient light levels are metered by the camera. In P and Tv modes, the ambient aperture value is determined and stored, but not set. In Av and M modes, the ambient aperture value is user-set.

- In order to determine the approximate distance from the flash to the main subject, the flash unit fires a preflash (either near-infrared light from a front-mounted secondary flash tube, or white light from the main flash tube, depending on the flash unit and operating mode) in conjunction with the ambient light metering. In P mode only, the correct aperture value to expose the main subject is then calculated.

- In P mode only, the two aperture values (ambient and flash) are compared when the shutter release is fully depressed. The camera typically sets the smaller of the two apertures, particularly if the distance to the subject is determined to be fairly close. In Av and M modes the aperture is determined by the user setting, and in Tv mode the aperture is determined by the ambient light meter settings.

- If the photo is being taken under bright lighting conditions (10 EV or brighter), auto fill reduction is applied, unless it has been disabled by a custom function. This can reduce the flash output by anywhere from 0.5 to 1.5 stops.

- The camera flips up the mirror and opens the shutter, exposing the film.

- The flash unit then sends out the actual scene-illuminating flash. The start time of the flash pulse depends on whether first or second curtain sync has been set. Duration of the flash pulse is determined by the standard OTF sensor, which is exactly the same as TTL flash.

- The shutter stays open for the full duration of the shutter speed time.

- The shutter closes and the mirror flips back down. If the flash unit has a flash exposure confirmation light, and if the flash metering was deemed adequate, then the light glows.

Appendix F: Lenses

Lenses With Distance Data

The following lenses are capable of returning distance data for use with E-TTL II flash metering. Most, but not all, of the lenses with distance data capabilities contain ring USM focus motors. The resolution of a typical lens distance decoder is fairly approximate compared to the accuracy of the autofocus system.

PRIME / FIXED FOCAL LENGTH EF

EF 14mm 2.8L USM
EF 14mm 2.8L II USM
EF 20mm 2.8 USM
EF 24mm 1.4L USM
EF 28mm 1.8 USM
EF 35mm 1.4L USM
EF 50mm 1.2 L USM
EF 85mm 1.2L II USM
EF 85mm 1.8 USM
EF 100mm 2 USM
EF 100mm 2.8 macro
EF 100mm 2.8 macro USM
EF 100mm 2.8L macro IS USM
EF 135mm 2L USM
EF 180mm 3.5L macro USM
EF 200mm 2.8L USM
EF 200mm 2.8L II USM
EF 200mm 2.0L IS USM
EF 300mm 2.8L IS USM
EF 300mm 4L USM
EF 300mm 4L IS USM
EF 400mm 2.8L IS USM
EF 400mm 4 DO IS USM
EF 400mm 5.6L USM
EF 500mm 4L IS USM
EF 600mm 4L IS USM
EF 800mm 5.6L IS USM
EF 1200mm 5.6L USM III

ZOOM EF

EF 16–35mm 2.8L USM
EF 16–35mm 2.8L II USM
EF 17–35mm 2.8L USM
EF 17–40mm 4L USM
EF 20–35mm 3.5–4.5 USM
EF 24–70mm 2.8L USM
EF 24–85mm 3.5–4.5 USM
EF 24–105mm 4L IS USM
EF 28–70mm 2.8L USM
EF 28–90mm 4–5.6 III
EF 28–80mm 3.5–5.6 USM
EF 28–105mm 3.5–4.5 USM
EF 28–105mm 3.5–4.5 II USM
EF 28–105mm 4–5.6
EF 28–105mm 4–5.6 USM
EF 28–135mm 3.5–5.6 IS USM
EF 28–200mm 3.5–5.6
EF 28–200mm 3.5–5.6 USM
EF 28–300mm 3.5–5.6L IS USM
EF 35–135mm 4–5.6 USM
EF 70–200mm 4L USM
EF 70–200mm 4L IS USM
EF 70–200mm 2.8L USM
EF 70–200mm 2.8L IS USM
EF 70–210mm 3.5–4.5 USM
EF 70–300mm 4.5–5.6 DO IS USM
EF 70–300mm 4–5.6 IS USM
EF 90–300mm 4–5.6
EF 90–300mm 4–5.6 USM
EF 100–300mm 4.5–5.6 USM
EF 100–400mm 4.5–5.6L IS USM

EF-S

EF-S 60mm 2.8 macro USM
EF-S 10–22mm 4.5–5.6 USM
EF-S 15–85mm 3.5–5.6 IS USM
EF-S 17–55mm 2.8 IS USM
EF-S 17–85mm 4–5.6 IS USMS
EF-S 18–55mm 3.5–5.6
EF-S 18–55mm 3.5–5.6 IS
EF-S 18–55mm 3.5–5.6 II
EF-S 18–55mm 3.5–5.6 II USM

EF-S 18–135mm 3.5–5.6 IS
EF-S 18–200mm 3.5–5.6 IS
EF-S 55–250mm 4–5.6 USM

SPECIAL-PURPOSE

TS-E 17mm 4L
TS-E 24mm 3.5L II
MP-E 65mm 2.8 1–5x macro

Lenses Without Distance Data

PRIME / FIXED FOCAL LENGTH EF

EF 15mm 2.8 fisheye
EF 24mm 2.8
EF 28mm 2.8
EF 35mm 2
EF 50mm 1.0L USM
EF 50mm 1.4 USM
EF 50mm 1.8
EF 50mm 1.8 II
EF 50mm 2.5 compact macro
EF 85mm 1.2L USM
EF 135mm 2.8 soft focus
EF 200mm 1.8L USM
EF 300mm 2.8L USM
EF 400mm 2.8L USM
EF 400mm 2.8L II USM
EF 500mm 4.5L USM
EF 600mm 4L USM

ZOOM EF

EF 20–35mm 2.8L
EF 22–55mm 4–5.6 USM
EF 28–70mm 3.5–4.5
EF 28–70mm 3.5–4.5 II
EF 28–80mm 2.8–4L USM
EF 28–80mm 3.5–5.6
EF 28–80mm 3.5–5.6 II
EF 28–80mm 3.5–5.6 II USM
EF 28–80mm 3.5–5.6 III USM
EF 28–80mm 3.5–5.6 IV USM
EF 28–80mm 3.5–5.6 V USM
EF 28–90mm 4–5.6
EF 28–90mm 4–5.6 II
EF 28–90mm 4–5.6 USM
EF 28–90mm 4–5.6 II USM
EF 35–70mm 3.5–4.5
EF 35–70mm 3.5–4.5 FA
EF 35–80mm 4–5.6
EF 35–80mm 4–5.6 PZ
EF 35–80mm 4–5.6 USM
EF 35–80mm 4–5.6 II
EF 35–80mm 4–5.6 III
EF 35–105mm 3.5–4.5
EF 35–105mm 4.5–5.6
EF 35–105mm 4.5–5.6 USM
EF 35–135mm 3.5–4.5

EF 35–350mm 3.5–5.6L USM
EF 38–76mm 4.5–5.6
EF 50–200mm 3.5–4.5L
EF 50–200mm 3.5–4.5
EF 55–200mm 4–5.6 USM
EF 55–200mm 4–5.6 II USM
EF 70–210mm 4
EF 75–300mm 4–5.6
EF 75–300mm 4–5.6 USM
EF 75–300mm 4–5.6 IS USM
EF 75–300mm 4–5.6 II

EF 75–300mm 4.5–5.6 II USM
EF 75–300mm 4.5–5.6 III USM
EF 75–300mm 4.5–5.6 III
EF 80–200mm 4.5–5.6
EF 80–200mm 4.5–5.6 USM
EF 80–200mm 4.5–5.6 II
EF 80–200mm 2.8L
EF 100–200mm 4.5A
EF 100–300mm 5.6L
EF 100–300mm 5.6

SPECIAL-PURPOSE

TS-E 24mm 3.5L
TS-E 45mm 2.8
TS-E 90mm 2.8

Sigma and Tamron were not able to state which of their Canon EF compatible lenses support distance data and which do not. However, both manufacturers mentioned that all of their current lenses at time of writing return distance data, and some older lenses may as well. Presumably their future lenses will also. Tokina did not respond to my inquiry.

Appendix G: Troubleshooting

Built-in flash

Why does the screen on my camera say "BUSY" with the flash symbol? The built-in flash won't fire.

There are two possible reasons for this. The word "BUSY" appears briefly while the built-in flash charges up, during which time it's unavailable. Also, if the built-in flash is fired too many times, then it goes into shutdown mode to avoid overheating. The unit has to cool down before the BUSY indicator goes away. See 7.22.1.

There's a dark curved shadow at the bottom of my photos.

The lens or lens hood is blocking the built-in flash unit. Try a smaller lens, remove the hood, or best yet, avoid built-in flash. See 8.1.1.

Speedlite power issues

My flash unit will not power on.

Are the batteries in the right orientation? The battery compartment has a small picture indicating the correct polarity for each cell. See 2.2.

Are all the batteries charged or fresh? One or more dead or low batteries will prevent the unit from working.

Are you turning the unit on using its power switch and not its wireless on/off switch? See 9.17.

My flash unit doesn't fire when I take a photo.

Are the batteries fresh?

Has the flash unit recycled and the PILOT light turned red? See 2.2.

Are the contacts clean? Does the flash unit respond in any other way to camera commands, such as adjusting zoom settings when the zoom lens is adjusted?

Is the flash unit a 580EX II in "E" mode on its display? If so, set custom function 5 to 0 to disable autoflash. This problem occurs because the camera is an older model that does not report ISO data to the flash unit. See 9.26.1.

My flash unit has two off switches. What do they do?

One is the main power on/off switch. The other controls wireless mode, and the "off" position means wireless is not engaged. See 9.17.

Why does my flash unit turn itself off after a minute or two?

The flash unit has an "auto power off" or "save energy/SE" mode designed to reduce battery drain. It can be reawakened by pressing the button marked PILOT on most flash units, or if the flash unit is on-camera, by half-pressing the shutter release. Many later Speedlites have the ability to extend or turn off SE mode through use of a custom function. See 9.25.

Flash won't fire when I have Live View turned on.

The camera probably has Silent Shooting turned on, which isn't compatible with flash. Turn it off. Also, some cameras can't fire non-Speedlite flash units when in Live View mode. See 9.34.

My flash unit buzzes and doesn't operate reliably, even when off camera.

Try changing the batteries. Some older Speedlites function erratically when power is low.

Flash unit compatibility

Can I use my Speedlite flash unit with a non-Canon EOS camera?

Probably not in an automatic fashion. Virtually no non-EOS cameras have flash metering systems compatible with Canon EOS. You should be able to get the flash unit to fire at full power when the camera takes a photo. If the flash unit has manual controls, then you can use it as an all-manual device.

Why won't my old Speedlite E or EZ flash work with my digital EOS camera? (See appendix C.)

Speedlite E, EG, and EZ flash units don't work automatically with digital EOS cameras. They may be used in all-manual mode if that function is built into the flash unit, but not in any automatic fashion. This is because these flash units predate E-TTL flash metering, which is the technology used by digital EOS cameras. See 7.2.2.

Some digital bodies will fire an older TTL unit at full power only, whereas other bodies won't fire them at all. See Appendix C.

Why won't my non-Canon flash unit work with my Canon camera?

Some non-Canon flash units don't support Canon's metering technologies. Those that do may not support it properly, and thus may not be compatible with all Canon cameras. If the flash unit is a recent model, contact the manufacturer and see if there's a firmware update to fix the problem. If not, and if the flash unit lacks manual controls, then I'm afraid it's not worth keeping. See 8.5.

Why does my camera say my flash unit is incompatible? It seems to work OK.

Recent EOS digital cameras have the ability to control the settings on recent Speedlite flash units via a menu system. However, if an older flash unit is put onto one of these cameras, and the "flash control" menu is selected, this error message appears. This does not mean that the flash unit as a whole is incompatible with the camera, just that it's not compatible with menu control. See 9.29.

I connected my camera and flash with a generic PC cord, but it only fires at full power.

PC cords are simple two-conductor cables that carry synchronization signals (fire the flash now!) but do not carry any other information. This means that correct metering information can't be sent from a camera to a flash using a PC cord. See 11.4.

If your camera and flash unit are otherwise capable of communicating with each other (e.g., an EOS camera and a Speedlite flash unit), then you'll need a different type of cord—see 11.5.1. Alternatively the flash unit can be used in full manual mode (chapter 10).

My Speedlite EX flash unit doesn't work when I hook it up with Canon-branded flash extension cables.

The old-style Canon flash extension cables (round 6 pin connectors) support TTL metering only. They are not compatible with E-TTL in any form. See 11.5.2.

When I use a wireless adapter, my Speedlite fires once and then stops working.

This means you're using a wireless accessory, probably an optical slave adapter, that isn't compatible with Canon Speedlites. The flash unit will need to be turned off and turned back on again before it will respond. The best option is to buy a compatible flash trigger. See 11.7.6.

Using the flash unit

The aperture value is blinking in the viewfinder when flash is turned on.

The camera is in Tv mode and there isn't enough ambient light for the background to expose correctly. Either open the aperture wider, turn up the ISO, shoot in P mode, or just deal with an underexposed background. See 6.11.

The shutter speed value is blinking in the viewfinder when flash is turned on.
The camera is in Av mode and there isn't enough ambient light for the background to expose correctly. Either use a slower shutter speed, turn up the ISO, shoot in P mode, or just deal with an underexposed background. See 6.12.

My 580EX II won't work properly and just displays "E" or "EM" on its LCD.
The unit is in autoflash mode, referred to by Canon as "external metering". Set custom function 5 to setting 0 to disable autoflash. See 9.26.

Flash photos suddenly overexpose or the flash unit stops firing. The screen on the flash unit is displaying "TTL".
The flash unit's contacts are dirty or aren't contacting the camera's hotshoe properly. Try cleaning the contacts—gently, and without use of solvents or erasers, which can damage the equipment.

The lower section of a Speedlite-lit image is dark.
The subject may be too close to the flash unit. Try tilting the flash head to the 7° down position. If that doesn't work, try using the flash unit off-camera with a diffuser, or use a macro flash unit. See 9.4.

Why are the eyes of the people in my photos always half-closed?
E-TTL flash fires a preflash for metering purposes. There's an imperceptible delay between the preflash and the subject-illuminating flash, and a longer delay if second curtain sync is used. Though brief, this delay can be long enough for people with sensitive eyes to be caught mid-blink. Try disabling second curtain sync, if it's on. If it's not on, use FEL to fire the preflash manually, then take the photo. Warn your subjects that the flash unit will be firing twice. See 7.4.1.

Why is metering for my E-TTL flash photos always completely wrong?
Are you using the focus and recompose technique with an E-TTL camera? This will cause problems. See 7.4.1.
Is there a bright or highly reflective object in the frame when using E-TTL? Is the focus point over something really light or really dark? See 7.4.1.
Is the flash unit fully seated in the hotshoe? Does E-TTL appear in the flash unit's LCD if it has one?
Are you using an early digital EOS camera such as a D30, D60, or 10D? If so, try putting the lens into manual focus mode when using flash.
Is the flash unit in E or EM mode? If so, disable autoflash. See 9.26.

I need to take a bunch of flash photos really quickly, but the flash unit takes ages to charge up between shots.

This is a fundamental limitation of powering a flash unit with a few tiny AA batteries. The answer is a high-voltage battery pack. These packs are a bit cumbersome and can only be attached to high-end flash units, but they reduce cycle time from a few seconds to a second or two. See 12.12.

Flash unit features

Why does "CF" or "C.Fn" appear on my flash unit's display?

One or more custom functions have been set to a position other than the default. You have to go through the settings one by one to see which one has been set, however. See section 9.28 and appendix D.

My flash unit suddenly went crazy, buzzing and flashing the main tube for a moment.

This is probably the modeling flash, engaged by pressing the depth of field preview button (the unmarked button to the side of the lens mount on the camera). If desired, the modeling flash feature can be disabled on some units via a custom function. See 9.24.

The clear plastic lens over my flash unit's tube is faintly yellow. Is that normal?

Some non-Canon Speedlite flash units have a slightly warm tint to the Fresnel lens covering the tube. This is to compensate slightly for the bluish color that flash tends to produce. However, an orange or brown patch at the center of the lens indicates that the flash unit has been overdriven at some point, and the heat has melted the plastic. See 7.22.1.

Why can't I select second curtain sync?

Can both the camera and flash unit support it? A few really old film cameras can't use it. See Appendix C.

Is the camera in an icon mode? See 6.7.

Is the feature engaged, either via the camera's custom function or the flash unit's controls? See 9.15.

Is the flash unit in wireless master or slave mode? See 9.17.

Is the flash unit in stroboscopic (MULTI) or high-speed sync mode?

Are you using the camera's flash control menu to set a flash unit that can't be controlled by the External Speedlite menu? See 9.29.

Flash exposure lock (FEL) won't work.
Is the flash unit in E-TTL mode?
Is the camera a type A film model or a digital EOS body? See 7.6.
Is the camera in a non-icon mode? See 6.9.
Is Live View off? See 9.34.

Modeling flash won't work.
Is the camera in icon mode? See 6.7.
Is Live View engaged? See 9.34.
Is the camera a type B film body or an EOS 300/Rebel 2000 camera, which does not support modeling flash? See 7.6.

High-speed sync keeps resetting.
Sigma flash units will not stay in high-speed sync mode if the camera's shutter speed drops below X-sync. If this occurs, then the feature must be turned back on again on the flash unit. Canon Speedlites don't do this and switch automatically between regular sync and high-speed sync as appropriate whenever the flash unit is in HSS-capable mode. See Appendix A.

What is the unlabeled light on my flash unit for?
The LED with no markings is usually a flash exposure confirmation light. This light illuminates to indicate that enough light was produced by the flash to expose the image adequately. It lights up for a few seconds after a picture is taken. See 9.22.

Autofocus assist

The autofocus assist light on my camera's flash unit isn't working.
Is your camera in AI Servo mode? AF assist will not work in this autofocus mode. See 9.7.1.
Do you have a camera with multiple focus points and a flash unit that can't cover all of those points? Try selecting the center focus point and see if the AF assist light goes on. See 9.7.2.
Do you have a custom function or menu option that disables the AF assist light?. See 9.7.1.
Does your flash have a very weak AF assist light (e.g., 160E, 200E), making it difficult to see?
Is the ambient light bright enough so the AF assist light won't fire?
Do you have a flash unit that has an AF assist light? See Appendix C.

Yargh! Why does my flash unit produce blinding lighting pulses with a scary electric buzz when I try to focus?

The flash unit, or camera if it's a built-in flash unit, is pulsing its main flash tube to help autofocus to work under low light conditions. This is an effective way to provide enough light to focus, but it's also pretty unpleasant for anyone in front of the lens.

This type of AF assist can be turned off. Less obtrusive forms of AF assist are also available. See 9.7.

Why don't the AF assist lights on my Speedlite cover all the autofocus points on my camera?

Some Speedlite flash units don't have full coverage of all the autofocus points on all camera models. See 9.7.2.

Why doesn't AF assist work with my ultra-wide lens?

Speedlites with red AF assist lights typically cover up to 28mm. Wider than that, and only the central focus point is likely to be covered.

Why is the AF assist light on the front of my flash unit pulsing a bright red light every second?

This indicates that the flash unit is in wireless E-TTL slave mode, waiting to receive commands from a master flash unit. This blinking light can't be disabled, which can be annoying in low light conditions, so sometimes a piece of black gaffer tape is the best solution. This function can be useful for determining where light from the flash is likely to fall, and indicates whether a slave unit is actually going to fire because it's fully charged. See 9.7.1.

My Speedlite 270EX doesn't seem to have an AF assist, but it lists it in the manual.

The 270EX lacks the red autofocus assist light built into most other Speedlites. Instead, it has the ability to pulse its main flash tube during the autofocus process to help achieve lock, but this feature is only available on EOS digital bodies that can control external Speedlite units. Earlier digital cameras with this capability may need a firmware update for the 270EX AF assist to work. It may also be possible to enable the feature on a newer camera and then transfer the flash unit over to an older model. See 9.7.5.

Can I use my flash unit for autofocus assist without it firing a flash?

Maybe. Many camera and flash unit combinations support this functionality by custom functions. It depends on the specific combination of camera and flash unit. See Appendix C.

Flash head coverage

Why is the zoom position displaying — .— mm?
This indicates that the flash head has been tilted or rotated when the flash zoom position was set to automatic. See 9.4 and 9.5.2.

Can I use my 135mm lens with a flash unit that only zooms to 105mm?
Yes. There's no problem using any long telephoto lens with the flash unit, it's just that the flash head can't narrow down its beam to match focal lengths longer than 105mm. This simply means that light that doesn't affect the image is being wasted, but it has no adverse effects. If a longer throw of the beam is needed, consider purchasing a flash extender. See 9.5 and 12.6.5.

The wide setting on my flash unit's zoom, 24mm, is blinking continuously on the LCD.
This means that the lens currently in use is wider than the widest coverage possible with the flash unit's zooming motor. Change the focal length or flip down the diffuser panel. See 9.6.

Can I use a 14mm lens with a flash unit that covers only up to 17mm?
You can, but the edges of the picture will not be properly illuminated.

Why can't I adjust flash zoom settings?
The diffuser is probably pulled out, or possibly broken. See 9.6.

Why is all the text on my flash unit's LCD blinking?
Canon flash units do this if the wide panel is extended when the flash head is in any position other than straight ahead. This is a warning that use of the wide panel in bounce mode is not recommended by Canon. See 9.6.

Why is the bounce icon on my flash unit's LCD blinking?
Some Canon flash units do this to indicate that the flash head is tilted downwards by 7°. See 9.4.

Wireless

Wireless slave flash units sometimes don't fire.
Can the slave units see the master unit (i.e., is there line of sight between the master unit's flash head and the slave unit's front-mounted receiver)? Are the two devices close enough? See 11.8.2.
Is the master unit set to "master" and the slave units set to "slave"?

Are the units all on the same channel? See 11.8.3.

Are you waiting long enough for both master and slave units to recharge?

Can I set slave Speedlites to manual mode?

Yes. You can either set the master unit to manual mode (section 11.8.5), or you can set each slave unit to manual mode. To do so, engage slave mode, then press and hold down the MODE button on the slave unit for a couple of seconds. See 11.8.5.

Can I prevent a master flash unit from lighting the scene?

Yes. Speedlite flash units capable of wireless E-TTL master mode (with the exception of the macro flash units) are able to command remote slave Speedlites without themselves contributing any light to the scene. See 9.17.5. Sometimes onboard flash is useful as light fill, but often it's undesirable to have the master unit actually light things up.

Note that the master unit will still issue pulses of light for control purposes, but these are produced before the shutter opens.

Can I control slave Speedlites using built-in flash?

That depends on the camera you're using. Before the introduction of the EOS 7D in 2009, no EOS camera was capable of controlling a remote slave flash unit using wireless E-TTL without an add-on master flash unit. The 7D has this ability, and it is probable that subsequent EOS bodies with built-in flash will as well. See 9.18.

Studio lighting

Why won't my Canon Speedlite flash unit trigger my studio flash gear properly?

If the flash unit is in E-TTL mode or wireless mode, and if the studio gear is using an optical slave, then problems will arise. The preflash signals from the camera, used for E-TTL metering and for wireless control, will trigger the studio units' optical sensors prematurely. The studio units will fire, but their light will be mostly, or entirely, gone by the time the camera's shutter opens. See 11.7.3.

A Speedlite can only trigger studio flash if used in TTL mode (not recommended) or manual flash mode. The same applies to using built-in flash to trigger an optical slave, since most digital EOS bodies use automatic E-TTL preflash metering. The EOS 7D is one of the few EOS bodies that can avoid this problem, since it supports manual control over the popup flash unit, and manual flash does not use a preflash.

Why won't second curtain sync work with my remote flash triggers?

On Canon EOS cameras, second curtain sync doesn't sync via the center pin. The sync command is handled by complex digital commands instead. Therefore, second curtain sync will not work with non-Speedlite flash units. See 9.15.2.

Why is there a dark underexposed rectangle down the side of my photos when I use studio flash?

The most likely explanation is that your camera has a shutter speed that's too high for the flash unit in question. This maximum speed is the camera's X-sync value. Also, if the flash unit is controlled by radio triggers, there could be additional delays caused by the transmission. Try experimenting with slower shutter speeds on the camera. See 7.11.

A much less likely explanation—though one that might be the case if you see this problem when using an automated Speedlite-style flash, or if you see general exposure problems with all your photos—is that the shutter is failing.

Why does my camera manual specify two X-sync values?

Canon often specifies two maximum X-sync values: one for Speedlite external flash units, and a slightly lower one for studio flash units. This is because studio units often have a longer flash duration. There can also be delays in firing studio flash units as described above. See 7.11.1.

Can I use automatic and manual flash units simultaneously?

Quite often, yes. TTL/A-TTL metering with film cameras occurs after the shutter opens, and so manual flash would interfere with TTL metering. But E-TTL/E-TTL II metering occurs *before* the shutter opens. It's therefore possible to synchronize any number of manual flash units to fire at the same time as an automatic E-TTL unit. Naturally this will require careful adjustment of the manual slave or slaves to match the automated unit's output.

The manual slaves can be wireless E-TTL slaves with manual output controls (see 9.17.4) or simply ordinary flash units synchronized to a camera's PC socket. However, optical slave units cannot be used. See 11.7.3.

How can I shoot with wide apertures under studio lighting?

One drawback of studio lights is that they're often so bright that it isn't possible to shoot with a lens wide open to ensure narrow depth of field. It may be necessary to shoot at a low ISO setting such as 50, put darkening neutral density (ND) filters on the flash units, or an ND filter on the lens.

Appendix H: Online Resources

The Internet is the best place to keep up to date on the world of flash photography. Here are some useful sites worth investigating.

PhotoNotes.org. Run by your author, this site has a series of useful articles on photography, an online dictionary of terms and jargon, and a complete compatibility lookup table for Canon EOS gear. *photonotes.org*

Strobist.com. The site that revolutionized enthusiast use of off-camera flash. Founded by former photojournalist David Hobby, this site has introductory articles, a lively discussion area, and a huge community of avid Strobists. *strobist.com*

Discussion forums

FredMiranda. This site has a large collection of user-submitted equipment reviews, and its discussion forums have a good ratio of signal-to-noise. There are specific areas for Canon EOS gear and studio lighting equipment. *fredmiranda.com/forum/*

Photo.net. One of the oldest online photographic communities, Photo.net isn't flashy, but through strict moderation maintains a solid level of discussion. *photo.net/bboard/*

Reviews and information

Digital Camera Resource. One of the earliest online review sites, DCResource is focused on reviewing primarily consumer gear. *dcresource.com*

The Digital Journalist. Aimed at professional photojournalists, this site is also notable for carrying a regular column by Canon USA's chief guru Chuck Westfall. *digitaljournalist.org*

DPReview. Oriented towards the dedicated gearhead, DPReview is famous for its highly detailed camera reviews. *dpreview.com*

Imaging Resource. Another no-nonsense, tech-oriented review site. *imaging-resource.com*

The Luminous Landscape. With a focus on nature and landscape photography, this site has a lot of tutorials and personal product reviews. *luminous-landscape.com*

Neil van Niekerk. A professional wedding photographer and seminar leader, Neil's site also has a valuable set of flash photography tutorials. *planetneil.com/tangents*

Rob Galbraith Digital Photography Insights. Reviews, news, opinions. Some general blog posts, but also an array of highly detailed technical reviews and articles. *robgalbraith.com*

SportsShooter.com. While a valuable resource for professional sports photographers, this site contains content of interest to people of nearly all contemporary photographic disciplines. *sportsshooter.com*

Personal blogs

In the olden days, it took a lot of networking and apprenticing to understand what the pros were up to. Today they blog. Here are three high-profile, professional photographers with very interesting regular blogs. They aren't all necessarily Canon users, but like most pros, they are more interested in techniques and results than arguments over brands.

Chase Jarvis. *blog.chasejarvis.com/blog*
Vincent Laforet. *blog.vincentlaforet.com*
Joe McNally. *joemcnally.com/blog*

Credits and Acknowledgements

While many representatives of photographic equipment makers, distributors, and retailers generously assisted with this project, notable thanks must be extended to Richard Shepherd of Canon Europe, Chuck Westfall of Canon USA, David Hollingsworth of Bowens International, Paul Roper of Johnsons Photopia, and Chris Whittle of the Flash Centre.

Extra thanks to Gerhard Rossbach, Jimi DeRouen and Joan Dixon of Rocky Nook for their patience and helping me turn a pile of ones and zeroes on my computer into a real live book. *rockynook.com*

David Hobby, for his elegant and thoughtful foreword, and for kickstarting a whole movement in off-camera flash. *strobist.com*

Luke Cooper, Nahum Mantra, Lee Jones, and the whole team at the Shunt Lounge and Theatre Company. London, England. *shunt.co.uk*

Garfield Hackett, Liam Hayhow, and Tim Williams, Cordy House/Mutate Britain. London, England. *mutatebritain.com*

Jiichi Asami and Harue Asami. Shibuya, Tokyo, Japan.

Andreas Alefragís, Goulas ceramic art studio. Firostefani, Santorini, Greece.

Dave Shulman, Sean Orlando, Nathaniel Taylor, and the Raygun Gothic Rocketship team. Oakland, CA, USA. *raygungothicrocket.com*

Frank James, the Royal Institution of Great Britain. London, England. *rigb.org*

The Neverwas Haul company. Berkeley, CA, USA. *neverwashaul.com*

Lyle Rowell and LRRY. Rimini, Italy. *doghead.tv*

Steampunk paraphernalia and costumes courtesy Amanda Scrivener, Cory Doctorow, Paul Ewen, Matthew Kaye, Emily Nash, Santiago Genochio. Steampunk mask by Bob Basset. *bobbasset.com* Raughnold model 81 raygun by Tom Banwell. *tombanwell.com*

Marion Goodell, Andie Grace, and Heather Gallagher. Black Rock City LLC. San Francisco, CA, USA. *burningman.com*

Shipping and logistics by Naomi Guy.

Cory Doctorow. London, England. *craphound.com*

Yomi Ayeni. London, England. *yomster.com*

Mysterious Al. London, England. *mysteriousal.com*

Ed Saperia and the Clockwork Quartet. London, England. *clockworkquartet.com*

Makeup by Kate Sheehan. Hair by Olivia Crighton. *oliviacrighton.com*

Mad scientist set design by Catie Max with the Clockwork Quartet. Steam-drone by Will Segerman and Joe Schermoly.

Costumery by Nicholas Immaculate.

Bodypaint project coordination and hair by Fiona Tanner, costume by Lucinda Dickens, body painting by Lucy Norris. *ftmakeup.co.uk*

Harumasa Masaki and Takako Suzuki. Kikunoya machi-ya heritage guest house. Kanazawa, Japan. *machiya-kanazawa.jp*

Translation by Sanae Guy.

Fact checking and excellent advice: Nadine Ohara.

Apollo 11 lunar module model courtesy Piers Bizony. Model constructed by Richard Horton and Jonathan Sturgess, Arts University College at Bournemouth. Bournemouth, England. Photographed at Ale and Porter Arts, courtesy Fiona Haser. Bradford on Avon, England.

Graffiti art by SNUB23. *snub23.com*

Original flash output data courtesy Jeremy Stein, hosted by Toomas Tamm. *www.chem.helsinki.fi/~toomas/photo*

Carters Royal Berkshire Steam Fair. *carterssteamfair.co.uk*

Chitra Ramalingam, for correspondence on the subject of her extensive research on Talbot's early flash experiments. Cambridge, MA, USA. "Stopping time: Henry Fox Talbot and the origins of freeze-frame photography." Endeavour Vol. 32, No. 3. July, 2008.

Linda McQuillan and Ken Gannon. North London Aikido Dojo. *thewellbeingcentre.org*

Flame effects by Adam Chilson. Hesperia, CA, USA. *adamchilson.com*

Gudrun Van Moock, Modeatelier La Rose. Brugge/Bruges, Belgium.

Il Canovaccio Papier-mâché Masks and Theatrical Objects. Castello, Venice, Italy. *ilcanovaccio.com*

Christoffer Rudquist, Doug Jones, Sean Delaney, Jamie Sabau, Rick Mitra, Tarek Nouar, Toby Ewers, Kalpesh Raval, Vanessa Farinha, Gunther Schmidl, Ed and Kat Chiswell Jones.

Mr and Mrs T. Matsumoto. Kanazawa, Japan.

Manuscript written using Scrivener. *literatureandlatte.com*

Extra special thanks to John and Sanae Guy and the Low family.

And finally, love and thanks to book widow Jennifer Savage who quite literally made this whole thing possible.

Models

Firas Al-Tahan, Andreas Alefragís, Kiki Anku, Hannah Ballou, India Banks, Alessandro Barbini, Zuzana Benkova, Laura Bennett, Anisah Bhayat, Emily Cullen, Aran Dasan, Kevin Davison, Cory Doctorow, Thomas Dolby, Frankie Dubery, Brandy Easter, Susan Ekpe, Kay Elizabeth, Emma, Paul Ewen, Marie Favre, Catherine Francey, Anna-Mi Fredriksson, Ken Gannon, Ash Gardner, Santiago Genochio, Diana Gershom, Everick Golding, Marco Gouveia, Jason Griffiths, Nicola Healy, Martin Hood, Michelle Huizinga, Nicholas Immaculate, Pete Johnson, Matthew Kaye, Kameron King, Lucy Lawrence the Brit Chick, Stuart Lawson, Professor Maelstromme, Linda McQuillan, Daniel Morrison, Mysterious Al, Emily Nash, Rosie Neuharth, Sean Orlando, Tony and Sarah Pletts, Ed Saperia, Jennifer Savage, Amanda Scrivener, Will Segerman, Sara Shamsavari, Alan Sherwood, Daniel Spencer, Ebelah Tate, Floyd Taylor, Hannah Terry, Willow Tomkins, Hollie Tu, Steph West, Martina Ziewe.

Manufacturers, Distributors, and Suppliers

Richard Shepherd, Canon Europe—the European arm of Japanese camera maker Canon. *www.canon-europe.com*

David Hollingsworth, Bowens International. UK manufacturer of studio flash equipment. *bowens.co.uk*

Chris Whittle and Jeff Fagg, the Flash Centre. UK retail sales and rental chain, specializing in flash lighting. *theflashcentre.com*

Hardy Haase, Flaghead Photographic Ltd. UK distributor for several manufacturers of photographic equipment, including Quantum, Ringflash, Custom Brackets, and Honl. *flaghead.co.uk*

Paul Roper, Johnsons Photopia. UK distributor for a range of photographic gear, including Sekonic, Lastolite, and PocketWizard. *johnsons-photopia.co.uk*

Lon Coleman, FlashZebra. U.S. mail order retailer of specialty flash cables and adapters. *flashzebra.com*

Paul Reynolds, Sigma Imaging UK. UK arm of Japanese lens, camera, and flash unit manufacturer Sigma. *sigma-imaging-uk.com*

MoisheAppelbaum, Midwest Photo Exchange. U.S. mail order retailer and importer, specializing in studio and portable lighting. *mpex.com*

Simon and Vaughn at Calumet Drummond Street. Calumet is a camera retailer and rental chain, with locations in the U.S., U.K., Germany, Netherlands, and Belgium. *calumetphoto.com*

Bernard Davison, RadioPopper/Leap Devices LLC. U.S. developer and maker of the RadioPopper devices. *radiopopper.com*

David Schmidt and Lorenzo Gasperini, PocketWizard/LPA Design. U.S. developer and maker of the PocketWizard product line. *pocketwizard.com*

Vic Solomon, Bogen Imaging U.K. U.K. distributor of a range of photographic equipment, including Manfrotto tripods and stands. *bogenimaging.co.uk*

Paul DeZeeuw, Cognisys. U.S. maker of the Stop Shot high-speed photography timer and accessories. *cognisys-inc.com*

Ark Biel, Universal Timer. Canadian maker of the Universal Photo Timer high-speed timer. *universaltimer.com*

Richard McKitty, Rosco Europe. European arm of U.S. filter maker Rosco. *rosco.com*

Joe Demb, Demb Flash Products. U.S. maker of the Demb flash reflectors and brackets. *dembflashproducts.com*

Peter Geller, California Sunbounce. German maker of a wide range of reflectors and collapsible panels for pro lighting. *sunbounce.com*

Quest Couch, LumiQuest. U.S. maker of a range of reflectors and diffusers for battery-powered flash. *lumiquest.com*

Cactus Marketing, Harvest One. Hong Kong manufacturer and retailer for a range of camera accessories. *gadgetinfinity.com*

Lightshop Design. Malaysian maker of the Speedlight Pro Kit line of flash accessories. *speedlightprokit.com*

Craig Colvin. U.S. maker of the Gel Holder. *gelholder.com*

Hanson Fong Photography. U.S. wedding photographer and maker of a flash reflector. *hansonfong.com*

Arthur Morris/Birds as Art. U.S. wildlife photographer and online retailer of a select line of camera accessories. *birdsasart.com*

Naomi Wiggins, enlight photo. U.K./New Zealand maker of the orbis flash adapter. *orbisflash.com*

Arnd Abraham, MINOX USA. German camera maker and distributor of camera products. *minox.com*

Ernie Fenn, Sto-Fen Products. U.S. maker of the Omnibounce flash accessories. *stofen.com*

Phil Williams, Photosolve. Maker of specialty camera accessories and Lightscoop distributor. *photosolve.com*

Anna Adrian, Joby. Maker of the Gorillapod and other accessories. *joby.com*

Collectible Cameras. Retailer of antique photographic equipment. *collectiblecameras.com*

Chapter Opening Images

Chapter 1 – Fire Spinning. A relatively long shutter time recorded the whirling loops of flame of the burning fire staff. Two flash units, a 420EX on the ground to camera left as key, and a 580EX II on-camera as fill and E-TTL master, have frozen the action. EOS 5D, 1.6 seconds at *f*/4.5, ISO 100, 30mm.

Chapter 2 – Poulnabrone Dolmen. A megalithic portal tomb, some 5000 years old, in County Clare, Ireland. Although the photo was taken a few hours before solstice sunrise, the orange glow of the sky is actually the sodium street lights of a distant town. During the three-minute exposure I walked around to the other side of the dolmen and manually fired off a Canon 580EX flash unit three times at full power. This created the bluish glow and backlit the ancient stones. EOS 5D Mark II, 3 minutes at *f*/4, ISO 200, 40mm.

Chapter 3 – Film Noir. *Crime. Tough beat, though it pays the rent, and it's the best way to hustle a paper. But tonight, there was every film noir cliché in the book, stretched out cold. Brittle and shameless, like a drunk in the park. I turned to leave, but took a shot anyway. That on-camera Speedlite 580EX II wasn't set as an optical trigger by accident.*

Speedlite 580EX to camera left, zoomed to 105mm and triggered optically using a Sonia slave device at 1/32. The flash in the Graflex reflector is actually a small electronic flash unit from a toy camera, modified and installed inside a glass bulb. It was also triggered optically, to sync with the camera. EOS 5D Mark II, 1/200 sec at *f*/7.1, ISO 200, 100mm.

Chapter 4 – From Below. Most of the photos in this book have minimal post-production alterations—usually just a bit of contrast or brightness work. This is, after all, a book on flash photography and not Photoshop techniques. However, this shot required considerably more work in post-processing. It was taken on location, not in studio, with the model standing on a sheet of clear acrylic that was inside a wooden frame built for the shot. 580EX II with shoot-through umbrella to light the model. However, because a 17mm wide-angle was used, the frame was visible around the edges. A second shot was taken with the frame out of view, and the two pictures were combined digitally.

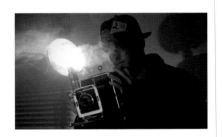

Chapter 5 – Faraday Theatre. The Faraday Theatre of the Royal Institution of Great Britain, London, England. It was here in 1864 that one of the earliest known flash portraits was taken. However, this photograph is illuminated not by magnesium wire, but by a single Elinchrom Universal 750S monolight triggered by a PocketWizard remote. EOS 5D, 1/60 sec at *f*/11, ISO 100, MC Zenitar 16mm fisheye.

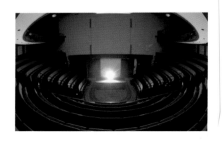

Chapter 6 – Carters Steam Fair. Carters Royal Berkshire Steam Fair, a traveling English funfair. This photograph of the circa 1895 steam-powered Gallopers carousel was taken using two 580EX flash units linked by PocketWizard ControlTL radios. The on-camera flash performs light fill, which highlights the gold leaf. The slave unit was handheld camera left to illuminate the front-most horses. EOS 5D Mark II, 1/6 sec at *f*/8, ISO 100, 24mm.

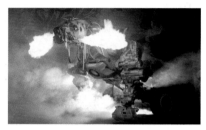

Chapter 7 – LRRY. LRRY is a walking, fire-breathing kinetic sculpture by artist Lyle Rowell. Constructed from scrap car and motorcycle parts, LRRY is powered by an automobile engine from a Citröen 2CV and is shown here at Mutate Britain's 2009 exhibition. *doghead.tv* and *mutatebritain.co.uk*. Graffiti art by Elate and Vibez.

Chapter 8 – Seven Masks. Historic Japanese Noh masks, courtesy Noh master Jiichi Asami of Shibuya, Tokyo, Japan. 580EX II flash unit on an off-camera shoe cord, shooting into a Westcott collapsible silver umbrella. Each mask was shot individually. EOS 5D, 1/60 sec at *f*/4, ISO 100, 70 mm.

Chapter 9 – The Whole Family. A representative of every E-series Canon Speedlite produced between 1986 and 2009.

Chapter 10 – London Eye. Snowfall over the London Eye Ferris wheel. A 580EX II flash unit was handheld over the camera and triggered manually at half power in order to illuminate and freeze the falling snow. Without flash the fast-moving and dimly lit snowflakes would not have recorded in the final picture. EOS 5D, 0.8 sec at *f*/5.6, ISO 100, 22mm.

Chapter 11 – Goulas Ceramic Studio. Firostefani, Santorini, Greece. On-camera 580EX as E-TTL master, set to 1/64 power in manual mode for slight foreground fill. 580EX II with full CTO gel on shelf below the seahorse, illuminating the back wall as E-TTL slave. EOS 5D Mark II, 1/15 sec at *f*/8, ISO 100, 55mm.

Chapter 12 – Motorbike. An EOS 5D was attached to the motorcycle's handlebars using a Manfrotto Magic Arm and SuperClamp. A 580EX II was mounted on-camera and fired in E-TTL mode with the diffuser panel down. Safety note: the setup was extensively tested on a motionless bike before proceeding, as a blinded motorcyclist is not something anyone would want. 0.4 sec at *f*/5 to ensure motion blur of the areas not lit by flash, ISO 100, 17 mm.

Chapter 13 – Steampunk. *With a sharp twist of his cane, Dr. Lymington-Ffyfe prised open the ancient Gladstone bag whence the mysterious ethereal energy emanated. In utter silence, a brilliant yet insubstantial luminous globe burst forth, to hover unassisted and resplendent above the table, coldly indifferent to the astonishment of the assembled Guild. Light of a purity rarely seen by mortal man pierced the Stygian gloom. "By Jove!" cried the Aviator in unalloyed wonder. "Who could have known that the evil Captain Synge possessed so formidable a source of power?"*

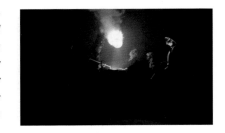

Elinchrom Ranger Quadra inside a foam sphere on a boom over the table, triggered by an EL-Skyport. Two Speedlite 580EX IIs inside the bag, firing at manual full power and triggered by one Elinchrom EL-Skyport Universal and one Sonia optical slave. EOS 5D Mark II, 1/60 sec at *f*/4, ISO 100, 24mm.

Chapter 14 – Mysterious Al. In 1949, photographer Gjon Mili visited Pablo Picasso in France. Together they hit upon the idea of painting with light, which is simply sketching out a picture in the air using a flashlight in total darkness. Here artist Mysterious Al demonstrates the same technique. Handheld 580EX II zoomed to 105mm fired at 1/32 manual power at the end of the drawing. EOS 5D Mark II, 25 sec at *f*/4, ISO 400, 29mm.

Chapter 15 – Blue Water Drop. 580EX II with blue gel, positioned behind a sheet of white paper. 430EX II with red gel located camera right. ST-E2 as wireless E-TTL trigger. *f*/6.3, ISO 100, 100mm macro.

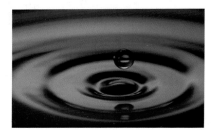

Conclusion – Bamboo. Sagano bamboo forest. Kyoto, Japan. Sometimes flash can be used to very subtle effect. This photo uses predominantly ambient lighting, but a 580EX II was fired at full power to lighten the color of the nearest bamboo trees, providing a little more depth to the scene. 0.6 sec at f/11, ISO 100, 17 mm.

Appendices – Star Trails over Mobius Arch. This rock formation is sometimes referred to as Galen's Arch in honor of late mountaineer and nature photographer Galen Rowell. Alabama Hills, Owens Valley, California, USA. The picture was taken over a one-hour period, facing north so that the Earth's rotation would be recorded as trails of stars appearing to turn around Polaris. Exposure was allowed to continue until shortly before moonrise so that the gradual lightening of the sky would reveal the distant rocks and hills as a silhouette. While the shot could have been done as a single exposure, this particular image consists of about 80 individual 45-second exposures, taken using an interval timer and stacked together digitally to keep noise to a minimum. During the last exposure, a single half power burst of flash from a 580EX II, equipped with a 1/2 CTO filter, was fired by hand. This illuminated the arch, which would otherwise have been completely black. EOS 5D Mark II, 80x 45 sec at f/4, ISO 200, 17mm.

Index